INÁCIO
JULY 2005

The Maecenas and the Madrigalist

The Maecenas and the Madrigalist

PATRONS, PATRONAGE, AND THE ORIGINS OF
THE ITALIAN MADRIGAL

Anthony M. Cummings

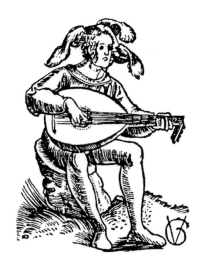

American Philosophical Society

PHILADELPHIA

2004

Memoirs of the American Philosophical Society
Held at Philadelphia
For Promoting Useful Knowledge
Volume 253

Library of Congress Cataloging-in-Publication Data

Cummings, Anthony M.
 The Maecenas and the madrigalist : patrons, patronage, and the origins of the
Italian madrigal / Anthony M. Cummings.
 p. cm. — (Memoirs of the American Philosophical Society held at
 Philadelphia for Promoting Useful Knowledge, ISSN 0065–9738 ; v. 253)
 Includes bibliographical references.
 ISBN 0–87169–253–8
 1. Music patronage—Italy—Florence. 2. Madrigals, Italian—Italy—16th
 century—History and criticism. I. Title. II. Memoirs of the American
 Philisophical Society ; v. 253.
 Q11.P612 vol. 253
 [ML290.8.F6]
 780'.79'4551—dc22
 2004054782

Contents

Illustrations and Musical Examples

ILLUSTRATIONS

MUSICAL EXAMPLES

Preface

MUSICAL life in early sixteenth-century Florence was characterized by variety in the forms of patronage activity, which can be roughly classified and distinguished from one another. The contrasting stylistic characteristics of the principal Florentine musical repertories of the time may be described in relation to that variety.

The late Eric Cochrane offered the following useful taxonomy of agents of patronage: (1) princes; (2) private patrons, who, "anticipating the salons of the eighteenth century, associated as equals with the artists and writers they regularly invited to their houses"; (3) the academy; (4) preparatory schools; and (5) the printing presses.[1] Primary historical sources from early Cinquecento Florence contain illuminating and important documentation of the activities of various kinds of informal, quasi-private institutions that flourished there—not only informal literary societies or academies of the type included in Cochrane's second and third categories (such as the group that met in the garden of the Rucellai and the Sacred Academy of the Medici), but also convivial companies (such as the Companies of the Palaiuolo and Cazzuola) and organizations of young aristocrats with overt political ambitions and objectives (such as the Companies of the Broncone and Diamante). The membership rosters and musical activities and programs of these institutions can be reconstructed on the basis of the extant primary material. Interesting insights into the musical culture of early Cinquecento Florence and the musical experiences of early Cinquecento Florentines are afforded by these sources. Their principal music-historical significance is that they illuminate the ultimate origins of the Italian madrigal of the sixteenth century, which was a direct reflection of the specific patronage practices that produced it, especially in its stylistic properties.

Ironically, the most loosely organized of these Florentine institutions of the early Cinquecento—the famous group that met in the garden of the Rucellai—was in many respects the most consequential, both with respect to the distinction of its members and the substance of its intellectual program, which are reflected in the fullness of the documentation. Its significance notwithstanding, the Rucellai group—an informal "literary society"[2] distinguished by directed and purposeful conversation on literary and political matters and restricted commensality—is never referred to by contemporaries in more specific or enlightening terms than "our company,"[3] "these afternoon friends,"[4] or "those *letterati* of the garden of the Rucellai."[5]

The closely related institution known as the Sacred Academy of the Medici was more formally organized, to judge from its regularized protocols, the nomenclature used to refer to it, and its concrete programmatic activities. The terms of reference are "Florentine Academy,"[6] "Sacred Gymnasium,"[7] or "Sacred Academy,"[8] and the Academy commissioned the editing of texts and undertook other specific initiatives designed to conserve and celebrate the Florentine literary past, such as the return of Dante's remains from Ravenna to Florence.

The Company of the Cazzuola (which organized informal dinners and staged performances of the leading Florentine comedies of the day) and the Companies of the Broncone and Diamante (groups of young Florentine aristocrats with responsibility for Florentine carnival festivities) are never referred to other than as *compagnie*,[9] a term that although reminiscent of the casual nomenclature applied to the Rucellai group, in this case does not necessarily suggest as informal an organization. In fact, the Company of the Broncone had formal articles of association such as those drafted to govern the operation of medieval commercial partnerships.

Indeed, the use of the term "company" in the context in which it appears in this study evokes associations with two similar contemporary institutions: the religious confraternity[10] and the business partnership.[11] A medieval company in the second sense assumed a contractual agreement—joint and unlimited liability on the part of all compagni—among its members, who originally were from same family; eventually, the company extended the privileges and responsibilities of partnership to nonfamily members as well, although they were customarily related through marriage or other kinds of personal associations.[12]

Such features also typify the Companies of the Cazzuola, Broncone, and Diamante, as the commonality of nomenclature itself suggests. The convivial and political companies had a familial character to them, in the specific sense that the Diamante counted two of the Medici and two of their Rucellai in-laws among its members; relationships among members of the various companies resulting from intermarriage were even more numerous and significant. More importantly, in the case of the Broncone, the formal statutes specify an organizational structure, assign responsibility for specific administrative functions, establish a mechanism for the accumulation of resources (entrance fees), and outline organizational objectives; they articulate protocols for the pooling of capital—both human and material—and the sharing of liability for the company's ventures.

Ultimately, the use of the term "company" for the Rucellai group on the one hand and the Cazzuola, Broncone, and Diamante on the other suggests that a fundamental distinguishing characteristic and motivating principle for all of them was merely a delight in fraternal fellowship. In that respect they were companies simply in the sense of loose gatherings of "companions,"[13] a word whose etymological origins in the medieval Latin *cumpanis*—"one eating the same bread"[14]—are identical to that of "company."

The members of the Company of the Diamante were sons of men who had been members of Lorenzo il Magnifico's similar Company of the Magi in the late Quattrocento; the Company of the Broncone was formed expressly to compete with the Diamante. The Company of the Cazzuola appears to have been self-perpetuating with respect to its membership: members selected future members, presumably on the basis of their collegiality, profile, and potential to contribute to the company's formal and informal programs. The members of the Rucellai group were probably identified on the basis of the least highly articulated protocols of all: Cosimino di Cosimo Rucellai (and his grandfather Bernardo before him) invited those considered to be especially *simpatici* to the informal gatherings in the family garden. The overlap in membership among the groups is noteworthy, as is the complex network of relationships that linked individual members of these institutions to one another. These interconnections are treated in detail throughout this book and more specifically in the Conclusion, where their significant effects are assessed.

Although membership in these associations sometimes entailed specific responsibilities, in most cases there was the expectation that members would do little more than convene regularly with their companions for food, drink, and conversation, whether academically substantive conversation or sexually suggestive (and these institutions embraced both sorts of discourse, which need not, of course, have been mutually exclusive). Music—whether performed by the members themselves, commissioned by them, or otherwise experienced by them as an audience—was essential to the complex of elements that constituted the institutions' programs. The distinctive and contrasting objectives, purposes, programs, activities, and cultural output of these various institutions are described in detail in the chapters that follow.

The relevance of these informal institutions to the origins of the Cinquecento madrigal, the most important secular genre in the musical culture of early modern Europe, is as follows.[15] It is known that the first essays in the new genre were composed in Florence around 1520 by Florentines and northern composers working there. But less is known about the precise conditions under which they were composed. A failure to account satisfactorily for the origins of the new genre results from a concomitant failure to consult the appropriate historical sources. Much of the scholarship on Florentine musical traditions of the early modern period has been based on archival materials documenting the musical practices of public, corporate institutions of ecclesiastical patronage: the Cathedral and Baptistery of Florence, other conventual churches, and similar institutions. Given the nature of the madrigal as a secular musico-literary genre, information concerning its origins would not be found among the records of such institutions. The relevant information is instead found in source materials documenting the musical practices of the literary societies and convivial and political companies of the early sixteenth century. Virtually all of the leading Florentine artistic, intellectual, and political

figures of the time—Michelangelo; Machiavelli; the Florentine historians Bartolomeo Cerretani, Jacopo Nardi, and Filippo de' Nerli; the political theorist Roberto Acciaiuoli; several of the Medici, the Rucellai, and the Strozzi; and many others—were members of such institutions. The earliest madrigal composers—the Florentines Francesco de Layolle and Bernardo Pisano and the northerner Philippe Verdelot—were either intimates of the institutions' members or were members themselves; as is well known, Verdelot wrote some of his earliest madrigals to be sung between the acts of comedies by Rucellai group member Niccolò Machiavelli. In undertaking their first essays in the new genre, the earliest madrigalists played to the musical tastes and experiences of the distinguished Florentines who were their patrons. Insofar as the musical activities of such institutions can be reconstructed, the conditions of patronage that lay behind the emergence of the new genre can be illuminated. The musical properties of the earliest madrigals were in an important sense shaped by those of works performed at meetings of these contemporary informal institutions.

Other scholars have advanced arguments about the importance of academic activities to the origins of the madrigal. Iain Fenlon and James Haar signaled the importance of such institutions in their fundamental 1988 monograph.[16] Martha Feldman's excellent book *City Culture and the Madrigal at Venice*[17] also emphasizes the importance of academies and academic life to the madrigal as a cultural phenomenon.[18] As the sixteenth century wore on, the significance of academic life and activities for the musical culture of Italy increased, as suggested by the following examples: the madrigal composed by Giovanthomaso Cimello for a comedy performed by the Accademia de' Sereni in Naples;[19] the musical components of the performance of Sophocles' *Œdipus* staged by the Accademia Olimpica in Vicenza;[20] the kinds of musical activities that must have typified the program of the Accademia Filarmonica of Verona;[21] the musical practices of the Accademia della Morte of Ferrara, which employed Luzzaschi and Frescobaldi as organists;[22] G. M. Artusi's account of the performance of madrigals in "the house of Signor Antonio Goretti, a nobleman of Ferrara, a young virtuoso and as great a lover of music as any man";[23] and the activities of such Venetian institutions as the Accademia degl'Incogniti and the Accademici Discordati, which cannot properly be classified with the Accademia Olimpica and Accademia Filarmonica but nonetheless are of crucial importance in the history of Italian opera.[24] Laura Macy's interesting article on sexual metaphors in the language of the Cinquecento madrigal also suggests the importance of academic settings for music-making and for the musical culture of the time, especially in Florence.[25]

What is offered here is the fullest available account of the cultural—and specifically musical—activities of the academic societies and convivial and political companies that flourished in the place where the madrigal originated, early Cinquecento

Florence. Above all, this book is a study of the styles, forms, and conditions of patronage that explain the emergence of the Cinquecento madrigal and its distinguishing stylistic characteristics in its earliest incarnation, and specifically of the importance of Medici patronage to the early madrigal. To this day, the Italian words for patron (*mecenate*, i.e., maecenas) and patronage (*mecenatismo*) pay overt and explicit tribute to the ancient Roman statesman and patron Maecenas, benefactor of Horace and Vergil. The book's title was suggested by the importance to its thesis of the traditions of patronage, by Italians' linguistic homage to Maecenas, and by the evidence of the tendencies toward classicization overlaying many of the patronage practices that explain the emergence of the sixteenth-century madrigal.

Acknowledgments

I WELCOME the opportunity to acknowledge my indebtedness to my fellow *italianisti* and others, whose criticism and assistance were invaluable. My friend Professor Daniel E. Bornstein of the Department of History at Texas A&M University read a draft of the Introduction and offered a number of penetrating and helpful observations; I am grateful to him. Several colleagues and friends at Tulane University—Professors George L. Bernstein (Dean of Tulane College), James M. Boyden, Linda A. Pollock (Associate Dean of the Faculty of the Liberal Arts and Sciences), and the late Charles T. Davis of the Department of History, and Linda L. Carroll of the Department of French and Italian—cheerfully and graciously answered numerous questions on various matters; I am grateful to them and regret so very much that my dear colleague Charles Davis did not live to see this book. I owe a very special debt to my esteemed colleague and friend Professor Carroll, who read the entire manuscript with an impressive thoroughness and sensitivity; I am so very grateful to her for having undertaken and completed so ungratifying a task. Professor Frank A. D'Accone—*doyen* of musicologists who work on Florentine subjects—read an early version of my manuscript and suggested improvements. My friend Professor Donna G. Cardamone Jackson of the University of Minnesota read the section on the courtesan La Nannina Zinzera and suggested a richer interpretation of the material than I had initially attempted; I am grateful to her. My old friend Dr. Sabine Eiche of Florence assisted in many ways, particularly by securing photographs of images reproduced here. Dott. Giuliano di Bacco located important unpublished documents, arranged for photocopies, and graciously undertook transcriptions. My friend Dr. Sheryl E. Reiss—the author of an important Princeton doctoral dissertation on Cardinal Giulio de' Medici as a patron of art—has always willingly and generously shared important materials with me and responded to my endless questions. Similarly, Dr. Alexandra Amati-Camperi—the author of an important Harvard doctoral dissertation on Philippe Verdelot—shared critical materials and answered numerous queries. Professor William Prizer of the University of California at Santa Barbara generously shared numerous unpublished documents and thoughtfully permitted their publication here for the first time. Professor Richard Sherr of Smith College answered several questions and also willingly furnished unpublished material.

Fifteen years ago, the late Felix Gilbert—distinguished historian and former member of the School of Historical Studies at the Institute for Advanced Study in

Princeton, New Jersey—suggested to me the importance of the garden academies and informal literary societies of early Cinquecento Florence. His thesis was precisely the one I present here: that in the absence of more regularized, more formalized institutions of patronage during the complicated period of political transition between 1512 and 1530, the informal societies were of critical importance to the secular cultural life of sixteenth-century Florence. In the absence of a stabilized tradition of Medicean patronage comparable to that of the Laurentian Florence of the late Quattrocento, there was no true secular parallel to the formal patronage practices of the ecclesiatical institutions, and the informal quasi-academic salons furnished what there was in the way of organized patronage activity. Professor Gilbert's advice proved to be immensely profitable; I do wish that he might have lived to see the result.

The musical examples for this book were expertly prepared by three students at Tulane University, music majors all: Jennifer A. Gosnell (Newcomb College '03), Joseph M. Mace (Tulane College '03), and James Shoemaker (Tulane College '04). I am very grateful to them.

I completed some of the research for this book at the Biblioteca Berenson at Villa I Tatti, The Harvard University Center for Italian Renaissance Studies, Florence; anyone who has had the privilege of being associated with I Tatti will understand immediately why I hasten to express my gratitude to then director Professor Walter J. Kaiser, to the immensely talented Dott. Gino Corti, and to the able and energetic staff. For similar reasons, I am grateful to another institution: the Newberry Library in Chicago, which permitted me to consult its extraordinarily rich holdings on early modern Europe.

Two colleagues and friends here at Tulane—Sarah Richards Doerries, Assistant Director of Student and Alumni Programs at Tulane College and former Editorial Assistant for *The Southern Review*, and Mary Ann Travis, Senior Editor in the Office of University Publications—edited the manuscript and suggested numerous improvements in my presentation, virtually all of which I gladly accepted; I am extremely grateful to them.

I always welcome the opportunity to acknowledge my debt to my mentor in life, William G. Bowen, president emeritus of Princeton University (where I reported to him as a member of his administrative council) and current president of The Andrew W. Mellon Foundation (where I subsequently reported to him as a member of his program staff). In this instance, it was Dr. Bowen who suggested that I consider the monograph series published by the American Philosophical Society as a possible venue for the publication of my book. His advice, as ever, proved to be invaluable, and the American Philosophical Society proved to be the ideal publisher for my book. I am grateful to Dr. Bowen and to Mary McDonald, Editor at the American Philosophical Society, to Drs. Richard S. Dunn and Mary Maples

Dunn, Co-Executive Officers of the American Philosophical Society, M. Yvonne Ramsey, copy editor, and Fred Thompson, project manager.

Publication of this book in the American Philosophical Society's *Memoirs* series was supported with a generous subvention from The Lila Acheson Wallace/ Reader's Digest Publications Subsidy at Villa I Tatti, Florence, for which I am enormously grateful.

My book is lovingly dedicated to the memory of my dear late mother, from whom I inherited my love of music, my love of Italy (her parents' homeland), and much else, for which I shall forever be thankful.

The Maecenas and the Madrigalist

Introduction

THE ITALIAN madrigal of the sixteenth century originated in the cultural practices and activities of informal, private institutions of patronage in early Cinquecento Florence. The importance of such institutions to the emergence of the new genre has been incompletely appreciated by scholars. The principal public institutions of musical patronage of the time, quite apart from their status as ecclesiastical institutions, were not characterized by the requisite organizational culture and conditions of patronage that would have stimulated and supported experimentation with new secular musico-literary genres such as the madrigal. These public, formal ecclesiastical institutions have been the subject of essays by Professor Frank A. D'Accone, who has shaped current understanding of the musical culture of late medieval and early modern Florence.[1] D'Accone's studies are based principally on archival materials documenting the musical activities and patronage practices of the Florentine Cathedral and Baptistery and similar institutions. The information contained in such materials relates to the membership of the musical establishments at such institutions, the compensation of the members, and so on. Professor D'Accone's published work is thus concerned—principally though not exclusively—with musical practices and traditions of patronage of a certain type. It is a critically important type, but only one type nonetheless.

Documentation for the activities of the contemporary informal private institutions substantiates on historical grounds a thesis on the origins of the madrigal advanced on musical grounds by Walter Rubsamen and Joseph Gallucci. I attempt in this book to reconstruct the activities and programs of the private associations, and I marshal evidence that they supported the composition and performance of precisely those genres identified by Rubsamen and Gallucci as important source musics for the Cinquecento madrigal. Before considering the historical references assembled here, it is necessary to place the Rubsamen-Gallucci thesis into the context of important musicological opinion concerning the origins of the Cinquecento madrigal in order to evaluate its distinctiveness and validity.

ALFRED EINSTEIN

Alfred Einstein's magisterial three-volume study of the Italian madrigal offers complex and imposing arguments concerning the origins of the genre.[2] However, there are difficulties with his thesis. Einstein was intent on advancing an argument

about continuities between the north-Italian genre of the *frottola* (typified by the opposition of a vocal soloist and instrumental accompaniment) and the madrigal (a Florentine genre in its earliest incarnation, typified by an all-vocal conception). Such an argument imposes a symmetry on complex historical dynamics and is thus difficult to sustain.[3] Iain Fenlon and James Haar also observed that Einstein (and others) were guilty of a "sin of cultural evolutionism" when they saw "fully-texted, fully-'vocal' polyphony as a condition to which Italian song aspired and which it attained in order to make possible the development of the madrigal."[4] Indeed, Einstein committed a sin of cultural evolutionism and saw tidy continuities where there may have been none: the frottola and madrigal are not on the same continuum. Within specifically Florentine musical traditions, however, there is, in fact, a continuum leading from Florentine secular antecedents of the madrigal at one end to the madrigal itself at the other. An evolutionary argument is more convincing, less contrived and strained, and less susceptible to the charge that it entails a sin of cultural evolutionism when advanced in reference to the appropriate cultural tradition. Some of those elements of continuity were identified by Rubsamen and Gallucci, who thus avoided Einstein's ultimately unsustainable argument about the frottola as a direct musical antecedent of the new musical genre.

Walter Rubsamen

Rubsamen,[5] alternatively, noted a connection between the Florentine carnival song and the "new" *chansons* of Antoine Bruhier, Antoine Brumel, Loyset Compère, Jean Mouton, and Ninot le Petit, which he identified as an important source music for the madrigal.[6] As examples of the latter genre, he cited Ninot's *En l'ombre d'ung aubepin;* Bruhier's *Frapez petit coup* and *Jacquet, jacquet;* and Compére's *Alons fere nos barbes.*

Rubsamen further argued that the Franco-Netherlanders were the first to elaborate Italian popular tunes polyphonically and use them in an entirely vocal context, thus laying the groundwork both for the future *villotta* and the equivalence of textually conceived voice parts in the madrigal. As examples, he cited Heinrich Isaac's quodlibet *Donna di dentro,*[7] Compére's *Che fa la ramançina,*[8] and Josquin Desprez's *Scaramella va alla guerra.*[9]

Rubsamen emphasized the importance of Michele Pesenti, one of the first Italian composers of the Cinquecento to write works in textually conceived imitative counterpoint. He also made special mention of Sebastiano Festa, who in his setting of the Petrarchan sonnet *O passi sparsi* comes closer to the madrigal in one important respect—expressiveness—than any of his Italian contemporaries.[10] Rubsamen cited Festa's *L'ultimo dì di maggio* as evidence of both the composer's familiarity with purely vocal elaborations of Italian popular melodies and the relationship between the early madrigal and the villotta.

Most of the forces at play in shaping the early madrigal are represented directly or indirectly in the Florentine manuscript Florence, Biblioteca Nazionale Centrale, Magliabechiano XIX.164–67, which dates from around 1520:[11] (1) the protovillotte of Josquin and Compère, which led to Pesenti's works in the same vein; (2) the polyphonic Florentine carnival songs of Isaac; (3) the "new" chansons of Ninot, Brumel, Bruhier, and Compère, which closely resemble the Florentine *canto carnascialesco;* and (4) the protomadrigals of Festa, which fuse the homorhythmic, homophonic style of the frottola with the equivalence of parts created in the image of their poetry and a preference for Petrarchan texts. The most necessary feature of the madrigal—the parity of textually conceived voices—is inherited from the new chanson and Italian compositions of the Franco-Netherlanders, the Florentines, and Michele Pesenti.

Joseph Gallucci

Gallucci[12] focused more narrowly on the Florentine carnival song and related festival music as exercising a formative influence on the new genre, citing several affinities between them. Carnival song texts—particularly in their allusions to history and mythology—represent a higher literary standard than frottola texts, which may have resulted from Lorenzo de' Medici's late Quattrocento Florentinist efforts to enhance the quality of vernacular literature; Jacopo Nardi, a distinguished playwright, historian, and translator of Livy, was the author of carnival-song and festival-music verse.[13] Gallucci further suggested that the literary relationship between the carnival song and the madrigal was not limited to content but extended to poetic form. The free alternation of seven- and eleven-syllable lines typical of some carnival-song verse anticipates the freedom of madrigal verse and contrasts with the formulaic metrical schemes found in the frottola repertory. Gallucci also characterized canti carnascialeschi as manifesting a greater tendency toward strophic through-composition; the determining principle is proper declamation of text, which discourages the musical repetitions motivated by the repeated elements in the text that are characteristic of the frottola repertory. The concern with the text brings the canti closer still to the aesthetic principles of the madrigal. In addition, all-vocal performance sharply distinguishes the canto carnascialesco from the frottola. Finally, the chordal style of the early madrigal finds rather few precedents in the frottola literature but a great many precedents in the carnival-song literature.

Iain Fenlon and James Haar

Iain Fenlon and James Haar elaborated particularly on Rubsamen's observations about the importance of the French "new" chanson specifically as an antecedent of the madrigal:

> Given the evident popularity among Florentine aristocrats of this chanson style, with its fully-texted, four-voice texture, syllabic declamation, and alternation of imitative entries with chordal patter, one wonders whether the madrigal style of Verdelot and his Florentine contemporaries, in many respects an adaptation to Italian texts of just these chansonesque properties, was a direct response to the aristocratic tastes of patrons.[14]

Professors Fenlon and Haar suggest that composers of Italian secular music adapted the textural and declamatory properties of the French chanson, specifically the chordal patter of the lighter chansons of Petrucci's *Canti C* (1504). They further argue that if frottola settings did not provide Verdelot with needed models of Italian declamation, the work of Sebastiano Festa did, as did much of the villotta repertory circulating in the 1520s. They suggest that anomalous as it may seem, patrons of the early madrigal—concerned with reviving and extending the vernacular tradition of Tuscan poetry—favored a musical style in part foreign to the native tradition; Italian secular song, they argue, may have seemed either too much identified with the popularizing styles of the Quattrocento, to which the frottola was heir, or too austerely polyphonic, as in the ballata cultivated by Isaac and his contemporaries, to allow for direct and affective enunciation of the text.[15]

There is also a thesis—not fully and explicitly articulated and developed, at least in print, but alluded to obliquely[16]—that the patronage of the Strozzi was in some way more important to the emergence of the madrigal than the patronage of the Medici, which runs counter to an earlier thesis advanced by Nino Pirrotta.[17] This alternative thesis, to which Professors Fenlon and Haar subscribe, is based on a few documents in the Strozzi papers in the Florentine archive[18] and also on the putative relative absence of similar documentary references to Medici patronage of early madrigalists. Although documentary evidence for Medici patronage of the early madrigal is in fact more extensive than has been recognized by those subscribing to the alternative thesis, it is nonetheless true that there are relatively few references to Medici patronage of the new genre among the archival references published by D'Accone, which constitute the principal documentary basis for the alternative thesis.

Documents pertaining to the musical activities of the Florentine Cathedral and Baptistery would not contain references to Medici patronage of the early madrigal. To argue from the absence of such references that the Medici did not evince much interest in the early madrigal is tantamount to arguing that the musical culture of the court of Louis XIV cannot have been very remarkable because there are no references to it in the records of the Cathedral of Notre Dame of Paris. If one looks for documentary evidence for Medici patronage of the early madrigal in the archival references published by D'Accone, one is looking in the wrong place.

Professors Fenlon and Haar wrote as follows:

The memory of the glories of the Laurentian past was powerfully evoked in a variety of ways after the [Medici] restoration [of 1512] as part of a calculated attempt to consolidate the new regime, to establish its continuity and legitimacy. The re-establishment of the chapels [of the Cathedral and Baptistery] was clearly part of this wider consideration, and the manner in which it was achieved reveals the Medici's keen appreciation of the political benefits of open involvement in the affairs of these cherished symbols of civic pride and public piety. Such calculations had served them well before and were to do so again. But, as will be seen, *this interest did not much extend to the new song forms, private and familial, but rather was concentrated on public and institutionalised repertories* [emphasis added]. In effect, the body which Verdelot was appointed to direct [the *cappella* of the Florentine Cathedral] was the nearest thing to a court chapel that the Medici could hope to achieve in the fragile semi-Republican atmosphere of the early sixteenth century. For all their connections with the ruling family, the Cathedral and Baptistery remained the focal point of communal worship.[19]

Underlying this passage are assumptions about the central importance of the traditions of the Cathedral and Baptistery to Florentine musical culture of this time and about the nature of Medici musical patronage in the early sixteenth century. They are, I believe, assumptions resulting from the absence of evidence to the contrary. In its reference to the effect that Medici interest "did not much extend to the new song forms, private and familial, but rather was concentrated on public and institutionalised repertories," the passage accurately summarizes the evidence assembled in D'Accone's studies, but it does not take adequate account of the possibility that there are other kinds of documentary evidence that D'Accone did not utilize, and understandably so, given the circumscribed focus of his studies. If one accepts the testimony of D'Accone's work at face value, the practices of the Cathedral and Baptistery indeed appear to be of unrivaled importance to the musical culture of early Cinquecento Florence. Further, in the absence of extensive evidence of Medici interest in the early madrigal in the documents he published, one is led to assume that Medici interest was instead concentrated more or less exclusively on "public and institutionalised repertories."

Important as the musical practices of the Cathedral and Baptistery were, Florentine musical culture of this period cannot be understood exclusively or even principally in such terms. There is an abundance of evidence that suggests the Medici were considerably more active as private patrons of music than has been supposed and is assumed in recent studies of the origins of the Cinquecento madrigal.[20] Such evidence is reviewed and evaluated in Chapter 4.

This book substantiates Rubsamen and Gallucci's thesis on the importance to the origins of the madrigal of the particular antecedents they identified, specifically the Florentine carnival song, and especially as their thesis contrasts with Fenlon

and Haar's about the importance of French antecedents. It also seeks to restore the Medici to a position of central importance in the complex network of patronage practices that explains the emergence of the new genre. The cultural activities of the informal institutions of patronage reconstructed here are documented by revealing testimony to the origins of the madrigal, which has yet to be considered with due thoroughness. The influence of the musical traditions of these institutions on the development of the madrigal was significant, especially in light of the fact that they were institutions where the cultural and intellectual interests of an important group of Florentine letterati were given expression.[21]

With respect to their capacity to support the kind of musical practices the new genre represents, such organizations had inherent virtues as institutions of patronage and afforded clear advantages over other kinds of contemporary institutions, for any number of reasons. Their private, more intimate, even domestic scale afforded a kind of flexibility and capacity for experimentation that larger, better established public institutions could not have supported so readily, given their better defined and more routinized traditions and practices and their better articulated public role in the society. The private, in some cases informal, institutions were bound by no particular set of inherited protocols and could therefore indulge an interest in new forms and genres and emerging traditions. Such institutions were more familial in character, less like the great public institutions; they inspire one to view them as exemplifying a kind of associational history, or even as a general extension of family history. And although the members of the private associations were often aristocrats—representatives of that same Florentine social elite whose members populated the public government magistracies—the nature of and institutional setting for their activities in this context were altogether different in kind from those of the government magistracies. In some cases, the private institutions in question are characterized by complex membership profiles that contrast with those of the great public institutions; the Company of the Cazzuola accommodated a range of socioeconomic types and biographical profiles in a way that defies easy categorization of the company with respect to the character of its membership and all that might entail in the way of programmatic objectives, commonality of purpose among the members, and so on.

Such informal institutions and private settings have a venerable place in the history of Italian music of the early modern period. Already in the mid-fifteenth century, there is a reference to the composer Arnulphus Gilardus's having composed a piece "in the renowned evergreen gardens of Cosimo [de' Medici]," [22] which suggests "that the musical pastimes of this high-bourgeois family usually went on in their private gardens." [23] Evidence from other centers of patronage substantiates testimony documenting Florentine practice: in sixteenth-century Rome, Francesco Berni (1498–1535), M. Giovan Francesco Bini (ca. 1485–1556), M. Lelio Capilupo,

Monsignor Giovanni della Casa (1503–56), Abbot Agnolo Firenzuola, Signor Pietro Ghinucci, Giovio da Lucca, Lucio Mauro, and M. Federigo Paltroni—all members of the Accademia dei Vignaiuoli, which was founded shortly after 1532—would gather almost daily at the home of Uberto Strozzi, where their meetings included musical performances.[24] Both Berni and Capilupo were poets whose verse finds reflection in the Italian musical culture of the sixteenth century, and in that respect their situation is precisely parallel to that of various members of the group that met in the Rucellai garden in Florence in the early sixteenth century.[25] Similarly, Angelo Colocci was the proprietor of one of the most renowned sculpture gardens, where he would host antiquarian banquets; here, too, musical performances might well have taken place.[26]

In early Cinquecento Florence, during precisely the period when the sixteenth-century madrigal emerged, such private institutions of patronage were of particular importance because of the complex and mutable political conditions of that "Machiavellian moment," to invoke J. G. A. Pocock's felicitous phrase.[27] At that time, there was no aristocratic court in Florence in any formal, constitutional sense; the establishment of the Medici principate was still some years in the future. Moreover, the de facto aristocratic court traditions of the Quattrocento had essentially disappeared with the exile of the Medici in 1494, and the restored Medici regime (1512–27) had some distinctive characteristics that would have complicated an inclination to restore the productive secular Laurentian patronage practices of the late Quattrocento precisely as they had been organized at that time. The principal representative of the Medici family in the early sixteenth century was an ecclesiastic, Cardinal Giovanni di Lorenzo ("il Magnifico"), who was elected pope in March 1513, a little more than six months after his family's restoration to Florence in September 1512. His younger brother Giuliano soon followed Leo to Rome. Giuliano's successor as his family's principal representative in Florence—Leo and Giuliano's nephew Lorenzo di Piero di Lorenzo il Magnifico—was young, spoiled, and ineffectual, hardly the sort of individual with the requisite personal resources and cultural interests to recreate a vital tradition of organized Medicean patronage.

Where would composers and letterati with an interest in experimenting with new secular genres find an outlet for their compositional activity? The informal academies and companies furnished the necessary institutional infrastructure for the activity of the earliest madrigal poets and composers. Apart from private household patronage, there was no other infrastructure of any real consequence in early Cinquecento Florence that might have served this purpose, no viable and substantial alternative institutional framework that might have supported such secular musical activity. And the academies and companies—by virtue of their greater size, quasi-formal status, and eminent membership—provided a more robust infrastructure than most private patrons could furnish independently within the confines of their private household.

(This is not to suggest, however, that any number of private patrons were not adequately positioned to support patronage practices independently. One has only to recall that the sixteenth-century descendants of the principal fifteenth-century representatives of the Medici, Pazzi, and Rucellai families inherited substantial wealth from their ancestors. The 1457 *catasto* documents that only three families of the more than seventy-five hundred who filed returns paid taxes in excess of one hundred florins; two of the three were the Medici and the Rucellai, whose families furnished many of the most prominent members of the societies and companies of the early Cinquecento; the Medici bank, moreover, was the largest such institution of its time. And of the eight families that paid taxes of between fifty and one hundred florins, two of them were Pazzi, represented by their descendant Alessandro, a member of several of the early Cinquecento societies and companies.[28])

The informal institutional infrastructure provided was often material as well as human, in the sense that some of these early Cinquecento organizations had substantial physical spaces associated with them (such as the family garden of the Rucellai), where cultural activity could be well accommodated and supported. The members of the academies and companies were a remarkably distinguished group, and the organizations they populated were the principal patronage organizations at the very moment when the first madrigals were being composed. Whether entirely consciously or not, the private institutions perceived a vacuum, assumed—indeed asserted—traditional aristocratic prerogatives with respect to cultural patronage, and claimed a role that had been effectively abdicated by the Medici, owing to the distinctive political conditions of the late Quattrocento and early Cinquecento. Medici patronage, which was critical to the emergence of the madrigal, was expressed and exercised through the agency of these private informal institutions rather than through the agency of a more regularized, systematic set of household patronage practices such as characterized Laurentian patronage of the late Quattrocento. Many of the members of the early Cinquecento private institutions were the beneficiaries of Medici patronage; others were Medici themselves. Medici influence, though expressed obliquely rather than directly, was nonetheless of enormous consequence.[29]

To some extent, the character of the informal Florentine institutions is expressed even in the source materials attesting their activities. These materials contrast with the more institutionalized documentation for public, corporate entities, such as *entrata/uscita* (debit/credit) registers and official documents in formulaic Latin. The public institutions were complex bureaucracies that maintained an elaborate record-keeping apparatus; there were legal protocols to satisfy, and compliance with regularized procedures had to be demonstrated. The documentary record is fuller, more detailed, and better preserved precisely because it was mandated and was in the institutions' self-interest to maintain such a record.

The informal institutions reconstructed here are attested instead by documentation that is very different in kind. Because the historical record of their activities was compiled voluntarily—not in response to a public mandate but of their own volition—it may be incomplete, irregular, and idiosyncratic in form and content as contrasted with the records of public institutions. Moreover, because it attests activities that do not conform to norms that had been publicly vetted and sanctioned during centuries of institutional history, the terms of its discourse may be more difficult to interpret persuasively; it may attest more elusive phenomena: sentiment, spirituality, or private political belief. The activities of the Rucellai group, for example, are documented by literary and poetic works, the private correspondence of the members, forewords to contemporary scholarly editions of texts, dialogs and philosophical treatises, political tracts, contemporary Florentine histories, and other such sources. The Sacred Academy of the Medici is attested by the academy's correspondence, among other sources. The activities of the Companies of the Cazzuola, Broncone, and Diamante are documented by the writings of the contemporary artist and art historian Giorgio Vasari, by contemporary Florentine histories and editions of poetic works, private (though formal) statutes governing the organization and functioning of the companies, and so on.

Moreover, the informal Florentine institutions of the early Cinquecento are similar to institutions in other centers of musical patronage, such as Venice, in their distinctive organizational profiles and programs and their independence from the principal public institutions of the city. Early modern Venice supported the institution of the *scuole*, ably described by Jonathan Glixon in a series of fundamental articles;[30] among the other private institutions flourishing there were the academy of Domenico Venier and similar organizations, which are the subject of Martha Feldman's important work.[31] Correspondences between the Florentine institutions and their Venetian analogues extend beyond matters of organizational profile in the very specific sense that the musical genres favored by the Venetian institutions bear a relationship to those cultivated by the private, informal institutions of early sixteenth-century Florence. The principal musical genre associated with the Venetian lay confraternities was the *lauda*, a spare, homorhythmic composition stylistically similar to Florentine festival music and incontrovertibly related to the carnival song in that scores (if not hundreds) of musical settings of lauda texts served equally well as the music for canti carnascialeschi and related festival texts.[32] Similarly, the musical activities of Venetian academies were evidently characterized by the practice of solo song, which, as we shall see, may well have been typical of the practices of Florentine associations such as the Rucellai group and the Sacred Academy of the Medici.[33]

The historical evidence testifying to these alternative traditions of Florentine cultural patronage and the informal institutions supporting them documents mem-

bers' actual musical experiences and tastes, some of which can be reconstructed
and described in great detail and with unusual precision. Such historical evidence
substantiates the conclusions drawn from musical evidence about stylistic affinities
between musical antecedents of the madrigal and the madrigal itself, demonstrat-
ing an active engagement on the part of the Florentine cultural elite with the very
genres Gallucci and Rubsamen identified as having a formative influence on the
style of the early madrigal. Specifically, it suggests that distinctively Florentine tra-
ditions such as solo song and the canto carnascialesco, as well as the villotta, were
central to the complex of influences on Francesco de Layolle, Bernardo Pisano, and
Philippe Verdelot when they were composing their first works in the new genre.
Verdelot's Florentine patrons thus need not have looked quite so far afield as Pro-
fessors Fenlon and Haar suggest for models of precisely those stylistic properties
they identified as characteristic of the early madrigal; such properties typify the
venerable Florentine carnival song. The argument that patrons of the early madri-
gal favored a style foreign to the native tradition overlooks the historical evidence
assembled here and the musical evidence assembled by Rubsamen and Gallucci
that documents the relevance of these specifically Florentine traditions.[34]

A truer understanding of the origins of the madrigal thus requires that these
distinctively Florentine idioms be given sufficient emphasis in our consideration
of the different stylistic influences on Layolle, Pisano, and Verdelot, that they be
featured more prominently in our thinking and set alongside the extant, notated
French polyphonic repertories identified by Fenlon and Haar as important to the
emergence of the new genre. The importance of works in the French chanson tradi-
tion has been overestimated in part because of an inordinate attention to notated
musical sources as a class of document, as distinct from historical records testify-
ing to other kinds of musical practices that are not as completely reflected in the
musical sources. As one historian observed, "books . . . are in themselves mute and
unyielding sources . . . , for though it is obviously important to know what was
available and desired . . . , the critical question is what the . . . material meant to its
possessors . . . , what was derived from it, whether and how it made a difference."[35]
The importance to the musical experiences of the Florentine cultural elite of spe-
cifically Florentine idioms would not be fully appreciated were there a reliance
solely on the evidence of the notated musical sources containing the repertory of
French chansons. We know little or nothing about the actual uses of the chanson
repertory contained in Florentine manuscripts; indeed, there is little historical evi-
dence documenting incontrovertibly that members of the Florentine elite in fact
knew, as actual sounding music, the French chansons preserved in contemporary
Florentine manuscripts, though speculation that they did is not extravagant. On
the other hand, the Florentine cultural elite did know and practice the musical tra-
ditions identified here, which illustrates the fallacy of relying too heavily on extant

notated works, on books, as exclusive witness to the character of a musical culture. The historical sources, as distinct from the musical sources, thus convey a more ramified sense of the contemporary musical culture than can be gained solely from an analysis of the extant notated repertory, preserved in sources such as the manuscript Cortona, Biblioteca Comunale, 95, 96/Paris, Bibliothèque Nationale, Nouvelles Acquisitions Françaises 1817, Florence, Biblioteca del Conservatorio, Basevi 2440, and Florence, Biblioteca Nazionale Centrale, Magliabechiana XIX.164–67, which provide a conspectus of premadrigalian types.[36]

This is not to deny altogether the importance of polyphonic compositional traditions represented by the repertory of the public ecclesiastical institutions, nor is it to deny the importance of French polyphonic antecedents for the madrigal identified by Fenlon[37] and Haar.[38] Rather, it is simply to achieve a different, more nuanced balance among the different musical traditions of the time in current and future musicological opinion about the varied stylistic influences on the early madrigal.

Pirrotta spoke of the "composite image" of the early madrigal.[39] The contribution of this book to the composite is the evidence testifying to the experiences of the Florentine cultural elite and the centrality of the genres they favored. An argument that highlights the importance of these distinctively Florentine genres is a more efficient, less extravagant argument, since it relates the Florentine genre of the madrigal to specifically Florentine antecedents known to have been elements in the musical experience of Layolle, Pisano, and Verdelot's Florentine patrons and *amici,* and thus avoids the historigraphic difficulties of Einstein's thesis. Such an argument entails less of "a series of . . . leaps . . . across gaps in the evidence"[40] than an unnecessarily complicated thesis highlighting the importance of French genres, such as Fenlon and Haar's; it reduces the number of elements in the interpretive scheme and applies Ockham's razor to the matter at hand.

Subsequent chapters offer a close reconstruction of the membership rosters, intellectual programs, and musical activities of the principal informal, private institutions of patronage in early sixteenth-century Florence, of the settings where the madrigal emerged, and of the musical tastes and cultural proclivities of the members of the Florentine cultural elite for whom Philippe Verdelot composed his first essays in the new genre.

The *Orti Oricellari*

W HEN Philippe Verdelot first went to Florence, he was likely to have been acquainted with particular Florentine intellectual figures and to have frequented cultural circles of a particular kind. The actual musical experiences and tastes of those figures are susceptible to reconstruction. The kinds of Italian secular music with which they—and he, therefore—were likely to have been involved can be identified.

As the historian Steven E. Ozment has written, "If one desires to know what a particular author said, it suffices simply to read the works of this author. Should one, however, wish to . . . understand why this author said what he said, then one must read

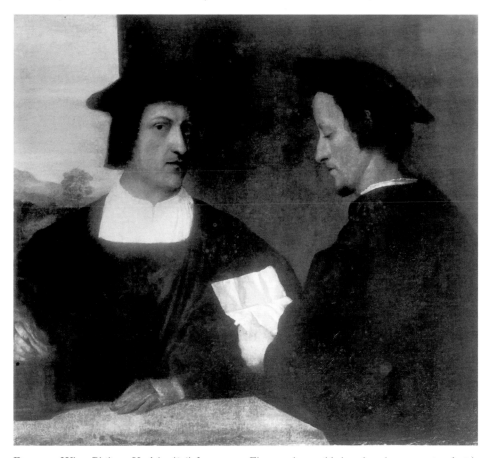

Figure 1.1. When Philippe Verdelot (*left*) first went to Florence, he was likely to have been acquainted with particular Florentine intellectual figures and have frequented cultural circles of a particular kind.

what he read."[1] Should one wish to understand why Verdelot composed his earliest madrigals as he did, then one must identify the kinds of Italian secular music he heard. Verdelot composed his earliest madrigals in a particular setting and for a particular audience. When he arrived in Florence, he encountered a vital secular musical culture with a distinctive profile and a local repertory whose works had distinctive stylistic characteristics. When composing his first madrigals, he would have been influenced to some extent by local experience in setting Italian poetry to music. Consciously or unconsciously, he would almost certainly have sought models in the local secular repertory that suggested ways of treating Italian texts and solutions to compositional challenges

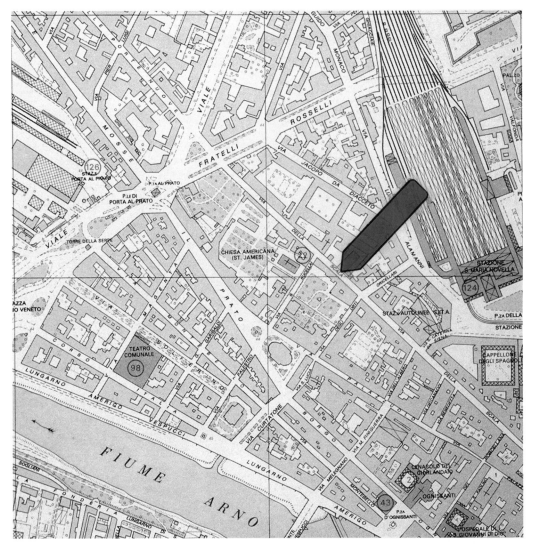

Figures 1.2 and 1.3 Pietro Crinito recorded that Rucellai, "no longer concerned with the actions of . . . Princes or in fear of the power of Kings, . . . retires to his flowering garden," which was situated in an area bounded by what are today the Via della Scala, Via degli Orti Oricellari, and Via Palazzuolo.

encountered in providing Italian verse with a musical setting. Insofar as the principal elements of the secular musical culture of early Cinquecento Florence can be identified and described, the most proximate musical influences on Verdelot during the composition of his first madrigals will also have been identified. Insofar as the actual musical experiences of the members of the cultural elite that presumably constituted Verdelot's audience can be reconstructed, the principal components of the musical tradition to which he was presumably responding will also have been identified.

Verdelot is said to have frequented the Rucellai gardens. We begin there.[2]

The Establishment and Design of the Gardens

The Rucellai gardens represented an extraordinary attempt at a figurative restoration of ancient Roman patronage practices. Through imaginative architectural, horticultural, and sculptural means, the Rucellai created a space reminiscent of those

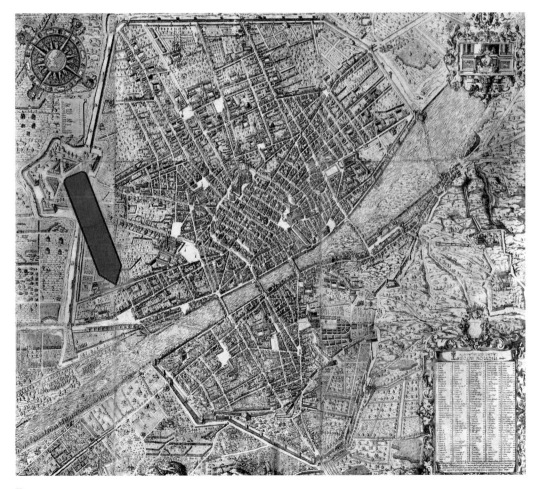

Figure 1.3

settings that had accommodated the informal intellectual life of the ancient impe-
rial capital. Through the programmatic activities located in their gardens—musical
and theatrical performances, banqueting, declamations of texts, and less formal yet
nonetheless substantive literary and political discussions—they sought to recap-
ture and restore the sorts of activities that had typified the practices of Maecenas
and his fellow ancient Roman patrons. The programmatic activities of the Rucellai,
in ways both direct and oblique, form an uncommonly important background to
the emergence of the Cinquecento madrigal.

In 1494, the Medici were exiled from Florence following a half-century of de
facto rule. A series of subsequent experiments in constitutional reform culminated
in 1502 in the establishment of an important republican institution, the position of
gonfaloniere a vita, borrowed from Venetian political tradition. Its first incumbent
was Piero Soderini.[3]

Upon Soderini's election, his political enemy Bernardo Rucellai (1448–1514)—
for many years an important participant in the civic life of his native Florence, and
the principal representative of his famous family during the first decade of the six-
teenth century—partly abandoned the *vita activa* for the *vita contemplativa.* From
1502 until 1506 (when Rucellai embarked on a series of travels throughout France
and Italy), he devoted himself principally to intellectual pursuits.[4] Pietro Crinito
recorded that Rucellai, "no longer concerned with the actions of . . . Princes or in
fear of the power of Kings, . . . retires to his flowering garden,"[5] which was situated
in an area bounded by what are today the Via della Scala, Via degli Orti Oricellari,
and Via Palazzuolo. Crinito described the location: "From here . . . you will see . . .
the city walls / And twin-peaked Fièsole."[6]

Earlier—in 1495, shortly after the exile of his Medici in-laws—Rucellai had
attended a meeting of Giovanni Gioviano Pontano's academy that, in Felix Gil-
bert's words, "convened regularly in a garden at the foot of Vesuvius," and Rucellai's
experience in Naples may have been the impetus for the decision to establish his
own garden academy in Florence.[7] There, Rucellai hosted gatherings of prominent
Florentine cultural and intellectual figures; the activities supported were in the
venerable Florentine tradition of literary and political discussions that began with
the conversations recorded in the *Paradiso degli Alberti* and the debates collected in
Landino's *Disputationes Camaldulenses.*[8]

Though reduced in size, the Rucellai gardens still exist and are even today a peace-
ful asylum amidst the traffic and noise of the modern *urbs.* In Bernardo Rucellai's
time, they contained a number of rare plants that Rucellai himself had had imported
so as to have represented all of the species mentioned in classical literature; Machia-
velli furnished an evocative description of the horticulture in the *Arte della guerra:*

> Fabrizio Colonna . . . decided, as he was passing through Florence, to rest some days
> in that city in order to visit His Excellency the Duke [of Urbino, Lorenzo di Piero de'

Medici].... Hence Cosim[in]o [di Cosimo di Bernardo Rucellai] thought it proper to invite him to a banquet in his gardens.... [W]hen the pleasures of the banquet were over, ... since the day was long and the heat great, Cosim[in]o thought ... it would be well ... to go to the most secluded and shady part of his garden. When they had arrived there and taken seats, some on the grass, which is very fresh in that place, some on the seats arranged in those spots under the shade of very tall trees, Fabrizio praised the spot as delightful, and observing the trees closely and failing to recognize some of them, he was puzzled. Observing this, Cosim[in]o said: "You perhaps do not know some of these trees; but do not think it strange, because some of them were more renowned by the ancients than today they are by common custom." And having told him their names and how Bernardo his grandfather had busied himself with such cultivation, he was answered by Fabrizio: "I was thinking that it might be as you say, and this place and this avocation were making me remember some princes of the Kingdom [of Naples], to whom these ancient plantings and shades give pleasure."[9]

Fabrizio Colonna's observations (as Machiavelli figuratively recorded them) about the garden's "plantings and shades" suggest, once again, that Neapolitan practices may have served as a model for Bernardo Rucellai's garden. Machiavelli's text suggests further that banqueting was among the activities that took place in the garden of the Rucellai.

The garden may also have exhibited portrait medallions of ancient Roman nobles, orators, and poets, some from the collections of the Medici and all bearing informative inscriptions; they embodied characteristics appropriate to Rucellai's programmatic objectives in decorating the garden, with its conscious reference to the images and horticultural practices of the antique world.

In various accounts of the activities of the Rucellai group, one reads that the garden paths were also lined with statues—some from the collections of the Medici—of intellectual, literary, and political figures of the ancient world. But in pursuing the relevant bibliographical references, one finds that such an assertion is unsubstantiated. Its ultimate source is a letter of Michaëlis Verini (d. 1483), and although it does permit one to conclude that some objects in the art collections of the Medici indeed passed to the Rucellai, there is no warrant for inferring on the basis of that text alone that they were displayed in the Rucellai garden in the early sixteenth century. Moreover, Guarino of Verona had observed in the fifteenth century that paintings and statues were of limited utility for purposes such as Rucellai's, because they are "*sine litteras* ... and ... not conveniently portable,*" to quote Michael Baxandall's summary of Guarino's argument. On the other hand, didactically inscribed portrait medallions would indeed have served Rucellai's programmatic purposes.[10]

Marble benches and a summer house that Rucellai had had constructed[11] completed the harmonious assemblage of architectural, horticultural, and sculptural elements that gave the gardens their singular character.

Bernardo Rucellai's objectives in establishing his garden salon were manifold. With the 1494 exile of the Medici, there was no longer a robust tradition of aristocratic patronage of the arts and letters of the kind that had characterized late Quat-

trocento Laurentian Florence. As the principal representative of his family, Rucellai
was positioned like few others in prerestoration Florence—senior representatives of
the Strozzi, for example, and perhaps of one or two other families—to recreate a vital
tradition in Florence of private artistic patronage. Rudolf von Albertini, who spoke
with unusual authority on this period in Florentine history, argued that despite a ten-
dency to characterize the sensibilities of members of the Rucellai group as republican
or Savonarolan, they were originally *Ottimati* (Optimates, or leading citizens), with
aristocratic objectives.[12] Among such objectives would have been patronage of artists
and letterati of the type supported by Rucellai's brother-in-law Lorenzo il Mag-
nifico de' Medici (brother of Rucellai's wife, Nannina). That patronage of this kind
redounded to the credit of the patron and enhanced his prestige must have appealed
to Rucellai, especially during a phase of his life when he was not involved in civic
life and therefore lacked the public affirmation typically resulting from such involve-
ment. The establishment of his garden academy may be seen as an attempt to reclaim
his status, though in a different way, and implicitly challenge the preeminence of his
political enemy Soderini. Affirmation need not have been expressed solely in politi-
cal terms; the patronage of intellectual figures burnished Rucellai's reputation and
had the effect of stabilizing his "rival court," which was established on aesthetic and
cultural (as consciously contrasted with political) principles.

Patronage practices of the sort Rucellai envisioned, and the attendant activi-
ties, required a proper venue, and the Rucellai garden served as the physical infra-
structure that facilitated Rucellai's patronage. The specific design of the garden ex-
pressed a poignant antiquarianism, utterly characteristic of the Italian Renaissance.
The careful evocation of classical horticulture and the equally careful evocation of
images of public figures of the classical world suggest an attempt to recreate a clas-
sical *ambiente*.

Above all, Rucellai's specific strategies suggest that he was consciously indulging
in overt and explicit "self-fashioning," to invoke the title of Stephen Greenblatt's pro-
vocative and influential book.[13] Such strategies are an expression of Rucellai's capacity
to imagine—or, more accurately, reimagine—himself, his built environment, and his
position in Florentine society. The images and materials he deployed suggest that he
imagined himself a patron in the ancient Roman mold, a latter-day Maecenas. The evi-
dence that he modeled his practices on Neapolitan ones is equally suggestive, since Na-
ples was a kingdom when Rucellai visited Pontano's academy in 1495. In this instance,
as in many others, the traditions of the royal court of Naples exercised an influence on
Florentine practice and Italian practice more generally, especially the practices of those
Italians with aristocratic aspirations, who were anxious to emulate and appropriate cus-
toms that were royal in origin and character. The symbolism for Cosimino di Cosimo di
Bernardo Rucellai of his grandfather's having designed the family garden in such a way
as to evoke comparison with the royal gardens of Naples must have been powerful. As

J. R. Hale observed, this was precisely the period in European history when the political elite was engineering its own rearistocratization: aristocratic and royal pretensions were cultivated, and traditionally aristocratic and royal prerogatives were asserted, both by members of the historic feudal aristocracy and also by those who, like the Medici, had acquired a wealth that enabled them to envision a social and political status for themselves in European society that transcended their mercantile origins.[14] Rucellai's activities may be seen in that wider context.

THE MEMBERSHIP OF THE RUCELLAI GROUP

Extant contemporary texts testifying to the activities of the Rucellai group document two discrete phases of activity.[15] Pietro Crinito died in 1505, and his *De Honesta Disciplina*—which makes reference to the gardens—was published in 1504;[16] the gardens must have been in existence by that time.[17] The sources suggest that in addition to Crinito and Rucellai himself, the following frequented the gardens during this earlier phase: Crinito mentions Joannes Corsius[18] and Lacetius [*sic*] Niger;[19] Bartolomeo Fonzio mentions Dantes Populeschus.[20] A passage in the writings of another participant, Giovan-Battista Gelli (1498–1563), substantiates Crinito's references. And not only does it furnish the names of some of the participants during the earlier phase, it also confirms that from the first, linguistic and literary concerns were central to the program of the Rucellai group. (Gelli's reference to ambassadorial orations also documents another kind of activity that took place within the gardens.) Although self-serving, and therefore somewhat suspect with regard to its veracity, the self-portrait of the young, awestruck Gelli boy in the *Ragionamento intorno alla lingua*, which portrays him as a budding intellectual who would contrive to find a way into the Rucellai gardens so that he might listen to the learned discussions of his elders, is nonetheless of some significance. Cosimo Bartoli is depicted as engaged in a discussion of language with the author, and at the conclusion of a long disquisition on the "greatness," "nobility," and "natural sweetness" of the Florentine language, Bartoli remarks that such qualities are especially evident when speakers of the language have devoted themselves to letters,

> applying themselves to their studies, as—in the period of your boyhood—would Bernardo Rucellai, Francesco da Diacceto, Giovanni Canacci, Giovanni Corsi, Piero Martelli, Francesco Vettori, and other *letterati*, who at that time would assemble in the garden of the Rucellai, where you—when you were able now and then to insinuate yourself by various means—would stay to listen to them talking among themselves, with the reverence and attention typically accorded oracles. And, moreover, I still remember having heard you say that when ambassadors would come, you would gladly go to hear them deliver their orations, the custom in those days being that the first time they would [make their reports] publicly.[21]

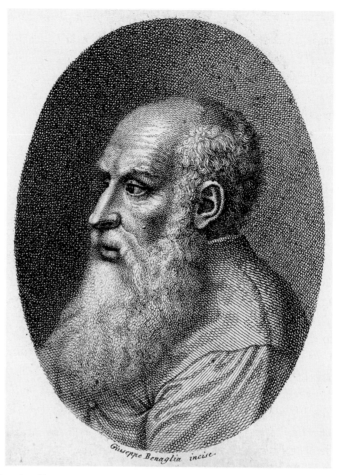

Giuseppe Benaglia incise.

Figure 1.4 Although self-serving, and therefore somewhat suspect with regard to its veracity, the self-portrait of the young, awestruck Gelli boy in the *Ragionamento intorno alla lingua* portrays him as a budding intellectual who would contrive to find a way into the Rucellai gardens so that he might listen to the learned discussions of his elders.

Other participants during this first phase probably included Fonzio himself,[22] Archbishop Cosimo de' Pazzi, and Bindaccio Ricasoli.[23]

Information about the membership during the later phase, subsequent to the 1512 restoration of the Medici, is provided by a number of period authors. Establishing an accurate membership roster is critical, since the group claimed an impressively high proportion of the foremost Florentine cultural figures of the early Cinquecento as its members, many of whom enjoyed an intimate relationship with the first generation of madrigal composers. The profile of the membership is the most revealing manifestation of the programmatic objectives of the Rucellai in establishing and supporting their garden academy.

The famous Florentine historian Jacopo Nardi reported in his history that Luigi (di Piero) Alamanni, Zanobi Buondelmonti, Francesco da Diacceto,[24] Francesco di Zanobi Cattani da Diacceto,[25] and Jacopo (da Diacceto)[26] were the guests of Bernardo Rucellai's grandson Cosimino di Cosimo (1495–1520), who—confined to a seated position as a result of having contracted a venereal disease[27]—hosted the gatherings during the second decade of the century. Nardi's report also clearly implies that Machiavelli was a member,[28] as do Machiavelli's own dedications to Buondelmonti and Cosimino of his *Discourses* on Livy[29] and to Alamanni and Buondelmonti of his *Vita di Castruccio Castracani*.[30] Nardi's account is substantiated by Nerli's history, which identifies Alamanni, Buondelmonti, and Machiavelli as members of the group and adds the further names of Nerli himself and Batista della Palla.[31]

Both Nardi and Nerli reported on the activities of the Rucellai group in connection with the abortive 1522 *congiura* (conspiracy) against Cardinal Giulio di Giuliano de' Medici, then his family's principal representative in Florence.[32] The conspiracy suggests a characteristically Florentine fascination and sympathy with the more striking expressions of Roman republicanism, the sort that led, most notoriously, to the assassination of Julius Caesar; Bernardo Rucellai's classicizing impulses and his efforts to evoke and restore the practices of the ancient Roman world may have had extravagant consequences that he himself did not anticipate and would not have endorsed.

These are the historical witnesses to the membership of the Rucellai group in the later phase of its activity; there are also literary witnesses. Machiavelli's *Arte della guerra* (dedicated to Lorenzo di Filippo Strozzi) is cast in the form of a *ragionamento* in the gardens, whose participants are Alamanni, Buondelmonti, Colonna, della Palla, and Cosimino Rucellai;[33] however, the epistemological status of this reference is not the same as that of Nardi's and Nerli's histories. The same might be said of Benedetto Varchi's brief reference in his *Lezioni*, where he testified to the membership of "M. Luigi Alamanni," "Zanobi Buondelmonti," "Nicolò Machiavelli," "M. Cosimo," and "M. Giovangiorgio Trissino" and implied his own.[34]

That Nardi's and Nerli's interests were principally political in nature explains why the participants they identified were largely of the one type. Other authors—specifically, Gelli and the philosopher Antonio Brucioli—identified figures of a different type: the aristocratic Florentine poet Francesco Guidetti and the philologists Janus Lascaris and Giangiorgio Trissino.[35] Gelli's reference to Lascaris is of interest since it suggests that in this second phase, as in the first, linguistic and literary matters figured prominently in the discussions of the Rucellai group, as is implicit in Lascaris's equation of *Trecento* literary achievement with ancient Greek: "I once remember hearing it said that [Janus] Lascari, that Greek for whom these moderns have such high regard, would say at table in the garden of the Rucellai ... that, with respect to

eloquence and *modo di dire,* he would not recognize Boccaccio as inferior to any of their Greek writers and that he regarded Boccaccio's *Cento Novelle* as highly as one hundred [such *novelle*] by their poets."[36]

Although neither Nardi nor Nerli explicitly identifies Brucioli himself as a member of the Rucellai group, both mention him in their accounts of the 1522 congiura, and both identify him as one of Alamanni, Buondelmonti, and Jacopo da Diacceto's co-conspirators, which in itself suggests that Brucioli was a member of the Rucellai group.[37] If further evidence of Brucioli's own relationship to the membership is required, there is the testimony of his *Dialoghi* [*della morale filosofia*],[38] which in addition to suggesting his own participation also casts Jacopo Alamanni, Buondelmonti, Nardi, and della Palla as interlocutors in one dialog[39] and Luigi di Tommaso Alamanni and Jacopo da Diacceto in another,[40] in addition to the examples already cited.[41]

Thus the membership of the Rucellai group may be established as follows.[42] In the early phase:

<div align="center">

TABLE I

MᴇᴍʙᴇʀsʜɪP ᴏғ ᴛʜᴇ Rᴜᴄᴇʟʟᴀɪ Gʀᴏᴜᴘ ɪɴ ᴛʜᴇ Eᴀʀʟɪᴇʀ Pʜᴀsᴇ

</div>

1. **Giovanni Canacci** (as is suggested by Gelli's *Ragionamento*)
2. **Giovanni Corsi** (Crinito's *De Honesta Disciplina* and Gelli's *Ragionamento*)
3. **Pietro Crinito** (Crinito's "Ad Faustum: De sylva Oricellaria" and *De Honesta Disciplina*)
4. **Dantes Populeschus** (Fonzio's correspondence)
5. **Francesco da Diacceto** *"il Nero"* (Crinito's *De Honesta Disciplina* and Gelli's *Ragionamento*)
6. **Bartolomeo Fonzio** (Fonzio's correspondence)
7. **Giovan-Battista Gelli** (Gelli's *Ragionamento*)
8. **Piero Martelli** (Gelli's *Ragionamento*)
9. **Cosimo Pazzi** (Corsi's forewords)
10. **Bindaccio Ricasoli** (Corsi's forewords)
11. **Bernardo Rucellai** as host (Crinito's "Ad Faustum: De sylva Oricellaria" and *De Honesta Disciplina,* Fonzio's correspondence, Gelli's *Ragionamento,* and Nerli)
12. **Francesco Vettori** (Gelli's *Ragionamento*)

And in the later phase:

<div align="center">

TABLE 2

MᴇᴍʙᴇʀsʜɪP ᴏғ ᴛʜᴇ Rᴜᴄᴇʟʟᴀɪ Gʀᴏᴜᴘ ɪɴ ᴛʜᴇ Lᴀᴛᴇʀ Pʜᴀsᴇ

</div>

1. **Jacopo Alamanni** (as is suggested by Brucioli)
2. **Ludovico di Piero Alamanni** (Machiavelli's correspondence)
3. **Luigi di Piero Alamanni** (Brucioli, Gelli's *Ragionamento,* Machiavelli's *Arte della guerra* and his correspondence, Nardi, Nerli, and Varchi)

4. **Luigi di Tommaso Alamanni** (Brucioli, Nardi, and Nerli)
5. **Antonfrancesco degli Albizzi** (Machiavelli's correspondence)
6. **Antonio Brucioli** (Brucioli, Nardi, and Nerli)
7. **Zanobi Buondelmonti** (Brucioli, Gelli's *Ragionamento,* Machiavelli's *Arte della guerra* and his correspondence, Nardi, Nerli, and Varchi)
8. **Fabrizio Colonna** (Machiavelli's *Arte della guerra*)
9. **Francesco da Diacceto "il Nero"** (Nardi)
10. **Francesco di Zanobi Cattani da Diacceto "il Pagonazzo" (the Purple)** (Nardi)
11. **Jacopo da Diacceto** (Brucioli, Machiavelli's correspondence, Nardi, and Nerli)
12. **Francesco Guidetti** (Brucioli, Gelli's *Ragionamento,* and Machiavelli's correspondence)
13. **Janus Lascaris** (Brucioli and Gelli's *I Capricci del Bottaio*)
14. **Niccolò Machiavelli** (Machiavelli's correspondence, his *Arte della guerra,* and the dedications to his *Discourses* on Livy and *Vita di Castruccio Castracani;* Nardi; Nerli; and Varchi)
15. **Jacopo Nardi** (Brucioli and Machiavelli's correspondence)
16. **Filippo de' Nerli** (Machiavelli's correspondence and Nerli)
17. **Batista della Palla** (Brucioli, Machiavelli's *Arte della guerra* and his correspondence, and Nerli)
18. **Pierfrancesco Portinari** (Machiavelli's correspondence)
19. **Cosimino Rucellai** as host (Brucioli, Gelli's *Ragionamento,* Machiavelli's *Arte della guerra* and his correspondence, Nardi, Nerli, and Varchi)
20. **Lorenzo di Filippo Strozzi** (the dedication to Machiavelli's *Arte della guerra*)
21. **Giangiorgio Trissino** (Brucioli, Gelli's *Ragionamento,* and Varchi)
22. Perhaps **Alessandro de' Pazzi** (Machiavelli's correspondence)
23. Perhaps **Benedetto Varchi** (Varchi)

Of the participants during the later phase, Ludovico di Piero di Francesco Alamanni (1488–1526) enjoyed a particularly close relationship to Lorenzo di Piero di Lorenzo de' Medici.[43] Alamanni is currently known to musicologists principally because his name occurs in a fascinating correspondence during 1525 and 1526 between Machiavelli and Francesco Guicciardini concerning a projected performance in Faenza of Machiavelli's comedy *Mandragola.* The performance was to have included musical *intermedii, canzone* on texts by Machiavelli himself, and the "*canzona* before the comedy"—newly written for the projected performance—contains a conciliatory gesture toward Giulio de' Medici, by then Pope Clement VII. The gesture is to be understood in reference to the 1522 congiura against Cardinal Giulio and other political events of the preceding few years, given that Machiavelli and Alamanni, both of whom had had intimate connections to the Rucellai group, were involved in arranging the projected performance of 1526;[44] their involvement with the performance afforded them an opportunity to disavow their conspiratorial colleagues in the Rucellai group and extend an overture to the intended victim of the abortive conspiracy, an

opportunity they exploited in the deferential "*canzona* before the prologue." More important for our purposes is that their correspondence demonstrates an involvement with the early madrigal on the part of two influential members of the Rucellai group. That Machiavelli and Ludovico Alamanni had a particularly close relationship is suggested by the character and vivid language of their correspondence.[45] Their correspondence generally and the exchange concerning the projected performance of *Mandragola* specifically suggest a mutual interest in literary matters on their part, which is yet further witness to the program of the Rucellai group.

Ludovico's brother Luigi Francesco (6 March 1495–18 April 1556)—poet and translator of Sophocles' *Antigone*—was one of the most illustrious literary figures

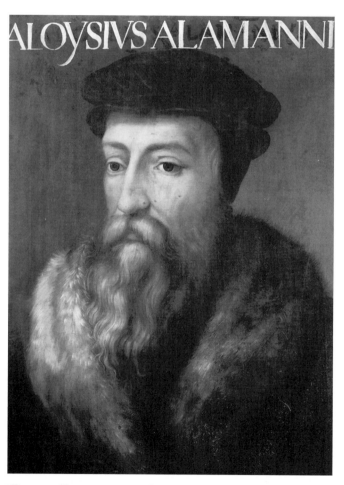

Figure 1.5 Luigi Francesco Alamanni—poet and translator of Sophocles's *Antigone*—was one of the most illustrious literary figures of the early sixteenth century, the author of much verse set to music by early madrigalists. His poetic sensibilities may be characterized as neo-Petrarchan, specifically in its post-Bembist phase of development.

of the early sixteenth century, the author of much verse set to music by early madrigalists. His poetic sensibilities may be characterized as neo-Petrarchan, specifically in its post-Bembist phase of development.[46]

When considering the thesis that the cultural circles Verdelot frequented were in some sense anti-Medicean,[47] it is important to remember Ludovico Alamanni's close associations with Lorenzo de' Medici the Younger and his involvement with the projected 1526 performance of *Mandragola*, with its conciliatory gesture toward Pope Clement VII (Giulio de' Medici). Ludovico and Luigi's father, Piero di Francesco (1434–1519),[48] was an intimate of Lorenzo il Magnifico and one of his trusted agents. Any number of references document both an association with the Medici extending over many years and a conversance with music on the part of Piero di Francesco Alamanni and his son Ludovico; that conversance was also characteristic of Luigi di Piero, who was demonstrably associated with the madrigalist Francesco de Layolle. Piero Alamanni, who has been characterized as "one of the pillars of the [Quattrocento Medici] regime," served for a time as Lorenzo's envoy in Rome, and it is a coincidence, though a highly interesting one, that in that role he figures in an important correspondence documenting Lorenzo's efforts to furnish the Venetian ambassador with a book of compositions by Heinrich Isaac. In the first of these letters, dated 25 June 1491, Lorenzo instructed Alamanni to "[t]hank the magnificent Venetian ambassador for having requested these songs of me [Ringratiate il magnifico oratore veneto davermi richiesto di questi canti]," and in the second, dated 8 July 1491, he wrote to Alamanni that "I send to you by this cavalcade a book of musical compositions by Isac according to the request of the magnificent Venetian ambassador [Mandovi per questa chavalcata uno libro di musica di compositioni del Jsac secondo la richiesta del magnifico oratore venetiano]."[49]

Janus Lascaris was the preeminent Greek scholar of his age,[50] director of Leo X's Greek Academy, and manifestly an intimate of Leo.[51] Gelli's reference[52] to Lascaris's attendance at meetings in the garden suggests the importance of his classical scholarship to the program of the Rucellai group, and by virtue of Lascaris's own earlier involvement with Renaissance Hellenizing activities in Quattrocento Florence,[53] he was already conversant with such self-fashioning as was subsequently practiced by Bernardo Rucellai and his descendants. Lascaris may, in fact, have assisted Bernardo and Cosimino Rucellai in envisioning and executing the classicizing element of the program of the Rucellai group.

Discussion of Niccolò Machiavelli's demonstrable and significant relationship to Verdelot is for the moment deferred.

Lorenzo di Filippo Strozzi (1483–1541) was a musician and playwright and a most distinguished poet; his musical activities afford insights into the musical tastes of at least one member of the Rucellai group. He must certainly have been an intimate of the renowned composer, madrigalist, and letterato Bernardo Pisano[54] and was de-

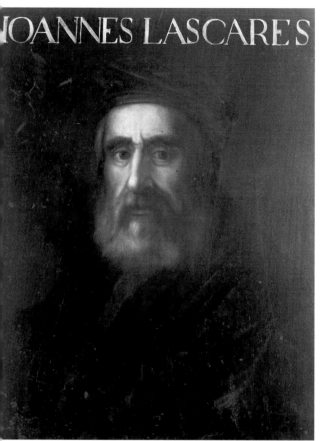

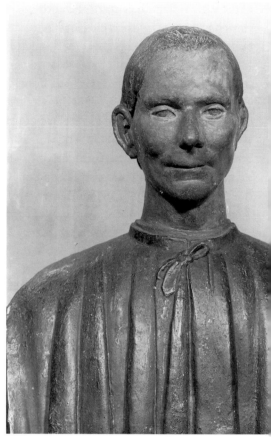

IOANNES LASCARES

Figure 1.6 Janus Lascaris was the preeminent Greek scholar of his age, director of Leo X's Greek Academy, and manifestly an intimate of Leo. Lascaris's attendance at meetings in the garden suggests the importance of his classical scholarship to the program of the Rucellai group.

Figure 1.7 Niccolò Machiavelli.

monstrably associated with the composer and organist Baccio degl'Organi.[55] Strozzi's accounts record payments to Baccio, Pisano, and other musicians.[56] Particularly important is the evidence that Lorenzo was himself a lutenist, which is suggested by a famous reference that he took part, costumed "alla moresca," in a performance of his own "Commedia in versi" in the Palazzo Medici in 1518, on the occasion of the wedding of Lorenzo di Piero de' Medici and Madeleine de la Tour d'Auvergne.[57]

Finally, the Vicentine letterato Giangiorgio Trissino (1478–1550) was a literary theorist of great importance and distinction[58] and subsequently the patron of Andrea Palladio.[59] Trissino's experiences as a member of the Rucellai group may be relevant to the founding of the formal Accademia Olimpica, chartered in Vicenza in 1555. The Olimpica supported poetry readings, concerts, and theatrical productions and in the late 1550s began to sponsor a series of elaborate stage productions,

among them Trissino's own *Sofonisba* (performed in 1562); in 1579–80 a building was constructed for the Accademia on Palladio's design, whose principal feature was a theater.[60] The Rucellai gardens may also have been the site of a theatrical performance, about which Trissino may therefore have been very well informed.[61] That the Rucellai group and the Vicentine Accademia Olimpica had a commonality of purpose and program is interesting and perhaps not coincidental, given Trissino's demonstrable relationship to both centers of activity.

The references that follow surpass in importance those presented up to this point, since they pertain specifically to musicians—madrigalists, in fact—who may have frequented the garden of the Rucellai. Though published, the first of these important texts is evidently new to the musicological literature. It suggests that Bernardo Pisano, one of the most preeminent early Florentine madrigalists, was personally known not only to Lorenzo Strozzi but also to several other mem-

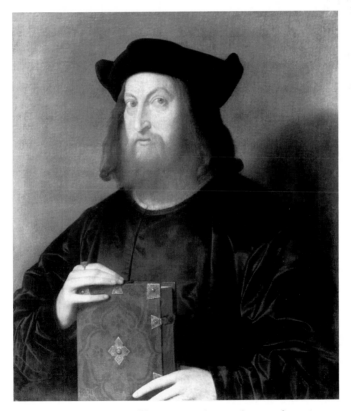

Figure 1.8 The Vicentine *letterato* Giangiorgio Trissino was a literary theorist of great importance and distinction, and subsequently the patron of Andrea Palladio. Trissino's experiences as a member of the Rucellai group may be relevant to the founding of the formal Accademia Olimpica, chartered in Vicenza in 1555. The Olimpica supported poetry readings, concerts, and theatrical productions and in the late 1550s began to sponsor a series of elaborate stage productions, among them Trissino's own *Sofonisba* (performed in 1562).

bers of the Rucellai group. In a September 1521 letter, Palla di Bernardo Rucellai wrote to Janus Lascaris that "as for the provisions for the college, there came . . . from Bonaccorso [Rucellai], the subventions for August and September. . . . Concerning the [college's] new Latin master, I have given them one messer Bernardo Pisano, [so called] although he is Florentine and native born; [concerning] what I said—that he had a good style and also that he has some Greek—he has already lectured them for two weeks and begun certain exercises in letter writing; and thus, similarly, they will do some declamations and translations from Greek to Latin. And, in sum, he is very studious and has inculcated in them a great desire to study hard."[62]

Given the evidence suggesting that the composer Bernardo Pisano was also a classical scholar (and known as such to Filippo di Filippo Strozzi[63]), the Bernardo Pisano mentioned in Palla Rucellai's letter may well be the famous composer. If so, there is documentary evidence that Pisano was known to such members of the Rucellai group (or intimates of members) as Janus Lascaris and Palla Rucellai, as well as Filippo and Lorenzo Strozzi.[64]

The following complex of references is more important still, since it documents unequivocally that Francesco Layolle, another of the most important of the earliest Florentine madrigalists, was an intimate of two of the most prominent members of the Rucellai group: Luigi di Piero Alamanni and Antonio Brucioli.

Together with "M. Luigi Alamanni," "M. Hieronimo Beniuieni," "M. Gia[n]batista Borghini," and "M. Zanobi Buondelmonti," "Francesco dell'Aiolle" is cast in the role of interlocutor in Dialogo IV, "Della natura delle stelle," in the fourth book of Brucioli's dialogs, the *Dialogi [della metaphisicale philosophia]*, where Layolle is proclaimed a "perfetto musico" by Borghini and engages in a learned disquisition on the music of the spheres.[65] The fact that he was so portrayed cannot be taken as incontrovertible evidence that he attended the meetings in the Rucellai gardens, but given that so very many of Brucioli's interlocutors are known from other sources to have been his compagni in the Rucellai group, one can easily hypothesize that Layolle had also been a member before his departure from Florence for Lyons, which may have occurred as early as 1518.[66]

The evidence linking Alamanni and Layolle is even less equivocal. Layolle is mentioned explicity and matter-of-factly in at least three letters either from Alamanni alone or from Alamanni and Buondelmonti, all of them in the hand of one or the other of the writers, and all of them directed to Batista della Palla, one of their co-conspirators in the 1522 congiura.[67]

Moreover, among the *SONETTI DI LVI [GI] ALAM [ANNI]*[68] is the sonnet *My Layolle, kind, courteous friend.*[69] And in the *EGLOGA PRIMA, COSMO RV-CELLAI* of the *EGLOGHE DI LVIGI ALAMANNI, AL CHRISTIANISS. RÈ DI FRANCIA, FRANCESCO PRIMO,* Alamanni wrote of "our Tuscan Layolle,

in whom Florence sees as much harmony, as much art, as has ever come among us mortals since Terpsichore."[70] Layolle returned these gracious compliments by naming his son Alamanno[71] and setting two of Alamanni's poems to music.[72]

Layolle's poetic choices more generally also constitute evidence of his membership in the Orti Oricellari. Among his madrigals are settings of texts by Niccolò Machiavelli,[73] Filippo di Filippo Strozzi (the brother of the Lorenzo who was a member of the Rucellai group),[74] and Lorenzo di Filippo himself,[75] besides the two settings of texts by Luigi Alamanni.[76] In addition, there are settings of a text by Boccaccio,[77] and of no fewer than sixteen by Petrarch, which almost certainly reflects the influence of Layolle's amici in the Rucellai group:[78]

TABLE 3
SETTINGS BY LAYOLLE OF VERSE BY PETRARCH

L'amoroso pensiero
Anima bella da quel nodo sciolta
Chiusa fiamma e più ardente e se pur crescie
Così potess'io ben chiuder in versi
Felice lalma che per voi sospiro
In dubbio di mio stato hor piango hor canto
Ite dolci pensier parlando fuore
Lasciar il velo o per sol' o per ombra (also ascribed to Arcadelt)
Lasso la dolce vista
Nessun visse giamai più di me lieto
O passi sparsi
O quant' era il peggior' farmi contento
Occhi mia lassi
Perchè quel che mi trasse ad amar prima
Quel foco che io pensai che fussi spento
Sel dolce sguardo di costei m'ancide

Finally, a bit of evidence—more circumstantial—suggests that Layolle may have frequented the Rucellai gardens, and, further, that it may indeed have served as a setting for musical performances. The poet Eustorg de Beaulieu,[79] who resided in Lyons between 1534 and 1537, gives a picture of Layolle's life there. Significantly, his reference makes explicit mention of Layolle's garden, which evidently served as a gathering place for musicians.[80] Did Layolle's garden in Lyons represent the poignant attempt of a Florentine expatriate, nostalgic for his native city, to recreate the *Orti Oricellari* and the venerable Florentine tradition of hosting musicians and letterati in one's garden? There is unequivocal documentation that Layolle remained in contact with Filippo di Filippo and Ruberto di Filippo di Filippo Strozzi (the brother and nephew of the Lorenzo Strozzi who was a member of the Rucellai group), which permits us to posit that one

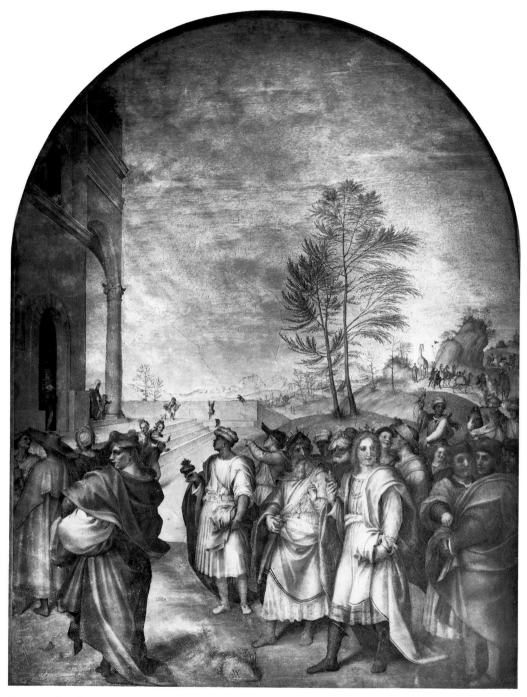

Figure 1.9 Layolle's portrait was painted by leading painters of Florence: Andrea del Sarto (the Florentine *caposcuola*) and perhaps by Sarto's pupil Jacopo Pontormo. Sarto's portrait forms part of his 1511 fresco in the first *cortile* of the Church of the Santissima Annunziata, where Layolle had earlier been a singer of laude.

basis for the relationship among these figures was a common interest in music, and perhaps even that Layolle himself had indeed frequented the *Orti Oricellari*.[81]

Of course, Alamanni, Buondelmonti, della Palla, and Layolle all left Florence, the first three due to their role in the conspiracy against Cardinal Giulio. The foregoing material does not constitute incontrovertible evidence that they knew one another well in Florence or that Layolle attended the meetings in the Rucellai gardens, but in aggregate the references constitute substantial testimony. Moreover, the very fact of the expatriates' relationship to one another is in itself important, even if it developed fully only within the setting of the substantial Florentine expatriate community in Lyons. Layolle's continuing relationship with other Florentine cultural and intellectual figures and his continuing access to Florentine music of the sort documented here are also important, as is the fact that some of his works are preserved in Florentine manuscript sources of the late 1520s and the 1530s.[82]

In any event, there can be no doubt that "Antonio Francesco Romolo di Agniolo di Piero Aiolle" (4 March 1492–ca. 1540)[83] was well known to prominent members of the Florentine artistic and intellectual communities. He was lauded by Benvenuto Cellini in his famous autobiography as "a great organist and excellent musician and composer" who "taught me singing and composition."[84] His portrait was painted by leading painters of Florence: Andrea del Sarto (the Florentine *caposcuola*), and perhaps by Sarto's pupil Jacopo Pontormo. Sarto's portrait forms part of his 1511 fresco in the first *cortile* of the Church of the Santissima Annunziata,[85] where Layolle had earlier been a singer of laude.[86] Pontormo's work is a formal portrait, datable no later than about 1518–19.[87] Both Sarto and Pontormo had associations with the Florentine cultural elite that furnished the membership of some of the other early Cinquecento institutions to be considered here.

That Layolle was once a singer of laude is of considerable importance. Early in his career, it gave him direct experience with music on Italian texts for more than one vocal part. The evidence of Layolle's experience as a laudese is relevant to the question of madrigal origins since it provides historical substantiation for observations made on stylistic grounds about the musical antecedents—the source musics—of the new genre, given the influence of the canto carnascialesco repertory on the style of the early madrigal that various scholars have identified,[88] on the one hand, and, on the other, the historical relationship between the polyphonic lauda and the canto carnascialesco. A given lauda is often related to a particular canto carnascialesco by virtue of the fact that the two were sung to the same music. Indeed, in the text sources, lauda texts are often accompanied by the rubric "cantasi come" ("sung like") and the title of a corresponding canto carnascialesco; it is then left to the performer, or the modern editor, to underlay the text of the lauda to the music of the related canto carnascialesco (or vice versa).[89]

Figure 1.10/1.11 Layolle's portrait was painted by leading painters of Florence: Andrea del Sarto (the Florentine *capos-cuola*) and perhaps by Sarto's pupil Jacopo Pontormo. Pontormo's work is a formal portrait.

Philippe Verdelot's connections to the Rucellai group are somewhat more dif-ficult to substantiate. There is little question that he knew Machiavelli well,[90] and there is the evidence of his poetic choices. Besides settings of poetry by Francesco Guidetti,[91] Machiavelli,[92] and Giangiorgio Trissino[93]—all of whom frequented the Orti Oricellari—there are settings of Petrarchan texts, which, as in the case of Layolle, may suggest the direct or indirect influence of the Rucellai group.[94]

When speculating about the possibility of Verdelot's participation in the meet-ings of the Rucellai group, one should recall that little or nothing is known about precisely when various members of the group frequented the gardens.[95] The period of Guidetti's participation may not have coincided with Verdelot's at all, assum-ing that Verdelot in fact attended. Similarly, the reference in Gelli's *Ragionamento* documenting Trissino's participation loosely associates it with the 1515/16 visit to Florence of Pope Leo X (Giovanni di Lorenzo de' Medici),[96] and it has not been

suggested that Verdelot was in Florence as early as that date. My objective is simply to convey something of the general character of the cultural ambiente within which Verdelot surely moved and to isolate some of the principal elements in the complex of cultural influences on him. The available documentation does not substantiate that Verdelot knew Guidetti—though that is hardly an extravagant hypothesis— nor that he was acquainted with Trissino.

The Program of the Rucellai Group
The "Questione della Lingua"

A number of members of the Rucellai group thus had demonstrable links to the earliest madrigalists: Layolle, Pisano, and Verdelot. Any number of members were poets whose verse was set to music in the new madrigal style. More generally, the membership was vitally interested in the problem of language, the "questione della lingua."[97] Linguistic and literary concerns were as important to the informal program of the Rucellai group as political ones, and in addition to the two texts already quoted that substantiate that observation, a third is of particular relevance since it refers explicitly to the "Three Crowns" of the medieval Tuscan literary tra- dition—Dante, Petrarch,[98] and Boccaccio—and to early sixteenth-century efforts to recapture the refinements of that tradition. Giovan-Battista Gelli, once again, is the reporter:

> Our ancestors, having attended to commerce and not letters together with the host of enterprises that have always existed here, made us remain behind for a long time, and almost caused the practices and craftsmanship in our language employed by the above-mentioned "Three [Crowns]" to be lost altogether; and the first who began in Florence to observe them once again, in speech and in writing, were those same *letterati* who frequented the Orti Oricellari. Some of these learned men—Cosimo Rucellai, Luigi Alamanni, Zanobi Buondelmonti, Francesco Guidetti, and several others, who, keeping company with Cosimo, often met at the gardens with those older men[99]—began to draw out these said observations and put them so much into effect that the language then regained that esteem that you see.[100]

In Gelli's view, the principal program of the Rucellai group was the restitution of Trecento literary values and practices, and Gelli's text suggests that members' engagement with the matter of language was not exclusively discursive in nature, but that they had a decidedly practical objective as well: "Some of these . . . men . . . began to come by these . . . reflections and put them very much into effect, so that the language thereby regained . . . esteem." Trecento literary standards, having been lost, were to be reclaimed, and the contemporary literary language refashioned and purified along the lines suggested by the literary output of the "Three Crowns." Among the members likely to have been particularly interested in the literary ele-

ment of the program were Antonio Brucioli (who was the first Italian to translate the entire Bible into the vernacular), Gelli, Guidetti, Lorenzo Strozzi (whose own poetic efforts exemplify and fulfill the objectives of the literary program unusually closely), and Trissino.

The restitution of Trecento literary values in the Cinquecento also surely explains the simultaneous restitution of the very term applied to the new Italian secular musical form: "madrigal." The restoration of the Trecento nomenclature may be an expression of Florentine (or even specifically Medicean) nostalgia for fourteenth-century Florentine literary achievement,[101] as is also suggested by the Medici family's possession of the famous Squarcialupi codex, the primary source of the Trecento musical repertory, including settings of madrigal verse by Francesco Landino, his predecessors, contemporaries, and immediate successors. Such a nostalgia may be among the earliest manifestations of a kind of Florentinism, a carefully constructed evocation and celebration of an idealized Florentine past, which had the effect of enhancing Florentine identity and therefore even potentially stabilizing the Florentine polity.[102] Another manifestation of the same nostalgia is the 1509 publication of Antonio da Tempo's fourteenth-century treatise *De ritimis vulgaribus*.[103]

Political Program

There was also a political element to the activities of the Rucellai group. Nardi's history states that "Niccolò Machiavelli had once written … his *Discourses* for Cosim[in]o and his other companions,"[104] and Nerli's history is more explicit still in articulating a connection with the Rucellai group: "through letters, they [the members of the Rucellai group] trained themselves in the lessons of history and on them, and at their instance Machiavelli composed that book of his of Discourses on Titus Livius and also that book of treatises and dialogues on the military."[105] The express relationship that Nerli draws between the discussions of politics and the decision to attempt a coup d'état suggests that the conspirators sought to translate the lessons of Roman history into concrete political action that would, like the assassination of Julius Caesar, have the practical effect of restoring a vital tradition of republican government, specifically by means of arresting the incipient aristocratization of the Medici family. Among the members likely to have been particularly interested in the political element of the program were Machiavelli, Nardi, Nerli, and, of course, the 1522 conspirators.

The Classicizing Overlay

The context for both kinds of intellectual concern—literary and political—was an interest in classical exemplars and in restoring and celebrating classical practices, models, and standards. The metaphoric and literal frame for the activities of the Rucellai group—the garden itself, with its neoclassical horticulture and portrait

medallions—was the clearest material expression of such classicizing impulses. The group's activities were the programmatic expression of such Romanizing and Hellenizing tendencies: Machiavelli's treatise was a series of discourses on Livy; the 1522 congiura, even in its own time, was seen as having been undertaken in imitation of the ancients, as Nerli's history documents; the principal impetus for the literary program was an interest in determining if the Tuscan language, as a potential vehicle for sophisticated literary expression, was comparable to ancient Greek and Latin, and in that context one recalls that Gelli has Lascaris compare Boccaccio's *Decameron* favorably to the poetic output of the Greeks. The classicizing element of the program was likely to have been of particular interest to such members as the classical scholar and translator Luigi di Piero Alamanni, the translator Dantes Populeschus, Gelli, Lascaris, the translator Alessandro de' Pazzi, Bernardo Rucellai, and perhaps the composer and classicist Bernardo Pisano, if, in fact, he was a member of the Rucellai group.

The inspiration for the forms and the nature of the actual activities of the Rucellai group was also classical in origin. Nardi's and Nerli's accounts[106] are evidently the sources for the assumption that Machiavelli read early drafts of his *Discourses on Livy* in the Rucellai gardens. Although the two texts do not really substantiate that assumption, the notion—quintessentially humanistic in nature—that intellectual figures would have read their works to their colleagues in draft form in informal academies and salons was nonetheless clearly supported by ancient Roman references, such as Pliny's letters.[107]

One imagines, then, more or less formal presentations of texts "in progress." Otherwise, the literary activities presumably consisted of informal exchanges and discussion. That so many of the sources attesting the activities of the Rucellai group are themselves written in dialog form is noteworthy; in at least one important case the title of the work in question is specifically *Dialoghi*. The form of the sources documenting the program of the Rucellai group itself therefore parallels the kind of activity that typified the program, and the literary tradition of "dialogic genres" thus "fictionalized the interchanges of salons, academies, and schoolrooms."[108]

There is an unusually elegant illustration of the degree to which the stylistic characteristics of the early Cinquecento madrigal express the distinctive conditions of patronage that produced it. Among the subgenres of the early Cinquecento madrigal is the secular dialog, in which the voices alternate in antecedent-consequent fashion, in imitation of a verbal exchange. Where appropriate, the composer also contrasts vocal ranges so that the superius and altus parts deliver text in the female voice, whereupon the altus, tenor, and bassus, responding, deliver text in the male voice. Such contrasts in voice are obvious in Italian and other languages in which nouns and their modifying adjectives are inflected according to gender, even if there are no other devices employed by poets to identify the sex of the speaker. However, Anne

MacNeil's sensitive readings of Renaissance texts in her richly contextualized portrait of Isabella Andreini suggests that it might be possible on occasion to read text cast in the female voice in secular dialogs as the words of a homosexual male, especially in light of Michael Rocke's findings concerning homosexuality and male culture in Renaissance Florence specifically, which MacNeil cites: "as Rocke shows, submissive partners in sodomitic relationships are consistently gendered as feminine in court records and diaries as well as in carnival songs, even though their sex is decidedly male." The plausibility of such interpretations is increased by the evidence of the nature of the membership of such associations as the Rucellai group and the other institutions reconstructed here, which were resolutely masculine; indeed, women appear in anomalous, compromised, "suspect" roles (as courtesans, for example) in such institutions, which the material assembled below on the Rucellai group's Nannina Zinzera *cortigiana* suggests. MacNeil argues that period evidence "suggests an attitude towards the characterization of masculinity and femininity in Renaissance drama that is anything but rigidly constructed, although it clearly plays on the gendered hierarchies propounded by academicians," an ambivalence that is especially pertinent in the context of the academic settings that are the subject of this study and affords the possibility of readings of secular dialog texts along the lines of that proposed here.[109]

Among the composers represented by the subgenre of the secular dialog was Rucellai-group familiar Bernardo Pisano, who employed the dialog technique in setting verse by Rucellai-group member Lorenzo Strozzi. Did Strozzi and Pisano develop an interest in such compositional procedures, in musical "dialoghi," through an acquaintance with the authors of the literary "dialoghi" who frequented the *Orti Oricellari*?[110]

Other Garden Activities

The gardens are also said to have accommodated banquets,[111] and on occasion the activities occurring there had a different character altogether. An unpublished chronicle of the Rucellai family notes that "in Florence, [on] the morning that [the names of] the cardinals were made public there,[112] many leading citizens were at the garden of the Rucellai to look for Palla [di Bernardo Rucellai], because they were certain that his brother Giovanni had been made cardinal."[113]

When speaking of the program of the Rucellai group, one must bear in mind that its organization was loose and informal. It is never referred to in terms suggesting any more formal an organization than "our company"[114] or "these afternoon friends."[115] In that respect it was unlike others of the institutions described here, which had more or less fixed programs (the Broncone and Diamante Companies' execution of the 1513 carnival festivities, for example) or formal statutes (the Sacred Academy of the Medici and the Broncone, for example).

What, then, was the place within this scheme of the musicians known to have been members, or intimates of members, of the Rucellai group? A proper academy of the

type Bernardo Rucellai supported might well have included musical performances among the elements of its program, if for no other reason than that such an element would have been consistent with Rucellai's classicizing objectives and his interest in restoring ancient Greek and Roman practice. Bernardo Pisano, classicist and composer, would have been altogether comfortable attending gatherings in the Rucellai garden, and would have been a welcome addition to the group, due to such factors as his classical scholarship; his evident association with Janus Lascaris, Palla di Bernardo Rucellai, and Filippo and Lorenzo Strozzi; and his setting of Lorenzo Strozzi's verse.

The evidence linking Layolle with members of the Rucellai group is incontrovertible. In Brucioli's *Dialogi*, Layolle discourses easily on the music of the spheres, and in that respect he demonstrates a conversance with music as it figured in the mediaeval *quadrivium*. Whether Layolle in fact had the kind of speculative, quasi-scholastic interest in music that would make Brucioli's portrait of him credible is not known. However, one can readily imagine him actually frequenting the gardens, more so than Pisano or Verdelot, because of his many demonstrable associations with members of the group.

Lorenzo Strozzi's activities as a poet—in which he implicitly honored that element of the literary program that called for a refinement and purification of contemporary literary practice, modeled on the Florentine past—and his mastery of the art of solo singing to the accompaniment of his own lute playing are especially consistent with the aims and objectives of the Rucellai group.

There is thus a significant relationship of the members of the Rucellai group to Florentine musical life of the early Cinquecento and—more to the point—of the group's cultural and intellectual activities to the emerging Italian madrigal of the sixteenth century. Some historians have suggested, with good reason, that the literary concerns of the Rucellai group were critical to the origins of the madrigal. They are a more proximate source for some of the literary influences that shaped the early madrigal than Pietro Bembo's abstract literary theorizing.[116] In its earliest phases, the Cinquecento madrigal was indisputably a Florentine genre, and specifically Florentine literary influences are likelier to be relevant in this context. There are reports from at least one member of the Rucellai group of discussions of language, and specifically of the distinction of the Florentine literary tradition and the achievements of its foremost figures, for these purposes most notably Petrarch.[117] Insofar as such discussions served to shape the literary sensibilities and guide the poetic efforts of the earliest madrigal poets—and among the members of the Rucellai group there were many—they are of particular interest in the present context. More importantly, if the earliest madrigalists resident in the city of Florence in fact frequented the garden of the Rucellai (although inconclusive, the evidence is nonetheless suggestive), they would have been privy to learned discourse about linguistic and literary matters, which almost inevitably would have stimulated, in-

fluenced, and refined their thinking about the musico-literary genre known as the Cinquecento madrigal.

As in the case of the attempt by the 1522 conspirators to translate abstract political theorizing into concrete political action, in this case, too, the discursive activities of the letterati of the Orti Oricellari yielded tangible results, in that the earliest madrigals are the concrete musical expression of the literary discourse that occurred in the garden of the Rucellai. The classical interests of the Rucellai letterati explain both the fascination with Roman republicanism and the conviction that classical Greek and Latin could serve as models of refined literary expression for those then writing in the Tuscan language. What triggered the transformation from precept to program in the case of the 1522 congiura against Cardinal Giulio de' Medici was the precipitous aristocratization of the Medici family, which effectively constituted an assault on the traditions of Florentine republicanism. In the case of the initiative to emulate the linguistic practices of the "Three Crowns," the motivating principle was the conviction that a once-viable tradition, at that moment lost, was eminently worthy and capable of revival as a means of enhancing Florentine cultural prestige ("those . . . letterati who would [frequent] the Orti Oricellari . . . began to come by these said reflections and put them very much into effect, so that the language thereby regained that esteem that you [now] see");[118] the earliest madrigalists were thus provided with neo-Petrarchan verse that was especially suited to musical setting in the new madrigal style.

The documentation thus evokes a vivid sense of an informal academy—a salon—whose members, representatives of the Florentine cultural elite, "that group of bright young men . . . who were then the bearers of humanist culture in Florence,"[119] would gather in Bernardo Rucellai's garden to dine; to hear Machiavelli and others read their philosophical and literary works in draft form; to discuss common intellectual interests, principally political and literary in nature; on occasion to translate those interests into specific activities and concrete objectives (the restoration of Trecento literary standards), sometimes with destabilizing consequences (the 1522 congiura); and to engage in other kinds of cultural activity. Layolle, Pisano, and Verdelot would thus have been witness to a remarkably vital, intellectually substantive set of programmatic activities whose consequences for their aesthetic, poetic, and musical development can scarcely be overestimated.

Musical and Theatrical Activities

A space such as the Rucellai garden would have been an ideal setting for musical performances. There are references suggesting that it served such a purpose, although only one of them is specifically to a musical performance, that in *I marmi;* the other is to a theatrical performance of Giovanni Rucellai's *Rosmunda.* Both are of uncertain value but are considered here in turn.

In the second part of Anton Francesco Doni's *I marmi,* in the "Ragionamento della stampa fatto ai Marmi di Fiorenza," there is a passage[120] wherein the author sketches a scene in the gardens in which there is music-making. Among those present in Doni's fictional account is the poet Francesco Guidetti, known from other, more reliable sources to have been a member of the Rucellai group. The account is amusing and the context interesting and rich in implications.

Doni's interlocutors—the Florentine courtesan La Zinzera, a group of Florentine plebeians, and none other than Philippe Verdelot himself—are portrayed as engaged in a competition, a witty exchange of tales, often suggestive in content:

> VERDELOT: At least if Bruett, Cornelio, and Ciarles[121] were here, we would tell a dozen *franzesette* and regale this pack of plebeians here.
>
> PLEBEIANS: Since you're not able to content us with music, *we* will annoy *you* with some of the risqué stories we tell one another.
>
> LA ZINZERA: I'll tell one of them, too, when I've heard each [of you] tell his to the others.
>
> PLEBEIANS: We'll be the first; we're happy [to be]. . . .

Each of the interlocutors then proceeds to tell a tale. At the conclusion of the plebeians' second, Verdelot exclaims:

> VERDELOT: *Bellissima*! Tell another of them.

But La Zinzera interjects:

> LA ZINZERA: *I* want to tell that, the other night, I was at the garden of the Rucellai, to sing, where there was a tremendous discussion about Petrarch among those learned men; and there was one who held that this Laura had been [a metaphor for] "Philosophy," and not a woman, [on the basis of] that *canzone* that begins:

> > "A lady much more beautiful than the sun,
> > more bright and of equal age, . . .
> > drew me to her ranks when I was still unripe."[122]

There ensues an animated exchange, at the end of which there was one who said:

> "Love held me twenty-one years burning."[123]

And another responded: "This is impossible, to remain such a long time in reflection and demanding nothing in the way of romantic *dolcitudini*." At which I turned to him with a withering look and said: "I know a woman who remained for twenty-*five* years, who throughout loved another—and he her—and never, *never* did they consummate [*si copularono*] a genuinely adulterous relationship." At this the laughter began. . . . [T]hey didn't want to believe it, and I was swearing it. [Francesco] Guidetti said: "O God, *Zinzera,* it must have been *you,* this chaste woman. Is it true?" I was swearing, "No," and denying it; but there was never a disposition to say anything other than, "It must have been you, *Zinzera.*" Then all of them at once accorded me the victory in the exchange, saying, "It wasn't she! It wasn't she!"

And there was a bit more laughter; then we took to [making] music [*poi ci demmo alla musica*].[124]

What can be concluded from Doni's entertaining tale? First, it may corroborate the testimony of Brucioli's *Dialoghi* [*della morale filosofia*] and Gelli's *Ragionamento* [125] that Francesco Guidetti was a member of the Rucellai group. That the references in Brucioli and Gelli seem, in turn, to confirm Doni's increases the likelihood that Doni's account is accurate in some of its other particulars, although the possibility of an influence of the earlier of these texts upon the later ones cannot be discounted. As a philosophical work, a literary treatise, and an imaginative work of fiction, Brucioli's, Gelli's, and Doni's accounts do not have the epistemological status of archival references. Second, it suggests once again—if further evidence were needed—that literary discussions figured prominently among the activities of the Rucellai group; it was a *disputa* concerning Petrarch that forestalled the music-making. Third, it associates the courtesan La Zinzera with the meetings in the garden, although one cannot discount the possibility that this was mere literary license.[126]

La Nannina Zinzera cortigiana is a figure of considerable interest. In at least three of his poetic works, Anton Francesco Grazzini ("Il Lasca") (22 March 1503–18 February 1584)[127] lauded "la Nannina Zinzera cortigiana,"[128] who must be identical with Doni's La Zinzera, characterized as a contemporary representative of "the petite and voluptuous type of woman," one of the innumerable Nannas and Nanninas "whose *noms de guerre* indicated their diminutive dolly-type of charm."[129] Indeed, La Zinzera's name, "Nannina," is the diminutive of Giovanna, which must have been her real name; she thus exemplifies that tendency among courtesans "toward the deliberately artificial . . . , starting with their names."[130] Her sobriquet, "Zinzera,"[131] may suggest something about her complexion, or the color of her hair, or—more interestingly still—her piquant personality. In one of Il Lasca's poetic tributes to La Zinzera,[132] "Nannina" is cited with "Tullia [d'Aragona, another famous courtesan] e Totta e Fioretta."[133] Il Lasca's poetic works confirm that La Zinzera was not exclusively a product of Doni's literary imagination and, moreover, that the tradition—whether historical or literary—was that she was indeed a musician, which suggests that this important element of Doni's portrait of her in *I marmi* may be grounded in historical fact: Il Lasca's laudatory *capitolo* makes explicit mention of La Zinzera's musical abilities.[134]

Such poetic encomia in praise of female musicians who frequented academic circles were by no means an exclusive feature of Florentine experience. The Venetian academician Domenico Venier directed a similar tribute to the singer Franceschina Bellamano in 1565.[135] Moreover, the literary references assembled here may be further contextualized within a network of references attesting specifically Florentine activity. Doni's literary reference is related to historical references docu-

menting that Filippo Strozzi (brother of the Lorenzo who frequented the Rucellai gardens) maintained a *villino* near the Porta San Gallo, where he would host his friends (Lorenzo di Piero di Lorenzo de' Medici among them) and the courtesans Alessandra Fiorentina, Beatrice, Brigida, and Camilla Pisana, the last of whom was Strozzi's mistress, a poetess, and a musician; her letters contain references to musical instruments and to her predilection for singing.[136] Such informal salons— whose members often included musically gifted courtesans—were therefore part of Florentine cultural experience. Doni's reference cannot be dismissed as unrealistic, although, as has been said, it may not be historically accurate in its particulars.

La Zinzera more than likely did not sing in the garden of the Rucellai, which may have been closed in 1522 at the time of the congiura against Cardinal Giulio. If Doni's account was accurate in this respect, La Zinzera would have to have sung there before that date. On the contrary, inconclusive evidence for the dates of her activity—such as the *madrigalone* addressed to her by the mid-sixteenth-century figure Il Lasca—make it unlikely that she was active as early as the second decade of the sixteenth century or very early in the third. Let us suppose that she was about twenty years old when she sang in the Rucellai garden: unless Il Lasca's madrigalone was among his very earliest literary efforts, she would have been considerably older when made the subject of his verse. Is that not unlikely, especially given Il Lasca's explicit description of her physical characteristics?

The various literary references to La Zinzera do support some conclusions, however. The fact that Il Lasca's madrigalone addressed La Zinzera explicitly as "cortigiana" makes clear that she was a courtesan, which would also have been suggested by her status as an otherwise unaccompanied woman in the company of men. Doni has her quote Petrarch, which suggests that she would have been regarded by contemporaries as a learned courtesan (or "cortigiana onesta"); unlike other cortigiane oneste named "Imperia," or "Lucretia," or "Tullia," however, La Zinzera did not bear a name that in and of itself immediately suggests that she was so.

Doni's treatment of her appearance in the Rucellai gardens assumed a knowledge on the part of his learned readers of a conventional image of courtesans, one that he employed imaginatively and ironically: their tendency to "practice the arts of deception."[137] When Doni had Francesco Guidetti challenge La Zinzera ("O God, . . . it must have been *you,* this chaste woman. Is it true?") and elicit her vehement denial, her denial was meant to be seen as dissimulation. The fact that she was dissembling specifically with respect to the matter of her personal sexual profile made Doni's literary strategy all the more ironic. She, a courtesan, tells the tale of a chaste woman. Her fellow members of the Rucellai group teasingly attribute the personal characteristic of chastity to her, of all people. Although the story is recounted in such a way as to substantiate their teasing assertions, she denies that the chaste woman was she. But given her very status as a courtesan, at some level she might well have regarded the

suggestion wistfully, despite her denials. The affectionate teasing that ensues[138] is followed by obviously contrived capitulation[139] and culminates in laughter, which suggests that the entire exchange was meant to be seen as charged with humorous irony and artful deception. The fact that the scene takes place in the Rucellai garden further suggests that the garden was to be seen metaphorically as a stage, a theater where the "arts of deception" were routinely practiced. As will be seen, the gardens may in fact have served as a stage, literally as well as metaphorically.

Perhaps, then, La Nannina Zinzera cortigiana, or someone like her, frequented the Rucellai gardens. Her presence among academicians would not have been anomalous, since there is evidence of other women in sixteenth-century Italy frequenting "the masculine world of the prestigious academies."[140] Her attendance at gatherings in the Orti Oricellai would have feminized somewhat the otherwise ultramasculine Rucellai group; her very presence would thus have enriched and extended the character of the membership. La Zinzera was a woman, a courtesan, and therefore perhaps a representative of a nonelite stratum of Cinquecento-Florentine society, in contradistinction to other members, and the simple fact of her attendance would serve to complicate any inclination toward facile characterization of the group that frequented the garden of the Rucellai. In short, Doni's reference in one stroke alters the image of the Rucellai group, since it locates an individual among the members whose profile is appreciably different from the profile of the others. The mixed character of the membership of the Company of the Cazzuola may also be seen as an expression of the similarly mixed associations of the Cazzuola's cultural program, and vice versa; Doni's reference to La Zinzera as a participant in the meetings in the Rucellai gardens perhaps permits a similar interpretation of the Rucellai group. The importance for the Cinquecento madrigal is that the activities of both institutions document a vital heterogeneity in the cultural conditions that lay behind the emergence of the new genre.

Our understanding of La Zinzera's position in the Rucellai garden academy is further enriched through reference to early seventeenth-century texts attesting the academic activities of Isabella Andreini, who in 1601 engaged in a poetic exchange with members of the Veronese Accademia Filarmonica, corresponded that same year with the Belgian academician Erycius Puteanus (then living in Milan), and was subsequently invited to join the Accademia degli Intenti of Pavia, of which Puteanus was also a member. Although not a courtesan, Andreini, like La Zinzera, nonetheless occupied a carefully circumscribed place within the academic settings of her time. Unlike noblewomen "who wrote and published poetry but eschewed contracts and monetary remuneration," Andreini of necessity sought benefactions. For her, the pursuit of such benefactions was assumed as a necessity: "financial security depended on . . . artistic success." Such an "association of creativity with economics. . . . fosters a sense of awareness in the analysis of Andreini's works of stratagems pertaining to the differences between men's and women's social

places—a compositional negotiation that is generally absent in the writings of noblewomen.... Andreini engaged in creative as well as economic barter with her benefactors, whereas noblewomen ... could perform similar creative roles within the circles of female court culture, with little or no regard for broaching the distance between themselves and masculine spheres of patronage."[141]

Thus Andreini—like La Zinzera before her—would have had an acute awareness of her own otherness relative to her fellow academicians, specifically with respect to social position, although the source of such awareness was obviously not identical in the two cases. La Zinzera was a woman, a courtesan, and a musician who quoted Petrarch; Andreini was a woman, a childbearer, a devoted wife, and a Christian mother,[142] yet also an actress, a musician, and a poet. Both women frequented academies whose membership was otherwise largely or exclusively masculine.[143] As such, their position was more precarious than that of other members, and their success depended on a skillful deployment of their artistic talents. Their somewhat anomalous position also explains, in La Zinzera's case, the tendency among courtesans "toward the deliberately artificial," the inclination to "practice the arts of deception,"[144] and, in Andreini's case, the tradition of "theatrical representation," her admission that "she deceives her audiences, play-acting divine madness and reciting not cosmic truth but lies": "she tells her readers that the poems open before them have their origins not in a book-lined cell or other private space where female authors are traditionally said to have sat in solitude with pen and paper, but rather on stage in the marketplace of imaginary lives enacted there."[145] Appropriately, the setting for the activities of both—for their performances—was a literal or metaphoric theater.

A portrait of another famous courtesan, Barbara Salutati—who, like so many other courtesans, was also noted for her musical abilities—aids in attempts to envision La Zinzera and to imagine the effect she may have had on her male contemporaries; indeed, Salutati is especially relevant in this context, since she was engaged as performer for the 1526 staging of *Mandragola* planned for Faenza by Ludovico Alamanni and Niccolò Machiavelli. Although these courtesans were subject to the "almost ubiquitous influence of Castiglione's ideal," and "musical proficiency was an important and often cited part of the arsenal of delights manipulated by these women, they were not professional musicians. They were, rather, imitations of the ideal *donna di palazzo*."[146]

Doni's account, finally, suggests something about the kinds of circumstances under which music might have been performed: as a complement to other sorts of activities and as the culmination and resolution of long and animated discussions.

On the debit side of the ledger, Doni's text alone does not permit the conclusion that Verdelot frequented the Rucellai gardens, despite the fact that some scholars have drawn that inference.[147] Indeed, his text should not yield too many inferences,

either about the phases of activity of the Rucellai group or about the chronology of Verdelot's career.[148] (Of course, the testimony of Doni's account is no longer required to argue for Verdelot's presence in Florence very early in the 1520s, since there is now documentation of his presence there in 1521.[149]) Once again, Doni's account is fictional, and its status as evidence has to be evaluated accordingly.

Another reference—its epistemological status somewhat less equivocal—similarly suggests that the gardens may have witnessed performance activity. There is a famous tradition that a renowned work by Cosimino Rucellai's uncle Giovanni di Bernardo (1475–1525)—the *Rosmunda*, the earliest extant tragedy in the Italian language[150]—was staged in the gardens. The tradition has become so vital that it is often invoked, almost invariably without substantiating documentation, even by distinguished scholars.[151]

The traditional assertion is that Rucellai's *Rosmunda* was performed in his family garden for Leo X during the pope's visit to Florence in late 1515 and early 1516, perhaps during the 1516 Carnival. The notice[152] is "not . . . otherwise documented,"[153] and until recently there was no known sixteenth-century reference substantiating the tradition. Among contemporary references heretofore known, there is Giovanni Rucellai's 5 November 1515 letter from Viterbo to Trissino at the court of Maximilian, shortly before the pope's arrival in Florence,[154] but the evidence of Rucellai's letter is equivocal. The papal master of ceremonies Paris de Grassis—ordinarily the most punctilious of official diarists—makes no mention of a performance.[155] And in a poetic account of Leo's visit by Zaccaria Ferreri da Vicenza,[156] Ferreri makes mention of a splendid banquet in the family garden, which Giovanni Rucellai hosted for the pope, but no mention of a theatrical performance.[157] More recently, however, Giovanni Falaschi reported[158] that a mid- to late sixteenth-century appendix to Giovanni di Paolo Rucellai's famous *Zibaldone*[159] contains a reference to the performance of *Rosmunda*: "In 1515, Pope Leo, finding himself in Florence, was fêted at the Rucellai garden, with all the cardinals, and in 1516 Giovanni Rucellai had his tragedy *Rosmunda* performed in Leo's presence."[160]

Other indirect evidence attests the plausibility of the tradition about theatrical performances in the garden of the Rucellai. Trissino's *Sofonisba* was later performed by the Vicentine Accademia Olimpica. One might speculate, extrapolating backward, that theatrical performances were among the elements of the program of the Rucellai group, given Trissino's associations with both the Rucellai group and the kinds of cultural and intellectual figures who constituted the membership of the Accademic Olimpica, and also Trissino's knowledge of the projected performance of Rucellai's *Rosmunda* in 1515/16. The theatrical performances staged by the Accademia Olimpica might be interpreted as an expression of the kind of activity Trissino thought appropriate to the program of an informal or formal academy, his thinking about such matters having been shaped by his earlier experiences with the Rucellai group. The same kind of argument by extrapolation about the nature of the

activities occurring in the Rucellai garden could be made on the basis of Giovanni di Bernardo Rucellai's subsequent patronage practices when he was *castellano* of the Castel Sant'Angelo in Rome in the 1520s.[161]

However one interprets the inconclusive references in Doni,[162] Negri,[163] and the appendix to the *Zibaldone*,[164] the desire to speculate that the reports are historically accurate is difficult to resist. The evocative descriptions of the landscaping in Machiavelli's *Arte della guerra*, the many allusions to animated discussions of language and politics, and other references easily permit the imagination to locate musical or theatrical performances in the gardens. They would have been a fitting and powerful complement to the other elements contributing to the gardens' stimulating *ambiente*. Moreover, the fact that Rucellai's *Rosmunda*, the earliest extant Italian tragedy (rather than, let us say, Dovizi's comedy *Calandria* or Machiavelli's comedy *Mandragola*), was said to have been performed in the garden once again suggests something about the academic consequentiality or seriousness of the group's program.

In one sense, what matters is not whether there is unequivocal historical evidence of musical or theatrical performances in the Rucellai gardens but that, in the sixteenth and early eighteenth centuries, historical documentation attests such performances; reporting or suggesting that there were was not thought to be extravagant or to strain credulity. For Doni and Negri, the gardens clearly seemed an appropriate venue for that kind of activity, and the fact that Doni's literary imagination readily permitted him to envision it occurring there suggests that the gardens may well have served such a function. Similarly, the more scholarly objectives of Negri's account did not prevent him, either, from reporting that the gardens served as a setting for a theatrical performance.

The Musical Tastes and Experiences of Members of the Rucellai Group

If the gardens were indeed the scene of musical performances, what kind of music would have been performed there? The writings of one of the most important members of the Rucellai group, Antonio Brucioli, suggest some answers. Brucioli's text in turn is the expression of a musico-literary tradition of unusual importance and durability, one attested by numerous texts whose dates and places of origin range from ancient Greece to eighteenth-century Italy. The more representative and illuminating of such references are among the best evidence available as to the actual musical activities of the Rucellai group and the musical sensibilities and experiences of its members.

In the fifth of Brucioli's *Dialoghi [della morale filosofia]*, "On the method of educating children,"[165] Cosimino Rucellai asks Giangiorgio Trissino what role he would have music play in the education of children.[166] Trissino responds:

With respect to music, which you asked me about, I would not take care [*non curerei*] that a young person thus expend his energy [*si affaticassi*], because there is nothing upright and honorable about something unsupported by a foundation of words and aphorisms [*sentenze*]. Moreover, when the delicate voices and voluptuous accents, with the softening effects [*moderamento*] of harmony [*concento*], reach the ears (affecting the spirit), or tempt the libidos of young souls, or cause them to be languishing in pain, or act rashly upon [*precipitosi*] the immediate impulses of the spirit, such things contaminate one's virtue not a little. And in this way, certainly, the Greeks first corrupted their upright, ancient, and laudable practices, indulging in [*frequentando*] theatrical performances, scenes, and choruses, with which they would excite the ears and spirit with various sentiments. Then this pernicious effeminacy was exported to Rome, which broke the [collective] stamina of its ancient [habits of] seriousness. And one will be able to see what good our own era could hope for from similar vocal music if one considers the practices and knowledge with which those who today make a profession of it are endowed, for which I do not judge it worthy of free men, that it could be of benefit to themselves and others.[167]

Brucioli's quintessentially Platonic arguments, which effectively constituted a humanist topos, belong to a venerable tradition whose lineage is worth tracing in some detail. One *locus classicus* was Cicero's *De legibus* (*The Laws*), II.xv.38–39.[168] As Cicero himself indicated, his authority in turn was Plato (the *Republic*, IV.424. b-IV.425.a):

To put it briefly, then, said I [i.e., Socrates], it is to this that the overseers of our state must . . . be watchful against its insensible corruption. They must throughout be watchful against innovations in music . . . counter to the established order, and to the best of their power guard against them, fearing when anyone says that that song is most regarded among men "which hovers newest on the singer's lips" [Socrates is quoting the *Odyssey*, I.351–52], lest haply it be supposed that the poet means not new songs but a new way of song and is commending this. But we must not praise that sort of thing or conceive it to be the poet's meaning. For a change to a new type of music is something to beware of as a hazard of all our fortunes. For the modes of music are never disturbed without unsettling of the most fundamental political and social conventions. . . . / It is here, then, I [i.e., Socrates] said, in music, as it seems, that our guardians must build their guardhouse. . . . / It is certain, he [i.e., Adimantus] said, that this is the kind of lawlessness that easily insinuates itself unobserved. / Yes, said [Socrates], because it is supposed to be only a form of play and to work no harm. / Nor does it work any, [Adimantus] said, except that by gradual infiltration it softly overflows upon the characters and pursuits of men and from these issues forth grown greater to attack their business dealings, and from these relations it proceeds against the laws and the constitution with wanton license, Socrates, till finally it overthrows all things public and private. . . . / Then, as we were saying in the beginning, our youth must join in a more law-abiding play, since, if play grows lawless and the children likewise, it is impossible that they should grow up to be men of serious temper and lawful spirit. . . . / And so we may reason that when children in their earliest play are imbued with the spirit of law and order through their music, the opposite of the

former supposition happens—this spirit waits upon them in all things and fosters their growth, and restores and sets up again whatever was overthrown in the other type of state.[169]

The sentiments of these revered classical authors were subsequently echoed by such fifteenth- and sixteenth-century humanist writers as Vittorino da Feltre's pupil Saxolus Pratensis (Sassuolo Pratese), who wrote that the popular music of his day was "polluted, indecent, corrupt, and corrupting";[170] Maffeo Vegio, who wrote that "the greatest watchfulness is needed in teaching Music, for we see many promising youths lose all vigour of mind and character in their absorption in unworthy harmonies";[171] and Paolo Cortese, who wrote that "many . . . think it to be hurtful for the reason that it is somehow an invitation to idle pleasure, and above all, that its merriment usually arouses the evil of lust."[172] In the Proem to Titus Pyrrhinus (1507) on Plutarch's *Musica*,[173] in a passage laced with sentiments that today would be regarded as virulently misogynistic, Carlo Valgulio further developed the conceit:

By increasing [the number] of strings and the variety of harmonies, by concocting dithyrambs for twin [*auloi*] and verses pleasing the crowd with glad deceit, they [i.e., classical poets] turned music from the forceful, severe, seemly, and simple [art that it was] into something soft, seductive—like a woman whose hair is curled with irons—and fickle. But someone may ask, what harm can come of this? Truly enormous harm, spreading widely, and even in the better things. Is not the softening and slackening of citizens' souls an evil? Is not the loss of chastity and corruption of morals an evil? . . . So great is the power of musical airs [*cantici modi*] in either moral direction that we ought to investigate which kinds should penetrate citizens' souls—particularly tender ones: whether they should be seemly, serious, and severe, or, on the contrary, fickle, languid, varied, and soft. . . . I would lament here the music of our time, had it not long since been loudly mourned. . . . The whole art and science [of today's musicians] consists in certain few syllables, and they sing almost nothing without reading from a book. In it nothing is written except certain notes and characters, and if at times they pronounce some words of songs, you may say that most of them are taken straight out of some commonplace sources.[174]

The extraordinary durability of the topos within Italian musical thought may be documented with a single eighteenth-century text, Lodovico Muratori's *Della perfetta poesia italiana*. Muratori asks, "[H]ow much more to be condemned is modern [music], which appears . . . incomparably weaker and more tender, and makes its listeners all the more weak and lascivious?" He continues:

Whether such effeminacy derives from the abuse of crotchets and quavers and minute notes, which break the gravity of the song, or from the voices of the performers, which are mostly feminine either by nature or by artificial intervention, and consequently bring too much softness and languor to the souls of the audience; whether it proceeds from the use of the *ariette* that tickle those who listen to them with im-

moderate pleasure . . . or else from a combination of all these factors, we can be sure that modern theatrical music is extremely harmful to the people, who are debased and always made more inclined to pleasure by listening to it.[175]

Elsewhere, Muratori explicitly invokes Plato when he says that

it cannot be denied that our theatrical music has reached such an immoderate degree of effeminacy as to be more apt to corrupt the souls of its listeners than to purify and make them better, *as ancient music did* [emphasis added]. . . . Everybody knows and feels which emotions are produced within by listening to competent *musici* in the theater. Their singing always inspires a certain languor and sweetness that secretly works to make people more and more debased and given to abject loves, for they absorb the artificial languor of the voices and take pleasure in the lowest affections spiced by an unhealthy melody. What would Plato say were he to listen to the music of our theaters?[176]

These texts share a vivid and explicit vocabulary: "languor," "corruption," "effeminacy," "sweetness," "softness." And the commonalities among them suggest a dependence of the later texts on the earlier ones, if not directly from one text to the next, then by way of intermediaries. The gendered critique of contemporary music in the Renaissance texts (Sassuolo, Vegio, Cortese, Valgulio, Brucioli)—their oblique and overt masculine/feminine dichotomies—has been aptly characterized in another context as "a formulaic intellectual gambit, . . . based on rhetorical tropes handed down through several generations of Renaissance scholars."[177] Giovan Maria Artusi's famous treatise of 1600 is merely a late Renaissance instance of Brucioli's rhetorical strategy, a "complex fabric of explicit and implicit gender references . . . that constitute an attempt to discredit modern music as unnatural, feminine, and feminizing of both its practitioners and its listeners."[178]

Brucioli's text is not so easily translated or interpreted. It is largely an enumeration of the effects of music and lacks a similarly full enumeration of the specific, concrete characteristics of music as a medium of expression. Therefore, we can only speculate as to whether Brucioli had a particular kind of music in mind, although the references to "a foundation of words and aphorisms [*siede di parole e di sentenze*]" (which suggests the central importance of a text), to the plural "delicate voices [*voci*]" (rather than to the singular "voice"), and to the "voluptuous accents [*voluttuosi accenti*]" and "softening effects of harmony [*moderamento di concento*]" must be to polyphonic vocal music specifically. So, too, must the concluding reference in Valgulio's text: "[today's musicians] sing almost nothing without reading from a book." His was a conventional pejorative allusion to what was considered a subservient dependence upon musical notation—the means by which polyphony was necessarily preserved and disseminated—as contrasted with the celebrated spontaneity of the performance of orally transmitted works. The most notable expression of this quintessentially humanistic principle is Castiglione's famous refer-

ence in *Il cortegiano* to the preferability of solo singing to string accompaniment, as contrasted with a polyphonic performance relying upon notation.[179]

Brucioli's argument is thus consistent with yet another venerable humanist topos. In Nino Pirrotta's formulation, "a constant residuum" of the sixteenth-century critique of polyphony "is the deep dissatisfaction that polyphony could soothe the ear with soft consonances or smoothly managed dissonances . . . but lacked the power of captivating . . . its audience. Two explanations were usually given. . . . According to the first . . . , both the structure and ways of performing polyphonic music hindered the understanding of the texts, with which the aesthetic conceptions of the time identified the emotional message of the composition."[180]

If Brucioli was referring specifically to polyphonic music, his reference to the pernicious effects of music on the ancient Greeks and Romans is ironic, since a tenet of humanist thinking is that the music of the ancients was not polyphonic. Besides, he seems to have been saying something different, and perhaps Brucioli was instead wary of the effects on young people of music of any type. Brucioli "repeats the traditional Platonic ideas on education of a Spartan character, conducive to sobriety, obedience, and bravery in war."[181] In such a scheme, musical training could have little or no place. Here again, however, there is an irony in the fact that Brucioli was demonstrably an intimate of one of the early madrigalists, Francesco de Layolle.

As a close comparison of Brucioli's text to Cicero's makes very clear, Brucioli was heavily dependent on classical Latin authority in framing his argument, and the simplest interpretation is that he was uncritically reproducing the themes, and even the language, of the ancient texts that served as his source material; perhaps a great deal should not be inferred from Brucioli's text about his own independent view of these issues, or the views of his colleagues in the Rucellai group. On the other hand, he does amplify somewhat the references in the classical material to the specific properties of music that were cause for concern. In his apparent reference to the characteristics of vocal polyphony, he reframes, reinterprets, and updates the classical argument in terms responsive to contemporary humanist discourse and understandable to his fellow Florentine humanists of the early Cinquecento. Yet Brucioli's text conveys a sense—as does Muratori's in the eighteenth century— that the various elements of the topos, specifically its vivid vocabulary, were applied reflexively to whatever musical traditions were at that moment deemed susceptible to criticism, the vocabulary being sufficiently general and flexible to serve as the means for a critique of various musical practices. The classical terms were the linguistic elements in the established idiom for constructing music criticism.

At the very least, Brucioli's text is redolent of humanistic thinking about music. The terms of his argument, and the images he invokes, are humanistic ones. Even if he was concerned about the effects of music in general and not simply polyphonic music, his very conception of the nature of music as a medium of expression evinces

humanistic sensibilities, and the powerful effects about which he was evidently concerned are those enumerated by other humanist writers.

How might the humanistic sensibilities of Brucioli and his colleagues in the Rucellai group have been reflected in their resultant musical tastes and in their actual musical experiences? Where there was conventional humanistic thinking about music, there were presumably conventionally humanistic kinds of music-making. To judge from the testimony of Brucioli's text, such music-making as there was in the Rucellai gardens is likely to have been principally of a particular type, evocatively described by Pirrotta.[182] In place of the polyphonic vocal music of the sort exemplified by the contemporary French chanson, there would instead have been solo singing to which the soloist himself provided his own string accompaniment, which had been characteristic of the musical practices of Italian humanist circles since the previous century. To Valgulio, such practices would have liberated the musician from a submissive reliance on musical notation. To Brucioli and his colleagues, such practices would have profiled and made intelligible the "foundation of words and aphorisms" and avoided the "pernicious effeminacy" of "delicate voices," "voluptuous accents," and "softening effects of harmony" deemed to be characteristic of contemporary vocal polyphony. Solo singing permitted a sensitive, expressive response on the part of the soloist to the meaning of the text and to individual text elements of the sort that is evident in the early madrigal, though translated into the polyphonic "maniera." Here, too, such musical practices were consistent with classical tradition (or at least with the Renaissance understanding of it), and in that respect they recall the garden design, the classical scholarship of several members of the group, and other expressions of the same classicizing tendencies.

Such concerns were all the more urgent because of the importance to the members of the Rucellai group of linguistic and literary matters. Gelli's reference to Lascaris's remarks "at table in the garden of the Rucellai" is an implicit equation of the Trecento Florentine literary tradition with the ancient Greek tradition. We cannot be certain of the historicity of Gelli's account, or even that Lascaris in fact visited the garden of the Rucellai, but the fact that Florentine/Roman cultural experience of the early sixteenth century was suffused with a consciousness and understanding of the classical Greek tradition was due in good part to Lascaris. And even if he himself did not say what he is reported to have said, the equation implicit in the remarks attributed to him would have been accepted by many early Cinquecento Florentine letterati.[183] The kinds of sentiments that were expressed permitted and prompted an expansion of the repertory of appropriate models for literary expression to include examples from the Trecento Florentine literary past. "The young men of the *Orti Oricellari* . . . devoted to their own Florentine and Italian tongues the same care and attention which Valla had dedicated to Latin. . . . The object was . . . to see whether the Italian or the Florentine language was capable of the same fluency and eloquence, the same precision of speech, the same potentialities of rhetorical expression as the Greek."[184] This, in turn, might give some

sense of what kind of music would have been deemed appropriate to the "program" of the Rucellai group. Under such circumstances, compositional or performative practices that clearly profiled the text and permitted the exquisite refinements of Petrarchan and neo-Petrarchan verse to be fully intelligible would have been favored.[185] That is an argument for solo singing to string accompaniment, rather than polyphony.

We are not dependent solely on such speculations as a means of gaining insight into the musical experiences of the members of the Rucellai group. As has been seen, there is period evidence of Lorenzo Strozzi's conversance with the tradition of solo song with string accompaniment; indeed, Strozzi himself was a practitioner.[186] There is also testimony to Giovanni Corsi's conversance with that tradition.[187] That Trissino, too, was conversant with the venerable practice is suggested by his description in the *Ritratti* of Isabella d'Este's mastery of solo singing to the accompaniment of her own lute playing.[188]

Moreover, there is contemporary documentary evidence that Jacopo Nardi was intimately familiar with that same tradition. Nardi's comedy *I due felici rivali*[189] was preceded by "stanzas sung to the lyre [by an actor representing the] poet Orpheus . . . when the . . . comedy was performed in the presence of the . . . Magnificent . . . Lorenzo de' Medici," which demonstrates that Nardi was actively involved with the practice. The stanzas, like the text of the comedy, must have been authored by Nardi himself; they are replete with Medicean conceits found in other of his literary works, and—given that it was important that the political message in the text of the stanzas be clearly conveyed—a compositional or performative technique such as that exemplified by solo singing was suitable to the objective of intelligibility.[190]

The musical activities of the Rucellai group would thus have been consistent with the musical practices of other similar institutions, Giovanni Pontano's Neapolitan academy among them.[191] The famous solo singers Serafino Aquilano and Il Chariteo (the Catalan musician Benedetto Gareth) were members of Pontano's academy,[192] which suggests that solo singing was a feature of his academic program. As documented earlier,[193] Bernardo Rucellai had frequented Pontano's academy in 1495, during his Neapolitan sojourn, and the musical practices of Pontano's academy might have suggested something in the way of a model to Rucellai.

These many references suggesting the importance of Neapolitan artistic traditions as models for the Florentines—for example, the nature of Pontano's academic activity generally, the horticulture of the Rucellai garden as evoking Neapolitan practice, the tradition of solo singing to string accompaniment as similarly practiced at Pontano's academy, and so on—might document, yet again, a Florentine fascination with Neapolitan royal custom that, for those Florentines who were adherents of the Medici (such as Lorenzo il Magnifico's brother-in-law Bernardo Rucellai, husband of Lorenzo's sister, Nannina), had additional important dimensions: the Medici had been restored to Florence in 1512 specifically by force of

Spanish arms, and a Florentine fixation on the artistic practices of the Aragonese Kingdom of Naples might be profoundly interconnected—in a ramified, complicated way—with contemporary political/military allegiances.[194]

Members of the Rucellai group were conversant as well with the Florentine carnival-song tradition. Several of them were also members of the companies responsible for the 1513 Florentine carnival festivities, which included the singing of explanatory canti carnascialeschi, as we shall presently see. Here, however, I am referring instead to evidence suggesting that in 1507, members of the Rucellai group organized *mascherate* that included the singing of canti. Filippo de' Nerli reported on the two political camps of early Cinquecento Florence, the one whose members supported the gonfaloniere a vita, Piero Soderini, and the other whose members favored the return of the Medici; according to Nerli, the second comprised individuals who frequented the garden of the Rucellai and organized mascherate.[195] In a February 1507 letter,[196] Lorenzo Cambi reported to Lorenzo di Filippo Strozzi on a maschereta organized during the carnival season then underway, "in the house of Prinzivalle [della Stufa], and the theme was 'Abundance,' as you'll be informed by [your brother] Filippo."[197] As Cambi's letter suggests, Filippo himself subsequently reported on the mascherata.[198]

These two letters associate Filippo and Lorenzo Strozzi, Antonfrancesco degli Albizzi, and Piero Rucellai with the organization of mascherate; all were members, or close relatives of members, of the Rucellai group during its later phase of activity.[199] The letters' relationship to Nerli's account in turn suggests that Albizzi, Piero Rucellai, and the two Strozzi were members of the Rucellai group during the earlier phase (the letters date from 1507), which one would not have known solely on the basis of the contemporary sources identified in Table 1 above. The letters also document the singing of the explanatory canto carnascialesco on the theme of "Abundance" by the famous Florentine composer Baccio degl'Organi, a canto preserved to this day, though in a fragmentary state.[200] This, in turn, substantiates other evidence documenting a familiarity with the Florentine canto carnascialesco tradition on the part of several of those who frequented the Rucellai gardens, which will be considered in Chapter 3.

The foregoing account summarizes all the relevant available evidence concerning the activities of the Rucellai group and its relationship to the earliest madrigalists and, more generally, to Florentine musical life of the early Cinquecento. Although detailed descriptions of the meetings themselves are lacking, other period texts assist in an attempt to envision the meetings in the garden and reconstruct their possible musical element. In a 1501 letter, Agostino Vespucci furnished future Rucellai-group member Niccolò Machiavelli with a description of how their Roman contemporaries were "continuously in the garden with women, . . . where they

awaken the silent muse with their lyre. . . . But, good God, . . . how much wine they guzzle after they have poetized. . . . They have players of various instruments and they dance and leap with these girls in the manner of the Salij or rather the Bacchantes."[201] Vespucci's letter thus describes a Roman garden where there are men in the company of apparently unspoken-for women, who therefore risk being characterized as courtesans, where there is the playing of a lyre and other instruments, declamations of poetry, liberal consumption of wine, and Bacchanalian dancing. With Vespucci's text as background, we return to the garden of the Rucellai.

Like their counterparts who gathered in a Roman garden in 1501, the compagni of the Rucellai garden academy would assemble there regularly during the second decade of the Cinquecento in search of fellowship and stimulating conversation; their infirm host, Bernardo's diminutive grandson Cosimino, would greet them from his customary seated position. Lorenzo Strozzi may have been a regular attendee, often with his lute in hand, as might Layolle, Pisano, and Verdelot, and La Zinzera or someone like her. One subset of the membership, comprising those whose interests were principally political in nature, would engage in conversation about contemporary Florentine political affairs, the discussion perhaps prompted by a more or less formal reading by Machiavelli of some of his work in progress. Another subset, comprising Guidetti and other literary figures, would engage in a different sort of discussion about the "questione della lingua" or the difficulties some of them had experienced in attempting to imitate the refinements of Petrarch's verse.

Lorenzo Strozzi might have a made a practice of accompanying himself in performances of musical settings of his own poems, or perhaps Petrarch's, presumably making use of a stock, formulaic "aëre da cantar" or "modo de cantar" sonnets or *capitoli* or *versi,* of the sort found in period sources, though embellished in his performance, of course.[202] Corsi, Nardi, and Trissino—all conversant with the tradition of solo song—would have stood at rapt attention, absorbed in Strozzi's performance.

When La Zinzera, Layolle, Pisano, and Verdelot "si danno alla musica," to adopt and adapt Doni's language, what might they, alternatively, have sung? Given Brucioli's reservations—quintessentially humanistic in nature—about the properties of vocal polyphony, the part music sung by La Zinzera, Layolle, Pisano, and Verdelot would ideally have been stylistically reminiscent of the typical, homorhythmic lauda or canto carnascialesco. Alternatively, to invoke Pirrotta's words, they sang "contrapuntal elaborations [of popular tunes] in the special type [of frottola] called *villota* (somewhat parallel to some French *chansons*). . . . *Villote* and French *chansons* are often associated in prints and manuscripts of the period preceding the ascent of the madrigal; they probably met the demand for polyphonic pieces to be sung *a libro* by dilettanti, a habit which may have contributed to the all-vocal development of the madrigal."[203] This characteristic of the

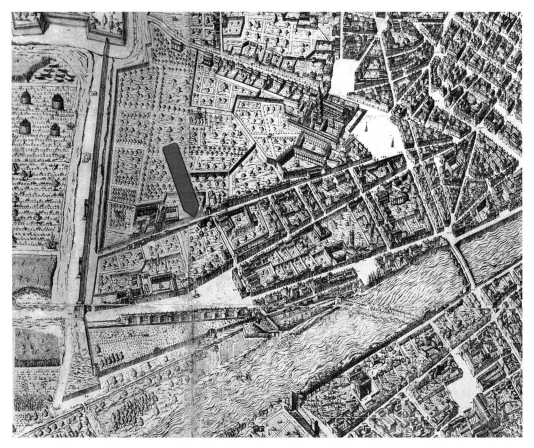

Figure 1.12 The compagni of the Rucellai garden academy would assemble there regularly during the sec-
ond decade of the Cinquecento, in search of fellowship and stimulating conversation.

earlier sixteenth-century madrigal has been described as the result of its being "an art
form for performers" rather than "one for listeners," depending "for its impact on the
effect of the individual part on the individual performer," rather than "the effect of the
whole on some outside person or persons," which is typical of the madrigal of the later
sixteenth century and reveals the impact of "the separation of audience and performer,"
resulting in "a new kind of polyphonic madrigal, designed to be performed by profes-
sionals and heard by patrons."[204]

La Zinzera, Layolle, Pisano, and Verdelot were not dilettanti. But the types of
pieces to which Pirrotta referred are found in prints and manuscripts of this period
and—more to the point—in Florentine sources of precisely this time.[205] Such mu-
sic had added virtues. Although it was part music, its part-writing is hardly of the
sort that would have troubled Brucioli, at least as it contrasts with the kind of imi-
tative writing one finds in the contemporary motet, for example. Sebastiano Festa
wrote music "of almost copybook simplicity."[206] Moreover, the melodic qualities of

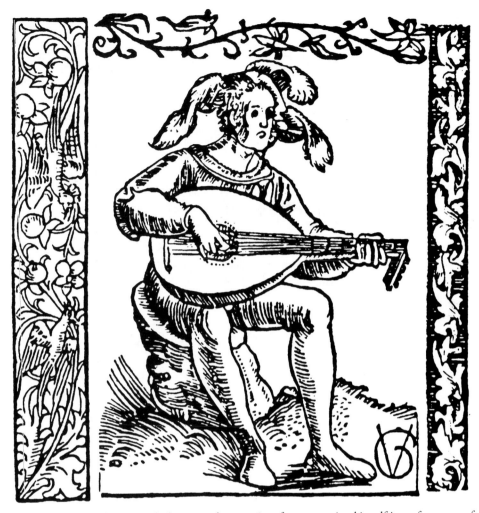

Figure 1.13 Lorenzo Strozzi might have a made a practice of accompanying himself in performances of musical settings of his own poems, or perhaps Petrarch's, presumably making use of a stock, formulaic "aëre da cantar" or "modo de cantar" sonnets or *capitoli* or *versi* of the sort found in period sources.

the popular tunes elaborated contrapuntally in the villotta and related genres would have been likelier to embody the characteristics of aria: "the quality . . . [of] being, as it were, precisely determined and inflected on an unavoidable course," "a sense of self-possessed determination," "the unrestricted and undiverted naturalness of the melody."[207] In the villotta, the popular tune is in the tenor, not the superius, but insofar as its melodic properties conditioned the character of the melodic writing throughout the entire texture, the superius would also have possessed some of the characteristics of aria; some of Festa's pieces are marked by a "uniformity of melodic style among all voices."[208] Such features, too, would sooner have met with Brucioli's approval than those of other contemporary types of part music.

Contrapuntal elaborations of popular tunes may not have satisfied Brucioli; the use of the popular material might not have been consonant with his refined humanistic objectives, nor might the characteristic refrain texts comprising nonsense syllables of the type found, for example, in Festa's *villotta L'ultimo dì di maggio*. But the general stylistic features of Festa's music—homorhythms, melodic writing embodying the characteristics of aria—would have been far likelier to meet Brucioli's exacting standard than those of other contemporary types of part music. Indeed, melodic construction exemplifying the attributes of aria would more readily have satisfied Brucioli than what he would have regarded as the contorted, artificial melodic contrivances characteristic of the part-writing in contemporary polyphony. If the thesis that Festa's *L'ultimo dì di maggio* might have been sung in Brucioli's presence in the Rucellai gardens is unsustainable, then Festa's *O passi sparsi*, on a sonnet by the revered Petrarch, can readily be substituted; with respect to its essential musical characteristics, it has a great deal in common with Festa's villotta.[209] Perhaps, then, when La Zinzera, Layolle, Pisano, and Verdelot and their "dilettantish" friends "si davano alla musica," they performed pieces that resembled the contemporary lauda or canto carnascialesco, or Festa's villotte, or other secular works by him.

In an early sixteenth-century manuscript (Milan, Biblioteca Trivulziana, 55), there is a setting for vocal soloist and three instrumental "voices" of the text "La morte tu mi dai per mio servire,"[210] which may give some sense of the kind of piece Lorenzo Strozzi might have performed in the Rucellai garden. The text, a *strambotto*, has been attributed to Baccio Ugolini, himself a famous solo singer who flourished in Florence in the late fifteenth century, of whom we shall hear more in succeeding chapters. In writing about this composition, Professor D'Accone noted "the recitational style of melody, hovering around the dominant A, which sets the opening line of the text and the contrast this provides with the more fluid and balanced phrases that bring the second line to a cadence on the tonic. In contemporary practice the setting of the first two lines of the text were used, with appropriate adjustments, for the remaining six lines of the stanzas."[211] The composition also relies more or less exclusively on conjunct motion in the vocal part, which proceeds almost without exception by careful stepwise motion, rather than by leap; upon root-position chords in the instrumental accompaniment, where the bass "voice," almost without exception, sounds the *a* of a-minor chords, the *d* of d-minor chords, and so on, rather than another note of the chord; and upon a homorhythmic design, in which the rhythmic design of the instrumental voices is largely derived from that of the vocal line, as in measure 7, where the rhythmic design of the instrumental *bassus* is modeled exactly on that of the vocal part, or in measure 9, where the rhythmic design of all three instrumental voices is derived exclusively from that of the vocal line. All of these characteristics suggest—if not that *La morte tu mi dai per mio servire* itself necessarily represents the writing-down of a

piece that originally circulated orally—at least a reflection of the kinds of stylistic features that typified works in that tradition.[212] A "recitational style of melody," stepwise motion in the vocal line, root-position chords, and homorhythms are the melodic, harmonic, and rhythmic results one would expect if a singer were embellishing a formularized vocal line in performance and improvising some elements of its instrumental accompaniment on a plucked- or bowed-string instrument.

Some of the same features—stepwise motion in the vocal part, root-position chords, and a rhythmic design in the instrumental voices closely paralleling that of the vocal part—characterize Michele Pesenti's setting of the *capitolo Ben mille volte*, published under the rubric "Modus dicendi capitula [Manner of reciting *capitoli*]" in the *Frottole libro primo*.[213] Such formulas were "intended to be used with any text of a given metrical structure": "the full title of the *Libro quarto, Strambotti, ode, frottole, sonetti et modo de cantar versi latini e capituli*, itself gives a clear indication of the contents of the work, which include an *Aer de versi latini* (Air for Latin verses) by the Brescian Antonio Caprioli, an *Aer de capituli* (Air for *capitoli*) by Filippo di Lurano, and an anonymous *Modo de cantar sonetti* (Manner of singing sonnets). Other anonymous *modi* for sonnets are to be found in the *Libro quinto* and *Libro sexto*, while authors of 'airs' for *capitoli* are named in the *Libro octavo* (I. B. Zesso), *nono* (Marchetto Cara) and *undecimo* (Joannes Lulinus Venetus)."[214]

There is also the spare musical setting of Serafino Aquilano's *ottava rima* text "Sufferir so disposto," which appears in a Neapolitan manuscript.[215] A convincing case has been made for Serafino's authorship of the music as well as the text, and it might therefore be an example of the kind of piece Serafino performed at meetings of Pontano's Neapolitan academy. If so, given Bernardo Rucellai's first hand conversance with the activities of Pontano's academy, Serafino's piece might have exercised an influence on the kind of solo song performed at meetings of the Rucellai group, particularly because the piece is also transmitted in an early sixteenth-century Florentine manuscript that must be almost exactly contemporary with the meetings of the Rucellai group. Although its instrumental voices are somewhat more active and rhythmically complex than those of the two compositions previously discussed, Serafino's is like them in the smooth melodic ductus of the vocal part, the general dependence of the rhythmic design of the instrumental writing on that of the vocal line, and concise phrase lengths in the vocal part, supported by readily comprehensible harmonic progressions in the instrumental accompaniment that lead briskly toward clearly defined tonal goals.[216]

If the performance of such works in fact typified the musical practices of the Rucellai group, they would therefore have been similar to those of other sixteenth-century academic settings. A 1589 performance of *La pazzia d'Isabella*, which has been sensitively interpreted in neoclassical terms, might have included French-style canzonette; "reference to this form and style in late sixteenth-century Italy implies

Example 1. In an early sixteenth-century manuscript, there is a setting for vocal soloist and three instrumental "voices" of the text "La morte tu mi dai per mio servire," which may give some sense of the kind of piece Lorenzo Strozzi might have performed in the Rucellai garden.

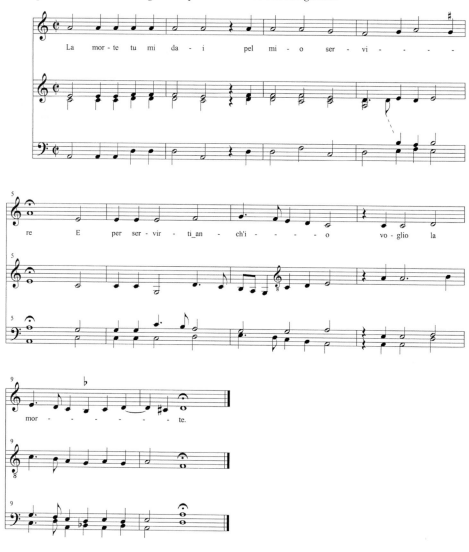

Example 2. Michele Pesenti's setting of the *capitolo Ben mille volte*, published under the rubric "Modus dicendi capitula" in the *Frottole libro primo*.

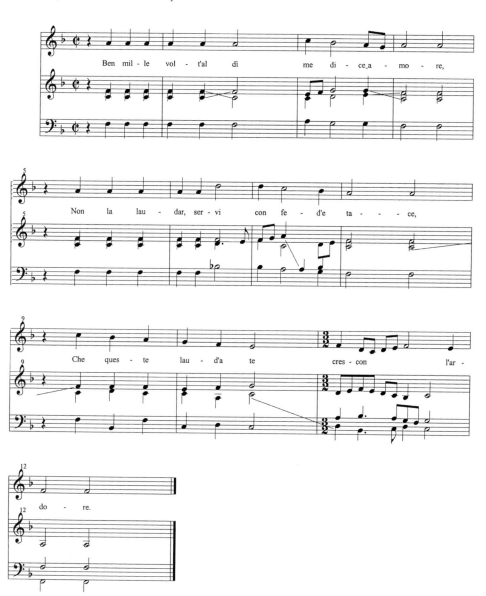

the influence of Pierre de Ronsard and of Jean-Antoine de Baïf's Académie de
Poésie et Musique in Paris, whose members sought to revive classical ideals. The
aims of the Académie were espoused on Italian soil by Gabriello Chiabrera and
Claudio Monteverdi, both of whom studied the poetry and music of the French
scholars." The neoclassical, naturalistic texts of the canzonette may have been per-
formed "to a simple harmonic accompaniment played on the lute or guitar," an "un-
complicated compositional style" that "heightens the recitation of strophic poetry
with a naturalistic use of melody and harmony."[217]

As for the kind of homorhythmic part music that might have been sung by La
Zinzera, Layolle, Pisano, Verdelot, and their companions, this compositional strat-
egy with respect to texture and rhythmic design is illustrated by Sebastiano Festa's
villotta *L'ultimo dì di maggio* and his setting of Petrarch's sonnet *O passi sparsi*,[218]
both of which have already been discussed. They display the uncompromisingly
spare, homophonic textures typical of the genre, though sometimes very lightly
inflected with conventional contrapuntal devices, usually at cadences (indepen-
dent rhythms in the different voices, as at measures 29–31 in *L'ultimo dì di maggio*,
or pairing of adjacent voices in contrast with the entire complement of four as a
means of achieving textural variety, as at measures 15–26 in the same composition),
as well as the typically concise phrase lengths and the clear tonal design. As sug-
gested, this kind of piece is found in Florentine sources of precisely this time: both
L'ultimo dì di maggio and *O passi sparsi* are preserved in the manuscript Florence,
Biblioteca Nazionale Centrale, Magliabechi XIX.164–67, which must have been
copied in Florence just before Verdelot's arrival there and the 1522 closing of the
Rucellai gardens.[219]

Indeed, the repertory of manuscript Magl. XIX.164–67 may be regarded as a
kind of musical manifesto of the "program" of the Rucellai group; it is about as close
as one is likely to get to direct musical evidence, as contrasted with the historical
evidence considered thus far, of the musical experiences and tastes of its members.
First, the manuscript contains a large number of settings of Petrarchan texts, and
no further evidence need be cited concerning the importance of Petrarch to the
poetic sensibilities of the young letterati who frequented the *Orti Oricellari*.

Second, the manuscript also contains a large number of settings of verse by
Lorenzo di Filippo Strozzi, himself a member of the Rucellai group. Many of the
settings of both Petrarch's and Strozzi's verse are by the composer Bernardo Pisano,
known to have been an intimate of Filippo and Lorenzo Strozzi, and perhaps of
Janus Lascaris and Palla Rucellai as well.[220]

Finally, Magl. XIX.164–67 has a number of pieces in common with two central
sources of the canto carnascialesco repertory.[221] That such members or intimates of
members of the Rucellai group as Alessandro de' Pazzi, Antonfrancesco degli Albiz-
zi, Giovanni Corsi, Filippo de' Nerli, Piero Martelli, Jacopo Nardi, and Giovanni

Example 3. Sebastiano Festa's *villotta L'ultimo dì di maggio.*

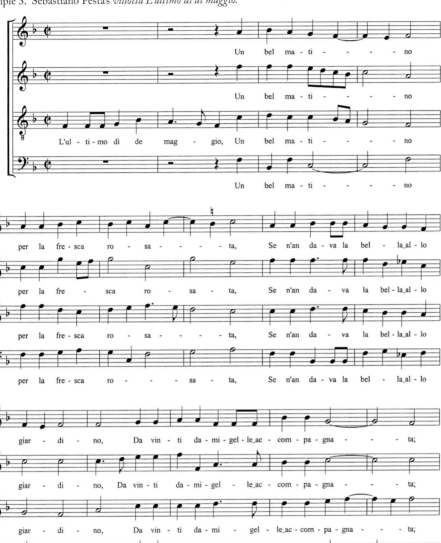

Example 3 (continued). Sebastiano Festa's *villotta L'ultimo dì di maggio.*

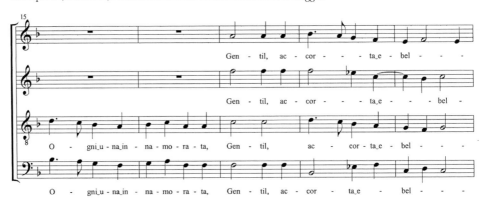

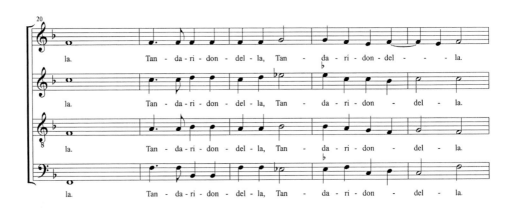

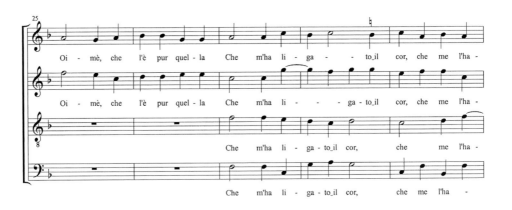

Example 3 (continued). Sebastiano Festa's *villotta L'ultimo dì di maggio.*

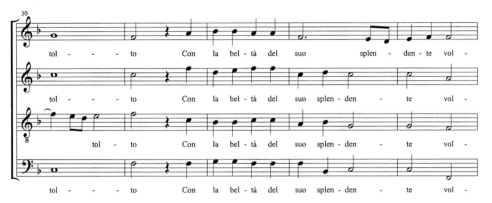

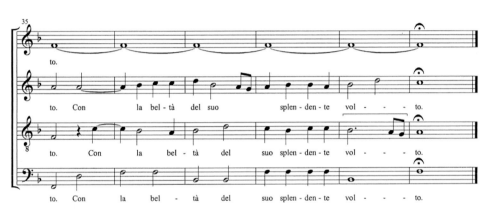

Example 4. Sebastiano Festa's setting of Petrarch's sonnet *O passi sparsi*.

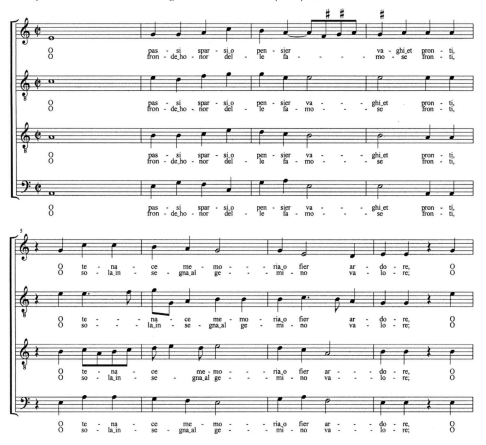

Example 4 (continued). Sebastiano Festa's setting of Petrarch's sonnet *O passi sparsi*.

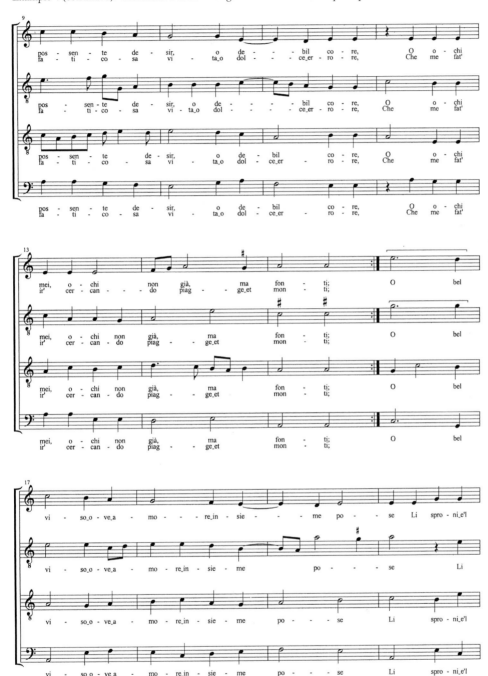

Example 4 (continued). Sebastiano Festa's setting of Petrarch's sonnet *O passi sparsi*.

Example 4 (continued). Sebastiano Festa's setting of Petrarch's sonnet *O passi sparsi.*

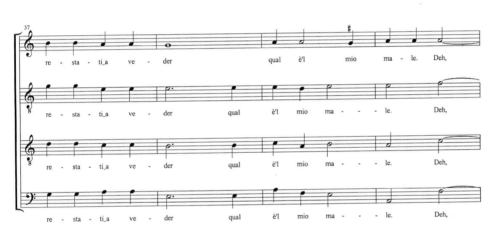

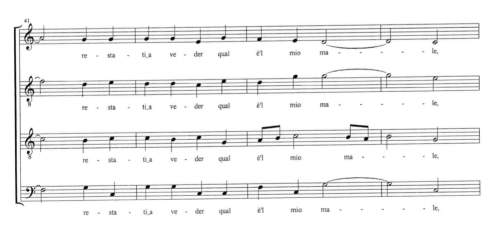

Example 4 (continued). Sebastiano Festa's setting of Petrarch's sonnet *O passi sparsi.*

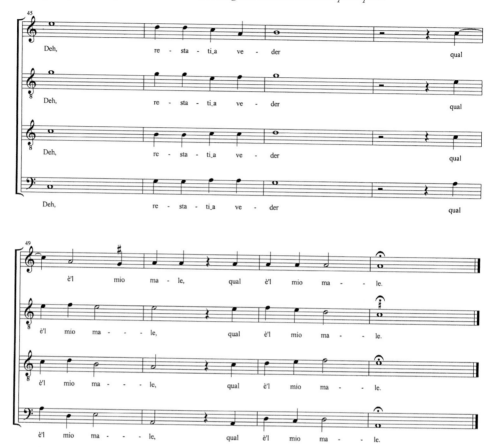

and Palla Rucellai were personally involved with the canto carnascialesco tradition is proved by their membership in or association with the Companies of the Broncone and Diamante, which had responsibility for the Florentine carnival festivities of 1513; the festivities' artistic elements included the singing of canti carnascialeschi, still extant, on texts by Jacopo Nardi and by Ludovico and Luigi Alamanni's first cousin Antonio.[222] The fact that there are works in common to these three primary musical sources suggests that, to contemporaries, the musical genres contained in the two canto carnascialesco sources and in Magl. XIX.164–67 were conceptually related. And because of the place of the canto carnascialesco tradition in the experience of members of the Rucellai group, that conceptual generic relationship links manuscript XIX.164–67, in turn, to the musical practices and experiences of the amici of the Orti Oricellari.

There is possibly another extremely important relationship between the canto carnascialesco manuscript Banco rari 230 and manuscript Magl. XIX.164–67, a rela-

tionship that to my knowledge has escaped notice until now: the scribe who copied Banco rari 230 may also have copied Magl. XIX.164–67. Moreover, this same scribe who may be common to Magl. XIX.164–67 and Banco rari 230 also copied pages 166–79 (fols. 83v–90r) of the manuscript Florence, Biblioteca del Conservatorio di Musica, 2440, which is so very much like Magl. XIX.164–67 in other respects. Four of the five pieces copied on pages 166–79 of MS 2440—a group of villotte, interestingly enough, including Festa's *L'ultimo dì di maggio*—appear in precisely the same order as nos. 42–45 of manuscript Magl. XIX.164–67. Significantly, Banco rari 230 and Magl. 164–67, in addition to perhaps sharing a scribe, also have three works in common: Michele Pesenti's *So ben ch[e]*, *Q[ua]n[do] lo pomo*, and *O Dio ch[e] la brunetta mia*, which in Magl. XIX.164–67 occur as a group (nos. 31–3). (Although two of the three also appear one after the other in Banco rari 230 (fols. 65r and 65v), the order is not the same as in Magl. XIX.164–67.) More interesting still, the three works also occur as a group in MS 2440. This increases one's sense of a network of relationships among these sources.[223]

A picture thus emerges of an intricate network of important relationships of different kinds among the principal primary musical sources of this crucial transitional phase.[224] In several important respects—chronological, geographical, scribal, codicological, and repertorial—there is a continuum from the complex of transitional sources represented by the canto carnascialesco manuscript Banco rari 230, Magl. XIX.164–67, and other closely related sources (such as Biblioteca del Conservatorio 2440) to what is perhaps the first important madrigal manuscript, Bologna Q21. To this complex of interrelated sources, I should add the early madrigal manuscript Yale 179, which is closely related to Florence 164–67 with respect to numbers of concordances (eight), as well as to Cortona/Paris (one concordance) and Florence Basevi 2440 (two concordances).[225] In addition, a madrigal by Costanzo Festa, one of the most important of the earliest madrigalists, is included in manuscript Basevi 2440.[226]

Michele Pesenti's setting of the villottistic text *O me, che la brunetta mia* furnishes another example of melodic writing likely to have been favored by Rucellai-group members. At first glance, the piece appears not as relevant in this context as the others discussed. It is a four-voice work, and the four voices imitate one another, with the entries of the four voices staggered so that one follows another—unlike the other compositions for vocal ensemble considered thus far, in which the four voices essentially declaim the text simultaneously. And, unlike fully nine of Pesenti's other secular works, it does not exist in a contemporary arrangement for solo voice and lute accompaniment, which would have made it like those compositions for solo voice and string accompaniment discussed above, and therefore appropriate in that respect to the artistic aims of Brucioli and his colleagues.[227] However, it is contained in the Petrucci *Frottole Libro I* [RISM 1504⁴], along with five of Pesenti's other works arranged elsewhere for solo voice and lute accompaniment,[228] and the

Example 5. Michele Pesenti's setting of the villottistic text *O me, che la brunetta mia.*

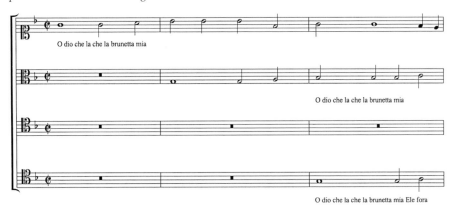

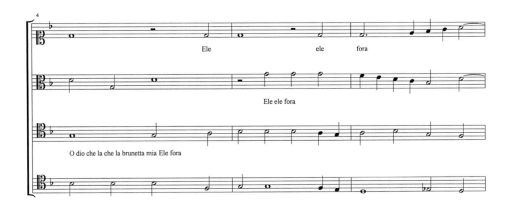

style of its melodic writing is similar to that of the works that are so arranged, which suggests that its melodic characteristics might have appealed to the aesthetic sensibilities of Brucioli and his discerning companions in the Rucellai group. The "fossil record" is inevitably incomplete, and Pesenti's *O me, che la brunetta mia* might well have once been accorded the same treatment that produced arrangements for solo voice and lute of others of his four-voice works.

Notwithstanding the qualifications enumerated above, this piece is especially relevant in this context. It is preserved in the same Florence manuscript Magl. XIX.164–67[229] that is so proximate—geographically, chronologically, and reper-torially—to the activities of the Rucellai group. It is also preserved in the two principal sources of the canto carnascialesco repertory, the manuscripts Banco rari 337[230] and Banco rari 230;[231] and, given the importance for madrigal origins of the canto carnascialesco tradition on the basis of a conversance with that tradition on the part of the early madrigalists' *confrères* in the Florentine elite, the preservation of villotte and villottistic works, such as the Festa and Pesenti pieces discussed here,

Example 5 (continued). Michele Pesenti's setting of the villottistic text *O me, che la brunetta mia.*

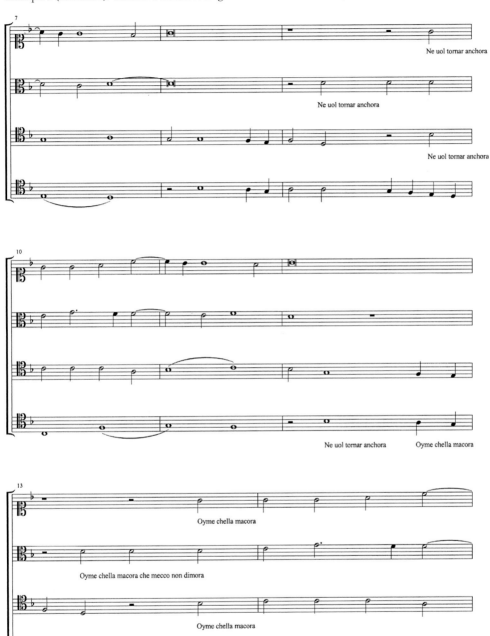

Example 5 (continued). Michele Pesenti's setting of the villottistic text *O me, che la brunetta mia.*

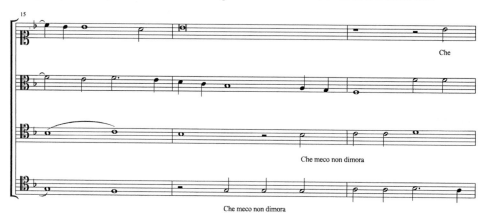

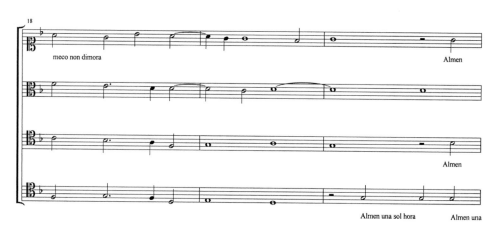

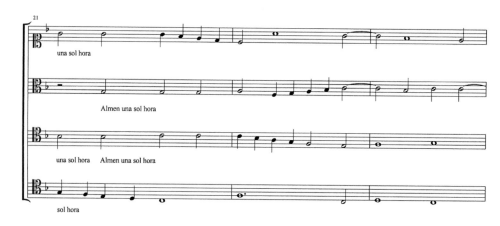

Example 5 (continued). Michele Pesenti's setting of the villottistic text *O me, che la brunetta mia.*

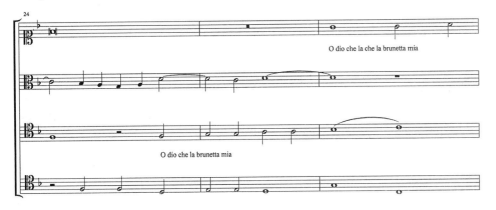

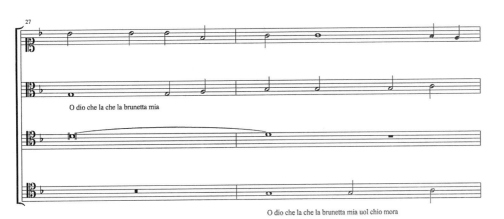

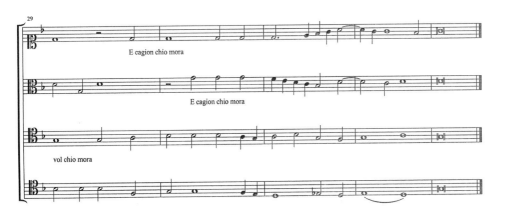

Example 6. Anonymous setting of the tune *Tambur tambur*.

Example 6 (continued). Anonymous setting of the tune *Tambur tambur.*

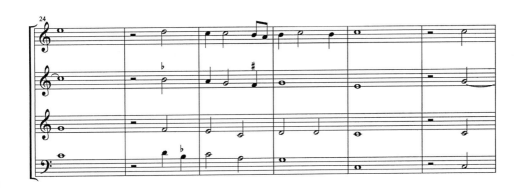

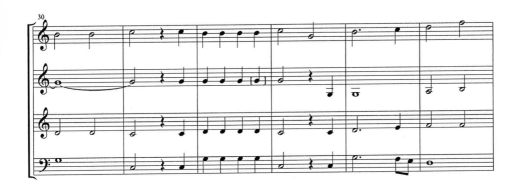

Example 6 (continued). Anonymous setting of the tune *Tambur tambur.*

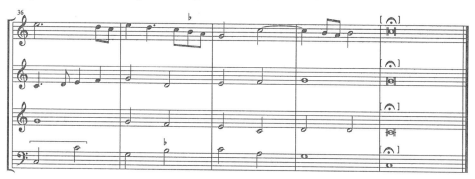

in canto carnascialesco sources is suggestive. Finally, Verdelot employed the discant of Pesenti's work in his six-voice madrigal *Hoime che la brunetta mia,*[232] which is evidence that Verdelot knew this piece (although one cannot entirely discount the possibility of there having been some kind of intermediary), and that—for whatever reason—its musical characteristics appealed to him. This, in turn, suggests the importance to the early madrigal of this genre and of this kind of approach to melodic writing.

As an example of a four-part polyphonic arrangement of a French popular tune—as a genre, closely related to the Italian villotta in its use in the tenor voice of a preexistent melody—there is a work transmitted in two early sixteenth-century Florentine sources:[233] the anonymous setting of the tune *Tambur tambur,* which, though textless in one of its sources, was surely intended to be sung to the French text preserved in Florence 164–67's most closely related source, the Cortona/Paris partbooks.[234] Stylistically, such works are closely related to the villotta and share that genre's principal musical characteristics (homorhythms; contrapuntally inflected homophony; evidence of clear, symmetrical tonal planning; and so on), which explains their transmission in some of the same sources preserving the villotta repertory.

Although unequivocal evidence about the precise musical practices of the Rucellai group is lacking, the archival record testifies to the actual musical experiences of any number of its members, known to have been members as well of the Sacred Academy of the Medici, whose musical practices are better documented.

The Sacred Academy of the Medici

I N its aims and purposes, and in the intellectual profile of its members, the Sacred Academy of the Medici bore a considerable resemblance to the group that met in the Orti Oricellari. In fact, nine of the participants in the garden meetings were also members of the Sacred Academy. Like the Rucellai group, the Sacred Academy and other similar organizations—"starting as informal literary clubs"—"became gradually the archetypes of the modern learned societies," "with regular statutes, membership, officers, and meetings. They organized recitals, lectures, and discussions and sponsored their publication. Many of the poems and prose works of the sixteenth century originated in these Academic activities."[1]

The Sacred Academy—which existed from 1515 (at the latest) to 1519—considered itself a revival of the famous fifteenth-century "Platonic academy" of Florence rather than a continuation of it. Pope Leo X (Giovanni di Lorenzo de' Medici) granted it a charter that conferred upon it the right to crown poets and orators and an annual allocation of fifty florins so that it might rent a room in which to meet. It held formal deliberations, and—in emulation of Florentine city officials—voted on resolutions with black beans.[2]

The academy had been known principally for its efforts to effect the return of Dante's remains from Ravenna to Florence, which suggests something of a commonality of purpose with the Rucellai group; such efforts are themselves an expression of a concern with the Florentine literary past. Of the four texts documenting those efforts—a formal petition to Leo X of 20 October 1519, and the correspondence of academy members with Pietro Bembo,[3] Cardinal Giulio di Giuliano de' Medici, and Pope Leo—the petition is of particular importance since it furnishes evidence about the academy's membership.

As the initiative to return Dante's remains to Florence and to construct a monument to him suggests, one of the elements of the academy's program, like that of the Rucellai group, was a glorification and celebration of the Florentine past and an implicit elevation of models of literary excellence and expression from that past to a level comparable to that of classical Latin models. The Sacred Academy thus sought to translate its interests, which shaped the substance of the informal conversations that took place among the members, into a concrete, specific program. In addition, in November 1515 the academy commissioned "Maestro Antonio da Cortona frate di S. Domenico" to undertake a revision and correction of the Vatican

TABLE 4

MEMBERS OF THE MEDICI SACRED ACADEMY

(Signatories of the Petition to Pope Leo X Concerning the Return of Dante's Remains to Florence)*

1. **Robertus Acciaiolus** (i.e., Roberto Acciaiuoli)
2. **Lodovicus Alamannus** (i.e., Ludovico (?) di Piero Alamanni** †)
3. **Jacobus Althychyerus de Florencia** *ex Ordine Servorum Sacre Theologie humilis professor*
4. **Hieronymus Benivenius** (i.e., Girolamo Benivieni**)
5. **Michelagnolo** *schultore* (i.e., Michelangelo Buonarroti)
6. **Bartholomæus Ceretanus** (i.e., Bartolomeo Cerretani)
7. **Joannes Cursius** (i.e., Giovanni Corsi**)
8. **Franciscus Cataneus Diacetius** (i.e., Francesco di Zanobi Cattani da Diacceto "il Pagonazzo" [the Purple]**)
9. **P. Andreas Gam[maro]** *reverendissimi Archiep [iscopi] Flor[entini] Vicarius* (i.e., the vicar of the Archbishop of Florence, Cardinal Giulio de' Medici)
10. **Petrus Martellus** (i.e., Piero Martelli**)
11. **Gerotius de Medicis**
12. **Petrus Franciscus de Medicis** (i.e., Pierfrancesco de' Medici)
13. **Jacobus Modestus Doctor** (i.e., Jacopo Modesti)
14. **Jacobus Nardus** (i.e., Jacopo Nardi**)
15. **Alexander Paccius Gulielmi** *filius* (i.e., Alessandro di Guglielmo de' Pazzi**)
16. **Petrus Franciscus Portinarius** (i.e., Pierfrancesco Portinari**)
17. **Pallas Oricellarius** (i.e., Palla Rucellai)
18. **Laurentius Salviatus** (i.e., Lorenzo Salviati)
19. **Alphonsus Stroza** (i.e., Alfonso Strozzi)
20. **Laurentius Stroza** (i.e., Lorenzo di Filippo Strozzi**)

* *Il sepolcro di Dante*, ed. Ludovico Frati and Corrado Ricci, Scelta di curiosità letterarie inedite e rare 135 (Bologna: Premiato Stab. Tip. Succ. Monti, 1889), pp. 55–57, and Paul Oskar Kristeller, "Francesco da Diacceto and Florentine Platonism in the Sixteenth Century," *Studies in Renaissance Thought and Letters*, Storia e letteratura, Raccolta di studi e testi LIV (Rome: Edizioni di storia e letteratura, 1984), pp. 287–336, esp. pp. 302–3 n. 60.

** Also members of the Rucellai group.

† On the distinction between Ludovico di Piero and Luigi di Piero Alamanni, see nn. 37 and 44 in Chapter 1.

manuscript Barberini lat. 4109 (a fifteenth-century parchment codex containing Matteo Palmieri's *Città di Vita*).

The Sacred Academy thus represents one of the earliest institutionalized, formalized instances in Florentine history of what the historian Giuliano Procacci has termed "Florentinism," "a tendency [among the Florentines] to close in on themselves with a self-sufficiency and aloofness"; "[i]n this satisfied contemplation of their own past, the

Florentines certainly displayed a pride in being the heirs and continuers of that past." But such self-satisfaction had some less productive consequences. "[T]he restlessness, ...dissatisfaction, and ...sense of independence that may have in part been responsible for the vitality of Florentine culture in the past had given way to quiet, satisfaction, and servility, and to the conviction that not much was left to do but to sit back and enjoy what had already been accomplished. This self-satisfaction may have been in part responsible for the unmistakable flatness in the personalities of late sixteenth-century Florentines."[4] Its negative effects to the contrary notwithstanding, such a "satisfied contemplation of their own past" is the principal causation of the robust academic movement that flourished in Cinquecento Florence; the Medici Sacred Academy stands at or near the very head of that movement in a chronological sense.

The membership roster of the Sacred Academy includes some of the most illustrious artistic, literary, and political figures of the period. To say anything about Michelangelo in this respect—other than that, in signing the petition, he offered to build the tomb for Dante—would be redundant in the extreme. Jacopo Nardi, as discussed in Chapter 1, was a distinguished historian, poet, and playwright. The Florentine aristocrat Bartolomeo Cerretani (1475–1524) wrote one of the most important narrative accounts of this period in Florentine history, the "Storia in dialogo della mutazione di Firenze," rich in references to the musical elements of several important festivals for which Nardi furnished explanatory verses.[5] Lorenzo di Filippo Strozzi, also discussed in Chapter 1, was poet and playwright and one of the most accomplished and renowned literary figures of the early Cinquecento. Palla Rucellai (1 July 1473–4 April 1543) was the uncle of the Cosimino who hosted the meetings in the gardens during the second decade of the sixteenth century and a loyal Medici partisan, even during such periods of fundamental challenge to the continuity of the regime as the "Last Republic" of 1527–30.[6] Jacopo Modesti da Prato—student and correspondent of Angelo Poliziano—was one of Cardinal Giulio di Giuliano de' Medici's trusted agents in the years when Cardinal Giulio was responsible for the Florentine government (1519–23).[7] Ludovico Alamanni, as discussed in Chapter 1, was Machiavelli's correspondent and his collaborator on a projected performance of *Mandragola* in the 1520s. Girolamo Benivieni was a distinguished cultural figure and a musician.[8] If the testimony of Brucioli's *Dialogo IV* of *Liber IV* of his *Dialoghi* is trustworthy, Benivieni was another of the members of the Rucellai group.[9] He was also the author of laude for Savonarolan festivals, and his status as a member of both the Rucellai group and the Medici Sacred Academy and as a composer of lauda verse is relevant to the thesis advanced here concerning the origins of the madrigal, since the stylistic properties of the lauda—and its secular counterpart, the canto carnascialesco—had a formative influence on the style of the early madrigal. Finally, Roberto Acciaiuoli (7 November 1467–6 August 1547) was a political theorist of great distinction.[10]

The Sacred Academy's membership had a clear association with the Medici even beyond that suggested by the very name by which the institution is customarily designated. Two members of the Medici family were members of the academy. Another member, Andrea Gammaro, was the vicar of the Archbishop of Florence, Cardinal Giulio de' Medici. Doctor Jacopo Modesti was Cardinal Giulio's lieutenant at the end of the second decade of the sixteenth century and the beginning of the third. Giovanni Corsi and Palla Rucellai were among the most loyal of Medici supporters.[11] The academy's maecenas, in some important sense, was Pope Leo X, with whom the academy corresponded officially; in one of the sources attesting its activities, the academy is characterized as "his [Leo's] Sacred Academy." The many associations between members of the Sacred Academy and the Medici on the one hand and, on the other, the fact that several members of the academy also frequented the Rucellai garden complicate any facile tendency to characterize the Rucellai group too simplistically as republican, or anti-Medicean. The substantial overlap in membership and the similarity in intellectual profile have implications for our ability to make surer determinations about the musical activities of the Rucellai group and the musical tastes and experiences of its members, which can be ascertained by reference to the better-documented cultural activities of the Sacred Academy.

Knowledge of its activities, and its musical activities, was advanced by Paul Oskar Kristeller, who was first to publish several texts that supplemented the information contained in previously known documents.[12] In two of the texts published by Kristeller addressed to Giovanni Rucellai, Palla's brother, Giovanni is expressly called "our protector and benefactor,"[13] which suggests a further close link between the memberships of the Sacred Academy and the Rucellai group. Especially important in this context is the fact that fully five of the eighteen known texts documenting the Sacred Academy's activities are addressed to musicians: two letters are directed to Bernardo Accolti—the so-called Unico Aretino—and three to Atalante Migliorotti, both of whom were illustrious solo singers of the late fifteenth and early sixteenth centuries.[14] Migliorotti is also mentioned in one of the letters to Accolti,[15] and one of those addressed to Giovanni Rucellai records that Rucellai had been unanimously elected "our protector on the twentieth of the present month [April of 1515], together with the *Unico*."[16]

Accolti and Migliorotti are well known to music historians. In his famous treatise *De cardinalatu libri tres*, Paolo Cortese wrote of several practitioners of the art of "singing *ex tempore* on the lyre in the vernacular tongue"—Accolti, Jacopo Corso,[17] and Baccio Ugolini[18]—and of Accolti he claimed: "Although he recites improvised verses, and although one should be prepared to make allowances for [faults deriving from] the rapidity [of the exploit], most of what he does is commendable, and very little needs to be forgiven; [yet his is] the merit of a prolific but unreflexive talent."[19]

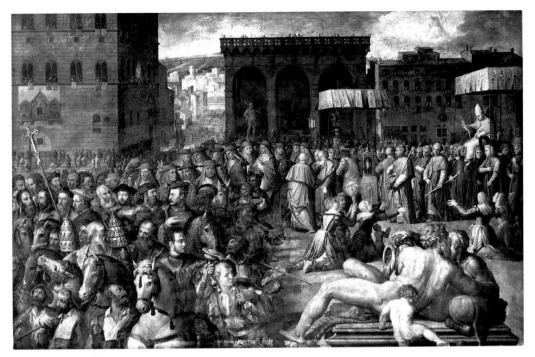

Figure 2.1 The Singular Aretine was almost universally acclaimed, celebrated enough to have been depicted among the participants in Leo X's 1515 Florentine entrata in Vasari's famous fresco in the Palazzo Vecchio in Florence.

Was Cortese correct in his qualified assessment? An account of the activities of Cortese's own Roman "academy" suggests that Accolti had frequented it at the very end of the fifteenth century and the very beginning of the sixteenth,[20] as Corso perhaps did as well.[21] Accolti, therefore, was personally known to Cortese, and we might thus be inclined to accept his measured evaluation of Accolti's poetic and musical gifts as authoritative or, at minimum, as well informed.

Cortese, "a born critic,"[22] offered an assessment that cannot have been widely shared. The Singular Aretine was almost universally acclaimed, celebrated enough to have been depicted among the participants in Leo X's 1515 Florentine entrata in Vasari's famous fresco in the Palazzo Vecchio in Florence[23] and in Sigismondo Fanti's *Triumpho di fortuna*, where he appears with Notturno Napolitano,[24] a fellow solo singer (both images are reproduced here, and the resemblance of Accolti's portrait in Fanti's *Triumpho* to Vasari's suggests that Vasari's may be modeled on the earlier one);[25] celebrated enough to have had his name invoked explicitly in Ariosto's *Orlando furioso*[26] and to figure prominently in Castiglione's *Cortegiano;* celebrated enough that Castiglione also referred to him approvingly in his fascinating and revealing reports from the court of Leo X to his Mantuan patrons: on 6 February 1521 (to cite only one example), Castiglione related to Federico Gonzaga

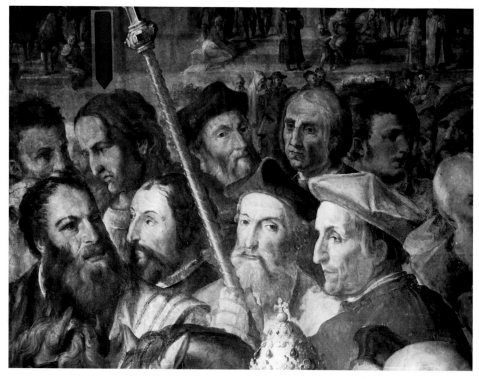

Figure 2.2 The Singular Aretine was almost universally acclaimed, celebrated enough to have been depicted among the participants in Leo X's 1515 Florentine entrata in Vasari's famous fresco in the Palazzo Vecchio in Florence.

that "last night, in the presence of a very large audience, the *Unico Aretino* improvised before the pope for three hours, wonderfully, as is his custom."[27]

Contemporary evidence suggests that Atalante Migliorotti was also widely regarded as one of the ablest practitioners of the improvisatory art that Cortese described. Among the elegant Latin verses authored by the Florentine humanist Naldus Naldius (1436–after 1513) in honor of such figures as the Duke of Urbino, Marsilio Ficino, Lorenzo de' Medici, Lorenzo's agent Niccolò Michelozzi, Angelo Poliziano, the Florentine chancellor Bartolomeo della Scala, Cardinal Ascanio Sforza, and Piero Soderini (gonfaloniere a vita of Florence during the period between the exile of the Medici and their restoration) are two addressed "Ad Athlantem Meliorottum adolescentem ingenuum" and "Ad Athlantem Manetti Meliorotti filium," the second of which is replete with flattering references to Migliorotti's singing to the lyre.[28]

Migliorotti's career is vividly and evocatively documented. He had been instructed in the art of playing the lyre by Leonardo da Vinci, who was sent by Lorenzo de' Medici with Migliorotti to present a lyre to the Duke of Milan;[29] an entry in Leonardo's so-called codice atlantico to "a portrait of the head of Attala[n]te, who was looking up [vna tesst(a) ritratta d(')attalāte che alzava il uolto]," is to a drawing, now lost, that may have been of Migliorotti.[30]

Figure 2.3 The Singular Aretine was celebrated enough to have been depicted in Sigismondo Fanti's *Triumpho di fortuna*, where he appears with Notturno Napolitano, a fellow solo singer.

Migliorotti, further, is the subject of a fascinating and informative correspondence of October and November 1490 and May, June, and July 1491 that documents the attempts of Mantuan agents to secure his services for a theatrical performance.[31] In June 1493, Marchesa Isabella d'Este Gonzaga of Mantua wrote to Migliorotti to request that he have "a good and fine small cithara [una bona et bella cithara picola]" made for her "a uso nostro gallante et de quante corde parerà a vui," for which he would be compensated by Manfredo de' Manfredi, her father's agent, "the ambassador of the Most Illustrious Duke of Ferrara."[32] On 8 July of that year, Niccolò da Correggio, poet and musician, wrote to the marchesa and promised to forward the "lyra" that Migliorotti had sent him.[33] References from August and September 1494 document that Manfredi represented the marchesa at the baptism of Migliorotti's daughter, born on 24 August of that year and named Isabella in the marchesa's honor.[34] A year later, Migliorotti reported to the marchese that he was constructing a "new . . . form of lyre."[35] Migliorotti, through the agency of proximity, may in some measure have fortuitously inherited Leonardo da Vinci's extraordinary artistic versatility, as is suggested by an entry in a papal register from Leo X's time,[36] recording payment to "Magistro Attalante de Migliantibus suprastanti fabricarum S.D.N.,"[37] although one cannot discount the possibility that the position was a sinecure, a reward for years of faithful service to the Medici.

The references to Accolti and Migliorotti in the correspondence of the Sacred Academy of the Medici are of particular interest and importance since they document that musical performances were among the academy's activities. They furnish invaluable evidence of the actual musical experiences of the distinguished Florentine intellectuals who were members of the academy and demonstrate their active support of and experience with the venerable practice of solo singing.[38] In one of the academy's letters to Accolti, in which Accolti is addressed as "our protector and benefactor [Magnifice Domine protector et benefactor noster colendissime],"[39] Migliorotti is called "Athalante, our most delightful orator." And in an April 1515 letter in which Migliorotti is compared extravagantly to Orpheus, the members of the academy informed him that, having known for some time of his abilities as a player of the "dolce cetra," they had elected him "lutenist in perpetuity [perpetuo cytharedo] of our Sacred Academy" on the twentieth of that month, "and made you our ambassador to His Holiness for one year, to begin the first of next May."[40] On 1 June they wrote to confirm that "it pleases us that you have accepted the office that this Sacred Academy has conferred upon you."[41]

One can envision the members of the Medici Sacred Academy periodically suspending their learned conversation and animated exchanges to delight in the rhapsodic deliveries of the Singular Aretine and Atalante Migliorotti: Accolti stands, hooded, amidst the seated Michelangelo Buonarroti, Jacopo Nardi, and Lorenzo di Filippo Strozzi, his aquiline features (to appropriate Vasari's description) revealing subtle changes in expression prompted by changes in the mood of the texts to

La Rapresentatione di Dieci

Mila Martiri Crocifissi nel Monte Arat, Appresso alla Citta
d'Alexandria, come riferisce San Hieronimo al tempo di
Adriano:& Antonino Imperadori. Anno Domini
CXVIII. Et adi. xxii. di Giugno.
Nuouamente Ristampata:

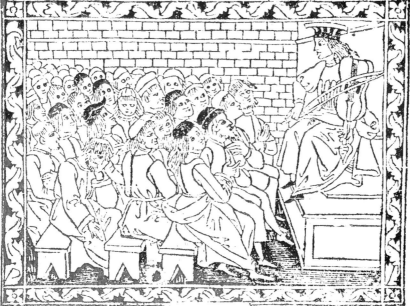

Figure 2.4 One can envision the members of the Medici Sacred Academy periodically suspending their learned conversation and animated exchanges to delight in the rhapsodic deliveries of the Singular Aretine and Atalante Migliorotti.

which he was performing musical settings. Innumerable contemporary representations of the practice of solo singing, such as that reproduced here, assist in attempts at an imagined reconstruction.

Solo singing, which was central to the musical practices of Italian cities and courts in the fifteenth century,[42] is thus documented in yet another setting, one of particular importance to the cultural and intellectual life of early Cinquecento Florence.[43] The musical elements of the Sacred Academy's program also relates it to that of contemporary Roman academies, and to Roman musical life in general.[44] Of significance is that Accolti had earlier frequented Paolo Cortese's Roman academy,[45] and both Accolti and Migliorotti were intimates of Leo X, evincing links between the musical practices of restoration Florence and Leonine Rome.[46]

Convictions about the centrality of instrumentally accompanied solo singing to the musical practices of the classical world were of exceptional importance to humanist thinking, as the Sacred Academy's references to Migliorotti as Orpheus themselves suggest. A proper academy in the sixteenth century thus had to include such activities among the elements of its program, as necessary to a full restoration of classical practices and their earlier restitution in the fifteenth century by the so-called Platonic academy of Florence. Of importance in this context, as discussed earlier, is that these references to the musicians Accolti and Migliorotti occur in documents pertaining specifically to the activities of a group that regarded itself as a revival of the fifteenth-century academy.[47]

Notwithstanding some important scholarship on solo singing in Quattrocento and Cinquecento Italy,[48] the tradition is susceptible to fuller reconstruction. In its time, the tradition must have been remarkably widespread and must have typified the musical practices of many different kinds of settings and many different strata of society, and by no means was it characteristic solely of Italian or "pan-Mediterranean" musical traditions. Elizabethan English sources document an instance of a more "popular" expression of the practice, comparable to the Florentine tradition of the *cantimpanche* represented by Antonio di Guido, the famous strolling player of Piazza San Martino.[49]

None of Accolti's or Migliorotti's music is known to have survived—not surprisingly, given that it exemplified practices that did not require musical notation. Some conclusions about the stylistic characteristics of Accolti's and Migliorotti's music can be drawn from period writings, such as that of Vincenzo Calmeta[50]—the author of an important account of Cortese's Roman academy and its musical activities[51]—and from surviving notated pieces that, however imperfectly, appear to reflect the practices of the oral tradition.

Calmeta's advice to frivolous young lovers—who, "being accustomed to take pleasure in the art of song, wish to win the favor of their ladies by their singing, more particularly by singing in diminution"—was "to practice around *stanze,* bar-

zellette, frottole, and other pedestrian styles and not to rely upon subtleties and
rare inventions, which, when associated with music, are not only overshadowed but
obstructed in such a way that they cannot be discerned."[52]

But to those with more refined literary and musical objectives, Calmeta urged

> that in their manner of singing they should imitate Chariteo and Serafino, who in our
> time have held the palm in such practice of more refined styles of singing and striven
> to accompany their rhymes with smooth and relaxed music, so that the beauty of their
> profound and witty texts could be better understood . . . [thus imitating] the judgment
> of a discerning jeweler, who, having to show the finest and whitest pearl, will place it,
> not on a golden cloth, but on some black silk, that it might show up better.[53]

Calmeta's remarks are rich in implications. The fact that he specifically mentioned
Cariteo and Serafino is noteworthy, since both singers are said to have frequented
Pontano's Neapolitan academy, which Bernardo Rucellai had visited in 1495. Its
musical practices may thus have stimulated Rucellai's thinking as to the kinds of
activities he wished to support at his own garden academy, which was so much like
the Sacred Academy of the Medici in other important respects.

At first glance, Calmeta's advice appears ironic, perhaps even counterintuitive. For
those singers who wished to practice the art of diminution, the appropriate poetic
genres were stanze, barzellette, and frottole: "pedestrian styles," in Calmeta's words,
absent of poetic subtleties and rare poetic inventions. Ironically, such pedestrian lit-
erary qualities make stanze, barzellette, and frottole particularly appropriate texts
for more complex and elaborate musical treatment: "When associated with music,"
the "subtleties and rare [poetic] inventions" that the pedestrian genres lack "are . . .
overshadowed," "obstructed in such a way that they cannot be discerned." Precisely
because such refined literary qualities are absent from the text, musical settings of
the "pedestrian" genres need not take full account of—need not be fully responsive
to—the literary properties of the verse. Since their principal function was not to
render a "profound and witty" text fully intelligible but rather to form a background
for the soloist's singing and highlight his skill in the art of diminution, the musical
settings could afford to be more elaborate. Indeed, they ought to have been, in order
to compensate for the corresponding literary deficiencies of the poetic text. On the
other hand, the more refined the literary characteristics of the text, the simpler the
musical setting ought to be, the more like a black silk cloth, so that the refinements of
the text are highlighted and readily discernible to those witnessing the performance.
Therefore, in performing musical settings of their own subtle verse, or that of their
colleagues in the Sacred Academy—Lorenzo Strozzi, perhaps—Migliorotti and the
Singular Aretine might have practiced "more refined styles of singing and striven to
accompany their rhymes with smooth and relaxed music, so that the beauty of their
profound and witty texts could be better understood."

The distinction Calmeta drew explains the varied instrumental writing one finds in the frottola literature. One class of frottola shows "imitations and thick textures" in the instrumental accompaniment, "not imitation for its own sake but [in] the attempt to create a background of sonority for the solo singer."[54] Such densely imitative and continuous instrumental writing, executed by a consort of bowed-string instruments, would have been appropriate accompaniment for the pedestrian genres Calmeta identifies. On the other hand, the "more refined styles" presumably called for the solo singer to furnish a spare accompaniment himself on a lute or *viola da braccio*, to support his vocal line discontinuously with chords whose sound quickly died away, thus leaving the voice clearly and intelligibly projected in the absence of the competing sounds of a busy instrumental background to his singing.

Given the literary program of the Rucellai group and its closely related institution, the Sacred Academy, instrumental accompaniment of this kind as executed by academy members Atalante Migliorotti, Lorenzo Strozzi, and the Unico Aretino had considerable virtues and was unusually appropriate to the academy's programmatic objectives. An institution dedicated to a celebration of the Florentine literary past would have favored compositional and performative procedures that highlighted refined poetic texts. Solo singing to the accompaniment of one's own lute playing was the early Cinquecento manifestation of a quintessentially Italian interest in text setting and expression, of which the concerted madrigal was the early Seicento manifestation. As has been suggested with respect to the early seventeenth-century madrigal, "the advent of [the] *basso continuo* . . . helped to state . . . the exact relationship between certain phrases of the text and of the music, since the instrumental harmonic support provided by the *continuo* rescues the voices from those amorphous areas in which some of them, taking turns, must assume the function of harmonic or rhythmic background."[55] For this reason, members of the Rucellai group and the Sacred Academy likely favored solo singing to instrumental accompaniment over polyphonic genres such as the French chanson, or even quasi-polyphonic genres such as the villotta (the argument advanced in Chapter 1 to the contrary notwithstanding). Ideally, the human voice was not to be called upon to serve a harmonic or other structural function, which was instead to be consigned to the instrumental accompaniment; the role of the voice, as the text-bearing agent within the ensemble, was to deliver verse in an intelligible way. In short, instrumental functions were relegated to instrumental accompaniment, freeing the voice to execute that which it was uniquely equipped to execute: a flexible, expressive delivery of the text in a way that made the melodic line seem almost an extension of speech. The challenge for the early madrigalists was to translate such elements of solo song into the polyphonic "maniera."

The extant period repertory contemporary with the activities of the Sacred Academy also assists in attempting to reconstruct the music-making that took place at its meetings. A number of scholars have identified pieces in the repertory that exemplify the tradition

of solo song, and there are two that might serve specifically as documents of the musical activities of the solo singers of Leonine Rome and the Florence of the Medici restoration and the musical tastes of their patrons. The first is Michele Pesenti's setting of Horace's Sapphic ode *Integer vitæ scelerisque purus*,[56] which may serve as an excellent example of the second of Calmeta's styles, the "more refined" vocal idiom, accompanied "with smooth and relaxed music." Although published in 1504, almost a decade before Leo's election, it is an example of a work by a composer known to have been in Leo's service around 1520.[57] In its homorhythmic design and, more important, its almost exclusive reliance in the accompaniment on root-position chords, it exemplifies a style described by Claude Palisca as one "in which a subtle influence of Italy on France might be suspected . . . , the particular kind of homophonic harmony which one finds in the ['Parisian'] chansons of Claudin and Conseil," a type that, with rare exception, utilizes root-position chords. As Palisca suggested, such a musical conception is prevalent not only in the frottola and carnival song but also, more generally, in Italian music of the fifteenth and early sixteenth centuries. Performance conditions associated with the frottola—often a solo song with lute accompaniment—yielded the distinctive musical characteristics of the instrumental part. Lutenists, as Palisca observed, are less likely to be concerned with the careful melodic construction of a bass line and more likely to opt for root-position chords; accordingly, the style of melodic writing typifying the bass line in French chansons of the fifteenth century, in which the bass moves by step—"forming many sixth chords, and creating dissonances with the other parts"—is atypical of the frottola, its contemporary Italian analogue. The resulting harmonic conception—characteristic of the frottola, of dance songs in general, and of other Italian genres—may well have exercised an influence on the Parisian chanson of the early sixteenth century, many examples of which (for instance, Claudin's *Contre raison*) consist of nothing other than root-position chords.[58]

Such aspects of the harmonic and rhythmic design result from the particular compositional and performative techniques at issue here. As suggested in another context, genres such as the frottola that reveal the effects of oral transmission "tend towards greater concision and economy, especially in melodic writing but perhaps in harmonic practice as well." Conversely, the written practices of the polyphonic tradition are likelier to produce a different kind of harmonic result, precisely because the composer enjoyed the luxury of revision denied the performer who was executing compositions that were orally transmitted. Tonal relationships in the frottola and dance music that seem more familiar to us may result from distinctive performance practices and dynamics of transmission that are likely to produce tonal characteristics of a particular kind; the performance techniques and distinguishing characteristics of transmission in oral form may explain the "incipient tonality" seemingly present in secular works that are in part the result of such practices.[59]

In other words, the fact that some elements of compositions such as Pesenti's *Integer vitæ* may be the result of their transmission as compositions in the oral

Example 7. Michele Pesenti's setting of Horace's Sapphic ode *Integer vitæ scelerisque purus.*

repertory explains their distinctive characteristics: the use of root-position chords and homorhythms, and—in other such works if not necessarily in *Integer vitæ*—a harmonic plan comprising progressions that seem almost tonal. Some of the same features distinguish the typical formulaic "aëre" or "modi de cantar" capitoli, sonnets, or versi found in contemporary prints and discussed in Chapter 1; they, too, provide some insights into the musical characteristics of pieces presumably heard by members of the Sacred Academy. For such formulas to be easily mastered and retained in the memory, they had to embody a certain melodic and harmonic cogency, which may explain their distinctive musical characteristics.

Improvisatory elements in this tradition consisted in part of embellishment in performance of formularized materials that had been transmitted orally; the essential melodic, rhythmic, and harmonic substances of such stock materials as the formulaic "aëre" or "modi" could readily have been mastered by a skilled lutenist-singer and committed to memory, leaving room in performance for elaboration. But ultimately those melodic, rhythmic, and harmonic substances may themselves have been partly improvisatory in origin; they have that compelling cogency and logic—a "concision and economy"—that argues for a distinctive kind of compositional origin, described by Milton Babbitt: "The delegation of an unusually broad area of . . . choice to the performer, resulting in 'improvisation,' . . . is . . . likely to produce a highly constrained result, since the performer, composing with little opportunity for circumspection and no opportunity for revision . . . is likely to be a more constrained composer than the non-'real time' composer, who also is more likely to have at his command or to be able to invent from experience more and new modes of musical continuity."[60] Once the

formulas entered the repertory, whether within the written or unwritten tradition, the improvisatory element consisted of elaboration during the performance of the received materials. Other distinctive elements of the musical style are presumably explained by such factors as Palisca identified: the technical capabilities, characteristics, and limitations of the instruments providing the accompaniment, which resulted in idiomatic writing specifically matched to such capabilities.

Another example is Bartolomeo Tromboncino's setting of a stanza from Ariosto's *Orlando furioso, Queste non son più lachryme che fore.*[61] Unlike Pesenti, Tromboncino is not known to have been employed in either Leonine Rome or restoration Florence. But there is a reference documenting that Tromboncino was recommended to Leo (or was to have been recommended to him) at the behest of the renowned astrologer Luca Gaurico,[62] which suggests that Tromboncino may have been known to the pope (at least by reputation), and may even suggest something about how highly regarded he was in Leonine Rome.[63] Tromboncino was demonstrably known to Leo's father, Lorenzo il Magnifico.[64]

Tromboncino's setting of Ariosto's stanza, attributed to "B.T.," appears in an Antico print published in Rome in 1517,[65] which demonstrates that the piece was known in Leonine circles; indeed, the print contains the text of Leo's privilege to Antico,[66] dutifully signed by Leo's secretary "Iacobus Sadoletus."[67] Whether Tromboncino's music mirrors improvisatory practices cannot be known for certain, but several features suggest that it does: "its restricted range, its musical separation between odd and even lines of text, its shift to a higher pitch level for the last couplet."[68]

A third example—perhaps not so directly representative of the musical activities of Leonine Rome and restoration Florence—also exemplifies the practice of solo singing. Once again, as seen earlier in this chapter and in Chapter 1, Il Chariteo, who was reported to have sung verses at the behest of the king of Naples, was a member of Pontano's Neapolitan academy; because Bernardo Rucellai had frequented Pontano's academy, the musical activities of the Neapolitan academy may have served as a model for the musical practices of the Rucellai group.[69] Chariteo's *Amando e desiando io vivo*—its lower parts intabulated for lute—is found in *Tenori e co[n]trabassi intabulati col soprano in canto figurato per cantar e sonar col lauto Libro Secundo. Francisci Bossinensis Opus.* [*Tenors and contrabasses in tablature, with the soprano in mensural notation, for singing and playing with the lute, Second Book. The Work of Francesco Bossinensis*],[70] and it might be representative of the kind of piece Chariteo performed at meetings of Pontano's academy, and therefore the kind of piece Migliorotti or the Unico Aretino performed at meetings of the Medici Sacred Academy. It displays the by-now predictable conjunct motion in the vocal part and root-position chords in the lower voices, although as transmitted in the version intabulated for lute, its instrumental accompaniment is more rhythmically active than that of other examples discussed here.

Example 8. Bartolomeo Tromboncino's setting of a stanza from Ariosto's *Orlando furioso, Queste non son più lachryme che fore.*

Given the documented relationship of Accolti and Migliorotti to the Sacred Academy's membership, such characteristics of solo song as detailed here were fundamental to the musical experience of the members of the Florentine cultural elite for whom Layolle and Verdelot wrote their first madrigals, and to Florentine poets such as Luigi di Piero Alamanni, Niccolò Machiavelli, and Lorenzo di Filippo Strozzi, whose verse was set to music in the new madrigal style; indeed, Strozzi was himself a lutenist.[71] Further, a text by Accolti may have been set by Verdelot. The *ottava rima Fugite l'amorose cure acerbe,* which refers to the Medea myth and was published in the *Madrigali a cinque Libro primo,*[72] appears as a separate *Epitaphio* in the *Comedia del preclarissimo messer Bernardo Accolti Aretino Scriptore Apostolico & Abreuiatore . . . [& Capitoli & Strambocti].*[73]

Among the stylistic influences on the early madrigal to be identified, enumerated, and evaluated are thus compositions exemplifying such characteristics of solo song, which helped to shape the musical sensibilities of Layolle and Verdelot's

Example 9. Chariteo's *Amando e desiando io vivo*—its lower parts intabulated for lute—is found in *Tenori e co[n]trabassi intabulati col soprano in canto figurato per cantar e sonar col lauto Libro Secundo. Francisci Bossinensis Opus.*

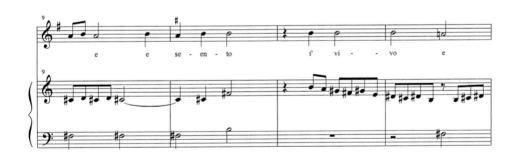

Example 9 (continued). Chariteo's *Amando e desiando io vivo*—its lower parts intabulated for lute—is found in *Tenori e co[n]trabassi intabulati col soprano in canto figurato per cantar e sonar col lauto Libro Secundo. Francisci Bossinensis Opus.*

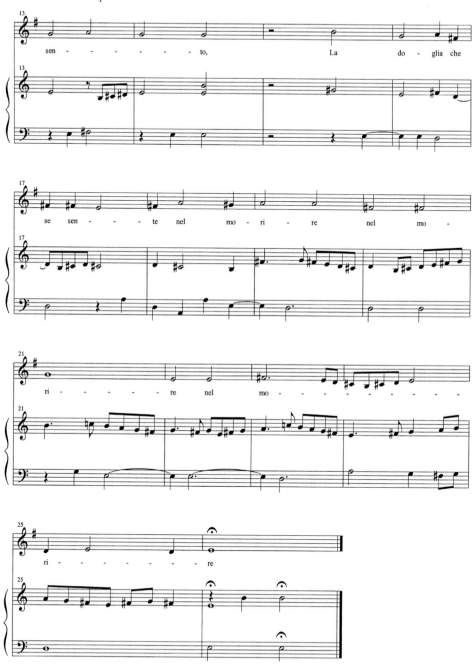

Florentine contemporaries. A solo singer—providing his own spare, chordal accompaniment—would have had room for expressive responses to individual words and phrases of the sort denied singers taking part in the ensemble performance of a polyphonic work. It is this characteristic that the early madrigal may have inherited from the tradition of solo singing. As striking an instance of text setting as that at the word "Morte" in Arcadelt's famous madrigal *Il bianco e dolce cigno* reflects this element of the tradition of solo song, as subsequently expressed in the polyphonic "maniera."

The Companies of the Paiuolo, Cazzuola, Broncone, and Diamante

The more serious and sober institutional purposes of the Medici Sacred Academy and the Rucellai group were fundamentally different from those of convivial organizations such as the Companies of the Paiuolo and Cazzuola, as Giorgio Vasari made abundantly clear in his biography of the sculptor Giovan Francesco Rustici. Vasari reported that the Paiuolo met at the Sapienza; that its members included Rustici, the painter Andrea del Sarto, and the architect Aristotile da San Gallo, among others; and that the meetings featured musical performances. The Cazzuola counted artists, musicians, heralds of the Florentine Signoria, literary figures, and representatives of the Florentine social and political elite among its members, and it gathered for banquets and staged theatrical productions:

> There used to assemble in [Rustici's] rooms at the Sapienza a company of good fellows who called themselves the Company of the Paiuolo [Cauldron]; and these . . . [included] our Giovan Francesco, Andrea del Sarto, . . . Aristotile da San Gallo, . . . [and] Domenico Baccelli, who played and sang divinely, [among others]. One evening, . . . when Giovan Francesco gave a supper to that Company of the Paiuolo, he arranged that there should serve as a table an immense cauldron made with a vat, within which they all sat. . . . [W]hen they were all seated at table in the cauldron, . . . there issued from the centre a tree with many branches, which set before them the supper, that is, the first course. . . . This done, it descended once more below, where there were persons who played music, and in a short time came up again and presented the second course, . . . and so on in due order, while all around were servants who poured . . . the choicest wines. The Company of the *Cazzuola* [Mason's Trowel], which was similar to the other, and to which Giovan Francesco belonged, had its origin in the following manner. One evening in the year 1512 there were at supper in the garden that Feo d'Agnolo the hunchback, a fife-player and a very merry fellow, had in the Campaccio, with Feo himself, . . . Il Baia [and others], and, while they were eating their ricotta, the eyes of Baia fell upon a heap of lime with the trowel sticking in it. . . . Whereupon, taking some of the lime with that mason's trowel, he dropped it all into the mouth of Feo, who was waiting with gaping jaws for a great mouthful of ricotta from another of the company. Which seeing, they all began to shout: "A Trowel, a trowel!" That Company being then formed by reason of that incident, it was ordained that its members should be in all twenty-four, twelve of those who, as the phrase was in those times, were "going for the 'maggiore,'"

and twelve of those who were "going for the 'minore'";[1] and that its emblem should be a trowel, to which they added afterwards those little black tadpoles that have a large head and a tail, which are called in Tuscany Cazzuole. Their Patron Saint was S. Andrew, whose festal day they used to celebrate with much solemnity, giving a most beautiful supper and banquet according to their rules. The first members of that Company, . . . those "going for the 'minore,'" [were] Ser Bastiano Sagginati, Ser Raffaello del Beccaio, . . . Francesco Granacci the painter, . . . Feo the hunchback, his companion Il Talina the musician, Pierino the fifer, [and] Giovanni the trombone-player. . . . The associates were . . . Maestro Jacopo del Bientina and M. Giovan Battista di Cristofano Ottonaio, both heralds of the Signoria, . . . and Domenico Barlacchi [another of the heralds]. And not many years passed (so much did they increase in reputation as they held their feasts and merrymakings), before there were elected to that Company . . . Signor Giuliano de' Medici, . . . Giovanni Gaddi, . . . Luigi Martelli, . . . and together with these, at one and the same time as associates, Andrea del Sarto the painter, Bartolomeo Trombone the musician, [and] Ser Bernardo Pisanello. The feasts that these men held at various times were innumerable. . . . [I]t being the turn of [Matteo da Panzano] . . . to be master of the Company, . . . he, in order to reprove some of that Company who had spent too much on certain feasts and banquets . . . , had his banquet arranged in the following manner. . . . [W]hen it was seen that all who were to be there had arrived, in came S. Andrew, their Patron Saint, who . . . laughingly commanded them that, in order not to be too wasteful with their superfluous expenses, . . . they should be contented with one feast, a grand and solemn affair, every year. . . . And they obeyed him, holding a most beautiful supper, with a comedy, every year over a long period of time; and thus there were performed at various times, . . . the *Calandria* of M. Bernardo [Dovizi], Cardinal of Bibbiena, the *Suppositi* and the *Cassaria* of Ariosto, and the *Clizia* and *Mandragola* of Machiavelli, with many others.[2]

Vasari's account suggests that the Company of the Cazzuola was formed in 1512; his statement that "not many years passed . . . before" Giuliano de' Medici was elected a member provides another date, since Giuliano died prematurely in 1516, although the company could well have continued to function after his death, and surely did (as another of Vasari's references cited below suggests).

Vasari's account itself already documents institutions of a very different type from the Rucellai group and the Sacred Academy. The venue for meetings, the complex and interesting character of the Cazzuola's membership, the more convivial nature of its program, and the abundant evidence of institutions that playfully challenged various contemporary protocols and codes of cultural behavior are all indicative of the differences.

The reference to Rustici's "rooms at the Sapienza" is to a group of buildings in Florence between the Churches of the Santissima Annunziata and San Marco that housed artists' workshops and in some instances, perhaps, artists' residences as well. Among the artists known to have maintained quarters there, besides Rustici himself, were the painter Franciabigio (Francesco di Cristofano di Francesco), the painter Jacopo Pontormo, the sculptor Jacopo Sansovino, and the painter Andrea

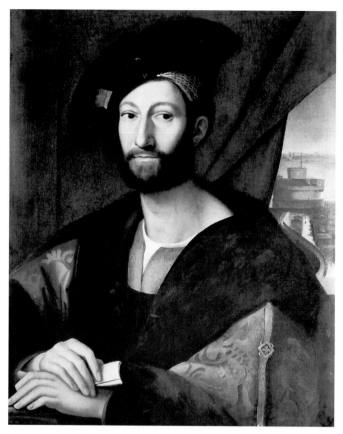

Figure 3.3. Giuliano de' Medici, the youngest son of Lorenzo "il Magnifico" and the younger brother of Pope Leo X, was an important music patron and among the most prominent members of early Cinquecento Florentine society, sufficiently prominent, indeed, to be the subject of a formal portrait executed in Raphael's studio.

Giovanni Gaddi was an intellectual figure of considerable importance and a member of a famous Florentine banking family. He was familiar with the music of madrigalist Francesco de Layolle.[10] Giuliano de' Medici, the youngest son of Lorenzo il Magnifico and the younger brother of Pope Leo X, was an important music patron and among the most prominent members of early Cinquecento Florentine society, sufficiently prominent, indeed, to be the subject of a formal portrait executed in Raphael's studio, reproduced here.[11]

The priest Raffaello del Beccaio, Isaac's brother-in-law, was a professional singer, a soprano active from 1501 through at least 1512.[12] The Bernardo Pisanello mentioned in Vasari's account has been identified with the classicist, composer, and papal singer Bernardo Pisano, one of the most important musical figures of the time.[13] Two of the heralds of the Florentine Signoria, Jacopo del Bientina and Giovan Battista di Cristofano Ottonaio, are known to have authored texts for canti

carnascialeschi, whose musical settings are in some cases still extant.[14] Ottonaio, in addition, was granted a request by the Florentine Signoria in 1515 to be permitted to publish music.[15] Feo d'Agnolo and Talina *sonatori* are documented as members of the corps of instrumentalists maintained by the Florentine Signoria;[16] the Bartolomeo and Giovanni *tromboni* mentioned in Vasari's account may also have been members of that group.[17] Vasari's Pierino *pifaro* was possibly the Pierino associated with Lorenzo de' Medici the Younger, who from 1513 until his death in 1519 was his family's principal representative in Florence.[18] Finally, and most importantly, the Cazzuola's Luigi Martelli was perhaps the distinguished literary figure Ludovico di Lorenzo Martelli.[19] Martelli was associated with Cardinal Ippolito de' Medici, illegitimate son of Cazzuola member Giuliano di Lorenzo, and also with the company's Giovanni Gaddi. In 1533, Gaddi had as many of the late Martelli's works published as he had been able to collect, dedicating the edition to Cardinal Ippolito, and the suggestion about the identity of the Cazzuola's Luigi Martelli may be substantiated by the fact that Gaddi was editor of Ludovico's works; that Martelli had served Cardinal Ippolito—a relationship confirmed by a remark of Gaddi's in the dedication to his edition of Martelli's *Rime* and *Opere*—may be further substantiation still. In Verdelot's [*T*]*erzo libro de madrigali* is a setting of a text that appears as a chorus in Martelli's tragedy *Tullia;* Layolle also set several of Martelli's poems.[20] The composers' poetic choices may document a relationship between Martelli on the one hand and Layolle and Verdelot on the other; if there were such relationships, and if Ludovico Martelli were the Cazzuola's Luigi, there is further important evidence of the company's importance to early sixteenth-century Florentine musical life and, specifically, to the early madrigal.

The mixed character of the membership of the Cazzuola is one important index of the differences between the Cazzuola and the Rucellai group and Medici Sacred Academy. Painters and a sculptor (two of whom frequented a bohemian artists' colony), instrumentalists, the priest-singer Ser Raffaello del Beccaio, and heralds of the Florentine Signoria fraternized comfortably with scholars and intellectual figures and members of the Florentine political and social elite.[21] Vasari's account of the activities of the Cazzuola provides tantalizing insights into Florentine popular culture of the early Cinquecento and the kinds of popular music-making that occurred in that society.

But precisely because some members of the Cazzuola represented the Florentine social elite, the account also substantiates what historians have increasingly been arguing: that a sharp distinction between elite and popular cultures is difficult to sustain. Given that the Cazzuola mixed elites and nonelites, its membership as well as its musical activities challenge the traditional distinction, which ultimately may issue from Marxist assumptions about the stratification of societies. What may have been an appropriate and convincing model for an analysis and critique of northern European society in the nineteenth century is not fully applicable to

Italian society of the early modern period. As François Laroque noted in a different context, "The idea that festivals, poor and rich alike, draw upon the same mythical and imaginary stock is an attractive one, for it could blow apart the watertight compartments set up by ideologies and call into question the idea that class struggle is universal. . . . Festivity is profoundly ambivalent and, for that very reason, tends to repel dialectical interpretations."[22] If festivity—"profoundly ambivalent"—"tends to repel dialectical interpretations," so, too, does the membership of Cinquecento convivial institutions such as the Company of the Cazzuola, with its free and sociable mixing of representatives of various elements and classes of Florentine society. Their easy interaction at gatherings of the Cazzuola indeed calls into question "the idea that class struggle is universal" and suggests that a Marxist interpretive model in this context is anachronistic.

In a superficial sense, the forms of the Cazzuola's programmatic activities were not dissimilar to those of the Rucellai group and the Medici Sacred Academy: extravagant banquets (garden banquets specifically), conversation, and theatrical productions. But if the forms were superficially similar, the causation was not. In contrast to the Rucellai group, a tiny percentage of the Cazzuola's members was educated in the *studia humanitatis,* which explains the absence of those tendencies towards classicization and the antiquarian interests that characterized the activities of the Rucellai group and the Sacred Academy. Members of the Rucellai group would gather in the Orti Oricellari, where—stimulated by the classicized horticulture (and possibly portrait medallions)—they engaged in discussions of the Italian language and its putative comparability to classical languages as a vehicle for refined literary expression, reflected upon the lessons of ancient history, and perhaps staged and witnessed a production of Giovanni Rucellai's tragedy *Rosmunda.* The members of the Sacred Academy undertook to effect the return of Dante's remains to his native Florence, commissioned redactions of texts, and luxuriated in the poetizing of Lorenzo Strozzi and the solo singing of Atalante Migliorotti and the Singular Aretine. In contrast, the Cazzuola staged the leading comedies of the day and gathered at the Campaccio, where they engaged in good-natured sparring—both verbal and physical—and indulged freely in food and drink.

One must be careful not to draw such distinctions too sharply. At least one member of the Cazzuola—the classicist and composer Bernardo Pisan[ell]o—may also have been a member of the Rucellai group; he was certainly closely associated with any number of its members. Other members of the Company of the Cazzuola—Giovanni Gaddi, Luigi (Ludovico?) Martelli, and Giuliano de' Medici—had the kind of biographical profile that would have made them entirely appropriate candidates for membership in the aristocratic Rucellai group or the Sacred Academy. Any tendency to construct the membership profiles of these various institutions too discretely is complicated by the overlap in membership.

The more open commensality of the Company of the Cazzuola—more open as contrasted with the evidently restricted commensality of the Rucellai group—may be the most powerful expression of this phenomenon. The Cazzuola's "rules of tabling and eating as miniature models for the rules of association and socialization"[23] and "its table fellowship as a map of . . . social hierarchy . . . and political differentiation"[24] suggest liberal protocols that afforded painters and instrumentalists occasion to dine with Giovanni Gaddi and Giuliano de' Medici. A further sampling of current scholarly opinion on the meaning of various forms of commensality suggests the same: "Once the anthropologist finds out where, when, and with whom . . . food is eaten, just about everything else can be inferred about the relations among the society's members";[25] "[e]ating is a behavior which . . . mediates social status and power . . . and expresses the boundaries of group identity."[26] The "vertical discriminations and lateral separations"[27] of early Cinquecento Florentine society were not reproduced in the miniature society of the Company of the Cazzuola; its "nondiscriminating table depicting in miniature a nondiscriminating society"[28] was a direct expression of the egalitarian character of its membership and of the profile of the institution more generally.

An indiscriminate mixing of socioeconomic profiles, the manifestly phallic imagery of the company's name, and liberal commensality are to some extent merely different manifestations of the same essential phenomenon: all served to question—even to challenge—customary distinctions, protocols, and boundaries. And the mixed associations of the company's cultural program and activity are a further expression of the same phenomenon: its principal musical manifestation, the venerable Florentine canto carnascialesco, exploited the same mixed and self-consciously provocative associations, especially the charged sexual imagery. The importance of these phenomena for the early madrigal cannot be overstated.

Cazzuola member Domenico Barlacchi, herald of the Florentine Signoria and a famous comic actor,[29] was responsible for a redaction of Lorenzo di Filippo Strozzi's "Commedia in versi," a work probably first performed—with elaborate musical intermedii—in Palazzo Medici in September 1518, on the occasion of the wedding festivities for Lorenzo di Piero de' Medici and Madeleine de la Tour d'Auvergne.[30] Barlacchi also participated in the festivities in Florence organized by Lorenzo di Piero de' Medici for the 1514 Feast of San Giovanni,[31] and he is known to have played a role in Bernardo Dovizi da Bibbiena's famous comedy *Calandria*, which "the Florentine nation had performed at the request of His Most Christian Majesty" on the occasion of "the magnificent and triumphal entry of the Most Christian King of France, Henry II, . . . done in the city of Lyons for him and his most serene consort, Catherine [di Lorenzo di Piero de' Medici], on September 21, 1548," to borrow the language of a rare contemporary pamphlet describing the festivities. The performance so pleased the king and queen of France that Henry "had 500 gold *scudi* given to the actors, and

the queen 300, such that Barlacchi and the other actors who were made to come from Florence returned there from here with a purse full of *scudi* for each."[32]

Barlacchi's profile and the fact of his membership in the Cazzuola serve to substantiate and extend the characterization of the company developed above. His status as a comic actor and his appearance as one of the "bufoni" on the "ship of fools" at the 1514 Feast of San Giovanni suggest an interpretation of the Cazzuola's membership and its program in terms of the carnivalesque, with all that such an interpretation entails. The company's very name—its phallic resonances—evokes the traditions of Florentine carnival, with its overlay of both oblique and overt sexual imagery.[33] In Florence as elsewhere, the carnivalesque also entailed a temporary reversal or inversion of norms of propriety and the standards governing interaction among representatives of different strata in the society. Vasari's account of the Cazzuola relates an incident that would have been regarded at the time as representing inversion of a different kind: there is, I should think, a homoerotic interpretation to be given to that scene where Il Baia drops lime from a cazzuola (that is, a mason's trowel/tadpole/penis) down Feo's throat.

In addition, Barlacchi evidently enjoyed an intimate relationship with Lorenzo di Piero di Lorenzo de' Medici, duke of Urbino, and he certainly fraternized with Machiavelli and Lorenzo Strozzi. He thus embodies that tendency among members of the Cazzuola to interact sociably with members of the intellectual, social, and political elite and exemplifies the collapsing of distinctions in profile.

Most importantly, Barlacchi was actively engaged with the tradition of theatrical uses of music, and especially with the practice of interpolating musical intermedii between the acts of comedies, a tradition of vital importance to the emergence of the Cinquecento madrigal. His redaction of Lorenzo Strozzi's "Commedia in versi," whose 1518 intermedii featured the solo singing to lute accompaniment of Strozzi himself, was copied by Machiavelli,[34] who subsequently employed the tradition of musical intermedii in performances of his own comedies.

Indeed, elsewhere in Vasari's *Lives,*[35] there is a reference to a performance by the Cazzuola of Machiavelli's *La mandragola:* "When the *Mandragola* . . . was to be performed by the . . . *Cazzuola,* Andrea del Sarto and Aristotile executed the scenery . . . ; and not long afterwards Aristotile executed the scenery for another comedy by the same author [that is, *La Clizia*] in the house of . . . Jacopo[36] at the Porta S. Fr[ed]iano."[37] The subsequent performance of *La Clizia*[38] is of unusual music-historical importance, since Philippe Verdelot's extant settings of Machiavelli's texts for the canzone before the Prologue and between the acts were almost certainly performed on that occasion.[39] Whether the earlier performance of *Mandragola* by the Cazzuola included musical intermedii is not known, but given the profile of the company's membership and the relationship to Machiavelli that Vasari's report suggest, it might well have included such elements.

Vasari's account of the life of Rustici, quoted *in extenso* at the beginning of this chapter, suggests that the Cazzuola performed Machiavelli's *La Clizia*. Was the performance of *La Clizia* "in the house of . . . Jacopo at the Porta S. Fr[ed]iano" the Cazzuola's specifically? Vasari's various texts do not necessarily permit that conclusion, but they are suggestive all the same. If the early 1525 performance "in the house of . . . Jacopo" was indeed the Cazzuola's, it would document both the membership's involvement with the madrigal and also a professional connection with the distinguished early madrigalist, Philippe Verdelot.[40] The membership's musical experiences are also evident, if indirectly, in the fact of Granacci and Sarto's membership and their documented involvement with festivities that included the singing of canti.[41]

The significance of these various references is that they highlight the importance of the Cazzuola to sixteenth-century Florentine cultural and musical life generally, and they also emphasize the particularly close associations between many of its members and some of the most distinguished artistic and literary figures of the entire period. Of principal importance is the company's active engagement with repertories and practices central to Florentine musical experience, in particular the canto carnascialesco repertory and various theatrical uses of music, and an involvement with those practices specifically on the part of important cultural figures such as Giovanni Gaddi, Ludovico (?) Martelli, and Giuliano de' Medici.

More so than in the case of the Medici Sacred Academy or the Rucellai group, there is direct testimony to the actual musical experiences of the Cazzuola's membership. A contemporary printed pamphlet in the Biblioteca Nazionale Centrale in Florence[42] contains the texts of four canti carnascialeschi, one of which was demonstrably sung on a specific occasion that can be reconstructed in detail: the *Canzona del bronchone* was performed by the Compagnia del Broncone on the evening of 6 February 1513. The reference in the title of the print to a *Canzona . . . della Chazuola* suggests that the Cazzuola, similarly, may have sponsored such performances, and perhaps even that its members themselves assumed responsibility for the musical element. Given that several of the members either were musicians or authored canti carnascialeschi verse, the reference is likely to a piece sung by the company's members on one of the festive occasions for which Florence was justifiably famous. Some scholars have suggested that it was the heralds of the Florentine Signoria who were responsible for the all-vocal performance of the canto carnascialesco repertory,[43] which is reasonable given their authorship of canto verse; several members of the Cazzuola were heralds.

Although not identified as such in the pamphlet, the canzona beginning "La gran memoria dell'età passata" can be shown by process of elimination to be the *Canzona . . . della Chazuola*, which another contemporary source attributes to Ottonaio, the herald of the Signoria who was a member of the Company.[44] The sug-

gestion that the heralds were responsible for the performance of *canti carnasciale-schi* may thus be substantiated by the evidence of the *Canzona ... della Chazuola*, the fact that its text may be by the herald Ottonaio, and the presence of heralds among the company's members.[45]

The text of the *Canzona ... della Chazuola* and a translation follow:

> *LA gran memoria dell'[']età passata* [1]
> *dove sempre virtù & amor crebbe,*
> *ci duole haver lassata,*
> *p[er]chè perpetuarsi ognun vorrebbe.*
> *Ma, poich['] el è dal cielo sì exaltata,*
> *ciaschino* [alternatively *ciascuno*] *amarla vuole,*
> *per restar vivo in sì splendida prole.*
>
> *Però voi, parvoletti, in cui non iace* [8]
> *anchor, sicome in noi, esperienza*
> *correte a tanta pace*
> *per fare anchora più triho[n] fare Fiorenza;*
> *& voi & noi accui lasciarla* [alternatively *lasciare*] *spiace,*
> *sopperisca* [alternatively *sofferisce*] *il favore:*
> *chè quella a tutti ancor porrà amore.*
>
> *Honora adunque, alma Ciptà, costei* [15]
> *ch['] è stata & è & fia* [alternatively *sia*] *la tua salute:*
> *pensa hora quel che tu sei*
> *& quel che fusti* [alternatively *eri*] *sanza sua virtute;*
> *&* [alternatively *che*] *se mai festa & fè regniò in lei*
> *con virtù, gratia e pace,*
> *saprallo el buon chè 'l ben sempre al buo[n] piace.*
> *Finis.*

It pains us to have left behind the great memory of past days ["*l'età passata*"] [i.e., to have died], where virtue and love grew ever greater, because all would like to perpetuate themselves [i.e., to live forever]. But because it [i.e., "*l'età passata*"?] is so exalted by Heaven, each wishes to love it [i.e., to mate with it], in order to live forever through such splendid progeny. However, *you*, charming children—whose experience is not yet as deep as ours—run toward such peace, in order to make Florence's triumph great once more; and you and we—whom it displeases to leave her [behind] [i.e., to die]—permit the favor, because she will still love everyone [i.e., including those who come after us]. Divine city: honor her who has been your well-being, and is, and will be! Reflect now upon what you are, and what you were without her virtue! And if ever festivity and faith reigned in her—with virtue, grace, and peace—good men will know it, because the good always pleases good men. The End.[46]

Within a formal scheme that consists of three seven-line strophes, the *Canto ... della Chazuola* consists of a free alternation of lines of seven and eleven syllables

(11-11-7-11-11-7-11), which, interestingly, is more typical of early madrigal verse than of canti carnascialeschi, most of which are in the more highly structured ballata form.[47] In a typical ballata, an opening couplet of seven- and eleven-syllable lines serving as the *ripresa* is followed first by a four-line stanza consisting of two piedi of two lines each, and then by a two-line volta related to the ripresa by means of the metrical and rhyme schemes: the lines of the volta, like the lines of the ripresa, are of seven and eleven syllables, and the second line of the volta rhymes (*A*) with the ripresa's (*a A*). By means of the rhyme, the first line of the volta, conversely, relates it (*c*) to the second and fourth lines of the stanza (*C C*). Thus, a ballata is typically an eight-line poem, structured as follows (lowercase letters in the rhyme scheme signify seven-syllable lines; uppercase letters signify eleven-syllable lines):

ripresa:	*a*
	A
stanza piede 1:	*B*
	C
piede 2:	*B*
	C
volta:	*c*
	A

What is the meaning of Ottonaio's obscure text for the *Canzona . . . della Chazuola?* In two of its sources, the *Canzona . . . della Chazuola* is identified as the response (risposta) to another of Ottonaio's canzone: the *Canzona del Diamante, Quel primo eterno amor,*[48] an elaborate allegory of the principal stages of an individual's life; I believe it is also an allegory of the stages of humankind's existence more generally, and of those of its social and political institutions and its polities, including the city of Florence. *Quel primo eterno* makes reference throughout to childhood, youth, and old age (pueritia, gioventù, and senectù); repeatedly deploys images of birth, life, and death; and invokes the names of Lachesis, Clotho, and Atropos, the Three Fates, who project and calibrate life's span, and spin and cut the thread of life. "Our Clotho," who, "spinning, gives life perfection [filando, dà la perfectione]," is honored in *Quel primo eterno amor* as the manifestation of the "happier state [più felice stato]" to which "spotless youth aspires [la biancha pueritia aspira a questa]," and "darkened old age, having lost it, weeps [senectù negra piange averla persa]." The canto further invokes images of ages "futura" and "presente" and of the "passato." By means of its recurrent threefold enumerations of elements in triadic complexes

of related items—childhood/youth/old age, birth/life/death, Lachesis/Clotho/Atropos, past/present/future, the one/the other/the final (l'una, l'altra, l'ultima), the beginning/ the middle/ the end (il principio, il mezo, il fine)—the imagery also implicitly invokes the extraordinarily rich symbolism entailed by the number three throughout the course of European history.[49]

As rejoinder to *Quel primo eterno amor*, the *Canzona . . . della Chazuola*'s meaning is somewhat clarified. Its reference to "past days [età passata; line 1]," the tripartite arrangement of the exhortation to "honor her who has been your well-being, and is, and will be [lines 15–16]," and the bipartite arrangement of the similar exhortation to "reflect . . . upon what you are, and what you were [lines 17–18]" invoke the imagery of the related *Quel primo eterno amor* as an allegorization of the principal stages in humankind's existence.

At one level, this is evidently the meaning of Ottonaio's *Canzona . . . della Chazuola*. But it may have another more oblique meaning, given its broader historical and political context and the possible dates for its composition.

There are only a few dates for the Cazzuola's activity. According to Vasari, it formed in 1512. Company member Giuliano di Lorenzo de' Medici had to have joined before 1516, the year of his death. The company is said by Vasari to have performed Machiavelli's *Mandragola* "not long" before the early 1525 performance of Machiavelli's *La Clizia*. We have no further dates for the company's activities, though we do have further dates for some of its members acting individually. The available dates thus suggest a period of activity for the company, and therefore a date for its *Canzona*, in the second and third decades of the sixteenth century; the canzona can be no earlier than 1512.

This is the period between the first restoration of the Medici to Florence in 1512 and their subsequent exile in 1527, prior to the final, decisive restoration of 1530 and the establishment of the Medici ducato. The memorable "past days [l'età passata; line 1]"—"so exalted by Heaven [line 5]," "where virtue and love grew ever greater [line 2]"—might therefore refer to the period of the Laurentian regime of the late fifteenth century. The speakers (the Florentines?) are said to be grieving, perhaps for having willfully and irresponsibly exiled the Medici and thereby forfeited the benefits of the Medicean regime (lines 1–3: "it pains us to have left behind the great memory of days gone by"). Florence is exhorted to "honor her [that is, the 'età passata,' the Laurentian era?] who has been your well-being, and is, and will be," and to "[r]eflect now upon what you are and what you were without her virtue," exhorted to contrast the current situation ("what you are")—when the city once again enjoys the benefits of a Medicean presence—with the period between 1494 and 1512, when the Medici were in exile. The *Canzona* suggests that "festivity and faith reigned in her [that is, the 'età passata,' once again?]—with virtue, grace, and peace [lines 19–20]"—and each is said to wish to couple with the "età passata," so as to ensure one's eternal existence through the agency of the progeny of such a union.

Further, the "charming children" to whom the canzona is addressed are said not to possess the experience of the speakers and to "run toward such peace [line 10]." By this the poet may have meant the state of peace that Italy enjoyed in Lorenzo de' Medici's last years, a condition Lorenzo personally was credited (extravagantly and exaggeratedly) with achieving almost singlehandedly.[50] The contrast drawn between the greater and lesser experience of the speakers on the one hand and the "charming children" on the other suggests that the speakers had experienced the "età passata" themselves, that they themselves had lived through it. There is a sense that the children are being exhorted to develop their own figurative relationship with the Laurentian era, to experience it imaginatively. To do so would have the effect of making "Florence's triumph great once more"; it would figuratively restore the ambiente of the Laurentian age in such a way as to lead to the greater glory of the city of Florence.

Finally, one senses that behind the *Canzona . . . della Chazuola* was an anxiety about issues of continuity and discontinuity, about ensuring the continued fragile existence of a figuratively restored "età passata." Such anxieties are generally characteristic of the period of the Medici restoration of 1512–27. Images in Medicean art and literature of Fortune's Wheel, of rebirth, renewal, regeneration, the return of a golden age, and so on, unconsciously reveal an obsessive but understandable preoccupation with the indeterminate prospects and uncertain continued viability of the Medici regime.[51]

Because its references (at least to a twenty-first-century reader) are so oblique, this interpretation of the canzona's text is offered diffidently. However, Giuliano de' Medici was a member of the Cazzuola, and such metaphorical references to ages past and present—in which the glories of a Medicean past are starkly contrasted with the impoverished political and cultural circumstances of the period of their exile—were typical of canto carnascialesco verse of the period of the Medici restoration.[52]

In any event, the *Canzona . . . della Chazuola* exemplifies the degree to which the genre was capable of sustaining a metaphoric use of language, delivered to its audience by means of a spare, intelligible musical setting—necessary preconditions to the emergence of the madrigal. The all-vocal conception of the canto carnascialesco—all-vocal as contrasted with the north Italian frottola specifically—was another precondition, and all of these preconditions are met in the carnival song of the Florentine Renaissance.

The *Canzona . . . della Chazuola*'s musical setting[53] and other canti carnascialeschi whose texts were authored by *Cazzuola* members[54] display the stylistic properties typical of the genre, of the music expressly commissioned and experienced by the company's members: the homorhythmic design and rhythmic variety achieved by means of temporary shifts in meter (as at measure 32 of the *Canzona . . . della*

Chazuola, where the meter shifts from duple to triple, and measure 44, where it shifts back), and the full sonorities and textural variety achieved by means of a reduced complement (as at measure 19), where in other examples of the genre there are sometimes brief, intermittent, simultaneous inflections of imitative writing.

One can readily imagine one of those festive occasions for which Renaissance Florence was renowned. The Company of the Cazzuola may have elected at a meeting in the Campaccio to sponsor a float, or a succession of floats, the cost of the event perhaps being underwritten by company members Giovanni Gaddi and Giuliano de' Medici, and the floats decorated with removable panels, designed and executed perhaps by company members Andrea del Sarto and Francesco Granacci. Their visual tropes would have aligned with the literary images invoked in the corresponding canto, Gaddi and Martelli perhaps having first commissioned Ottonaio's metaphoric verse, preserved to this day as the *Canzona . . . della Chazuola.* The extant musical setting perhaps was performed by company members Raffaello del Beccaio, Bernardo Pisano, and Jacopo del Bientina and Giovan Battista di Cristofano Ottonaio, heralds of the Florentine Signoria, and the procession of floats conceivably could have been accompanied by the instrumental playing of company members Feo d'Agnolo, Talina, Pierino pifaro, and Bartolomeo and Giovanni tromboni.

Speculation aside, evidence presented here incontrovertibly substantiates the arguments of Rubsamen and Gallucci and demonstrates an active engagement with the traditions of Florentine festival music on the part of Florentine artistic and literary figures of the sort Verdelot knew, and for whom he presumably wrote some of his earliest madrigals. When attempting his first essays in the genre, Verdelot to some extent was playing to expectations shaped by the musical experiences and tastes of his benefactors.

More specifically still, Verdelot "might well have been invited to join the Compagnia [della Cazzuola]."[55] If he did, what sorts of precise cultural and musical stimuli would he have received to which he would then have responded? He would have made the acquaintance of Giovanni Gaddi, an intimate of the madrigalist Francesco de Layolle, and Bernardo Pisano, a madrigalist himself. He would have become conversant with various uses of music in the Florentine theater, as exemplified by the company's staging of comedies and the professional activities of Domenico Barlacchi, who redacted Lorenzo Strozzi's "Commedia in versi"; such a conversance might explain Verdelot's setting of the text of a chorus from the *Tullia* of Ludovico Martelli and his setting of the canzoni for Machiavelli's *La Clizia.* Above all, he would have become conversant with the traditions of the Florentine carnival and related festivals by virtue of his association with Francesco Granacci and Andrea del Sarto, who designed the artistic elements for a series of such celebrations, and with the heralds of the Signoria, who authored canto verse; he would

Example 10. The *Canzona . . . della Chazuola*'s musical setting.

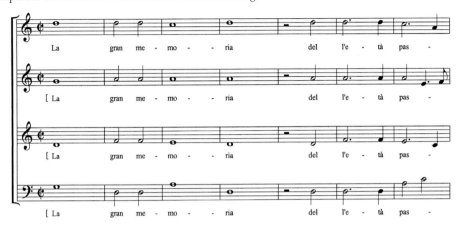

Example 10 (continued). The *Canzona . . . della Chazuola*'s musical setting.

Example 10 (continued). The *Canzona . . . della Chazuola*'s musical setting.

thus have become familiar with the stylistic characteristics of the canto carnasciale-sco, as exemplified by the company's own canzona and similar works that set verse authored by members of the company.

Pirrotta observed that "in terms of musical style, most Florentine masters appear to have . . . learned to attain variety through the alternation of chordal recitation by all voices with freer, even imitative, passages in counterpoint, as well as changes in color and sonority obtained by various groupings of the voices. That all this had gradually produced a new genre, the madrigal, . . . I have no doubt."[56] The very features identified as characteristic of the new genre, as well as the freer poetic schemes that are also typical of the early madrigal, are already present in the Cazzuola's canzona and similar works, reproduced below, that may have been the most proximate models for Verdelot when he was undertaking his first experiments in the new madrigal style.

Example 11. Alessandro Coppini's polyphonic setting of Cazzuola member Giovan Battista di Cristofano Ottonaio's *Canto dei giudei.*

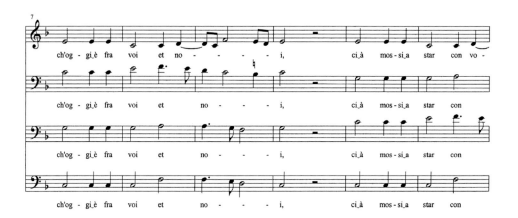

Verdelot's association with the Cazzuola would also have ensured that those elements of the comic and carnivalesque that characterized the company's programmatic activities were among the complex of influences on him when he was undergoing the processes of artistic maturation and assimilation of artistic stimuli. The overt sexual imagery of the Florentine carnival song was rendered more oblique, sublimated, and metaphoric in the language of the Cinquecento madrigal, but the relationship between the two genres in that respect is incontrovertible.[57]

A similar involvement on the part of members of the Florentine elite with the Florentine carnival—including the canto carnascialesco repertory—is documented by the activities of the aristocratic Companies of the Broncone and Diamante, but these were institutions of a different type. If the aims and purposes of the Medici Sacred

Example 11 (continued). Alessandro Coppini's polyphonic setting of Cazzuola member Giovan Battista di Cristofano Ottonaio's *Canto dei giudei*.

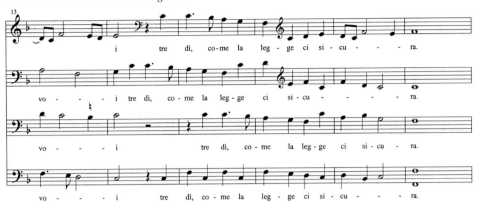

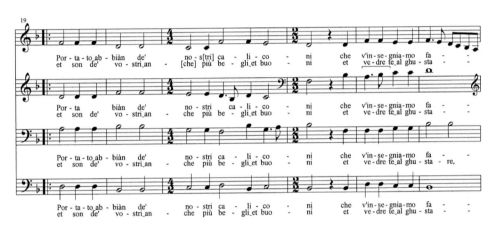

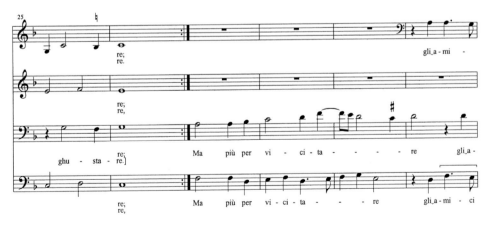

Example 11 (continued). Alessandro Coppini's polyphonic setting of Cazzuola member Giovan Battista di Cristofano Ottonaio's *Canto dei giudei.*

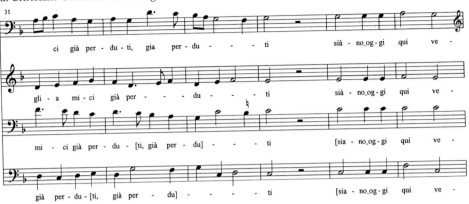

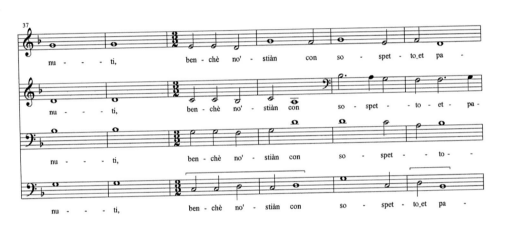

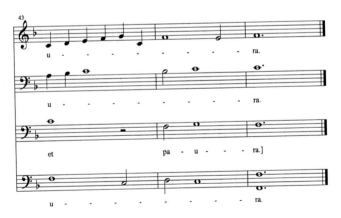

Example 12. Baccio degl'Organi's polyphonic setting of Cazzuola member Jacopo del Bientina's *Canto di pastori bacchiatori di bassette.*

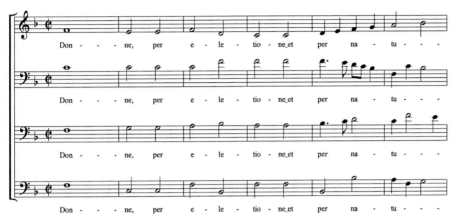

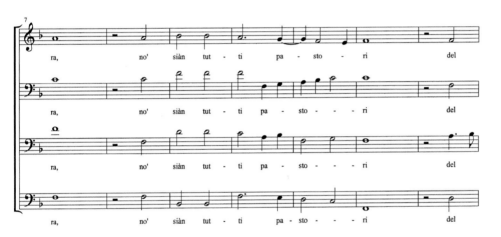

Academy and the Rucellai group were academic in nature, and the Cazzuola's largely convivial, those of the Broncone and Diamante Companies were at first overtly political. Within weeks, or at most a few months, of the restoration of the Medici to Florence in September 1512, the city's young aristocrats organized the two companies. Bartolomeo Cerretani described their founding in detail.[58] His account suggests that the founding occurred after 6 November 1512, since he implies that it followed soon after the departure from Florence that day of the papal legate to Bologna, Cardinal Giovanni de' Medici.[59] A letter of 8 January 1513 from Jacopo Guicciardini to his brother Francesco, the famous historian, suggests that they were founded no later than the end of November 1512 ("about a month-and-a-half ago").[60] The references thus permit an unusually precise date for the companies' formation.

Cerretani recorded that Giuliano de' Medici had had a group of his contemporaries summoned to dinner at Palazzo Medici, where he spoke:

Example 12 (continued). Baccio degl'Organi's polyphonic setting of Cazzuola member Jacopo del Bientina's *Canto di pastori bacchiatori di bassette.*

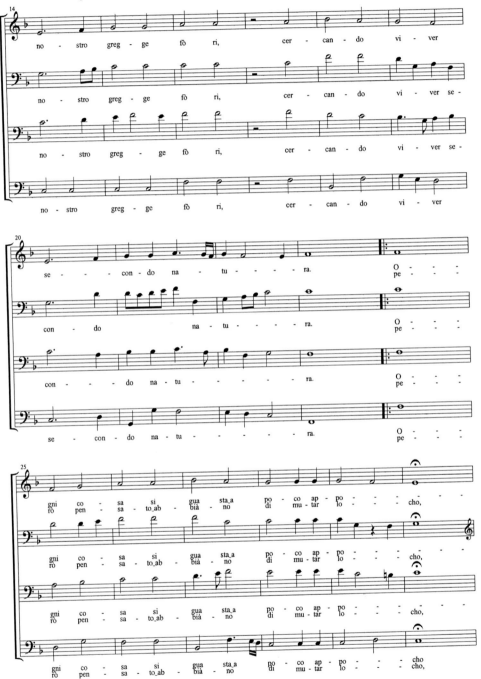

Example 12 (continued). Baccio degl'Organi's polyphonic setting of Cazzuola member Jacopo del Bientina's *Canto di pastori bacchiatori di bassette.*

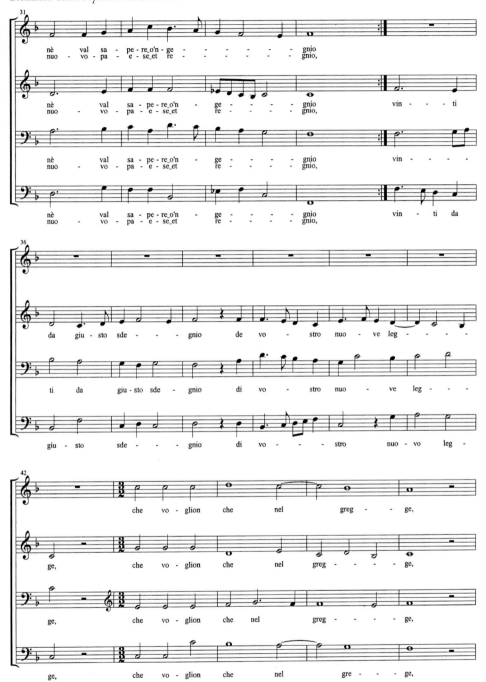

Example 12 (continued). Baccio degl'Organi's polyphonic setting of Cazzuola member Jacopo del Bientina's *Canto di pastori bacchiatori di bassette.*

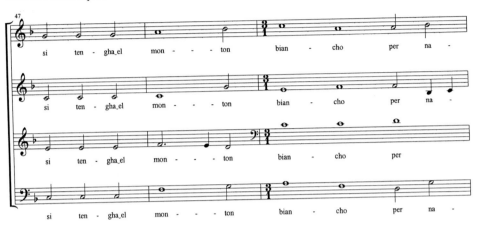

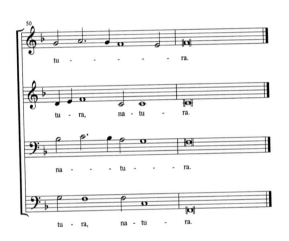

Pope Julius instructed Cardinal Giovanni to attend to the Ferrarese undertaking, and so he did, recommending his brother Giuliano to all his relatives and friends. At our urging, Giuliano formed a company like Lorenzo "il Magnifico"'s, and it was called the Diamante [Diamond], because it was an old device among the Medici. It had its beginnings in this way: we made a list of the 36 sons of those fathers who were with Lorenzo "il Magnifico" in the Company of the *Zampillo* (or, if you wish, of the Magi). And having had them summoned for an evening at Palazzo Medici, where they dined, Giuliano spoke, calling to mind how his family and the others who were there had happily possessed the city, and because that had to be, he encouraged and proposed feste for the coming carnival (and they were planned), Giuliano thinking of giving the order that this company govern the city, and already there wasn't a magistracy formed where there wasn't one of our number. Since no one of us prevailed because of the expectations of each, Giuliano began in his kindly way to suggest that each succeed in such a way that that close group of young men (who were his con-

temporaries) coalesce, as had happened with their fathers. It transpired that Lorenzo came to their meeting, the son of Piero and Alfonsina Orsini, about eighteen years old, raised in Rome without advantages but liberally. There were those who persuaded him that the city, having been his father's, belonged to him, which induced him to want to form a company, and he did and called it the Broncone [Laurel Branch], all of its members his contemporaries from the leading families, and they also ordered a pantomime, as we had previously done.[61]

The members of Giuliano's Company of the Diamante are identifiable:[62]

TABLE 5

MEMBERS OF THE COMPAGNIA DEL DIAMANTE

"In order to consolidate his position, Giuliano de' Medici ordered a company of thirteen young men at his house. I have seen the list of them written below, and the names are the undermentioned:

1. M Giulio di G.ⁿᵒ di p.ʳᵒ di Cosimo de Medici [i.e., Giulio di Giuliano de' Medici]
2. Giuliano di lorenzo di p.ʳᵒ di cosimo de Medici [i.e., Giuliano di Lorenzo de' Medici]
3. Giovanni di bardo di bartolo corsi [i.e., Giovanni Corsi**†]
4. Zanobi di ñofrī di zanobi acciaiuoli [i.e., Zanobi Acciaiuoli]
5. piero di braccio di м domenico martelli [i.e., Piero Martelli**†]
6. Ant.º di bettino d'ant.º da ricasoli [i.e., Antonio da Ricasoli]
7. Piero di ant.º di puccio pucci [i.e., Piero Pucci]
8. Bartolomeo di filippo di bar.ᵐᵉᵒ valori [i.e., Bartolomeo Valori]
9. Giovanni di м Guidant.º di Gio. vespucci [i.e., Giovanni Vespucci]
10. Palla di ber.ᵈᵒ di Gio. rucellai [i.e., Palla Rucellai†]
11. Pagolo di piero di f.ᶜᵒ vettori [i.e., Paolo Vettori*]
12. Gio. di ber.ᵈᵒ di Gio. rucellai [i.e., Giovanni Rucellai**†]
13. Antonf.ᶜᵒ di luca d'antonio delli albizi [i.e., Antonfrancesco degli Albizzi*]

It was called the Company of the *Diamante*."

SOURCE: Florence, Biblioteca Nazionale Centrale, MS Nuovi acquisti 985, Priorista Fiorentino dal 1282 al 1562, fol. 274r, marginal note.

* Also a member of the Company of the Cazzuola.

** Also a member, or a familiar of a member or members, of the Rucellai group.

† Also a member, or a familiar of a member or members, of the Medici Sacred Academy.

Among the members of the company—in addition to Giuliano himself, the company's maecenas, who was also a member of the Cazzuola—were his illegitimate first cousin Giulio di Giuliano (1478–1534), the future Cardinal and Archbishop of Florence and Pope Clement VII; Antonfrancesco degli Albizzi; Giovanni Corsi and Piero Martelli; Giovanni Rucellai; his brother Palla; Fra Zanobi Acciaiuoli;[63] Paolo Vettori (1477–1526), Francesco's brother; and others, any number

of whom had associations with the other private institutions of early Cinquecento Florence, as the accompanying table specifies.

Cerretani further recorded that Giuliano's ambitious young nephew Lorenzo di Piero di Lorenzo il Magnifico also attended the meeting, where those present "persuaded him that the city, having been his father's, belonged to him, which induced him to want to form a company, and he did and called it the Broncone, all of its members his contemporaries from the leading families." Jacopo Nardi may have drafted statutes for the governance of Lorenzo's Company of the Broncone. Whoever their author was, they specify that two of those associated with the establishment and initial organization of the Broncone were "Alexandro di Guglielmo de' Pazi" and "Filippo de' Nerli"; elsewhere, the statutes name an otherwise unidentified "Lorenzo" as one of the captains, who was presumably Lorenzo di Piero de' Medici, the company's maecenas.[64]

The Broncone's formal statutes—its articles of association[65]—provide valuable information about the company's organization, institutional objectives, and intended activities. Its role was evidently more precisely articulated, and conceived as more public, than the Cazzuola's or the Rucellai group's, although we are entirely dependent on the vicissitudes of survival of documentation for evidence as to those latter organizations' own perceptions of their mission. The Cazzuola may well have organized public processions of floats and performances of canti carnascialeschi, which is suggested by the existence of the *Canzona . . . della Chazuola*, but there is no unequivocal evidence that it did; to judge solely from the documentary record, its activities were instead limited to private dinners and the private staging of comedies for the members' own enjoyment. Conversely, the Broncone's statutes assert a public role in addition to a private one. "The above-said noble and sober youths have two principal intentions: one, to be as united and harmonious among themselves as possible; the other, to delight the city generously, according to their abilities."[66] Elsewhere, the intended objectives are still more boldly stated, and in a way that documents the Broncone's political aims as almost as overt and intentionally seductive as the Diamante's, as Cerretani described them; the penultimate statute articulates a series of provisions to be undertaken "so that one shall be able to give pleasure to the city, and the multitude shall be rendered well-disposed":[67] "it shall be the particular responsibility of the Captains to commission four of the brothers . . . , who shall have to refer their programmatic designs to the Captains, upon whom responsibility shall rest to execute everything referred to them, or other designs if they thought them better or more magnificent spectacles, which Captains . . . shall be required to create *festaiuoli*, who shall execute such spectacles, which will be ordered by them."[68]

The use of the term "brothers" evokes the language of the confraternity, which suggests a commonality of purpose and organizational profile between such quasi-

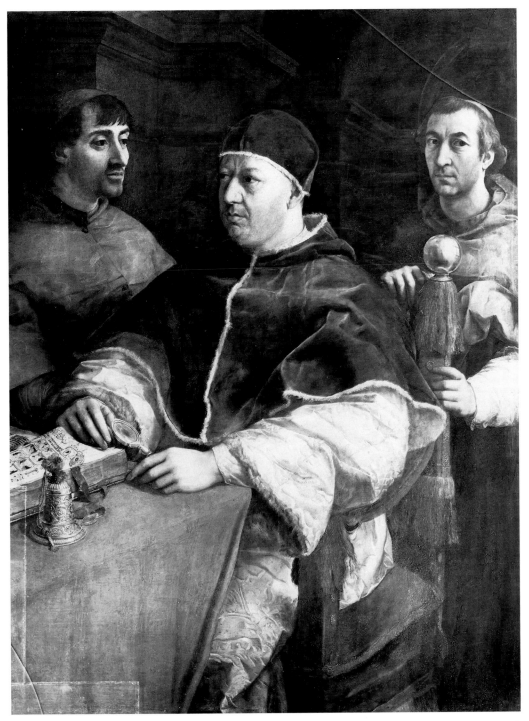

Figure 3.4 Among the members of the Company of the Diamante—in addition to Giuliano himself, the company's maecenas—were (*left*) his illegitimate first cousin Cardinal Giulio di Giuliano de' Medici.

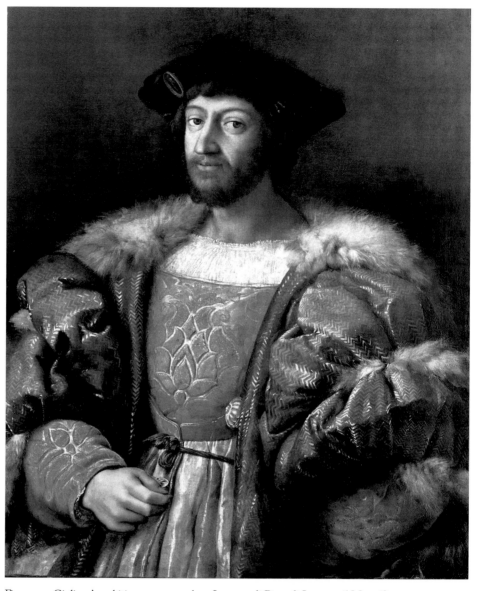

Figure 3.5. Giuliano's ambitious young nephew Lorenzo di Piero di Lorenzo il Magnifico.

religious institutions and the more overtly political Companies of the Broncone and Diamante. The Broncone's protocols contain other provisions that substantiate the same conclusion; they specify that "each year on the morning of [the Feast of] San Lorenzo" (the company's "protector and advocate [protectore et aduocato]"), "a solemn mass shall be celebrated in honor of San Lorenzo in the place of their residence, where all the Company shall attend."[69] Claiming San Lorenzo as their patron saint evoked associations with the Church of San Lorenzo (the Medici

parish church), with Lorenzo il Magnifico, and with his grandson Lorenzo, the company's maecenas; the statutes' reference to "the place of their residence" suggests that the company maintained administrative headquarters. The protocols also detail a schedule of membership dues,[70] which were presumably used in part to fund the group's elaborate carnival activities.

One's sense, then, is of two reasonably formal organizations of indulged young Florentine aristocrats, their Medici patrons having been newly restored to power, their agenda and purposes more or less overtly political in nature: to infiltrate the membership of the principal government magistracies ("already there wasn't a magistracy formed where there wasn't one of our number," as Cerretani reported) and thereby govern the city, and to seduce—and divert the attention of—their fellow Florentines by means of elaborate carnival feste.

Whatever explicit political ambitions the companies' members may have had, their political agenda is important in this context principally because it informed the iconographic content of the artistic and musical elements of the Florentine Carnival festivities of February 1513, for which the companies assumed responsibility. Allegorical figures on the monochrome panels decorating the carnival floats alluded to traditional Medicean political conceits, as did the texts of the extant explanatory canti carnascialeschi, whose music is also preserved.[71]

The Broncone's program and explanatory canto were authored by Jacopo Nardi, whose program, as recounted by Vasari, was an elaborate allegory of the effects of good government. Six floats represented religion, virtue, prosperity, history, poetry, and law. The seventh—a triumphal chariot representing the return of the golden age—featured a man dressed in rusted armor from which emerged a young boy, naked and gilded, who symbolized the Age of Gold as the issue of the Age of Iron.[72] Jacopo Pontormo, then about to emerge as one of the city's most gifted young painters, is said to have been responsible for the decoration of some of the seven Broncone floats.[73] He was assisted in his work by Baccio Bandinelli, said to have contributed figures in relief, among them representations of the four cardinal virtues.

The text of Nardi's explanatory canto for the procession of Broncone floats is printed in the same contemporary pamphlet that contains the *Canzona . . . della Chazuola*, in which it is entitled "Seven Triumphs of the Age of Gold made by the Company of the *Broncone*, 1513." Formally, it is like the *Canzona . . . della Chazuola* in its free alternation of seven- and eleven-syllable lines, as contrasted with the more highly structured ballata form in which canto carnascialesco verse was typically cast. The *Canzona del bronchone*'s unusually close correspondence to the company's program as recounted by Vasari leaves no doubt that it was the canto performed on the occasion of the 1513 carnival. References to the ages' varied states and the virtues and effects of good government (as they were metaphorically rep-

resented in the succession of floats), to the golden age and the rebirth of the happy age from the trunk of the green laurel (or "verde alloro," a venerable Medici device that exploits the aural resemblance between the word "alloro" and the name Lorenzo), to the phoenix, and to images of renewal all suggest the didactic, even hortatory, political function of the canto.

> *Colui che dà le leggi alla natura* [1]
> *In vari stati & secoli dispone;*
> *ma del bene è chagione,*
> *e[']l mal, quant[']e['] p[er]mette, al mo[n]do dura:*
> *onde in questa figura*
> *contemplando, si vede*
> *come con lento piede*
> *l[']un secol doppo l[']altro al mo[n]do viene,*
> *& muta il bene i[n] male, & il male i[n] bene.*

> *Dell[']oro el primo stato & più giocondo,* [10]
> *nelle seconde età men ben si mostra;*
> *& poi nella età vostra*
> *al ferro alla ruggin viene il mondo:*
> *ma hora, essendo in fondo,*
> *torna il secol felice;*
> *& come la Fenice,*
> *rinasce dal bronchon del verde alloro:*
> *così nasce del ferro un secol d[']oro.*

> *Perchè natura el cielo hoggi rinnuova* [19]
> *e[']l secol vecchio in puerile etade,*
> *& quello del ferro chade,*
> *che rugginoso, inutile si truova*
> *a queste virtù giova,*
> *a noi & a costoro*
> *che furno al secol d[']oro,*
> *tornando quel, tornare a star co[n] voi*
> *per farvi diventare simile a noi.*

> *Dopo la pioggia torna il ciel sereno:* [28]
> *godi, Fiorenza: & fatti lieta hormai,*
> *però che tu vedrai*
> *fiorir queste virtù de[n]tro al tuo seno,*
> *che dal sito terreno*
> *havien fatto partita:*
> *la verità smarrita,*
> *la Pace: & la iustitia, hor q[ue]lla hor q[ue]sta,*
> *t'inuiton liete insieme & ti fan festa.*

> *Trio[m]pha, poichè 'l cielo ta[n]to ti honora* [37]

sotto il favore di più benignia stella.
Ciptà felice & bella,
più ch[e] tu, fussi mai al mondo anchora:
eccho che vien quel['] hora
che ti farà beata
& infra l['] altre honorata,
sì, che alla gloria tua p[er] excellenza
basterà il nome solo, alma Fiorenza.[74]

He who gives the laws to nature arranges the ages' varied states. He is the cause of good, and evil persists in the world only insofar as He permits. Wherefore, in contemplating this image, one sees how, step by step, the one age after the other comes to the world and changes good into evil, and evil into good. The first state—that of gold—was the most cheerful. In subsequent ages a decline is clearly shown. And then in your age the world comes to rusted iron. But now, being at the lowest point, the happy age returns and is reborn from the trunk of the green laurel, like the phoenix. So, too, a Golden Age is spawned from that of iron. Because heaven today renews nature, and remakes the old era into a youthful age, and that of iron falls (which, rusted, discovers itself to be useless), it benefits us and those who existed during the Age of Gold that—that age returning—these virtues likewise return to remain with you, so that you are made to become similar to us. After the rain the serene sky returns. Rejoice, Florence, and be happy evermore, because you will see these virtues, which had departed from their earthly habitat, flourish within your breast: cheerful truth (once lost), peace, and justice, and this and that, summon you together and celebrate you. Rejoice, because heaven honors you greatly, under the favor of the most benign star! Happy and beautiful city—as of yet none more so than you on earth—behold that the hour has come when you will be blessed and honored among all others, so that, in order to celebrate you for your excellence, simply your name—divine Florence—will suffice.

The program for the procession of floats staged by the Diamante company, on the other hand, was authored by Andrea Dazzi, lecturer in Greek letters at the Florentine studio, whose program employed images of the principal phases of human existence. There were three floats, the first of which symbolized boyhood, the second manhood, and the third old age; each transported individuals costumed according to the particular age of man the float represented. Andrea del Sarto, Giuliano de' Medici's colleague in the Company of the Cazzuola, is said to have been involved in the design of the Diamante floats. The actual execution of the floats' design—their painting—was the responsibility, once again, of Sarto's pupil Pontormo, who is said to have depicted scenes of the gods undergoing transformation into different forms.[75]

Vasari's account suggests that the Diamante's explanatory *canto carnascialesco* was *Volon gli anni e' mesi e l'ore*, whose text was authored by Antonio Alamanni, a close relative of the brothers Ludovico and Luigi Alamanni.[76] However, the *Canzona*

. . . *della Chazuola* analyzed above is identified in a contemporary source as the "risposta" to another *Canzona del Diamante:* Giovan Battista di Cristofano Ottonaio's *Quel primo eterno amor,* contained in the same printed pamphlet that also contains the *Canzona del bronchone* and *Canzona . . . della Chazuola.* The images employed in Ottonaio's *Quel primo eterno amor* correspond exceedingly closely to Andrea Dazzi's program for the procession of floats staged by the Diamante company in 1513. As we have seen, Ottonaio's *Quel primo eterno amor,* similarly, utilizes images of "pueritia," "gioventù," and "senectù"; invokes the names of Lachesis, Clotho, and Atropos, the Three Fates; manipulates references to ages "futura" and "presente" and to the "passato"; and employs poetic schemes involving the triads birth/life/death, "l'una"/"l'altra"/"l'ultima," and "il principio"/"il mezo"/"il fine,"[77] all of which are extremely suggestive of a relationship to Andrea Dazzi's program for the 1513 carnival. Either Vasari was mistaken in his identification of the canto performed, or my inferences are incorrect, or there were two canzone of the Diamante performed in 1513: Antonio Alamanni's *Volon gli anni e' mesi e l'ore* and Giovan Battista di Cristofano Ottonaio's *Quel primo eterno amor.*

No matter which canzone of the Diamante was sung in 1513, an active engagement with an important element in Florentine musical culture on the part of distinguished artistic, literary, and political figures—such as Antonfrancesco degli Albizzi, Giovanni Corsi, Piero Martelli, Giuliano, Giulio, and Lorenzo de' Medici, Jacopo Nardi, Filippo de' Nerli, Alessandro de' Pazzi, Jacopo Pontormo, Giovanni and Palla Rucellai, Andrea del Sarto, and Paolo Vettori—is demonstrated.[78] In this instance, the commissioning and performance by the companies' members of Nardi's and Alamanni's *canti carnascialeschi Colui che dà le leggi alla natura*[79] and perhaps *Volon gli anni e' mesi e l'ore,*[80] performed on 6 and 8 February 1513, is documented by historical references.

One period historian furnished an informative statement on the function of the canti carnascialeschi performed in 1513: "each of the two said *trionfi* had a *canto* appropriate to the program of the *trionfi;* they went singing to the homes of those who had had them made, or their friends."[81] Actually, the statement may document two distinct, contrasting instances of music-making on the occasion of the 1513 carnival. One reference suggests that there were the more or less formal performances of the canti "appropriate to the program of the *trionfi,*" which one imagines occurring during the procession of the floats, perhaps executed by quasi-professional singers seated on the last float in the succession, who may have been heralds of the Signoria.[82]

The other reference—"they went singing to the homes of those who had had [the trionfi] made, or their friends"—may be to another kind of music-making altogether, by the young aristocrats of the Companies of the Broncone and Diamante, who made their way to "the homes of those who had had [the trionfi] made, or their friends."

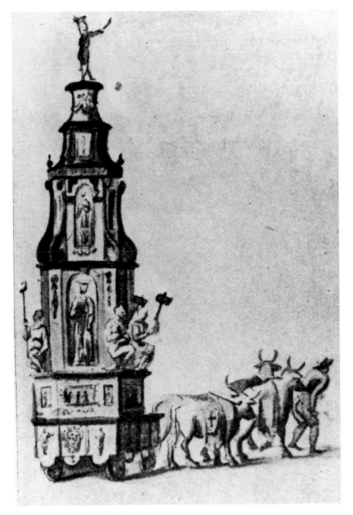

Figure 3.6. There were more or less formal performances of the canti "appropriate to the program of the *trionfi*," which one imagines occurring during the procession of the floats, perhaps executed by quasi-professional singers seated on the last float in the succession, who may have been heralds of the Signoria.

In the first instance, the pieces performed were those printed here, the homorhythmic settings of Antonio Alamanni's, Jacopo Nardi's, and Giovan Battista di Cristofano Ottonaio's explanatory canti. In the second, the pieces sung on the way "to the homes of those who had had [the trionfi] made" were presumably Tuscan popular songs, no longer extant, their texts replete with suggestive sexual references.

These texts suggest again the mixed character of the musical and cultural experiences of members of the Broncone and Diamante. Although they do not qualify as expressions of the very highest literary standard, Alamanni's and Nardi's canti invoke metaphoric images and deploy established, venerable literary topoi, princi-

Canzone per andare in mafchera p carnefciale facte da piu perfone.

Figure 3.7. "[T]hey went singing to the homes of those who had had [the trionfi] made, or their friends."

Example 13. The homorhythmic setting of Jacopo Nardi's explanatory canto.

pally the topos of the return of a golden age. On the other hand, the songs sung when the members of the companies "went singing to the homes of those who had had [the trionfi] made" exemplified the more popular, sexually suggestive practices of the carnivalesque as expressed in the Florentine tradition. In that respect, the activities of the Broncone and Diamante—although their membership rosters show considerable overlap with those of the Rucellai group and the Sacred Academy—are more reminiscent of the activities of the Cazzuola, which suggests once more that sharp distinctions are unsustainable. The interpenetration of carnivalesque practices with the more serious, academically consequential programs of the Rucellai group and the Sacred Academy further recalls Nerli's reference to the mascherate of the Rucellai group, which also problematizes any disposition toward clear discriminations. The cultural circumstances that witnessed and sustained the emergence and decisive establishment of any number of cultural phenomena and practices in early Cinquecento Florence—the madrigal among them—were

Example 13 (continued). The homorhythmic setting of Jacopo Nardi's explanatory canto.

Example 13 (continued). The homorhythmic setting of Jacopo Nardi's explanatory canto.

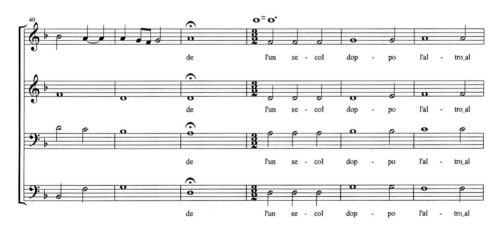

Example 13 (continued). The homorhythmic setting of Jacopo Nardi's explanatory canto.

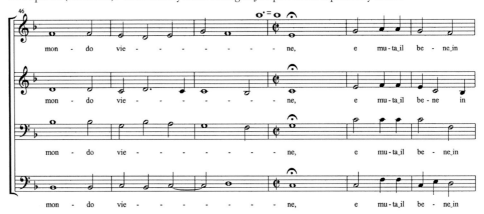

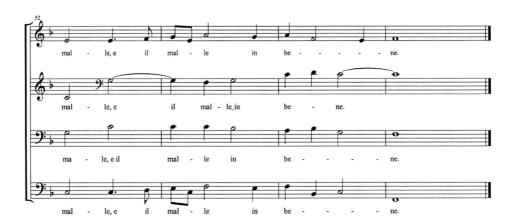

mixed, divergent, and ramified; they might be characterized as happily confused. Such heterogeneity in cultural stimuli would have been an important element in the artistic development of the early madrigalists.

For composers of canti carnascialeschi, the challenge was to achieve a balance between two contrasting, even incompatible, objectives. Canti carnascialeschi had a crucial explanatory function, which demanded that the text be intelligible. Normal contrapuntal devices—staggered, imitative entries of the different voices, poly-rhythms—were therefore customarily avoided, and the resulting rhythmic design, prevailingly homorhythmic, was intended to ensure and enhance the intelligibility of the text. Homorhythms in turn invite full triads in order to enrich the harmony, and ordinarily the four voices in the complement sing throughout.

On the other hand, any composer with aspirations to artistry would also have sought to invest these works with more complex musical characteristics that would engage and sustain the listeners' interest, and his own. Independent rhythms exist in the different

Example 14. The homorhythmic setting of Antonio Alamanni's explanatory canto.

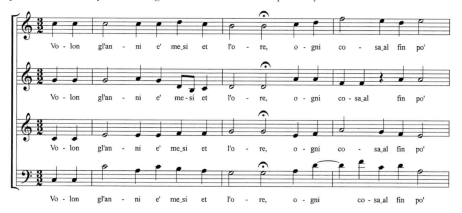

vocal lines, which thus serve to distinguish them from one another by means of the rhythmic design, but they typically occur at cadences, which mark the conclusion of text phrases, as at measures 14–15, 24–25, and elsewhere in the *Canzona del bronchone* (Example 13); variety in the rhythmic design is instead a function of metrical shifts, from duple to triple meter and back again, as at measures 43 and 49. Textural variety is achieved by means of an occasional reduction in the size of the vocal complement, which also entails intermittent inflections of imitative writing rather than full-scale imitative procedures involving the entire complement, as in measure 31 of the *Canzona del bronchone* or measures 32 and 36 of *Quel primo eterno amore* (Example 15). All of these characteristics typify the three examples given here, which suggests that at the Florentine Carnival of 1513, the musical elements were designed in accordance with time-honored compositional convention.

Example 14 (continued). The homorhythmic setting of Antonio Alamanni's explanatory canto.

Example 14 (continued). The homorhythmic setting of Antonio Alamanni's explanatory canto.

Example 14 (continued). The homorhythmic setting of Antonio Alamanni's explanatory canto.

Nardi's conversance with the canto carnascialesco and festival-music tradition is attested beyond his participation in the 1513 carnival festivities. He is said by Vasari to have been responsible for the "Triumph of Camillus" staged for the 1514 Feast of S. Giovanni,[83] the artistic elements of which included the singing of an explanatory canto. Although the music for this canto is no longer extant, its text survives, and it is like the canti for the 1513 carnival in that it elucidates the event's political meaning,[84] which suggests that it received a simple, homorhythmic setting in order to render the text and its meaning intelligible to its Florentine audience. Filippo de' Nerli and Filippo Strozzi are identified as festaiuoli for the 1514 San Giovanni festivities,[85] documenting a conversance with the festival-music tradition on the part of those two members of the Florentine cultural elite.

Nardi also authored the texts of the explanatory canti for several other festive occasions. Among the artistic elements of the festivities to celebrate Lorenzo di Piero de' Medici's conquest of Urbino in 1516 was "a song that explained the allegory [uno canto, che dichiarava la similitudine]"[86] represented by the succession of floats, which must be identical with the "Canzona di iacopo nardij" contained in a contemporary source.[87] And in 1518, on the occasion of Lorenzo's wedding to Madeleine de la Tour d'Auvergne, "there were three triumphs, Venus, Mars, and Minerva, with sublime songs [vennero tre trionfi, Venere, Marte e Minerva, con cãti divini],"[88] which must have included Nardi's *Canzona sopra il Carro delle tre Dee*.[89] These works are much closer in time to the date of composition of the earliest madrigals.

When Verdelot first began to spend time with the kind of men who constituted the membership of the Companies of the Broncone and Diamante, he would presumably have become familiar with the kind of music—particularly, the kind of Italian secular music—with which they were actively engaged. In this instance, the historical record is indisputable: such men commissioned and supported the performance of compositions in the venerable Florentine tradition of the canto carnascialesco.

Example 15. The homorhythmic setting of Giovan Battista di Cristofano Ottonaio's explanatory canto.

What is the significance of this historical evidence for the origins of the madrigal? The Cazzuola is said by Vasari to have performed Machiavelli's *Mandragola* and *La Clizia*, and the 1525 performance of *La Clizia*—though not demonstrably by the Cazzuola—featured the singing of Machiavelli's canzone. If the earlier performance of *Mandragola* by the Cazzuola had included intermedii, might not the members of the Cazzuola have turned to the one musical genre with which they are known to have been actively involved—the canto carnascialesco—for a model of the kind of stylistic language appropriate for the purposes at issue? We know

Example 15 (continued). The homorhythmic setting of Giovan Battista di Cristofano Ottonaio's explanatory canto.

that the Cazzuola's members supported the performance of compositions in the carnival-song tradition; we can therefore assume that they had an appreciation for the virtues of homorhythmic text setting, as appropriate to the function of providing intelligible commentary on the action of the play. If the theatrical performances attested by Vasari included musical intermedii, the Cazzuola might well have adopted the stylistic features of the carnival song for the intermedii, given their function. In turn, when *La Clizia* was performed in 1525, there would already have been an established, proximate tradition as to how one should set the texts of intermedii, a tradition to which Verdelot could turn for inspiration.

Example 15 (continued). The homorhythmic setting of Giovan Battista di Cristofano Ottonaio's explanatory canto.

Further, Rucellai-group member Jacopo Nardi composed the texts of a number of explanatory canti for Medici festivals. He was conversant, therefore, with the musical characteristics of the genre. Niccolò Machiavelli, his colleague in the Rucellai group, thus had a model in Nardi's activity—a precedent—for his own activity as the author of texts serving an explanatory function. Nardi's canti texts explained the meaning of a succession of floats, whereas Machiavelli's canzoni commented on the action of his own comedies. The functions and purposes are obviously related, and in collaborating with Verdelot on his theatrical productions, Machiavelli may have had the example of Nardi's poetic efforts, and their attendant homorhythmic musical dress, in mind. This is an argument on grounds of instrumentality: the dis-

Example 15 (continued). The homorhythmic setting of Giovan Battista di Cristofano Ottonaio's explanatory canto.

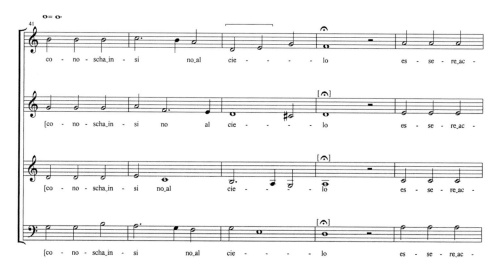

tinctive stylistic characteristics of the carnival song and the early madrigal—their use of a kind of "choral recitative," to borrow Pirrotta's words—derive from the fact that both genres were expressly deployed by those who commissioned their composition as instruments designed to provide intelligible commentary on the larger artistic event of which they were a part:

> The necessity, as strongly perceived by both organizers and commentators, "that the words be delivered with such clarity that they be perfectly intelligible in the theatre, right down to the smallest syllable," largely determines the musical style of ... [Andrea Gabrieli's 1585] *Chori* [*in musica composti sopra li chori della tragedia di Edippo Tiranno*]. Precluding as it does all possibility of contrapuntal effects, this require-

Example 15 (continued). The homorhythmic setting of Giovan Battista di Cristofano Ottonaio's explanatory canto.

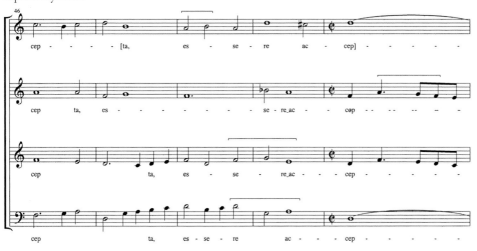

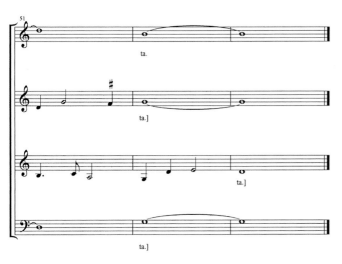

ment may have been one of the reasons for Filippo de Monte's nonacceptance of the commission. . . . In the *Chori*, homophony is supreme. Each syllable corresponds to a single note; syllables and notes are delivered simultaneously in all voices, with the exception of the bass which occasionally anticipates the opening syllable of a phrase. The result is an ample choral recitative, organized in a series of individual sections of varying length, which correspond to the syntactic articulations of the text; timbre and sonority are varied by changing the number and combination of voices from section to section, as also by a diversified rhythmic articulation and intensity of harmonic interplay, frequently characterized by bold modulations involving sudden and highly effective chromaticisms. . . . The *Chori* differ from the rest of Gabrieli's output by virtue of their strictly vertical, harmonic orientation and syllabic approach to word setting: a deliberate attempt to obtain a recitative-like effect.[90]

Both genres, Florentine carnival song and early madrigal, also employ the technique of a direct address to the audience, alternating (at irregular intervals) with singers' references to themselves. Both genres thus aim to engage the audience, to connect its members with the performers. The shared technique of apostrophe is coupled, in both genres, with a strategy of commenting on foregoing action, in the style of a Greek chorus, complete with very specific reference to individual events in the action that is receiving comment. The text of the *Canzona . . . della Chazuola* is as follows:

> [I]t pains us to have left behind the great memory of past days, where virtue and love grew ever greater, because all would like to perpetuate themselves. But because it is so exalted by Heaven, each wishes to love it, in order to live forever through such splendid progeny. However, *you*, charming children—whose experience is not yet as deep as ours—run toward such peace, in order to make Florence's triumph great once more; and you and we—whom it displeases to leave her—permit the favor, because she will still love everyone. Divine city: honor her who has been your well-being, and is, and will be! Reflect now upon what you are, and what you were without her virtue![91]

The text of the *Canzona del bronchone* is as follows:

> [I]n your age the world comes to rusted iron. But now, being at the lowest point, the happy age returns and is reborn from the trunk of the green laurel, like the phoenix. So, too, a Golden Age is spawned from that of iron. Because heaven today renews nature, and remakes the old era into a youthful age, and that of iron falls (which, rusted, discovers itself to be useless), it benefits us and those who existed during the Age of Gold that—that age returning—these virtues likewise return to remain with you, so that you are made to become similar to us. After the rain the serene sky returns. Rejoice, Florence, and be happy evermore, because you will see these virtues, which had departed from their earthly habitat, flourish within your breast: cheerful truth (once lost), peace, and justice, and this and that, summon you together and celebrate you. Rejoice, because heaven honors you greatly, under the favor of the most benign star! Happy and beautiful city—as of yet none more so than you on earth—behold that the hour has come when you will be blessed and honored among all others, so that, in order to celebrate you for your excellence, simply your name—divine Florence—will suffice.[92]

The text of Machiavelli's *canzona* before the prologue to *La Clizia* is sung by an ensemble of a nymph and three shepherds:

> Happy and cheerful, we, with our singing, shall join company with this, your undertaking, with such sweet harmony as you have never heard before.[93]

In all three instances, the singers thus address the audience directly, and may comment—with precious self-referentiality—not only on the independent action of which their performance is a part (the procession of floats, for example), but also on their very performance itself. This, too, is a feature of the early madrigal that may reveal the influence of a technique associated with the canto carnascialesco.

There are further correspondences between the carnival song and the earliest madrigals with respect to performance context, correspondences that may also explain the distinctive homorhythmic style of each. Both genres were performed out-of-doors: in the streets and *piazze* of Florence in the case of Giovan Battista di Cristofano Ottonaio's and Jacopo Nardi's canti carnascialeschi, in Jacopo Falconetti's garden in the case of Philippe Verdelot's canzone for Niccolò Machiavelli's *La Clizia.* The somewhat greater challenges with respect to ensemble control attendant on an outdoor performance—not to mention the inevitable intrusion of extraneous noise—emphasize the need for a simpler, starker musical design in which the four voices essentially declaim the same text simultaneously in block-chord fashion. The delicate and transparent polyrhythms of imitative polyphony would have been more difficult for performers to execute, and the audience to appreciate, when in competition with background conversation or other such sounds.[94]

Moreover, both carnival songs and the earliest madrigals were performed in contexts involving some modest degree of movement, some controlled kinetic or dynamic element. Carnival songs, of course, were performed during the procession of floats, although one imagines a moment or moments when the float bearing the singers paused temporarily for them to execute the canto under more favorable performance circumstances; similarly, the earliest precisely datable madrigals—those intended as intermedii between the acts of Machiavelli's comedies—were delivered by a small chorus of four soloists who moved quickly onto the "stage" after each act, paused momentarily, performed the madrigal, then withdrew. The movement preceding and following the performance—and the temporal constraints imposed by the frame in which the performances figured—also indicate the need for a simpler musical design in the early madrigal than would have been required under different, more favorable performance circumstances (circumstances that did not entail movement before and after the performance), when performance conditions were more controlled and less susceptible to unanticipated variables.

The historical evidence assembled on the Rucellai garden (see Chapter 1) prompts one final speculation. The courtesan and singer Barbara Salutati is known to have been engaged for the 1526 performance of *Mandragola* planned for Faenza by Rucellai group members Ludovico Alamanni and Niccolò Machiavelli. The courtesan and singer La Nannina Zinzera is said by Doni to have sung in the garden of the Rucellai, and she may have joined with others (perhaps Layolle, Pisano, and Verdelot) in the singing of villotte and related genres. There are thus parallels and precedents in performance practice and personnel, a kind of continuum in conditions of performance and performance context and setting: from the courtesan La Nannina Zinzera's performances in the Rucellai garden (if they indeed took place), to the (Cazzuola's?) 1525 performance of *La Clizia* in Falconetti's garden, to the courtesan Barbara Salutati's projected 1526 performance of the *Mandragola*

Example 16. Verdelot's setting of Machiavelli's text for the canzone before the Prologue to *La Clizia*. In collaborating with Verdelot on his theatrical productions, Machiavelli may have had the example of Nardi's poetic efforts, and their attendant homorhythmic musical dress, in mind.

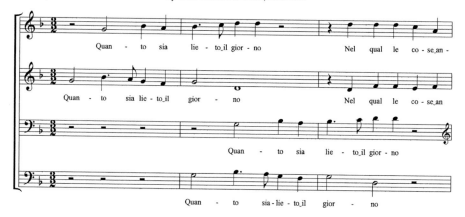

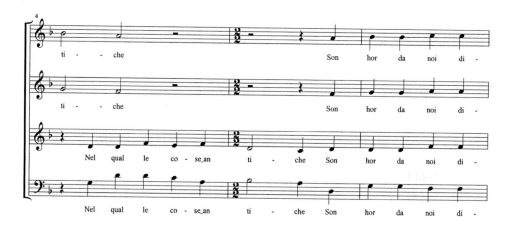

intermedii. Those responsible for the later performances might have looked to the earlier ones for models of how one cast such performances, where they might be staged, and what the musical element might comprise. The continuum in elements of performance practice might therefore be said to parallel a similar continuum of musical styles from the villotta and canto carnascialesco to the madrigal.

The compositional practices of one early madrigalist are inconsistent with evidence of his musical experiences and his conversance with the musical practices of the Company of the Cazzuola and the Rucellai group. Bernardo Pisano appears to have been an intimate of several members of the Rucellai group and might therefore have been witness to the solo singing and performances of villotte and other such works that may have taken place in the Rucellai garden. He also appears to

Example 16 (continued). Verdelot's setting of Machiavelli's text for the canzone before the Prologue to *La Clizia*. In collaborating with Verdelot on his theatrical productions, Machiavelli may have had the example of Nardi's poetic efforts, and their attendant homorhythmic musical dress, in mind.

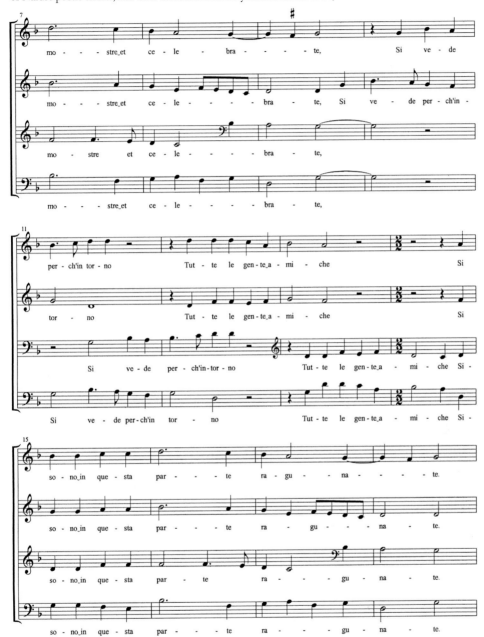

Example 16 (continued). Verdelot's setting of Machiavelli's text for the canzone before the Prologue to *La Clizia*. In collaborating with Verdelot on his theatrical productions, Machiavelli may have had the example of Nardi's poetic efforts, and their attendant homorhythmic musical dress, in mind.

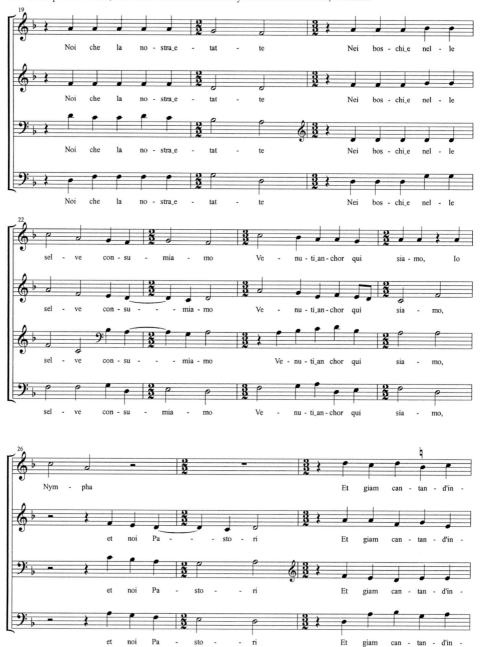

Example 16 (continued). Verdelot's setting of Machiavelli's text for the canzone before the Prologue to *La Clizia*. In collaborating with Verdelot on his theatrical productions, Machiavelli may have had the example of Nardi's poetic efforts, and their attendant homorhythmic musical dress, in mind.

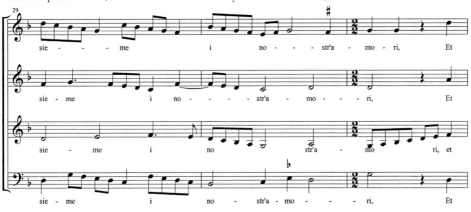

have been a member of the Cazzuola, which suggests that he would have been conversant with the carnival-song tradition. Furthermore, he was a laudese and therefore a practitioner of the musical style of the carnival song's sacred relative. However, Pisano's madrigals—if they may be called by that name—are densely imitative, unlike Layolle's and Verdelot's earliest experiments in the new genre, and his contributions to the genre in that sense may not be representative of the practices and values of the Rucellai group and the Company of the Cazzuola. In this respect, Professors Fenlon and Haar were correct when they characterized Pisano's madrigals as only intermittently suggestive of the style that Verdelot was to make canonic.[95]

That said, a tendency to dismiss Pisano's (and Elzear Genet's and Sebastiano Festa's) protomadrigals too quickly is unjustified. Simply because there is little relationship between the canonic style of the new genre as exemplified by Verdelot's madrigals and the protomadrigals of Pisano, Genet, and Festa does not warrant such a dismissal, which is tantamount to committing a different kind of sin of cultural evolutionism, one similar to Alfred Einstein's, one that privileges only those moments in a dynamic historical process that produce outcomes of particular interest to us and relegates to the margins other moments that fail to produce those outcomes. When Pisano, Genet, and Festa were composing their protomadrigals, neither they nor their contemporaries could have known that their experiments would fail to produce the canonic style. Their compositions ought to be cherished as interesting documents of the transitional phase, instances of the yeasty experimentation that ultimately yielded the canonic style of the 1520s.[96]

Medici *Mecenatismo* and the Early Madrigal

A PRINCIPAL objective of this study is to describe the patronage practices and musical activities of the Florentine associations that served as venues for the compositional experiments of the earliest madrigalists, but there is another important objective. The conclusion that emerges from the historical evidence is that the Medici played a much more important role in those practices and activities than current scholarly opinion assumes.[1]

The few available documents attesting Strozzi patronage of the early madrigalists date from well after the emergence of the new genre, whereas the references attesting Medici patronage assembled here either precede or are contemporary with the earliest precisely datable madrigals and with the professional activities of the earliest madrigals. By the 1530s—the time of the references to Strozzi patronage—the madrigal had already emerged.

Many of the members of the various informal associations were Medici, more, indeed, than were Strozzi. And the political allegiances of many members of the Florentine cultural elite with whom Verdelot must have been associated cannot be explained by the neat, dyadic pro- and anti-Medicean interpretive scheme underlying current musicological opinion. Several members of the Rucellai group were unquestionably loyal Mediceans. The available references convey a sense of the intimate, intricate relationship to the Medici of the foremost Florentine political and intellectual figures of the early Cinquecento, the members of the institutions that are the subject of this study.

Cerretani remarked that Giovanni Corsi, Francesco da Diacceto, Piero Martelli, and the sons of Bernardo Rucellai were dissatisfied with the moderate constitutional reforms of early September 1512, which carefully circumscribed the authority of the Medici.[2] More powerful still is the evidence that Cosimino di Cosimo di Bernardo, Giovanni di Bernardo, and Palla di Bernardo Rucellai were among those who accompanied Giuliano di Lorenzo de' Medici in his seizure of Palazzo Vecchio on 16 September 1512.[3]

Bartolomeo Fonzio addressed laudatory verses to Lorenzo il Magnifico, through whom, he said, "the age of Saturn now at last arises . . . / Now rise the arts, now poets live in honour."[4] Bernardo Rucellai, Lorenzo il Magnifico's brother-in-law and a member of the 1512 *balìa* that effected the return of the Medici, often requested

tax concessions from Lorenzo;[5] Bernardo's son Palla remained closely associated with the Medici throughout the transition to the *principato*.[6] Giovanni Corsi was a member of the same balìa of 1512, as was Francesco Vettori, who for many years was a loyal agent of the House of Medici. Fabrizio Colonna is depicted by Machiavelli in the *Arte della guerra* as having been invited by Cosimino to a banquet in his gardens on the occasion of Colonna's visit to Florence, which Colonna had undertaken expressly in order to visit Lorenzo di Piero de' Medici, Duke of Urbino.[7] Janus Lascaris was in the employ of both Lorenzo il Magnifico and his son, Pope Leo X. Alessandro de' Pazzi, Lorenzo il Magnifico's nephew,[8] authored a *Discorso al cardinale Giulio de' Medici*[9] and was said by Jacopo Nardi to have written "in praise of the liberality and high intellect of the . . . cardinal."[10] Filippo de' Nerli was loyal to the Medici throughout the transition from republic to duchy[11] and on at least one occasion was festaiuolo for an important Medici festival.[12] One contemporary historian, Giovanni Cambi, remarked on the close relationship that Cardinal Giulio had had with those involved in the 1522 congiura.[13]

Others probably had ambivalent feelings about the Medici. Donato Giannotti, an interlocutor in one of Brucioli's dialogs, authored verse in honor of Lorenzo the Younger.[14] Jacopo Nardi—ordinarily considered an ardent republican—nonetheless wrote the overtly propagandistic texts of the explanatory canti for a number of Medici festivals during the second decade of the sixteenth century, which are replete with traditional Medicean imagery, and he may have authored the program for Leo X's celebrated Florentine entrata of 1515.[15] Machiavelli dedicated his book on *The Prince* first to Giuliano di Lorenzo and then to Lorenzo di Piero di Lorenzo de' Medici, "wrote his *Florentine Histories* at the behest of the Cardinal [Giulio de' Medici]," was among those who "composed . . . orations in most singular praise of the person of the Cardinal,"[16] and incorporated conciliatory references to Giulio (then Pope Clement VII) into the text of one of his canzone for the projected 1526 performance of *Mandragola*. According to Nerli, Antonfrancesco degli Albizzi and the sons of Bernardo Rucellai were all opponents of Piero Soderini, the gonfaloniere a vita in the years immediately preceding the 1512 restoration of the Medici.[17]

To be sure, some of the men in the latter category were political realists who recognized that—whatever preferences they may have had after 1512 as to the form of the Florentine government—the Medici had been effectively restored, so that their own personal political fortunes were in some way linked with those of the city's first citizens. "[N]one of them found any difficulty accommodating themselves to the régime . . . imposed on them . . . , particularly after patriotic enthusiasm over the election of Giovanni de' Medici as Pope Leo X erased the memory of what had been, as a matter of fact, a *coup d'état*."[18] To some degree certain of these men probably experienced the kind of anxiety resulting from internal conflict over incompatible emotions: a sense of dependence on the Medici for their patronage[19]

and simultaneously a resentment of them because of that dependence and also because they may have been republicans at heart.

Even some of those ordinarily considered the most virulent of anti-Mediceans were at one time intimates—or would-be intimates—of the Medici. The historians who speak with greatest authority on the matter of the political sensibilities of members of the Rucellai group virtually agree. Von Albertini, one of the most informed students of this entire period in Florentine history, makes the important point that the members of the Rucellai group were originally neither republicans nor Savonarolans but Ottimati, with aristocratic objectives; the tendency in the current musicological literature to characterize them as otherwise is inconsistent with more informed scholarly opinion. Machiavelli's great nineteenth-century biographer Pasquale Villari said of Luigi Alamanni and Buondelmonti that "they … were friends of the Medici, like almost all of those who frequented the garden of the Rucellai," and cited a letter that "proves that the Alamanni were … great friends of the Medici." As Kristeller wrote, "that the meetings were discontinued as a result of [the 1522 congiura] is probable, but not as certain as most historians believe. At any rate, neither the Rucellai themselves, nor a majority of the members of the circle, belonged to the party opposed to the Medici. On the contrary, we know definitely that in the period prior to 1512, the same Rucellai Gardens were the center of a political fronde that was opposed to the government of Piero Soderini and favored the return of the Medici."[20] Moreover, although Batista della Palla, Luigi Alamanni, and Zanobi Buondelmonti are notorious for their role in the abortive 1522 *congiura* against Cardinal Giulio de' Medici, della Palla had nonetheless aspired to an ecclesiastical appointment (as Nardi reported), Alamanni had sought employment in the Medici political establishment (as Alamanni's own correspondence suggests),[21] and Buondelmonti was among those who accepted Cardinal Giulio's invitation of 1521 and 1522 to advance proposals for constitutional reform.[22]

The archival references cited in Chapter 1 as evidence for the organization of mascherate by several members of the Rucellai group suggest that among those who were opposed to the gonfaloniere a vita—such as the Medici—were two of the Strozzi, including the Filippo who subsequently became an opponent of the Medici regime. Such evidence, like much other evidence cited here, suggests once again that the intricate web of political relationships, alliances, and animosities was vastly more complicated than has often been assumed and that the membership of the Rucellai group cannot be characterized simply as republican, Savonarolan, or anti-Medicean. Above all, as von Albertini argued, its members were aristocrats, anxious to reassert their aristocratic prerogatives and wrest authority from the gonfaloniere; in this respect, their political objectives were rather naturally aligned with those of the Medici. This coalescence of political objectives existed within a context

overlaid with a complex network of personal relationships: the many instances of intermarriage of the Medici on the one hand and the Rucellai and the Strozzi on the other.

Under no circumstances did membership in the Rucellai group necessarily imply an anti-Medicean posture. By extension, the likelihood that Verdelot associated with members of the Rucellai group cannot be taken as evidence that the cultural circles where the madrigal originated were republican or anti-Medicean, or that the cultural influence of the Medici in those circles was inconsequential.[23] To argue thus is to argue too extravagantly on the basis of too-little, ambiguous evidence. Moreover, in the early 1520s, at precisely the time the republican elements in the membership of the Rucellai group were presumably most active, Verdelot was in Cardinal Giulio's favor, which suggests that it is unlikely that he was aligned or identified with those elements. In May of 1521, the year immediately preceding the possible closing of the gardens as the result of the congiura against Cardinal Giulio, Verdelot's name is mentioned in an important letter from Niccolò de' Pitti to Cardinal Giulio; this suggests that Verdelot was in some way closely associated with Giulio. And in 1523 and early 1524, after the possible closing of the gardens, Verdelot absented himself from the Florentine ecclesiastical institutions where he was employed so that he might travel to Rome on the occasion of Giulio's election to the papacy.[24] Had Verdelot been aligned with the 1522 republican conspirators against Cardinal Giulio, he likely would not have maintained such relations with Giulio. Had he been implicated in the 1522 congiura in any way (and the records of the judicial proceedings are extant), his appointment as chapel master would be scarcely conceivable, especially since Cardinal Giulio's "volontà" was critical in such appointments;[25] Verdelot's visiting Giulio in Rome shortly after his election to the papacy would also have been unlikely. In short, the argument that Verdelot's presumed association with the Rucellai group suggests an anti-Medicean posture is tenuous.

The sorts of political alliances characteristic of the membership of the Rucellai group were, if anything, even truer of the memberships of the other companies and societies. Medici Sacred Academy member Ludovico di Piero Alamanni authored an important political treatise of 1516 in which he flattered Lorenzo the Younger with an elaborate metaphor comparing him to Camillus, the second founder of Rome;[26] contributed to the anthology *Lauretum,* probably published in 1518 at the time of Lorenzo's wedding; and collaborated with Machiavelli on the projected 1526 performance of *Mandragola,* with its conciliatory gesture toward Clement VII. In 1518, at age twenty-four, Alamanni had been made ambassador to Milan at Lorenzo the Younger's behest.[27] A conversance with music on the part of both Ludovico and his father, Piero, an intimate of Lorenzo il Magnifico, is documented.[28]

Academy member Jacopo Modesti was one of the Medici family's trusted agents and on Lorenzo the Younger's instructions was named to a government office in

1514.[29] Roberto Acciaiuoli became a member of one of the principal government magistracies—the *Otto di Pratica*—upon the final restoration of the Medici to Florence in 1530;[30] in addition, he (along with Francesco Vettori) was among those invited by Clement VII in early 1532 to offer an opinion concerning the final resolution of the constitutional status of the city of Florence.[31] Archival references document that former Sacred Academy members Girolamo Benivieni and Giovanni Corsi, former Diamante company member Zanobi Acciaiuoli, and other members of the various societies all made requests of Pope Clement after the 1530 restoration and in some instances were the beneficiaries of papal munificence; in an April 1531 letter to papal *familiare* Bartolomeo Lanfredini, Corsi expressed thanks for having received "beneficij"; and in a October 1530 letter, Filippo Strozzi instructed Francesco Vettori to "tell Roberto Acciaiuoli that I have spoken of his affairs, and the pope is determined to oblige him as soon as possible, and he is displeased that it was settled some months ago without his knowledge."[32] Bartolomeo Cerretani, another member of the Sacred Academy, "owed his family fortune to Lorenzo [il Magnifico]'s patronage of his father."[33]

There are other references suggesting that various members of the academies and companies were intimates of the House of Medici. According to Nerli, Diamante company members Paolo Vettori and Bartolomeo Valori—like Antonfrancesco degli Albizzi and the sons of Bernardo Rucellai—were opponents of the gonfaloniere a vita Soderini.[34] Indeed, Vettori's name appears on a September 1512 list of Medici amici that at minimum had been approved by Cardinal Giovanni de' Medici (then soon to become Leo X) and may even have been compiled by him.[35] And in letters to his cousin Giulio di Giuliano, Cardinal Giovanni especially recommended Albizzi and Vettori.[36] Vettori suggested overtly to Cardinal Giovanni de' Medici that, although the cardinal's ancestors had governed the Florentine state "more with skill than force, for you it is necessary to use more force than skill."[37] Valori, for his part, was one of the most ardent Mediceans, even throughout the period of the "Last Republic" of 1527–30; he, in fact, was head of the balìa of twelve members named by the *parlamento* of 20 August 1530 that effected the final Medici restoration, and in that role he "personified the real power in the city."[38] A similar fidelity to the Medici characterized the political sensibilities of Sacred Academy and Diamante member Palla Rucellai,[39] who was explicitly named as one of "gli Magnifici XII. Riformatori" in the April 1532 constitution that established the Medici principate, along with "Ruberto di Donato Acciaijoli," "Bartolommeo di Filippo Valori," and "Francesco di Piero Vettori."[40] After the decisive establishment of the principate, Acciaiuoli, Vettori, and others of the "XII. Riformatori" served Duke Alessandro de' Medici as friends and influential private advisors.[41] In the days immediately preceding the 1512 restoration of the Medici, Diamante member Giovanni Vespucci was a Medici informant; he was rewarded for his loy-

alty after the restoration, when he was made eligible for all offices.[42] Humfrey Butters has characterized Diamante member Giovanni Rucellai as one of "[t]hose most committed to the Medici cause."[43] Diamante member Antonio da Ricasoli and his brothers were freed of tax debts after the 1512 restoration.[44]

Many other references of this type could easily be assembled. These men constituted the membership of the most important private Florentine intellectual and convivial institutions of the second and third decades of the Cinquecento and as such may be said to be representative of the Florentine cultural and political elite, the kind of men for whom the earliest madrigalists must surely have composed their first madrigals. The documents cited here suggest how very many of them were intimates and dependents of the House of Medici.[45] This evidence alone ought to convey something of the risks in inferring too much about the importance of Strozzi patronage of the early madrigal from the limited number of references attesting their patronage practices and the attendant risks in minimizing the importance of the Medici.

With the exception of Layolle, the earliest madrigalists—when the conditions of their employment are precisely specified—are first found in Medici employ. The earliest unambiguous and unequivocal documentation concerning Costanzo Festa places him in Pope Leo's chapel in 1517.[46] The earliest unequivocal documentation concerning Verdelot places him in Florence in May of 1521, associated in some way with Cardinal Giulio de' Medici; he is subsequently appointed chapel master at the public ecclesiastical institutions, assuredly at Giulio's instance.[47] Though Arcadelt is found in Florence in 1534, the earliest known documentation clarifying his employment status places him in the household of Duke Alessandro de' Medici in 1535.[48] Vasari appears to suggest that Alessandro and Ippolito de' Medici and Cardinal Silvio Passerini of Cortona (the family's principal representative during the interregnum of 1521–23) were among the members of the audience on the occasion of the early 1525 performance of Machiavelli's comedy La Clizia at the home of Jacopo di Filippo Falconetti detto "il Fornaciaio" in Santa Maria in Versaia, outside the Porta S. Fr[ed]iano in the Florentine city walls, a performance that featured the singing of Verdelot's canzoni set to Machiavelli's texts. Vasari implies in his account that the artist who designed the stage sets for the performance, Aristotile da San Gallo, in some way enjoyed the favor of Cardinal Passerini and of Alessandro and Ippolito.[49] To suggest that the composer of the canzone that served as intermedii was also in some way associated with Cardinal Passerini and his Medici charges is not too extravagant a speculation. Earlier, during the second decade of the sixteenth century, documents suggest that Medici patrons were interested in polyphonic settings of Italian texts, which may form the background to the emergence of the madrigal in Medici circles.[50] And with respect to the matter of the earliest madrigalists' employment status, as recently as 1994 Pirrotta restated his

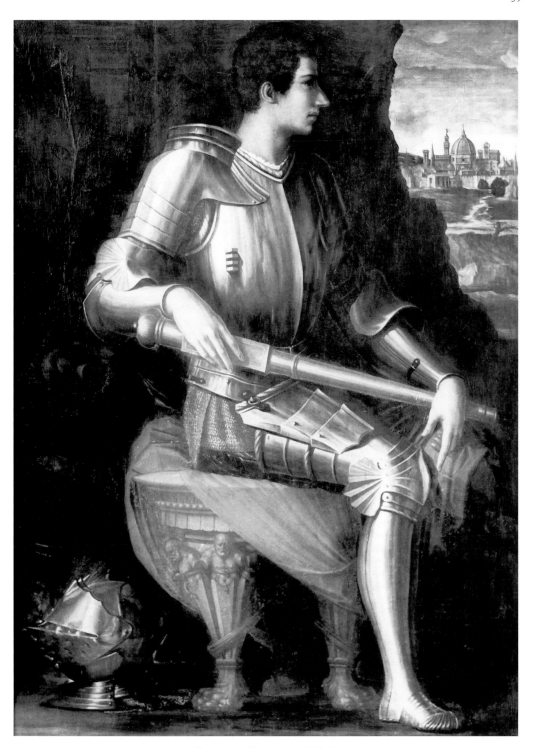

Figure 4.1. Alessandro de' Medici.

Figure 4.2. Ippolito de' Medici.

thesis about the importance of the Medici to the emergence of the madrigal: "the
transition from accompanied monody to the all-vocal, to some extent contrapuntal,
texture of the full-fledged madrigal . . . is represented by such men as Bernardo Pi-
sano, the two Festas, and Verdelot, whose names all point to a Florentine-Roman
milieu dominated by the tastes of members of the Medici family, among whom an
interest in polyphony, sacred and secular, had long been present."[51]

Moreover, "[m]ost of the poets of Verdelot's madrigals in the Newberry part-
books so far identified were either Florentines . . . or served Medici popes and
cardinals, like Tolomei, Trissino, Cassola, and Brevio."[52]

Professors Fenlon and Haar have correctly noted that there are few extant man-
uscript sources of the early madrigal that are demonstrably associated with the
Medici,[53] but there is always the possibility of losses. The Medici were exiled from
Florence in 1527, at the time of the sack of Rome, and although city officials man-

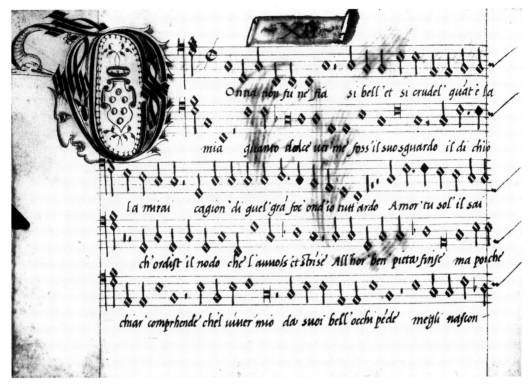

Figure 4.3. The manuscript Florence, Biblioteca Nazionale Centrale, Magl. XIX.122–25 contains evidence of Medicean associations.

aged to avoid a repetition of the wanton plundering of the Medici palace that had occurred on the occasion of their earlier exile in 1494,[54] there were nonetheless proceedings against some of the members of the family who remained in the city (and their adherents), and some confiscation of property.[55] Personal effects such as music manuscripts may have been among the items lost or confiscated after 1527, and in order to assess how reasonable such a speculation is, one has only to recall the example of an important musical document of the transitional period: the Cortona/Paris partbooks, clearly a Medici manuscript, whose bass partbook is lost and whose superius, altus, and tenor books are now divided between two European cities hundreds of miles apart.[56] There can easily have been other such sources of the proto- or early madrigal that have vanished without a trace, some of which might have been copied for or otherwise associated in some way with the Medici. To avoid advancing an argument based on the absence of evidence to the contrary is crucial. There were negative consequences of the Medici family's privileged status as Florence's first citizens and of their ever-increasing dominance of the city's political and cultural life: the feverish resentments that twice resulted in their exile and in the concomitant possibility of destruction or confiscation of their property,

Figure 4.4. The manuscript Florence, Biblioteca Nazionale Centrale, Magl. XIX.122–25 contains evidence of Medicean associations.

music books included. The Strozzi were more fortunate in that respect: their "lesser" status protected them and their possessions. The testimony of the documentary record must therefore be understood as incomplete. Moreover, the evidence of the surviving manuscript sources has not always been completely or accurately evaluated. To cite one example, the manuscript Florence, Biblioteca Nazionale Centrale, Magl. XIX.122–25 contains evidence of both republican and Medicean associations; the republican features[57] occur toward the beginning of the manuscript, and the Medicean ones toward the end.[58]

This evidence—and "a distinct break in copying . . . immediately before the . . . design incorporating the Medici rallying-cry"—has suggested to one scholar that "copying was well advanced by the time of Alessandro [de' Medici's] promotion [to Duke of Florence in 1532],"[59] and "that the books had been finished before this striking page was added, perhaps in response to the Medici restoration."[60] Further, presumably because of the seemingly mixed republican-Medicean associations of this manuscript, with respect to the possibility of Medici ownership "the case is not strong":[61] "one of the surprising features of the early Florentine sources of the madrigal is that while some of them were evidently copied for prominent local

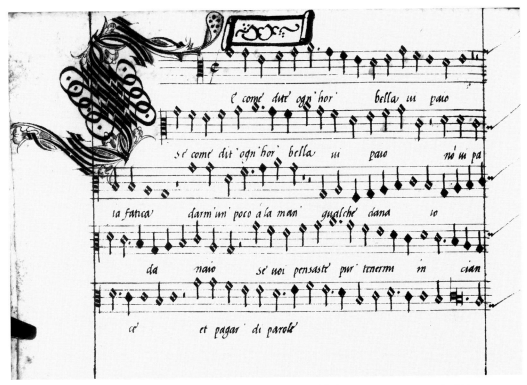

Figure 4.5. On fol. 21v of the cantus partbook (XIX.124) appears a tiny Medici stemma, incorporated within the calligraphic initial "S" of "Se come dite ogn'hor bella in paio," the incipit of Arcadelt's madrigal.

families such as the Strozzi, none of them can be indisputably associated with the Medici. One possible exception is" manuscript Florence Magl. XIX.122–25.[62] However, seemingly overlooked is that even within that section of the manuscript containing apparent evidence of republican associations, there is evidence of Medicean associations: on fol. 21v of the cantus partbook (XIX.124) appears a tiny Medici stemma, incorporated within the calligraphic initial "S" of "Se come dite ogn'hor bella in paio," the incipit of Arcadelt's madrigal.

Moreover, Alessandro's ambiguous title—expressly granted him by the 27 April 1532 constitution that established the Medici principate—was "Duca della Repubblica Fiorentina,"[63] which represents a poignant attempt to maintain the facade of republicanism, by then a fiction of almost a century's duration. Therefore, such apparent evidence of republican sensibilities as the initials "SPQF" need not be considered incompatible with evidence of pro-Medicean sensibilities, nor necessarily imply anything about various possible phases in the copying of the manuscript.[64] To put it differently: the seeming anomaly of a mixing of Medicean features with putatively republican features—which has prompted the argument that the evidence for Medici ownership of Magl. XIX.122–25 is equivocal—may be no anomaly

at all. When combined with the evidence of the Medici stemma appearing in the so-called republican section of the manuscript, the references to the "Senatus populusque florentinus" as interpreted here may actually be wholly consistent with a thesis of Medici ownership and also support a different argument concerning the internal chronology of the manuscript from that summarized above. The manuscript can more easily have been a Medici manuscript than has been suggested, and one need not equivocate quite so much on this point. At minimum, the evidence does not exclude that possibility to the extent argued.

There is other source evidence that suggests the importance of the Medici to the early madrigal. The manuscript Florence, Biblioteca Nazionale Centrale, Magl. XIX.164–67 looks to be an extremely important document of the transitional phase. It is replete with examples of madrigalian antecedents: protovillotte, canti carnascialeschi, polyphonic settings of French popular tunes (which are related to the contrapuntal villotta identified by Rubsamen as important to the origins of the madrigal), "new" chansons, works of Michele Pesenti and Sebastiano Festa, and so on.[65] There are repertorial relationships between 164–67 and the carnival song manuscript Banco rari 230; scribal relationships among 164–67, perhaps Banco rari 230, and Biblioteca del Conservatorio manuscript 2440; and codicological and repertorial relationships between 164–67 and Bologna Q21, one of the earliest sources for the madrigal to preserve a substantial repertory of works in the new genre; there is a codicological and repertorial continuum from the sources of the transitional phase (most notably manuscript 164–67) to Bologna Q21.

What relevance does the importance to madrigal origins of Florence 164–67 have to a thesis about the role of the Medici in the origins of the new genre?[66] Florence 164–67's most closely related source is the Cortona/Paris manuscript, which is demonstrably a Medici manuscript, full of internal and external evidence that it was copied for a Medici patron, specifically Cardinal Giulio de' Medici.[67] There are a great many works in common to the two manuscripts, including any number that fall into the categories identified by Rubsamen as important madrigalian source music. In addition, Cortona/Paris contains other works that, although not contained in Florence 164–67, are further examples of the kinds of genres figuring prominently in Rubsamen's thesis.[68]

The available evidence on the readings of works contained in both manuscripts suggests that the two sources descend from a common ancestor.[69] No other sources from this period are more closely related to one another than Florence 164–67 and Cortona/Paris, and although Florence 164–67 itself was not necessarily a Medici manuscript, there can be no question that it is extremely closely related to another manuscript that was. This relationship in turn suggests, although indirectly, that the Medici—and Cardinal Giulio specifically—were conversant with musical developments of the crucial transitional phase, had a taste for the musical styles of the

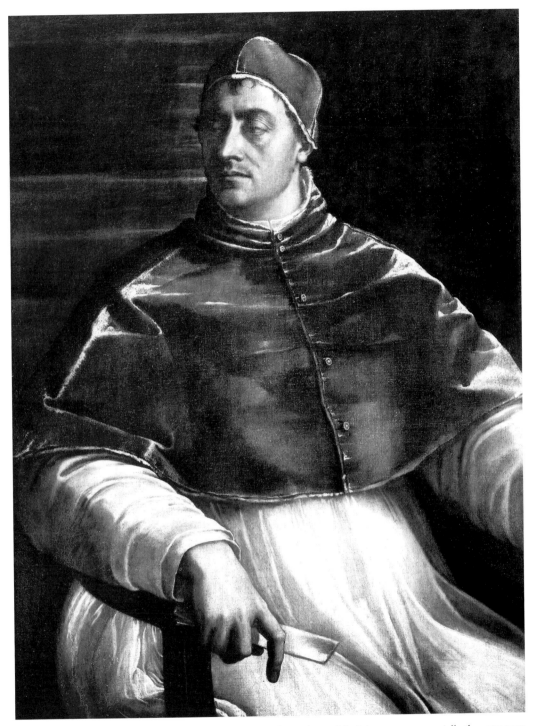

Figure 4.6. The musical sources show evidence of a close relationship to Medici patronage, especially the patronage, again, of Cardinal Giulio, identified long ago as the key patron in the emergence of the new genre.

genres identified here as madrigalian antecedents, and perhaps even played a role in supporting the compositional activity of composers who cultivated the transitional genres. This source evidence, though oblique, places the Medici exceedingly close to developments leading from madrigalian antecedents to the madrigal itself.

The importance of the Medici to madrigal origins, then, is evident. First, many representatives of the Florentine cultural elite—the men who frequented the Rucellai garden, attended meetings of the Medici Sacred Academy, and constituted the membership of the Companies of the Broncone, Cazzuola, and Diamante— were intimates or employees of the Medici or beneficiaries of their patronage, and in a number of cases were Medici themselves. They were the very individuals, or the kinds of individuals, for whom Layolle and Verdelot must surely have composed their first madrigals. Second, the earliest madrigalists, without exception, are first traced to Medici employ, including Verdelot, whose relationship to Cardinal Giulio can be described only as an employee/patron relationship, however indirect the evidence may be. Verdelot is first traced in Florence to Giulio's circles; he surely owed his appointment as chapel master to Giulio's "volontà"; he absented himself from Florence to visit Giulio, then Clement VII, shortly after the papal election. Finally, the musical sources, and especially such crucial documents of the transitional phase as Florence 164–67 and Cortona/Paris, which lead seamlessly to Bologna Q21, show evidence of a close relationship to Medici patronage, especially the patronage, again, of Cardinal Giulio, identified long ago by Nino Pirrotta as the key patron in the emergence of the new genre.[70]

Conclusion

THE diversity in profile of the principal institutions of patronage of early Cinquecento Florence and the corresponding diversity in styles of patronage and the nature of patronage activities permit a rough classification of the various traditions of mecenatismo according to their institutional settings. The public, corporate, ecclesiastical institutions—the cathedral, baptistery, and other conventual churches—were characterized by routinized protocols and practices that were developed and refined over many centuries; the sacred polyphonic musical repertories they generated are the perfect expression of their institutional characteristics and their established liturgies. The informal academies and companies that flourished simultaneously—apart from the obvious contrast with the ecclesiastical institutions with respect to the secular musical activities they sustained and the secular repertories they engendered—were considerably different in organization, membership, and institutional objectives and programs. Their more intimate scale, less formal organization, and less corporate and public character freed them to indulge in and support experimentation with new secular literary and musical forms; they were an ideal venue for the kind of abstract literary theorizing and low-risk assays in emerging genres that were so critical to the origins of the Renaissance madrigal. The contrast with the public ecclesiastical institutions with respect to their material infrastructure and secular organizational culture yielded a corresponding contrast in the stylistic profiles of the attendant musical repertories.

The institutional vacuum that existed in early sixteenth-century Florence—subsequent to the death of Lorenzo il Magnifico in 1492 and prior to the decisive establishment of the Medici ducato in the 1530s—created an opportunity for such associations. They were not only the modest secular counterpart to the more consequential contemporary institutions of ecclesiastical patronage but also successors to the vital Laurentian patronage practices of the late Quattrocento Medici household. (The term "Medici court" is not yet accurate in that historical and political context.) Lorenzo's descendants—his sons Cardinal Giovanni and Giuliano, his nephew Cardinal Giulio, his grandson Lorenzo the younger—were, for various reasons, inadequately positioned to revive the patronage practices that the elder Lorenzo, almost singlehandedly, had developed and perfected, although Giuliano, Giulio, and Lorenzo were all individual members of various early Cinquecento associations. The informal societies furnished the secular institutional infrastructure that had earlier been furnished by Lorenzo the Magnificent.

The importance of such institutions is precisely that they provided a venue for the kinds of fruitful interactions among the leading Florentine intellectuals of the time. In Malcolm Gladwell's formulation:

> We are inclined to think that genuine innovators are loners, that they do not need . . . social reinforcement. . . . But that's not how it works, whether it's television comedy or . . . the more exalted realms of art and . . . ideas. In his book "The Sociology of Philosophies," Randall Collins finds in all of known history only three major thinkers who appeared on the scene by themselves: . . . Everyone else who mattered was part of a movement, a school, a band of followers and disciples and mentors and friends who saw each other all the time and had long arguments over coffee and slept with one another's spouses. . . . Pissarro and Degas enrolled in the École des Beaux-Arts at the same time, then Pissarro met Monet and, later, Cézanne at the Académie Suisse, Manet met Degas at the Louvre, Monet befriended Renoir at Charles Gleyre's studio, and Renoir, in turn, met Pissarro and Cézanne and soon everyone was hanging out at the Café Guerboison on the Rue des Batignolles. . . . [I]nnovation is found in groups: . . . it tends to arise out of social interaction—conversation, validation, the intimacy of proximity, and the look in your listener's eye that tell you you're on to something. . . . People compete with each other and egg each other one, showboat and grandstand; . . . [Jenny] Uglow's book [*The Lunar Men*] reveals how simplistic our view of groups really is. We divide them into cults and clubs, and dismiss the former for their insularity and the latter for their banality. Yet if you can combine the best of those two states—the right kind of insularity with the right kind of homogeneity—you create an environment both safe enough and stimulating enough to make great thoughts possible.[1]

Gladwell's formulation, though obviously crafted for a different purpose altogether, nonetheless serves as a reasonable depiction of the kinds of stimulating, productive, and above all innovative exchanges afforded by the Rucellai group, the Sacred Academy of the Medici, and the Companies of the Cazzuola, Broncone, and Diamante.

More detailed conclusions to be drawn from the foregoing chapters fall into several discrete but overlapping categories. The first concerns the reconstructed memberships of the various informal institutions and what they reveal about the Florentine cultural elite of the early Cinquecento: their composition, the interrelationships among their members and the character of such interrelationships (personal, social, artistic, intellectual), and their cultural interests and programmatic objectives. The second concerns the relationship of members of the Florentine cultural elite to the earliest madrigalists: Layolle, Pisano, and Verdelot. The third concerns the musical experiences and tastes of members of the Florentine cultural elite and the influence they exercised on the early madrigalists and the style of their first essays in the new genre.

A comprehensive review of the available historical evidence for the origins of the Renaissance madrigal suggests the series of conclusions advanced in this book. The

data on which they rest are summarized and presented throughout the Conclusion and foregoing chapters, and citations of the relevant sources are as thorough as practicable, so that readers can satisfy themselves as to the quality and pertinence of the evidence cited. An independent reading of the historical evidence suggests that current theses on the origins of the Cinquecento madrigal may be incomplete, inadequate, or in some instances incorrect. Underlying historical data that support alternative, more compelling explanations for the origins of the madrigal suggest that those theses are susceptible to being supplemented or, in some respects, supplanted. Of course, there is evidence that may suggest different conclusions and has yielded contrasting theses from mine, but whether that evidence is as relevant and persuasive, whether it has been appropriately contextualized within the entire complex of available historical references or inadvertently lifted piecemeal out of its proper setting, and whether it is complete or fragmentary is open to question.

THE FLORENTINE CULTURAL ELITE

The extensive network of personal relationships among the members of the Florentine cultural elite is in itself notable and significant. Giovanni and Palla Rucellai —members of the Company of the Diamante—were sons of the Bernardo who laid out the Rucellai family garden and hosted the gatherings there during the first phase of activity, and they were uncles of the Cosimino who played host in the garden during the second phases. Palla was also a member of the Sacred Academy of the Medici, with which Giovanni clearly had associations as well.[2] The Alamanni brothers Ludovico and Luigi di Piero were members of the Rucellai group and the Sacred Academy. Their first cousin Antonio wrote the text of the explanatory canto for the 1513 Florentine carnival. Luigi di Tommaso, who frequented the Rucellai gardens, was a relative.[3] Francesco Vettori, member of the Rucellai group, and Paolo, member of the Diamante company, were brothers. Three members of the Diacceto family frequented the garden of the Rucellai; Francesco "il Pagonazzo" was a member of the Sacred Academy of the Medici as well. The Lorenzo di Filippo Strozzi (1482–1549) who frequented the Orti was the brother of the Sacred Academy's Alfonso (1467–1534). Lorenzo's wife, Lucrezia, was the daughter of Bernardo Rucellai and his wife, Nannina di Piero di Cosimo, the sister of Lorenzo il Magnifico. Lorenzo and Alfonso Strozzi's brother Filippo di Filippo was married to Clarice de' Medici, granddaughter of Lorenzo il Magnifico and niece of Pope Leo X (Giovanni de' Medici) and Giuliano de' Medici.[4] The Sacred Academy's Roberto Accaiuoli was related to the Diamante's Zanobi, though only very distantly.[5] Giuliano di Lorenzo de' Medici, member of the Company of the Cazzuola and head of the Company of the Diamante, and Diamante member Giulio di Giuliano were first cousins. Lorenzo di Piero di Lorenzo, head of the Company of the Broncone,

was Giuliano's nephew, Giulio's first cousin once removed, and the grandson of Lorenzo il Magnifico, who was the older brother of Giulio's father, Giuliano.

Further, the phenomenon of the large number of individuals in common to these various groups is interesting and crucially important, as illustrated and summarized in Table 6. The importance of the overlap in membership cannot be overstated: it afforded synergisms among the various groups, potentially productive interinstitutional exchanges of ideas, information about intellectual and musical practices, and programmatic activities. The contrasting and distinctive programs and cultural practices of these different groups—from the serious literary and political programs of the Rucellai group to the carnivalesque practices of the Company of the Cazzuola—were nonetheless susceptible to some degree of interaction, interpenetration, and amalgamation by virtue of the commonality of membership. Giovanni Corsi, Giovanni and Palla Rucellai, and Piero Martelli could readily export the musical practices of the Company of the Diamante to the Sacred Academy, thus informing and potentially recasting the institutional culture and musical practices of the academy through a conversance with the programmatic activities of the Diamante, and vice versa. Such a confrontation and interpenetration of institutional cultures and practices is of particular importance to the thesis advanced here on the origins of the madrigal, since the new genre, stylistically, represents a fusion of various compositional and performative techniques and cultural traditions of the sort that typified the programmatic activities of the institutions described in this study.

There were further interconnections among the members of these groups that the table does not illustrate. Jacopo Nardi, who was a member of both the Rucellai group and the Medici Sacred Academy, may also have drafted statutes for the Company of the Broncone; Nardi, in particular, must have been exceedingly well connected and therefore exceedingly well informed. Giovanni Rucellai was a member of the Diamante and had associations with the Sacred Academy, and—through his relatives—must surely have had associations as well with the members of the Rucellai group, especially given the evidence concerning the performance of his tragedy *Rosmunda* in the family garden.

Other important relationships among these men were intellectual or literary in nature. Roberto Acciaiuoli and Bernardo Rucellai were correspondents.[6] On one occasion, Machiavelli enclosed a sonnet (*Havea tentato il giovanetto Arciere*) in a letter to his friend Francesco Vettori in Rome, with whom he corresponded extensively;[7] both men were members of the Rucellai group, although apparently at different times. In preparation for writing his own history, Bartolomeo Cerretani—"closely associated with the disgruntled oligarchs in the circle of Bernardo Rucellai"—apparently read the *De Bello Italico* of Rucellai, whom Cerretani called "that most singular man";[8] Francesco Vettori seems to have been acquainted with Rucellai's work as well.[9] Though not himself a member of the Company of the Cazzuola, Lorenzo di Filippo

Strozzi must surely have had a personal relationship with Cazzuola member Do-
menico Barlacchi, as is suggested by Barlacchi's redaction of Strozzi's "Commedia in
versi" and Strozzi's sonnets in Barlacchi's honor. Cazzuola member Giovanni Gaddi
was the editor of Ludovico (Luigi?) Martelli's works, and the two men were associ-
ated in other ways, as suggested by Martelli's sonnet addressed to Gaddi. Martelli
was also associated with Ippolito de' Medici, the illegitimate son of Cazzuola mem-
ber Giuliano di Lorenzo. Andrea del Sarto, Giuliano's colleague in the Cazzuola, is
said by Vasari to have been involved in the design of Giuliano de' Medici's Diamante
floats, constructed for the 1513 carnival festivities. Cazzuola member Francesco Gra-
nacci was responsible for the artistic elements of the "Triumph of Camillus," staged
at the behest of Lorenzo di Piero di Lorenzo de' Medici for the 1514 Feast of San
Giovanni; Jacopo Nardi was apparently the author of the program.[10]

The members of these various institutions collaborated closely with one another
on designing and executing the programmatic elements of the Florentine public fes-
tivals; they corresponded extensively with one another, dedicated poetic and prose
works to one another, read one another's writings and modeled their own literary ef-
forts on one another's, and redacted, edited, and published one another's works. There
was an intricate, charged, and confused (though productive) network of personal,
intellectual, artistic, epistolary, and literary interconnections and relationships among
them, which linked them almost inextricably to one another and, in many cases, to the
city's institutions and institutional practices and activities. From the various sources,
principally epistolary and literary in nature, there emerges a picture of a relatively
small group of Florentine artists, letterati, and musicians and their patrons—most of
whom were personally known to one another by virtue of their membership in the
different academies and companies—who were responsible for the cultural activity
of the first years of the Medici restoration of 1512 and beyond. The intellectual and
cultural figures among them were the sorts of members of the Florentine elite for
whom Layolle, Pisano, and Verdelot composed their first madrigals; the references
assembled here testifying to their musical experiences and tastes are about as close as
one is likely to get to direct historical evidence of the cultural and intellectual influ-
ences on the earliest madrigalists when they were composing their first works in the
new genre. To adapt the words used in writing about another repertory, the language
of the early madrigal was formed "in ways that answer to the tastes and reflect the
practices"[11] of the Florentine cultural elite of the early Cinquecento.

The Florentine Cultural Elite and the Early Madrigalists

Yet another level of detail concerning these relationships, one more pertinent in
the present context, is the elaborate network of associations among the early mad-

TABLE 6

THE RUCELLAI GROUP (INITIAL PHASE)*	THE RUCELLAI GROUP (SUBSEQUENT PHASE)*	THE SACRED ACADEMY OF THE MEDICI*	THE COMPANY OF THE CAZZUOLA*	THE COMPANY OF THE BRONCONE*	THE COMPANY OF THE DIAMANTE*
	? Alessandro de' Pazzi **Antonfrancesco degli Albizzi** Antonio Brucioli	**Alessandro de' Pazzi** Alfonso Strozzi P. Andreas Gam[maro] reverendissimi Archiep[iscopi] Flor[entini] Vicarius	**Andrea del Sarto** ? Aristotile da San Gallo	**Alessandro de' Pazzi**	? Andrea Dazzi **? Andrea del Sarto** **Antonfrancesco degli Albizzi**
		Atalante Migliorotti			? Antonio Alamanni Antonio da Ricasoli
Bartolomeo Fonzio Bernardo Rucellai (host) Bindaccio Ricasoli	Batista della Palla ? Benedetto Varchi	Bartolomeo Cerretani	*Bartolomeo trombone* *Bernardo Pisan[ell]o*		Bartolomeo Valori
Cosimo Pazzi	Cosim[in]o Rucellai (host)				
Dantes Populeschus			Domenico Barlacchi		
Francesco da Diacceto "il Nero" Francesco Vettori	Fabrizio Colonna **Filippo de' Nerli** **Francesco da Diacceto "il Nero"** **Francesco da Diacceto "il Pagonazzo"** ? Francesco de Layolle Francesco Guidetti	**Francesco da Diacceto "il Pagonazzo"**	*Feo d'Agnolo sonatore* Francesco Granacci	**Filippo de' Nerli**	
Giovan-Battista Gelli	Giangiorgio Trissino	Gerotius de Medicis	Giovan Battista di Cristofano Ottonaio		**Giovanni Corsi**
Giovanni Canacci Giovanni Corsi	**? Girolamo Benivieni**	**Giovanni Corsi** **Giovanni Rucellai** **Girolamo Benivieni**	Giovanni Gaddi *Giovanni Trombone* **Giuliano di Lorenzo de' Medici**		**Giovanni Rucellai** **Giovanni Vespucci** **Giuliano di Lorenzo de' Medici** Giulio di Giuliano de' Medici

TABLE 6 (CONTINUED)

THE RUCELLAI GROUP (INITIAL PHASE)[*]	THE RUCELLAI GROUP (SUBSEQUENT PHASE)[*]	THE SACRED ACADEMY OF THE MEDICI[*]	THE COMPANY OF THE CAZZUOLA[*]	THE COMPANY OF THE BRONCONE[*]	THE COMPANY OF THE DIAMANTE[*]
	Jacopo Alamanni	Jacobus Althychyerus de Florencia ex Ordine Servorum	Jacopo del Bientina	**Jacopo Nardi**	
	Jacopo da Diacceto **Jacopo Nardi** Janus Lascaris	Jacopo Modesti **Jacopo Nardi**		? Jacopo Pontormo	
	Lorenzo di Filippo Strozzi	*Lorenzo di Filippo Strozzi*	Luigi (Ludovico di Lorenzo?) Martelli	Lorenzo di Piero de' Medici	
	Ludovico di Piero Alamanni Luigi di Piero Alamanni Luigi di Tommaso Alamanni *? la Nannina "Zinzera" cortigiana*	Lorenzo Salviati **Ludovico di Piero Alamanni**			
	Niccolò Machiavelli	Michelangelo Buonarroti			
Pietro Crinito **Piero Martelli**	**Pierfrancesco Portinari**	**Palla Rucellai** Pierfrancesco de' Medici **Pierfrancesco Portinari** **Piero Martelli**	*Pierino Pifaro*		**Palla Rucellai** Paolo Vettori **Piero Martelli** Piero Pucci
		Roberto Acciaiuoli	Raffaello del Beccaio		
		The "Unico Aretino" [Bernardo Accolti]	*Talina Sonatore*		
Zanobi Buondelmonti					Fra Zanobi Acciaiuoli

[*]Names of members of more than one institution are in bold. Names of musicians are in italics.

rigalists and the poets whose verse they set to music. There is extensive evidence of relationships among Francesco de Layolle and such members of the Rucellai group as Luigi di Piero Alamanni, Brucioli, Buondelmonti, and Batista della Palla. Sacred Academy member Girolamo Benivieni may also have known Layolle, given that both were cast in the role of interlocutor in one of Brucioli's dialogs. Layolle's music was demonstrably known to Cazzuola member Giovanni Gaddi and to Filippo di Filippo Strozzi, Lorenzo's brother. Layolle's portrait was painted by Cazzuola member Andrea del Sarto (in a group that included Sarto himself) and perhaps by Sarto's pupil Jacopo Pontormo, both of whom were responsible for some of the artistic elements executed for the 1513 carnival.

The "Lodovico Alamanni" mentioned in Machiavelli's correspondence with Guicciardini of 1525 and 1526 can only be Ludovico di Piero, not his brother Luigi di Piero or their relative Luigi di Tommaso, for the reasons given in Chapter 1. Therefore, he is presumably identical with the Sacred Academy's "Ludovicus Alamannus" and hence knew academy members Bernardo Accolti (the "Unico Aretino") and Atalante Migliorotti, musicians both.[12] If "Ludovicus Alamannus" is Ludovico di Piero, a conversance with the early madrigal on the part of at least one erstwhile member of the Sacred Academy is documented, since the 1525 Machiavelli correspondence in which Ludovico figures is concerned specifically with the musical intermedii for *Mandragola*.[13]

Benedetto Varchi reported on an important intellectual relationship between the early madrigalist Bernardo Pisano and Filippo di Filippo Strozzi, which is substantiated by documentary evidence (a passage from Varchi's *Storia fiorentina* and a Latin letter addressed "B. Pis. Ph. Strozo Ph. F.S." and dispatched to the "Magnifico viro Philippo Stroza, Philippi filio, patrono honorando").[14] There is evidence of a relationship between Pisano and Rucellai group members and amici Palla Rucellai, Lorenzo Strozzi, and Giangiorgio Trissino: a September 1521 letter from Rucellai to Trissino in which "uno messer Bernardo Pisano" is explicitly mentioned, the testimony of Strozzi's account books, and many musical settings by Pisano of Strozzi's verse.

The preceding is only a sampling of the documented personal acquaintanceships and friendships among members of the Florentine societies and the early madrigalists. Given the many references assembled throughout this study that document Layolle's, Pisano's, and Verdelot's familiarity specifically with the poetry of several members of these groups, little need be added about settings of verse by Rucellai group members, other than the briefest of summaries: Layolle set verse by Luigi Alamanni,[15] Niccolò Machiavelli, Filippo di Filippo Strozzi, and Lorenzo di Filippo Strozzi, all of whom were members (or, in the case of Filippo Strozzi, the brother of a member) of the Rucellai group; Verdelot set verse by Francesco Guidetti and Giangiorgio Trissino, both of whom frequented the Rucellai garden, as well as verse by Machiavelli.

Bernardo Pisano set much verse authored by Rucellai group member Lorenzo Strozzi, who was also a member of the Sacred Academy. There is the interesting bit of evidence (cited in Chapter 2) that suggests that a text by the Singular Aretine (another of the academy's members) may have been set by Verdelot. And although not as relevant in the present context, madrigal verse by academy member Michelangelo was set by a number of early madrigalists—Arcadelt, Jean Conseil (who was acquainted with the Gaddi), and Costanzo Festa (who was in the employ of the Medici pope Leo X)—as well as by Bartolomeo Tromboncino (who was known to Leo's father, Lorenzo, and may have been the subject of a letter of recommendation to Leo himself).[16]

Furthermore, although the dates of activity of Giuliano de' Medici (d. 1516) as poet and music patron are somewhat too early for our purposes, the famous Squarcialupi codex nonetheless was once in Giuliano's possession; his tastes in such matters as literary style and poetic language might well have been shaped by the Trecento literary contents of the Squarcialupi codex,[17] tastes that may subsequently have been communicated to Giuliano's colleagues in the Company of the Cazzuola and through them to the early madrigalists who spent time with Cazzuola members. Indeed, both Layolle and Verdelot set verse authored by Ludovico Martelli, who debated the literary ideas of Giangiorgio Trissino[18] and was perhaps identical with the Luigi Martelli mentioned by Vasari as a member of the Company of the Cazzuola; Ludovico's works were collected and published by Giovanni Gaddi, who may have been his colleague in the Cazzuola.

Many of these references prove only that Layolle, Pisano, and Verdelot knew the poetry of several members of these various groups. They do not demonstrate unequivocally that any of these men regularly frequented the Rucellai garden, nor do they alone demonstrate that the early madrigalists were well acquainted with members of the Medici Sacred Academy or the Company of the Cazzuola, although other evidence, such as Vasari's life of Rustici, does document such an acquaintance. Nonetheless, when aggregated, the references constitute substantial witness to the earliest madrigalists' conversance with the literary activities of these various groups.

The Musical Tastes and Experiences of the Florentine Cultural Elite and the Style of the Early Madrigal

The complex set of interrelationships between the earliest madrigalists and the members of the contemporary Florentine cultural elite is directly pertinent to the origins of the Cinquecento madrigal. The musical experiences and tastes of the members of that elite are especially relevant in this context and are summarized here. Such men would have been conversant with the polyphonic traditions of the

public ecclesiastical institutions, if only as members of a congregation that from time to time witnessed performances of the polyphonic repertory. Although we are rather ill-informed about the early sixteenth-century polyphonic repertory of the Cathedral, due to the relative absence of period sources demonstrably compiled there, some inferences are suggested by the membership of the chapels and the evidence of the output of those members who were also composers.[19]

However, the institutional settings where the earliest madrigals were likely to have been performed supported other musical practices that are more pertinent in this context. The evidence attesting the activities of the Rucellai group suggests that its musical practices were typified by solo singing to the lute or viol, or the singing of quasi-contrapuntal elaborations of popular tunes: villotte perhaps, or polyphonic settings of French popular tunes of the sort contained in contemporary Florentine sources such as the Cortona/Paris partbooks and the manuscript Magl. XIX.164–67. The evidence of the Sacred Academy's activities suggests that solo singing to string accompaniment as practiced by Lorenzo Strozzi, the Singular Aretine, and Atalante Migliorotti typified the musical experiences of its members. The evidence of the activities of the Companies of the Cazzuola, Broncone, and Diamante demonstrates their members' active engagement with the venerable Florentine carnival-song tradition.

Actual musical experiences shaped musical tastes; ever-evolving musical tastes in turn led members of the Florentine cultural elite to seek musical experiences that reflected those tastes and to support the compositional activity of madrigalists who composed in a style that resonated with their musical experiences, satisfied their musical predilections, and met their musical expectations. Cardinal Giulio de' Medici—who, as Verdelot's employer, was one of the most important patrons of the early madrigal—had been a member of the Company of the Diamante and therefore was actively involved in performances of the canto carnascialesco repertory. His first cousin Giuliano, a member of the Cazzuola, appears to have been an intimate of the famous lutenist-singer Serafino Aquilano[20] and owned the Squarcialupi codex, replete with Trecento madrigals. If the attribution of the 1512 "farsa recitata" to the Florentine herald and Cazzuola member Jacopo del Bientina is correct, it documents Bientina's active engagement with the tradition of solo singing. Rucellai group intimate Filippo Strozzi was festaiuolo for the 1514 Feast of San Giovanni and the 1533 Festa di San Felice, and therefore was demonstrably in a position to commission compositions in the lauda and festival-music traditions.[21] Rucellai group member Filippo de' Nerli was festaiuolo for the 1514 Feast of San Giovanni and demonstrably, therefore, was actively engaged with the tradition of festival music. Rucellai group and Sacred Academy member Jacopo Nardi wrote the texts of the introductory verses for *I due felici rivali* in 1513 and the explanatory canti for the 1513 carnival, the 1514 Feast of San Giovanni, the 1516 festivities for the

conquest of Urbino, and the 1518 wedding of Lorenzo the Younger and, therefore, was demonstrably active in employing elements of the traditions of solo singing to string accompaniment and the canto carnascialesco and related festival music.

Of course, conversance with the relevant musical traditions on the part of the early madrigalists was not exclusively secondhand (or even thirdhand), acquired solely through the intermediating agency of cultural and intellectual figures. Layolle and Pisano were themselves laudesi, and, by virtue of the historical relationship of the lauda to the canto carnascialesco, they were intimately familiar with precisely those stylistic characteristics said by a number of observers to have exercised a decisive influence on the musical language of the early madrigal.

The madrigal is thus a fusion of the polyphonic traditions represented by the French chanson and the practices of the Florentine Cathedral and Baptistery—a tradition in which Verdelot, Arcadelt, and other early madrigalists were trained—with compositional practices typified by the kinds of pieces performed at meetings of the informal academies and companies. Layolle, Verdelot, and other early madrigalists were gifted polyphonists, masters of counterpoint. Their conversance with the Florentine traditions of solo singing to string accompaniment and the canto carnascialesco and lauda contributed to the style of their madrigals in that it yielded a transformed madrigalian polyphony, purified by means of the distinctive features of these quintessentially Florentine musical idioms.[22] Among the characteristics of the earliest madrigals that may have resulted from a familiarity with these Florentine idioms are

1. the homorhythmic setting of the text, which may have been inherited from the lauda and canto carnascialesco;
2. the word painting and increased sensitivity to specific text elements (in short, "madrigalisms"), which may have been inherited from the tradition of solo singing, with its greater room for response to the meaning and emotional content of particular words and phrases;
3. a greater melodic naturalness, which may have been inherited from both the lauda/canto carnascialesco tradition and the practice of solo singing; and
4. distinctive tonal properties and harmonic progressions, which to us seem more "tonal" in some sense (especially as contrasted with contemporary sacred polyphony), and may also have been inherited from both the lauda/canto carnascialesco tradition and from solo song.

To take each of these in turn, first, the tendency in both the lauda/canto carnascialesco tradition and the earliest madrigals to set the text homorhythmically[23] is obvious. What has not been considered fully is that this particular stylistic affinity may not be solely attributable to a direct cause-and-effect relationship; it is indeed partly attributable to the direct influence of the lauda/canto carnascialesco tradition

but is also partly attributable to another phenomenon as well: both genres served particular—and similar—functions that exercised an influence on their texture.

The function of the carnival song repertory is clear: the songs accompanied the procession of floats and elucidated the meaning—religious or political—that the carnival's organizers intended to convey. The earliest precisely datable madrigals—datable beyond argument—are those intended to be sung before the prologue and between the acts of Machiavelli's comedies *La Clizia* and *Mandragola;* they served a Greek choruslike function of commenting on and interpreting the action of the comedies. The intended functions of the two genres are therefore closely related, and the compositional strategy adopted in each case was appropriate to the objective of rendering the text fully intelligible so that the explanatory function would be fulfilled. The context in which performances took place is exceedingly relevant, and their relationship with respect to function sharpens our understanding of the effect of performance context on compositional strategy. Though carefully engineered, the response of the Florentines to the restoration of the Medici in 1512 afforded the occasion for the elaborate 1513 carnival festivities; the need to ensure that the text of the explanatory canto was sufficiently intelligible so that the Florentines were appropriately ecstatic was the expedient that determined the compositional principle of a homorhythmic text setting.

The richly metaphoric language that the carnival song was capable of sustaining (as is seen in both the *Canzona del bronchone* and the *Canzona . . . della Chazuola* —a characteristic that it obviously shares with the early madrigal—may also explain the homorhythmic design. The objective of intelligible delivery of the text becomes more urgent as text images become more oblique and metaphoric; in opting for a spare homorhythmic design, the composer facilitated understanding of the subtle metaphors deployed by the canzona's poet.

Second, little need be added to what has already been said in the concluding remarks of Chapter 2 on the subject of the increased sensitivity to text elements evident in the madrigal. A solo singer—accompanied by his own discontinuous chordal playing, executed on a bowed- or plucked-string instrument—would have been afforded opportunities for an expressive reading of individual text elements of the type that would have been impossible in the performance of ensemble vocal polyphony.

Third, as contrasted with other contemporary contrapuntal genres, the early madrigal is distinguished by a greater naturalness in melodic style, which may have been inherited from the lauda/canto carnasialesco and solo song traditions. This characteristic in turn may be a consequence of the origins of the polyphonic lauda and canto carnascialesco in what originally were monophonic practices. For example, the text of Lorenzo il Magnifico's most famous canto, *Quant'è bella giovinezza,* otherwise known in a polyphonic version, is accompanied in one of its sources

by the rubric "Canzona written by the magnificent Lorenzo de' Medici, who had the Triumph of Bacchus staged for this carnival, where they were singing the following canzone, composed for lute [Chançona chonposta dal magnificho lorenzo de medici che questo charnascale fece fare el trionfo de bacho dove chantavano l'infrascritta chancone chomposte da leuto]." The reference to a polyphonic canto carnascialesco's having been "composed [i.e., 'arranged'?] for lute" suggests the possibility of a fluid alternation between contrasting redactions of works: sometimes performed as polyphonic, sometimes performed as monodic with string accompaniment; Lorenzo's famous polyphonic canto carnascialesco made its debut as a composition "chomposte da leuto."[24] The polyphonic lauda and carnival song may therefore have provided an example for the earliest madrigalists of how tunes could be treated polyphonically without sacrificing their melodic naturalness. Moreover, Michele Pesenti's oeuvre was important to the origins of madrigal style. Indeed, his work must have exercised a significant influence on the stylistic language of the new genre. Several of his polyphonic works were arranged for solo voice and string accompaniment, which suggests that, to contemporaries, the uppermost voice had melodic qualities that made it appropriate for this kind of refashioning. He was also a composer of villotte—polyphonic settings of preexistent monophonic popular tunes—that may also have served as examples of how tunes with a kind of intrinsic melodic naturalness could be treated contrapuntally without losing that quality. The mid-Cinquecento phenomenon of the *madrigale arioso* may represent an attempt to recapture for the polyphonic madrigal some of the characteristics of melodic writing that historically had typified solo song.[25]

Fourth, Pirrotta argued in effect that the tonal characteristics of the new genre represent a fusion of the more oblique harmonic progressions typical of contemporary counterpoint with the clearer sense of tonal direction characteristic of the frottola, that the tonal properties one finds in the early madrigal reflect a harmonic experience acquired through the practice of counterpoint as subsequently deployed in the essentially homophonic, homorhythmic textures of the new genre.[26] In the earliest examples of the Cinquecento madrigal, one has a sense of more clearly defined tonal goals than ordinarily typify other contemporary polyphonic genres, of directed harmonic progressions entailing transparent dynamic processes of tension and resolution unlike what one finds in other all-vocal contrapuntal genres, such as the early sixteenth-century motet. For Verdelot and Layolle, the Florentine tradition of the carnival song was a proximate model of such harmonic practice. The tonal characteristics of solo song are also relevant: solo singing to the accompaniment of a bowed- or plucked-string instrument was likelier to produce harmonic progressions that appear to lead more directly to clearly defined tonal goals than progressions found in genres of fully composed polyphony, for reasons that Richard Crocker articulated. The fully composed, written, polyphonic tradition entails com-

positional practices that afford "circumspection" and "revision," and various "modes of musical continuity and coherence" that result in "an avoidance of the obvious," in "unending chains of suspended functions."[27] This fusion of two different traditions of harmonic practice served, in Pirrotta's view, to produce a tonal language that combined a harmonic variety inherited from the practice of counterpoint (Crocker's various "modes of musical continuity") with a clearer sense of tonal direction reminiscent of the tonal language of solo song with string accompaniment, of the frottola, and of the canto carnascialesco.[28] To Pirrotta, "in terms of musical style, most Florentine masters appear to have … learned to attain variety through the alternation of chordal recitation by all voices with freer, even imitative, passages in counterpoint."[29] In this context, his observations concern the variety afforded by a range of choices about texture, but those textural choices produced a corresponding variety in harmonic practice, since "chordal recitation" elicited harmonic progressions reminiscent of canti carnascialeschi (which to us seem almost tonal), whereas the "freer, even imitative, passages in counterpoint" elicited harmonic progressions that resulted in "an avoidance of the obvious," in Crocker's "unending chains of suspended functions."

Such variety in harmonic practice was enthusiastically exploited by the early madrigalists, since it produced a madrigalian polyphony that manifested an unusual range and complexity of compositional (specifically harmonic and textural) technique. This characteristic may have been precisely what prompted Niccolò Machiavelli's effusive characterization in the text of the canzona before the prologue to *La Clizia*, sung by a vocal ensemble consisting of a "nymph" and three "shepherds":

happy and cheerful,	*Pertanto, allegri e lieti,*
we, with our singing, shall join company	*a queste vostre imprese*
with this, your undertaking,	*farem col cantar nostro compagnia*
with such sweet harmony	*con sì dolce armonia*
as you have never heard before.	*qual mai sentita più non fu da voi.*

As contrasted with the canto carnascialesco, the early madrigal also manifests a greater rhythmic flexibility and freedom, which it also surely inherited in part from contemporary contrapuntal practice. The symmetrical, ordered formal and metrical schemes typical of canto carnascialesco verse, especially as contrasted with the formal and metrical flexibility typical of early madrigal verse, coupled with the prevailingly syllabic musical setting of the text (a consequence of the need for intelligibility), resulted in a more or less foursquare, static rhythmic conception. The early madrigal, on the other hand, intermittently employs the polyrhythms and melismatic text setting typical of polyphonic writing; its episodic melismas, where one syllable of text is set to many notes of music, stand in sharp contrast with the

syllabic treatment of canto carnascialesco verse, where a syllable of text is matched to a single note of music. Such melismatic writing in the early madrigal produced a concomitant greater variety in note values (as opposed to the regular, ordered succession of equal note values typical of the carnival song), which opened up the rhythmic conception of the early madrigal and explains its fresher, more dynamic rhythmic qualities. Such rhythmic characteristics are also the result of the greater metrical freedom typical of madrigal verse, which engendered a corresponding flexibility in the rhythmic properties of the attendant musical setting.

Such analyses suggest the importance of the musical activities and intellectual tenets of the various Florentine literary societies and companies to the early madrigal's musical style, but their influence can be found in the new genre in other ways as well. The contrasting institutional profiles, objectives, and activities of the Rucellai group (or the Sacred Academy) on the one hand and the Cazzuola on the other are reflected in the more fundamental defining characteristics of the early madrigal as a genre, especially with respect to its poetic language, its relationship to the carnivalesque, and so on. The refined, academically substantive program of the Rucellai group and the Sacred Academy is mirrored in contemporary attempts to recapture the linguistic and literary accomplishments of the luminaries of the Italian Trecento, and such attempts are of immeasurable importance to the emergence of the Cinquecento madrigal and its refined poetic language. On the other hand, the carnivalesque practices of the Cazzuola, Broncone, and Diamante—whose memberships overlapped so inextricably with those of the Rucellai group and the Sacred Academy—form the background for that simultaneous use of sublimated sexual language in the new genre. The charged, overlapping, intertwined cultural forces at play in the activities of the societies and companies are expressed in the generic properties of the new musical idiom they spawned, in the mixed and seemingly discontinuous cultural elements that it nonetheless successively conjoined.

The thesis of this study is that this hitherto incompletely considered historical evidence informs and enriches our understanding of the origins and distinctive stylistic characteristics of the Renaissance madrigal. To return to the formulation of the thesis at the beginning of Chapter 1, should one wish to understand why Verdelot composed his earliest madrigals as he did, then one must identify the kind of Italian secular music he heard. Or to paraphrase John Shearman, "one central issue in [music] history . . . is to try to understand, in as many ways as possible, how it is that works of [music] came to [sound] as they do."[30]

How did the earliest madrigals of Verdelot and Layolle come to sound as they do? The musical experiences of the members of the Florentine cultural elite whose company Verdelot and Layolle kept—and the resultant musical tastes of those intellectual and cultural figures as shaped by their experiences—exercised a deter-

minative influence on the stylistic properties of the important new genre. The distinctive stylistic characteristics of the early Cinquecento madrigal cannot be fully understood without a prior understanding of the Florentine musical antecedents discussed here and the institutions that supported their composition and performance. The important new genre emerged in a cultural setting characterized by distinctive musical practices whose effects can be traced in the Italian madrigal of the early sixteenth century, a genre that, perhaps more than any other, exemplifies the secular musical culture of early modern Europe.

Biobibliographical Information on Members of the Florentine Academies and Companies

The Rucellai Group

Of the participants during the earlier phase of activity of the Rucellai group, **Giovanni di Bardo Corsi** (1472–1547), Ficino's first biographer, was—significantly—a member of the balìa of 16 September 1512 that restored the Medici to power after their eighteen-year exile. See Kristeller, "Un uomo di stato e umanista fiorentino: Giovanni Corsi," *La bibliofilia* 38 (1936): 242–57, reprinted in *Studies in Renaissance Thought and Letters,* Storia e letteratura, Raccolta di studi e testi LIV (Rome: Edizioni di storia e letteratura, 1984), pp. 175–90; on his membership in the balìa, see esp. pp. 244–45. Corsi has been described by Rudolf von Albertini, perhaps the most well-informed of students of this period in Florentine history, as "one of the most faithful of Medici followers." See von Albertini, *Firenze dalla repubblica al principato, Storia e coscienza politica,* Biblioteca di cultura storica CIX (Turin: Giulio Einaudi editore s.p.a., 1970), p. 106 n. 1. Indeed, in 1530, Corsi became Florentine gonfaloniere at the behest of Pope Clement VII (the former Cardinal Giulio de' Medici), upon the final restoration of the Medici to Florence. See von Albertini, *Firenze dalla repubblica al principato,* p. 180.

Dante Popoleschi was responsible for Italian translations of: (1) Caesar (on Popoleschi's translation of Caesar, *Commentarij della Guerra Gallica,* which went through a number of editions, see Eric Cochrane, *Historians and Historiography in the Italian Renaissance* [Chicago: University of Chicago Press, 1981], p. 257, and Mario E. Cosenza, *Biographical and Bibliographical Dictionary of the Italian Humanists,* 6 vols. [Boston: G. K. Hall & Co., 1962–67], 4:2931); and (2) the Latin adaptation of Plutarch's life of Scipio by the fifteenth-century humanist and Florentine statesman Donato Acciaiuoli (1429–78), a translation preserved to this day in the manuscript Florence, Biblioteca Nazionale Centrale, Magl. XXIII.86 (see Paul Oskar Kristeller, *Iter Italicum,* 6 vols. [Cologne: E. J. Brill, and London: The Warburg Institute, 1963–92], vol. 1:121, and Eugenio Garin, "Donato Acciaiuoli cittadino fiorentino," *Mediœvo e rinascimento: Studi e ricerche,* Biblioteca di Cultura moderna DVI [Bari: Editori Laterza, 1961], pp. 211–87; for assistance on Acciaiuoli and Popoleschi, I am grateful to the late Father Salvatore Camporeale, Research

Associate at Villa I Tatti, the Harvard University Center for Italian Renaissance Studies in Florence).

Bartolomeo Fonzio (1446–1513) was a pupil of Cristoforo Landino and Argyropoulos, for a time professor at the University of Rome, twice holder of the chair in eloquence at the Florentine studio, and a member of the circle around Lorenzo il Magnifico. On Fonzio, see F. Saxl, "The Classical Inscription in Renaissance Art and Politics," *Journal of the Warburg Institute* 4 (1940–41): 19–46. For some verses of Fonzio's in honor of Lorenzo il Magnifico, see Chapter 4. Fonzio authored what Felix Gilbert described as "the first brief history of historical writing." See Gilbert, *Machiavelli and Guicciardini: Politics and History in Sixteenth-Century Florence* (Princeton, N.J.: Princeton University Press, 1965), p. 207.

Francesco Vettori (1474–1539), also a member of the 1512 balìa that restored the Medici, was one of the most loyal of Medici servants (in John Najemy's words, "a powerful and trusted adviser . . . in several crucial phases of the long process that led from the restoration in 1512 to the consolidation of the principate in the 1530s"), Machiavelli's friend, and his correspondent in a fascinating exchange of letters from the second decade of the sixteenth century. Vettori, who had a humanistic education, was a historian of some importance and the author of an informative account of the period between the restoration of the Medici and their final exile in 1527; he may have been a pupil of the same Ser Paolo Sasso da Ronciglione who was Pietro Crinito and Niccolò Machiavelli's master. Vettori, moreover, was a close relative of his host Bernardo Rucellai, who was his mother's brother. On Vettori, see Rosemary Devonshire Jones, *Francesco Vettori, Florentine Citizen and Medici Servant* (London: Athlone Press of the University of London, 1972); on his correspondence with Machiavelli, see John M. Najemy, *Between Friends: Discourses of Power and Desire in the Machiavelli-Vettori Letters of 1513–1515* (Princeton, N.J.: Princeton University Press, 1993), which was the principal source of the information given in my brief biography of Vettori. On Ser Paolo Sasso da Ronciglione, master of the clerics at the Florentine Cathedral, as Crinito's and Machiavelli's master, see Gilbert, *Machiavelli and Guicciardini*, p. 321.

Of the participants during the later phase, the soldier **Luigi di Tommaso Alamanni**, Ludovico and Luigi di Piero's relative, was beheaded for his putative role in the 1522 congiura against Cardinal Giulio de' Medici. On Luigi di Tommaso, see Delio Cantimori, "Rhetoric and Politics in Italian Humanism," *Journal of the Warburg Institute* 1 (1937–38): 83–102, esp. p. 91 and n. 1; Jacopo Nardi, *Istorie della città di Firenze*, pub. per cura di Agenore Gelli, 2 vols. (Florence: F. Le Monnier, 1858), 2:73; and Filippo de' Nerli, *Commentarij dei fatti civili occorsi dentro la città di Firenze dall'anno 1215 al 1537*, which I consulted in the two-volume edition of 1859 (Trieste: Colombo Coen Tip. Editore), 2:14. On his role in the 1522 congiura, see Nardi's and Nerli's accounts and von Albertini, *Firenze dalla repubblica al principato*, p. 83.

Similarly, the poet **Jacopo da Diacceto**, though indebted to Cardinal Giulio for having received a lectureship in Florence, was nonetheless tortured (as a result, he revealed the plan to assassinate the cardinal) and then beheaded, on the same day as Luigi di Tommaso (7 June 1522), for his supposed role in the congiura. On Diacceto, see Cantimori, "Rhetoric and Politics in Italian Humanism," p. 91 and n. 1; on his execution, see the accounts in Nardi, *Istorie della città di Firenze;* Nerli, *Commentarij dei fatti civili occorsi dentro la città di Firenze dall'anno 1215 al 1537;* and von Albertini, *Firenze dalla repubblica al principato,* p. 83. Diacceto's intellectual profile was characterized by a "fusion of humanistic elements and Savonarolan religiosity," in von Albertini's words, in which respect Diacceto thus resembled his co-conspirators (see von Albertini, *Firenze dalla repubblica al principato,* p. 84). Diacceto's intellectual profile is evident particularly in some verses authored just before his execution, on which see P. Piccolomini, "Ultimi versi di Jacopo da Diacceto," *Giornale storico della letteratura italiana* 39 (1902): 327–34.

Although others of the conspirators—Luigi di Piero Alamanni, Brucioli, and Buondelmonti—managed to escape, their belongings were confiscated. See von Albertini, *Firenze dalla repubblica al principato,* p. 83. After the discovery of the congiura, **Antonio Brucioli** (last decade of the fifteenth century–4 December 1566) sought refuge first in Venice and then in Lyons. He then began a period of intense activity as a writer and editor. His *Dialoghi [della morale filosofia]*, part of a larger work, were certainly begun during the time he frequented the Orti Oricellari and continued in Lyons and published in Venice in 1526; in the 1537–38 edition, new dialogs were added to the original ones and the fictive classical names of the interlocutors of the first edition supplanted by the names of Brucioli's own friends, his fellows who congregated at the Orti: Luigi di Piero Alamanni, Cosimino Rucellai, Niccolò Machiavelli, Batista della Palla, and others. On Brucioli, see Cantimori, "Rhetoric and Politics in Italian Humanism," *passim;* and von Albertini, *Firenze dalla repubblica al principato,* pp. 73–74 n. 2, from which much of this material is borrowed directly. See also the relevant portions of Chapter 1 devoted to a discussion of Brucioli.

Luigi Francesco di Piero di Francesco Alamanni was one the Cinquecento's preeminent literary figures. In 1518, at a time when he must have been a regular participant in the discussions in the Orti Oricellari, he was engaged in copying antique scholia into the margins of a late fifteenth-century Florentine exemplar of Homer; his classical interests and scholarship are testimony to the intellectual program of the Rucellai group. Alamanni also figures prominently in Benvenuto Cellini's autobiography, in the role of Florentine expatriate at the court of François Ier. On Alamanni, see Henri Hauvette, *Un exilé florentin a la cour de France au XVIᵉ Siècle: Luigi Alamanni (1495–1556), Sa vie et son oeuvre* (Paris: Librairie Hachette & Cᶦᵉ, 1903); and Roberto Weiss, "Alamanni, Luigi," *Dizionario biografico degli italiani*

(Rome: Istituto della Enciclopedia Italiana, 1960–), 1:568–71. On the copying of the classical scholia, see Weiss, "Alamanni, Luigi," p. 568. On Alamanni's translation of the *Antigone*, see Gianandrea Piccioli, "Gli Orti Oricellari e le istituzioni drammaturgiche fiorentine," *Contributi dell'Istituto di filologia moderna, Serie Storia del teatro* I, Pubblicazioni dell'Università Cattolica del Sacro Cuore, Contributi, Serie terza: Scienze, filologiche, e letteratura 17 (1968): 60–93, esp. pp. 86–87 and n. 81. On his literary activity and settings of his madrigal verse, see *I musici di Roma e il madrigale,* ed. Nino Pirrotta, Accademia Nazionale di Santa Cecilia, L'Arte Armonica, Serie II: Musica Palatina, 1 (Florence: Libreria Musicale Italiana, 1993), p. xxxiii.

Janus Lascaris was professor of Greek at the University of Rome and editor of *Homeri interpres* [*Scholia on Homer*] (Rome, 1517). See James Hankins, "The Popes and Humanism," in *Rome Reborn: The Vatican Library and Renaissance Culture,* ed. Anthony Grafton (New Haven, Conn.: Yale University Press; Washington: Library of Congress; and Vatican City: Biblioteca Apostolica Vaticana, 1993), pp. 46–85, 295–97, and 305–6, esp. p. 55. The establishment of Leo's Greek Academy, in which Lascaris played a role, was celebrated in contemporary poetic works as the foundation of a "new Athens" on the Tiber. Leo and Lascaris's initiative would have been seen as a revival of the "new Athens" that had been the Florence of Leo's father Lorenzo il Magnifico, where Lascaris had also played a role. That Lascaris himself endorsed and advanced the conceit of Laurentian Florence as a new Athens is suggested by fragments of a lecture of his delivered in Florence around 1475. The identification of Leo as patron of Greek learning with his father, and of Leonine Rome as a new Athens with Laurentian Florence, became an important topos, which Lascaris had a significant part in developing. On the Greek Academy in Rome, see the material assembled in John Shearman, *Raphael's Cartoons in the Collection of Her Majesty the Queen and the Tapestries for the Sistine Chapel* (London: Phaidon Press Ltd., 1972), p. 73 and nn. 163–64, from which the foregoing was taken. Earlier, Lascaris had acquired Greek materials for Lorenzo (see Shearman, *Raphael's Cartoons,* p. 50 and n. 34 and p. 118 and n. 91, and Gilbert, *Machiavelli and Guicciardini,* p. 320; on Lorenzo and Lascaris generally, see Sebastiano Gentile, "Lorenzo e Giano Lascaris: Il fondo greco della biblioteca medicea privata," in *Lorenzo il Magnifico e il suo mondo, Convegno internazionale di studi* [*Firenze, 9–13 giugno 1992*], ed. Gian Carlo Garfagnini, Istituto Nazionale di Studi sul Rinascimento, Atti di Convegni XIX [Florence: Leo S. Olschki Editore, 1994], pp. 177–94). Lascaris also edited and lectured on the so-called *Greek Anthology,* a collection of hundreds of lyrics and epigrams that served as a text in Byzantium and the West; see Anthony Grafton and Lisa Jardine, *From Humanism to the Humanities: Education and the Liberal Arts in Fifteenth- and Sixteenth-Century Europe* (Cambridge: Harvard University Press), p. 120.

The musician, playwright, and poet **Lorenzo di Filippo Strozzi** was patron to the papal musician Galeazo Baldi as well as to Francesco Corteccia, Bernardo de Liuto, and others. See Frank A. D'Accone, "Transitional Text Forms and Settings in an Early 16th-Century Florentine Manuscript," *Words and Music: The Scholar's View, A Medley of Problems and Solutions Compiled in Honor of A. Tillman Merritt by Sundry Hands,* ed. Laurence Berman ([Cambridge]: Department of Music, Harvard University, 1972), pp. 29–58, esp. p. 33 n. 16; on the papal musician Galeazo Baldi, see Herman-Walther Frey, "Regesten zur päpstlichen Kapelle unter Leo X. und zu seiner Privatkapelle," *Die Musikforschung* 8 (1955): 58–73, 178–99, and 412–37, and 9 (1956): 46–57, 139–56, and 411–19, esp. 8 (1955): 417–18; the "Bernardo de Liuto" may be identical with the "m[aestr]o Ber[nard]o sonatore di liuto" who in 1520 and 1521 instructed Cardinal Giulio de' Medici's page, "Stefano di m[esser] Mario Crece[n]tio"; see my "Giulio de' Medici's Music Books," *Early Music History* 10 (1991): 65–122, esp. p. 73 n. 28. Strozzi is known to have purchased musical instruments, including a harpsichord, *organetto,* and lutes. His accounts also record payments for the copying and illuminating of books of music, and inventories of his possessions document that he indeed owned music manuscripts, as well as music prints and music-theoretical treatises; see D'Accone, "Transitional Text Forms," pp. 33–35 and nn. 17–19, 21–22, and 24–27. Further material on Lorenzo's musical interests and activities is contained in Richard J. Agee, "Filippo Strozzi and the Early Madrigal," *Journal of the American Musicological Society* 38 (1985): 227–37, esp. 228–29 n. 2.

Lorenzo's brother **Filippo di Filippo** was also an important music patron whose musical activities have been summarized by Agee in "Filippo Strozzi." On pp. 228–29, n. 2, of Agee's study, there is some theretofore unpublished material relating to Filippo's musical interests and activities, and elsewhere in Agee's article he reviews the available references attesting Filippo's musical patronage and experiences, to which I offer some additions and corrections: in 1510, Filippo paid Baccio's apprentice ten scudi for paper ruled for musical notation (the payment was not for music, as Agee had indicated) (see D'Accone, "Transitional Text Forms," esp. p. 34 n. 24); and letters of 1519 and 1520 document Filippo's relationship to an instrumentalist named Urbano (see Agee, "Filippo Strozzi," pp. 229–30 and the accompanying notes), who may be identical to the "Urbano sonator liuti" documented in Rome in 1526/27 (Domenico Gnoli, "Descripto Urbis e censimento della popolazione di Roma avanti il sacco borbonico," *Archivio della R[eale] Società romana di Storia patria* 18 [1894]: 467), a possibility Agee does not consider, and to the "Urbano sonatore" documented as being in the employ of Lorenzo di Piero de' Medici in 1516 (Richard Sherr, "Lorenzo de' Medici, Duke of Urbino as a Patron of Music," *Renaissance Studies in Honor of Craig Hugh Smyth,* 2 vols. [Florence: Giunti Barbèra, 1985], 1:627–38, esp. p. 637 n. 34). In addition to these documentary references, Agee cites other evidence pertaining to Filippo's musical

interests. For example, Benedetto Varchi claimed that Filippo enlisted the services of Bernardo Pisano as his companion in his humanistic studies. In his paper in the *Internationale Gesellschaft für Musikwissenschaft: Report of the Tenth Congress, Ljubljana, 1967* (Kassel: Im Bärenreiter-Verlag, 1970), pp. 96–106, esp. p. 98 n. 5, D'Accone cited a letter, evidently unknown to Agee, in the Archivio di Stato, Florence, *Carte Strozziane*, Serie Prima, filza 137, fols. 128r–129r [properly 127r–128r], in which Pisano thanks Filippo for assistance in his studies; for furnishing me with a transcription of this Latin letter, addressed "Magnifico viro Philippo / Stroza, Philippi filio, patrono honorando" on fol. 128v, and whose salutation reads "B. Pis. Ph. Strozo Ph. F.S.," I am grateful to Dott. Gino Corti. Filippo was also festaiuolo for several Medici festivals that involved musical performances; see Filippo di Cino Rinuccini, *Ricordi storici*, ed. Giuseppe Aiazzi (Florence: Stamperia Piatti, 1840), p. 180, on the 1514 Feast of San Giovanni, and Florence, Biblioteca Nazionale Centrale, MS N.A.982, fol. 163v, on the festivities organized for the 1533 visit to Florence of Margaret of Austria. These references attest a significant interest in music and enlarge the amount of material documenting the actual musical activities of members (or, more properly, intimates of members) of the Rucellai group.

Jacopo Nardi (1476–1563) was unquestionably one of the most important of contemporary Florentine historians, a playwright, and the author of the texts of the propagandistic explanatory canti for a number of Medici festivals. See my book *The Politicized Muse: Music for Medici Festivals, 1512–1537*, Princeton Essays on the Arts (Princeton, N.J.: Princeton University Press, 1992), Chapters 2, 7, 8, and 9.

Batista della Palla was the dedicatee of a manuscript copy of Nardi's comedy *I due felici rivali*, which is evidence of a relationship between them beyond that of their common membership in the Rucellai group. On fol. 1r of the manuscript Vatican City, Biblioteca Apostolica Vaticana, Barb. lat. 3911 (*olim* XLV.5) is the inscription "IACOBVS NARDUS. IO: BAP.ᵗᵃᵉ PALLÆ .S.P.D."; the dedication opens "Fabula hæc nostra, Johannes Baptista suavissime, Laurentij Medicis auspicijs acta: cũ maximo omniũ favore."

The historian **Filippo de' Nerli** (1485–1556) was loyal to the Medici before their exile in 1527, during the republican interregnum of 1527–30, and after the decisive establishment of the Medici principato in the 1530s. See Cochrane, *Historians and Historiography*, p. 278. I should point out, however, that "Philippo o Benedetto suo padre de' Nerli" were cited as possible members of a new government magistracy that would have been formed had the 1522 conspiracy succeeded in bringing the Medici regime to an end. This does not necessarily demonstrate that they were in agreement with the aims of the conspiracy; it need prove nothing more than that, as leading figures in Florentine political life, they would have been obvious candidates for government office under changed political circumstances. See von Albertini, *Firenze dalla repubblica al principato*, p. 84.

Alessandro de' Pazzi (1483–1530), the nephew of Lorenzo il Magnifico, the son of Lorenzo's sister, was among those young aristocrats who welcomed the 1512 restoration of the Medici with enthusiasm. He was a poet and translator and produced translations of Sophocles, Euripides, and Aristotle. In 1530, he was a member of the balìa that effected the final, decisive return of the Medici to Florence. In the early 1520s, he was among those who responded to Cardinal Giulio's invitation to submit proposals for constitutional reform; although one of the texts written in response to Cardinal Giulio's invitation—his Latin discourse that begins "Alexandri Paccij oratio pro Senatu, Populoque Florentino, ad Julium Medicem, Cardinalem amplissimum, de Republica"—is no longer extant, another of his treatises is preserved. On Pazzi, see von Albertini, *Firenze dalla repubblica al principato*, pp. 78–83 and the accompanying notes, on which I have relied heavily.

THE SACRED ACADEMY OF THE MEDICI

The "Storia" of **Bartolomeo Cerretani** has only recently been published in full, despite its importance; see Raul Mordenti, ed., *Dialogo della mutatione di Firenze, Edizione critica secondo l'apografo magliabechiano*, Temi e testi, Nuova serie XXXIV (Rome: Edizioni di storia e letteratura, 1990), and Giuliana Berti, ed., *Dialogo della mutatione di Firenze*, Istituto Nazionale di Studi sul Rinascimento, Studi e testi XXX (Florence: Leo S. Olschki Editore, 1993). It is preserved in the manuscripts Florence, Biblioteca Nazionale Centrale, II.IV.19 ("Sommario e ristretto cavato dalla historia di Bartolomeo Cerretani, scritta da lui, in dialogo delle cose di Firenze, dal'anno 1494 al 1519") and Florence, Biblioteca Nazionale Centrale, II.I.106 ("Storia in dialogo della mutazione di Firenze"), among others. In this study, all extracts are taken directly from the original sources, and the transcriptions are mine. On Cerretani, see Felix Gilbert, *Machiavelli and Guicciardini: Politics and History in Sixteenth-Century Florence* (Princeton, N.J.: Princeton University Press, 1965), entries in the index to Cerretani.

On **Jacopo Modesti da Prato** as Giulio's agent, see J. N. Stephens, *The Fall of the Florentine Republic, 1512–1530* (Oxford: Clarendon Press, 1983), pp. 147–49. That he was Poliziano's student and correspondent is suggested, for example, by the final letter of Book 5 of Poliziano's *Epistolarum libri duodecim*, now available in Angelus Politianus, *Opera Omnia*, ed. Ida Maïer, 3 vols., Monumenta Politica Philosophica Humanistica Rariora, Series I, XVI–XVIII (Turin: Bottega d'Erasmo, 1970–71), 1:69–72. On Modesti's scholarly activity, and on Florentine humanism in general in its "postclassical" phase, see also the excellent survey in Anthony Grafton, *Joseph Scaliger, A Study in the History of Classical Scholarship*, I, Textual Criticism and Exegesis, Oxford-Warburg Studies (Oxford: Clarendon Press, 1983), Chapter 2, "Poliziano's Followers in Italy, 1500–1560," esp. p. 53 and n. 43. Modesti was also the

author of an account of the sack of Prato in 1512, which led to the restoration of the Medici to Florence; see "Il Miserando Sacco dato alla Terra di Prato dagli Spagnoli l'anno 1512, scritto per messer Iacopo Modesti," *Archivio storico italiano* 1 (1842): 233–51, and the "Notizie sui Documenti del Sacco di Prato, tratte dalle Illustrazioni del sig. Atto Vannucci," pp. 229–32.

Girolamo Benivieni (6 February 1453–August 1542) was a student of Greek and Hebrew and an intimate of the famed philospher Giovanni Pico della Mirandola (this is suggested by the fragment of a letter published by Kristeller; see "Spigolature ficiniane," in *Studies,* pp. 139–74, esp. pp. 171–72). On Benivieni generally, see Cesare Vasoli, "Benivieni, Girolamo," *Dizionario biografico degli italiani* (Rome: Istituto della Enciclopedia Italiana, 1960–), 8:550–55. He was also a follower of Girolamo Savonarola (on Benivieni's Savonarolan sensibilities and his activity as an author of lauda verse, see Patrick Macey, *Bonfire Songs: Savonarola's Musical Legacy,* Oxford Monographs on Music [Oxford: Clarendon Press, 1998], for example, pp. 60, 73, and the entries in Macey's index for "Benivieni, Girolamo"); his presumed membership in the Rucellai group, which is reminiscent of Jacopo da Diacceto's, thus suggests that the membership's spiritual sensibilities may have had something of a Savonarolan cast to them (on Jacopo da Diacceto as a follower of Savonarola, see above).

The Company of the Cazzuola

Giovanni Gaddi (22 April 1495–1542) was the patron of Annibale Caro and Benedetto Varchi and clerk of the papal camera. On him, see H. Colin Slim, "Un coro della 'Tullia' di Lodovico Martelli messo in musica e attribuito a Philippe Verdelot," *Firenze e la Toscana dei Medici nell'Europa del '500,* 3 vols., Biblioteca di Storia toscana moderna e contemporanea, Studi e documenti XXVI (Florence: Leo S. Olschki Editore, 1983), 2:487–511, esp. pp. 488–91, and Annibal Caro, *Lettere familiari,* ed. Aulo Greco, 3 vols. (Florence: Felice Le Monnier, 1957–61), 1:1 n. 3, 2:195–98 (esp. p. 197 n. 19), and 3:91–93 (esp. pp. 92–93 and n. 5). Vasari stated elsewhere that Andrea del Sarto painted a *Madonna* for Giovanni Gaddi, which is now lost; see John Shearman, *Andrea del Sarto,* 2 vols. (Oxford: Clarendon Press, 1965), 1:2–3, 310–11; this reference suggests a further relationship between Sarto and Gaddi beyond that of their common membership in the Cazzuola. The Gaddi family library at one time contained some of the most important music manuscripts of the late fifteenth and early sixteenth centuries: (1) Florence, Biblioteca Nazionale Centrale, manuscripts Banco rari 229 (*olim* Magliabechi XIX.59; Gaddi 1024) (on which, see, above all, Howard Mayer Brown's study *A Florentine Chansonnier from the Time of Lorenzo the Magnificent: Florence, Biblioteca Nazionale Centrale MS Banco Rari 229,* 2 vols., Monuments of Renaissance Music VII [Chicago & London: University of

Chicago Press, 1983]; references to its having been in the Gaddi collection are in the Text Volume, p. 5 and accompanying n. 3 and pp. 25–26 and accompanying nn. 19–20); (2) II.I.232 (*olim* Magliabechi XIX.58; Gaddi 1113) (on which see my article "A Florentine Sacred Repertory from the Medici Restoration [Manuscript II.I.232 (*olim* Magl. XIX.58; Gaddi 1113) of the Biblioteca Nazionale Centrale, Florence]: Bibliography and History," *Acta musicologica* 55 [1983]: 267–332); and (3) Magliabechi XIX.56 (*olim* Gaddi 1112) (on which see ibid., p. 277 and corresponding n. 26), to list them in the order of their copying. (4) The manuscript Magl. XIX.57 (*olim* Gaddi 1103) is yet another music manuscript from the Gaddi library. The fact that the Gaddi music manuscripts 1024, 1103, 1112, and 1113 are numbered consecutively in the Magliabechi collection (Magl. XIX.56, 57, 58, and 59) suggests that they entered the Magliabechi collection as a group and at the same time. On the Gaddi library, see ibid., pp. 269–72; C. Bec, "La bibliothèque d'un grand bourgeois florentin, Francesco d'Agnolo Gaddi (1496)," *Bibliothèque d'humanisme et renaissance* 34 (1972): 239–47; Carlo Frati, *Dizionario bio-bibliografico dei bibliotecari e bibliofili italiani dal sec. XIV al XIX* (Florence: L. S. Olschki, 1934), p. 239; and Domenico Fava, *La Biblioteca nazionale centrale di Firenze e le sue insigni raccolte,* Le grandi biblioteche storiche italiane (Milan: U. Hoepli, 1939), pp. 35–39. One of the Gaddi —Giovanni's relative—was associated with the madrigalist and papal singer Jean Conseil in the Rome of Pope Clement VII (Giulio di Giuliano de' Medici); on the relationship of the Gaddi to Conseil, see Herman-Walther Frey, "Regesten zur päpstlichen Kapelle unter Leo X. und seiner Privatkapelle," *Die Musikforschung* 8 (1955): 58–73, 178–99, and 412–37, and 9 (1956): 46–57, 139–56, and 411–19, esp. 9 (1956): 145 [20 January 1526], "E a dì vinti ditto pagati a Bernardo Brazo duchatti dieci e a Bonocoro [*sic*] Rucelaio schudi sedeci a Gadi schudi dieci che sono in tuti trentasei, qualli havevano prestati a mastro Gian Consiglion____duc. 36"; given the brevity of the reference, determining which of the Gaddi loaned the money to Conseil and therefore what his relationship was to our Giovanni is not possible. Another member of the family, Cardinal Niccolò—the brother of our Giovanni —held curial offices under Pope Leo X, the older brother of Cazzuola member Giuliano de' Medici, which documents yet further relationships between the Gaddi and the Medici; however, Cardinal Niccolò subsequently developed into an opponent of the first duke of Florence, Alessandro de' Medici. On Cardinal Niccolò, who obtained the post of apostolic secretary under Leo X, see W. von Hofmann, *Forschungen zur Geschichte der Kurialen Behörden vom Schisma bis zur Reformation,* 2 vols., Bibliothek des Kgl. Preuss. Historischen Instituts in Rom XII[–XIII] (Rome: Loescher, 1914), 2:94, 121, and 185; on his opposition to Alessandro de' Medici, see the contemporary historian Benedetto Varchi, *Storia fiorentina,* ed. Lelio Arbib, 3 vols. (Florence: Società editrice delle Storia del Nardi e del Varchi, 1843–44), 3:117–19.

Giuliano de' Medici was at one time or another in possession of a number of music manuscripts, two of which are still extant: the celebrated Squarcialupi codex (on the inscription of Squarcialupi's nephew Raffaello documenting Giuliano's ownership—"Si R^mo Car^li de Med. Organa Antonij Squarcialupi avi mei grata extitere: nõ minoris puto fore librum hunc Juliano f[rat]ri suo optimo Vade ig[itu]r liber, & in eiusdem bibliothecã te confer meq³ & meos sibi & familie sue cõmenda:~"—see Johannes Wolf, ed., *Der Squarcialupi Codex* [Lippstadt: Fr. Kistner & C.F.W. Siegel, 1955], unpaginated introduction; Pirrotta has suggested that Giuliano's understanding of the madrigal as a genre may have been shaped by the contents of the Squarcialupi codex; see "Novelty and Renewal in Italy, 1300–1600," in *Music and Culture in Italy from the Middle Ages to the Baroque* [Cambridge: Harvard University Press, 1984], pp. 159–74 and the notes on pp. 406–8, esp. p. 408 n. 20) and the Cappella Giulia chansonnier (on the Cappella Giulia chansonnier, see Allan Atlas, *The Cappella Giulia Chansonnier* [Rome, Biblioteca Apostolica Vaticana, C.G. XIII.27], 2 vols., Musicological Studies XXVII [Brooklyn: Institute of Medieval Music, 1975]; that Giuliano owned other books of music, apparently no longer extant, is suggested by a reference in a letter of his of October 1513, in which he indicated that his older brother Pope Leo had requested "certi miei libri di musica che restorono costì [i.e., Florence] et maxima uno di messe" and another documenting that he sent a book of music to the king of Portugal; on the first reference, see my article "Medici Musical Patronage in the Early-16th Century: New Perspectives," *Studi musicali* X [1981], pp. 197–216, esp. p. 205; and on the second A. Pellizzari, *Portogallo e Italia nel secolo XVI* [Naples: 1914], pp. 150–51). He may also have been associated with the famous lutenist-singer Serafino Aquilano (see Chapter 2, n. 45, in this volume). For other references to Giuliano's music patronage, see my "Medici Musical Patronage," p. 205; Frank A. D'Accone, "Heinrich Isaac in Florence: New and Unpublished Documents," *The Musical Quarterly* 49 (1963): 464–83, esp. p. 481; F. Ghisi, *I canti carnascialeschi nelle fonti musicali del XV e XVI secoli* (Florence: Leo S. Olschki, 1937), pp. 43–44; Richard Sherr, "Verdelot in Florence, Coppini in Rome, and the Singer 'La Fiore,'" *Journal of the American Musicological Society* 37 (1984): 402–11, esp. p. 410; Edward E. Lowinsky, *The Medici Codex of 1518*, 3 vols., Monuments of Renaissance Music III–V (Chicago: University of Chicago Press, 1968), 1:32 n. 24; Richard Sherr, "Lorenzo de' Medici, Duke of Urbino, as a Patron of Music," *Renaissance Studies in Honor of Craig Hugh Smyth*, 2 vols., ed. Andrew Morrogh et al. (Florence: Giunti Barbèra, 1985), 1:627–38, esp. p. 627; William F. Prizer, *Courtly Pastimes: The Frottole of Marchetto Cara* (Ann Arbor, Mich.: UMI Research Press, 1980), p. 42; and Alessandro Luzio, "Isabella d'Este nei primordi del papato di Leone X e il suo viaggio a Roma nel 1514–1515," *Archivio storico lombardo*, 4th ser., VI (1906), pp. 99–180 and 454–89, esp. p. 148.

In the mid-1520s, **Ludovico di Lorenzo Martelli** contributed to the debate about linguistic usage (the "questione della lingua") with a *Risposta all'epistola del Trissino*

delle lettere nuovamente aggiunte and was thus linked to the intellectual activities of the Rucellai group. Upon his departure from Rome, two days before the arrival of the imperial army, he addressed a farewell sonnet, *Gaddo, io men vo lontan dai patri liti*, to Giovanni Gaddi; on the sonnet, see Caro, *Lettere familiari*, esp. 3:92–93 and n. 5. Martelli died before April of 1531. My biographical sketch of Martelli, here and in the main text, is taken from material in Benedetto Croce, *Poeti e scrittori del pieno e del tardo rinascimento*, Vol. I, Scritti di storia letteraria e politica XXXV (Bari: Gius. Laterza & Figli, Tipografi—Editori—Librari, 1945), pp. 281–89. On Ludovico's relationships to Giovanni Gaddi and Ippolito de' Medici, see also H. Colin Slim, "Un coro della 'Tullia' di Lodovico Martelli messo in musica e attribuito a Philippe Verdelot," *Firenze e la Toscana dei Medici nell'Europa del '500*, 3 vols., Biblioteca di Storia toscana moderna e contemporanea, Studi e documenti XXVI (Florence: Leo S. Olschki Editore, 1983), 2:487–511, esp. pp. 488–91, and Marzia Pieri, "La 'Rosmunda' del Rucellai e la tragedia fiorentina del primo Cinquecento," *Il teatro dei Medici, Quaderni di teatro, Rivista trimestrale del Teatro regionale toscano* 2(7) (1980): 96–113, esp. p. 112 and n. 40.

Several of the poetic works by **Jacopo del Bientina** and **Giovan Battista di Cristofano Ottonaio** that were set to music are now readily accessible in *Florentine Festival Music, 1480–1520*, ed. Gallucci, Recent Researches in the Music of the Renaissance XL (Madison, Wisc.: A-R Editions, Inc., 1981), nos. 17, 20–22, 24, and 27, and possibly no. 36. The anonymous *FARSA RECITATA A GLI EXCELSI SIGNORI DI FIRENZE. NELLA QVALE . . . IN LVOGHO DI PROLAGHO* [*sic*] *DI PROEMIO ET ARGVMENTO VNO IN SVLLA LIRA DICE* has been attributed to Bientina: see Alessandro D'Ancona, *Origini del teatro italiano*, 2 vols. (Turin: Ermanno Loescher, 1891), 2:37 n. 2, and Elvira Garbero Zorzi, catalogue entry no. 3.4, *Il luogo teatrale a Firenze: Brunelleschi, Vasari, Buontalenti, Parigi*, Spettacolo e musica nella Firenze medicea, Documenti e restituzioni I (Milan: Electa Editrice, 1975), p. 71. On the introductory verses "one says to the lyre in place of the prologue, proem, and argument," see also Nino Pirrotta, *Music and Theater from Poliziano to Monteverdi*, trans. Karen Eales (Cambridge: Cambridge University Press, 1982), p. 120. Ottonaio became herald of the Signoria in February of 1517; see Maria-Luisa Minio-Paluello, *La «fusta dei matti»: Firenze—San Giovanni 1514, Una barca di folli alla ricerca del metodo nella follia, E umori ed emulazioni fra Firenze, Roma e Venezia, primavera 1514*, Quadrangolo 3. (Florence: Franco Cesati Editore, 1990), p. 145 n. 7, quoting in turn Francesco Filarete, *Libro Ceremoniale della Repubblica*, Archivio di Stato di Firenze, Rep., Carte di Corredo 61, p. 39v. Filarete's text is available in Richard C. Trexler, ed., *The* Libro cerimoniale *of the Florentine Republic by Francesco Filarete and Angelo Manfidi, Introduction and Text*, Travaux d'Humanisme et Renaissance CLXV (Geneva: Librairie Droz S.A., 1978), p. 126: "A dì 24 di febbraio 1517. . . . Havendo . . . Ottonaio chiesto al magnifico . . . Laurenzio . . . de' Medici . . . , el mio ofizio dello heraldo della . . . Signoria di Firenze, . . ."

On **Feo d'Agnolo** and **Talina sonatori**, see Paolo Minucci del Rosso, "Di alcuni personaggi ricordati dal Vasari nella Vita di Gio. Francesco Rustici," *Archivio storico italiano,* 4th series, 3 (1879): 475–82, esp. p. 482. Minucci del Rosso states that Feo and Talina were among those turned out of office by the Medici upon their restoration to Florence in 1512 but provides no documentation. A "Feo tamburino" is mentioned in the "Novella decima" of the "Terza cena" of Antonfrancesco Grazzini's *Le cene;* see the edition of *Le cene* by Riccardo Bruscagli (Rome: Salerno Editrice, 1976), p. 352. Could he be our Feo? A Bastiani (that is, the son of a Bastiano) is listed in 1513 as an instrumentalist of the Signoria in Monte Comune, Camerlingo del Monte, Entrata e Uscita, no. 1877, fol. 410; see Keith Polk, "Civic Patronage and Instrumental Ensembles in Renaissance Florence," *Augsburger Jahrbuch für Musikwissenschaft* 3 (1986): 51–68, esp. 68. The reference could be to Michele di Bastiano. Interestingly, archival references published by Frank D'Accone pertaining to musicians in the employ of Duke Cosimo I de' Medici in the 1540s, 1550s, and 1560s list a Bastiano di Michele *sonatore d'arpa,* whose name is similar, though not identical, to the Michele di Bastiano detto Talina *sonatore di tamburino* hired by the Signoria in 1509. Could one of the sources have reversed his names and misidentified his instrument? See D'Accone, "The Florentine Fra Mauros. A Dynasty of Musical Friars," *Musica disciplina* 33 (1979): 77–137, esp. pp. 134 and 136–37.

Notes

Preface

1. Cochrane's taxonomy appears in a chapter entitled "Institutions of Culture," in *Italy, 1530–1630*, ed. Julius Kirshner, Longman History of Italy (London: Longman, 1988), pp. 55–68. Of course, Cochrane was limiting himself to institutions of secular culture, as distinct from ecclesiastical or religious institutions, such as churches, monasteries and convents, lay confraternities, etc.

2. The term is Paul Oskar Kristeller's; see "Francesco da Diacceto and Florentine Platonism in the Sixteenth Century," *Studies in Renaissance Thought and Letters*, Storia e letteratura, Raccolta di studi e testi 54 (Rome: Edizioni di storia e letteratura, 1956 [reprinted 1969, 1984]), pp. 287–336, esp. p. 301.

3. "la compagnia nostra"

4. "questi amici di meriggio"

5. "que' litterati de l'Orto de' Rucellai"; see Chapter 1, nn. 114 and 115.

6. "Achademia Fiorentina"

7. "Sacro Ginnasio"

8. "Sacra Achademia," or—more loosely—"alcuni huomini da bene litterati et amici." See the documents assembled in Kristeller, "Francesco da Diacceto," pp. 328, 329, 335. Kristeller (p. 301 n. 57) suggested that the modifier "Sacred" was merely a laudatory epithet "in the ancient style" and signified nothing about the substance or nature of the Academy's literary interests, a thesis substantiated by the evidence of the members' specific programmatic activities; see Chapter 2 below.

9. See the excerpts from Giorgio Vasari's *Lives* in Chapter 3, at nn. 2 and 37, for references to the Company of the Cazzuola, and excerpts from Bartolomeo Cerretani's "Sommario e ristretto cavato dalla historia di Bartolomeo Cerrtani, scritta da lui, in dialogo delle cose di Firenze, dal'anno 1494 al 1519" in Chapter 3, n. 61, for references to the Companies of the Broncone and Diamante.

10. "Compagnia" seems to have been the customary Florentine term for many such associations, connoting an informal fraternity or brotherhood. John Shearman has written that "[o]ne of the most characteristic features of the ordinary Florentine man's life in the Renaissance was his participation in the activities of brotherhoods or *compagnie*. These institutions performed various functions, partly religious, partly charitable and also, certainly, convivial; the latter aspect tended with time to assume prominence, but the existence of, for example, dowry funds for harassed fathers, and the regular observance of appropriate feast-days continued to characterize this aspect of corporate life until the general dissolution of the *compagnie* in 1785–6." See Shearman, *Andrea del Sarto*, 2 vols. (Oxford: Clarendon Press, 1965), 1:52.

at the Florentine Cathedral and Baptistery during the First Half of the 16th Century," *Journal of the American Musicological Society* 24 (1971): 1–50; "Transitional Text Forms and Settings in an Early 16th-Century Florentine Manuscript," in *Words and Music: The Scholar's View, A Medley of Problems and Solutions Compiled in Honor of A. Tillman Merritt by Sundry Hands,* ed. Laurence Berman ([Cambridge]: Department of Music, Harvard University, 1972), pp. 29–58; "Matteo Rampollini and His Petrarchan Canzoni Cycles," *Musica Disciplina* 27 (1973): 65–106; "Music and Musicians at Santa Maria del Fiore in the Early Quattrocento," in *Scritti in onore di Luigi Ronga* (Milan: Riccardo Ricciardi Editore, 1973), pp. 99–126; "Singolarità di alcuni aspetti della musica sacra fiorentina del cinquecento," in *Firenze e la Toscana dei Medici nell'Europa del '500,* 3 vols. (Florence: Leo S. Olschki Editore, 1983), 2:513–37; "Updating the Style: Francesco Corteccia's Revisions in His Responsories for Holy Week," in *Music and Context: Essays for John M. Ward,* ed. Anne Dhu Shapiro ([Cambridge]: Department of Music, Harvard University, 1985), pp. 32–53. This is not a complete bibliography of D'Accone's studies, of course, but a representative sampling; the extensive quotations in these writings from archival materials, principally from the ecclesiastical institutions, serve to illustrate the institutional focus of D'Accone's work.

2. Alfred Einstein, *The Italian Madrigal,* three vols., transl. Alexander H. Krappe, Roger H. Sessions, and Oliver Strunk (Princeton, N.J.: Princeton University Press, 1971).

3. The historian Geoffrey Barraclough wrote, "In my view continuity is by no means the most conspicuous feature of history. Bertrand Russell once said that 'the universe is all spots and jumps,' and the impression I have of history is much the same." Barraclough, *An Introduction to Contemporary History* (Baltimore: Penguin Books, 1964), p. 11.

4. Iain Fenlon and James Haar, *The Italian Madrigal in the Early Sixteenth Century: Sources and Interpretation* (Cambridge: Cambridge University Press, 1988), p. 6.

5. In what follows, I am paraphrasing or quoting directly from Rubsamen's arguments in "From Frottola to Madrigal: The Changing Pattern of Secular Italian Vocal Music," in *Chanson and Madrigal, 1480–1530: Studies in Comparison and Contrast, A Conference at Isham Memorial Library, September 13–14, 1961,* ed. James Haar (Cambridge: Harvard University Press, 1964), pp. 51–87, esp. pp. 62–65 and 69–72.

6. In both genres, the music is textually bound and singable throughout the parts, sections of isometric (frottolistic) homophony alternate with those in imitative counterpoint, and sections in ternary meter enliven the basically duple rhythmic pattern; themes are light and folklike, often in repeated notes of equal value.

7. The composition quotes both the text and melody of several folk songs.

8. The composition contains independent voices—now declamatory in nature, now in stepwise movement—as well as the entire compositional apparatus of the chanson, including alternating voice pairs and staggered, partly imitative entrances at the opening.

9. The imitative counterpoint is based on the folk melody.

10. By returning repeatedly to a sustained chord for the exclamation "Deh!"—especially when the superius leaps by an ascending tenth—Festa dramatically underscored the meaning of the word.

11. Although the manuscript had traditionally been thought to be a Florentine manuscript from around 1520, Fenlon and Haar, *Italian Madrigal,* pp. 173–76, argued for its

Roman associations. I believe that it was unquestionably a Florentine manuscript, for reasons argued in a forthcoming study of mine entitled *Florence, Biblioteca Nazionale Centrale, Manuscript Magliabechiana XIX.164–167.*

12. In what follows, I am paraphrasing or quoting directly from Joseph Gallucci, "Festival Music in Florence, ca. 1480–ca. 1520: *Canti Carnascialeschi, Trionfi,* and Related Forms," 2 vols. (Ph.D. diss., Harvard University, 1966), 1:240–47.

13. This is my observation, not Gallucci's.

14. James Haar, "The Florentine Madrigal, 1540–1560," in *Music in Renaissance Cities and Courts: Studies in Honor of Lewis Lockwood,* ed. Jessie Ann Owens and Anthony M. Cummings (Warren, Mich.: Harmonie Park Press, 1997), p. 145.

15. Fenlon and Haar, *Italian Madrigal,* p. 85.

16. Ibid., p. 22, for example; and Stanley Boorman, review of Fenlon and Haar, *Music and Letters* 72 (1991): 236–58, esp. pp. 238–39 and nn. 11–14.

17. Nino Pirrotta, "Music and Cultural Tendencies in 15th-Century Italy," in *Music and Culture in Italy from the Middle Ages to the Baroque: A Collection of Essays* (Cambridge: Harvard University Press, 1984), esp. p. 390 n. 60, "Novelty and Renewal in Italy: 1300–1600," in ibid., esp. pp. 173 and 408 n. 20, and "Rom," *Die Musik in Geschichte und Gegenwart,* 17 vols. (Basel: Im Bärenreiter-Verlag, 1949/51–86), vol. 11, cols. 695–707, esp. col. 706.

18. Richard J. Agee, "Ruberto Strozzi and the Early Madrigal," *Journal of the American Musicological Society* 36 (1983): 1–17; Agee, "Filippo Strozzi and the Early Madrigal," *Journal of the American Musicological Society* 38 (1985): 227–37.

19. Fenlon and Haar, *Italian Madrigal,* p. 41.

20. On the patronage practices and musical experiences of Giulio di Giuliano de' Medici, archbishop of Florence and cardinal from 1513 to 1523 and later Pope Clement VII, see my "Giulio de' Medici's Music Books," *Early Music History* 10 (1991): 65–122, esp. pp. 68–75 and nn. 6–34. Since completing that study, I have found further references to Cardinal Giulio's musical patronage practices, which will be published in a forthcoming article entitled "Three *Gigli.*"

For some representative references to Giuliano di Lorenzo's patronage, see, for example, my "Medici Musical Patronage in the Early Sixteenth Century: New Perspectives," *Studi musicali* 10 (1981): 197–216, esp. p. 205; Allan Atlas, *The Cappella Giulia Chansonnier (Rome, Biblioteca Apostolica Vaticana, C.G. XIII.27),* 2 vols., Musicological Studies 27 (Brooklyn: Institute of Medieval Music, 1975); and Johannes Wolf, ed., *Der Squarcialupi Codex* (Lippstadt: Fr. Kistner & C. F. W. Siegel, 1955), unpaginated introduction (for evidence of his ownership of two manuscripts of polyphonic music that are still extant); A. Pellizzari, *Portogallo e Italia nel secolo XVI* (Naples: Società Editrice F. Perrella, 1914), pp. 150–51; Frank A. D'Accone, "Heinrich Isaac in Florence: New and Unpublished Documents," *Musical Quarterly* 49 (1963): 464–83, esp. p. 481; F. Ghisi, *I canti carnascialeschi nelle fonti musicali del XV e XVI secoli* (Florence: Leo S. Olschki, 1937), pp. 43–44; Richard Sherr, "Verdelot in Florence, Coppini in Rome, and the Singer 'La Fiore,'" *Journal of the American Musicological Society* 37 (1984): 402–11, esp. p. 410; Edward E. Lowinsky, *The Medici Codex of 1518,* 3 vols., Monuments of Renaissance Music, 3–5 (Chicago: University of Chicago Press, 1968), 1:32 n. 24; Richard Sherr, "Lorenzo de' Medici, Duke of Urbino, as a Patron of Music," *Renaissance Studies in Honor of Craig Hugh*

Smyth, 2 vols., ed. Andrew Morrogh et al. (Florence: Giunti Barbèra, 1985), 1:627–38, esp. p. 627; William F. Prizer, *Courtly Pastimes: The Frottole of Marchetto Cara* (Ann Arbor, Mich.: UMI Research Press, 1980), p. 42; Alessandro Luzio, "Isabella d'Este nei primordi del papato di Leone X e il suo viaggio a Roma nel 1514–1515," *Archivio storico lombardo,* 4th ser., 6 (1906): 99–180 and 454–89, esp. p. 148; and Giuliano de' Medici, *Poesie,* ed. Giuseppe Fatini, Centro Nazionale di Studi sul Rinascimento (Florence: Vallechi Editore, 1939), p. 75.

For some representative references to Lorenzo di Piero di Lorenzo's, see Sherr, "Lorenzo de' Medici"; Sherr, "Verdelot," pp. 409–10; H. Colin Slim, "Gian and Gian Maria: Some Fifteenth- and Sixteenth-Century Namesakes," *Musical Quarterly* 57 (1971): 565–74, esp. p. 565; Frank A. D'Accone, "Alessandro Coppini," esp. p. 51 and nn. 69–71 and pp. 75 and 76; D'Accone, "Some Neglected Composers," esp. p. 282 n. 85; D'Accone, "Documentary History," 2:141; D'Accone, "Musical Chapels," esp. p. 16 n. 34; D'Accone, "Heinrich Isaac," p. 481; Ghisi, *I canti,* p. 43 and n. 4 and p. 44; Anthony M. Cummings, "Gian Maria Giudeo, Sonatore del Liuto, and the Medici," *Fontes Artis Musicae* 38 (1991): 312–18; Cummings, "Medici Musical Patronage," p. 207; Luzio, "Isabella de'Este," pp. 148 and 159; Howard Mayer Brown, "Chansons for the Pleasure of a Florentine Patrician," in *Aspects of Medieval and Renaissance Music: A Birthday Offering to Gustave Reese,* ed. Jan LaRue (New York: W. W. Norton & Company, Inc., 1966), pp. 56–66, esp. p. 64 n. 22; and G. L. Moncallero, ed., *Epistolario di Bernardo Dovizi da Bibbiena,* 2 vols., Biblioteca dell'"Archivum Romanicum" 44 and 81 (Florence: Leo S. Olschki, 1955 and 1965), 2:127.

And for some representative references to Ippolito di Giuliano's, see H. Colin Slim, "The Keyboard Ricercar and Fantasia in Italy c. 1500–1550" (Ph.D. diss., Harvard University, 1960), pp. 170–73; Hieronimo Garimberto, *La prima parte delle vite, overo fatti memorabili d'alcuni papi, et di tutti i cardinali passati* (Venice: Appresso Gabriel Giolito de' Ferrari, 1567), p. 515; Paolo Giovio, *Gli elogi: Vite brevemente scritte d'huomini illustri di guerra, antichi e moderni* (Venice: Apresso Giovanni de' Rossi, 1557), fols. 280r–280v; James Haar, "Cosimo Bartoli on Music," *Early Music History* 8 (1988): 37–79, esp. pp. 62 and 65; Giovanni Andrea Gilio da Fabriano, *Due Dialogi* (Camerino: per A. Giojoso, 1564), fol. 7r; and Elzear Geneti, *Opera omnia,* ed. Albert Seay, 5 vols., Corpus mensurabilis musicae 58 (n.p.: American Institute of Musicology, 1972–73), 3:9–12. These last references are now summarized and evaluated in my forthcoming "Three *Gigli.*"

21. For a discussion of another Florentine academy that flourished later in the sixteenth century and an assessment of the music-historical importance of "academic" activities generally, see Claude V. Palisca, "The Alterati of Florence, Pioneers in the Theory of Dramatic Music," in Palisca, *Studies in the History of Italian Music and Music Theory* (Oxford: Clarendon Press, 1994), pp. 408–31, esp. pp. 408–9 and the accompanying notes. See also the essays collected in David S. Chambers and François Quiviger, eds., *Italian Academies of the Sixteenth Century,* Warburg Institute Colloquia, 1 (London: Warburg Institute, 1995).

22. Albert Seay, "The *Dialogus Johannis Ottobi Anglici in arte musica,*" *Journal of the American Musicological Society* 8 (1955): 86–100, esp. p. 99: "Quemadmodum ab Arnulpho Gilardi in insignibus tauxetis Cosmi factum esse didicimus, cuius præceptor missam confecit quam pannum aureum inscripsit cum vellet duci Belgarum callide [persuadere] ut quod aliquod tempus [intermittatur] in honorem divæ Virginis quo tactis mittere non negligeret." My translation

of the reference cited is based on Reinhard Strohm, *The Rise of European Music, 1380–1500* (Cambridge: Cambridge University Press, 1993), p. 318. On Gilardus, see Frank D'Accone, "Some Neglected Composers," esp. pp. 264–71. On the Medici garden later in the fifteenth century, its location, and the function it served, see Caroline Elam, "Lorenzo de' Medici's Sculpture Garden," *Mitteilungen des Kunsthistorischen Institutes in Florenz* 36 (1992): 41–84.

23. Strohm, *Rise of European Music,* p. 318.

24. See Marco Sabino's dedication to Uberto Strozzi of his edition of the *INSTIT-VTIONI di Mario Equicola al comporre in ogni sorte di Rima della lingua volgare, con vno eruditissimo Discorso della Pittura, & con molte segrete allegorie circa le Muse & la Poesia.* (In Milano, l'Anno 1541): "Al Molto Magnifico & ornatissimo Caualiere, il Signor Uberto Strozzi Gentil'huomo Mantouano, Marco Sabino .S.... non prima da Napoli a Roma foste venuto, che la vostra Casa fu consagrata alle Muse, & diuentò il diporto di tutti i piu famosi Academici che fossero in Corte, iquali quasi ogni giorno faccendo iui il suo Concistoro, il Berni delle sue argute facetie, il Mauro delle sue attrattiue piaceuolezze, Mons. dalla Casa, all'hora in minoribus, de suoi ingegnosi concetti .M. Lelio Capilupo, l'Abate Firenzuola, M. Gio. Francesco Bini, & l'ameno Giouio da Lucca con molti altri, de' loro dilettevoli Capricci in presentia di V.S. nelli vostri musici conuiuij dottamente parlauano, riportandosi tutti al giudicio di due seueri Censori, cio è del molto auueduto Signor Pietro Ghinucci, et del scaltrito .M. Federigo Paltroni. Ne lascerò di dire, che iui i marauigliosi dicitori d'improuiso Gio. Batista Strozzi, il Pero, Niccolo Franciotti, & Cesare da Fano, sopra i soggetti impostigli all'improuista et prontissimamente cantando, riempieuano i petti di chi gli vdiua non di minor piacere, che di stupore." The "Gio. Batista Strozzi" mentioned in Sabino's dedication as one of the "marauigliosi dicitori d'improuiso" is presumably the same Giovan Battista di Lorenzo di Filippo Strozzi who, as a boy, played a role in Lorenzo di Filippo Strozzi's "Commedia in versi," performed in the Palazzo Medici in September of 1518 on the occasion of the wedding of Lorenzo di Piero de' Medici and Madeleine de la Tour d'Auvergne, especially since Strozzi was complimented for the evident "prontezza della [his] pronunzia" on that occasion; see Alessandro Parronchi, "La prima rappresentazione della Mandragola," *La bibliofilia* 64 (1962): 80–81. On Strozzi and his literary activity, see Lorenzo Bianconi and Antonio Vassalli, "Circolazione letteraria e circolazione musicale del madrigale: il caso Giovan Battista Strozzi," *Firenze e la Toscana dei Medici nell'Europa del '500,* 2:439–55. On the importance of gardens generally in the culture of the Rome of Leo X, see Domenico Gnoli, "Orti letterarî nella Roma di Leon X," *Nuova antologia, Rivista di lettere—scienze ed arti,* anno 65°—fascicolo 1387 (1930), pp. 3–19, and fascicolo 1388 (1930), pp. 137–48.

25. On Vignaiuoli member Francesco Berni and his literary activity, see James Haar, "Florentine Madrigal," nn. 19–20 and the accompanying text. On a polyphonic setting by Willaert of Vignaiuoli member Lelio Capilupo's *ballata Ne l'amar e fredd'onde si bagna,* see Martha Feldman, *City Culture and the Madrigal at Venice* (Berkeley: University of California Press, 1995), p. 63.

26. See Vittorio Fanelli, *Ricerche su Angelo Colocci e sulla Roma cinquecentesca* (Vatican City: Biblioteca Apostolica Vaticana, 1979), p. 117.

27. J. G. A. Pocock, *The Machiavellian Moment: Florentine Political Thought and the Atlantic Republican Tradition* (Princeton, N.J.: Princeton University Press, 1975).

28. See Raymond de Roover, *The Rise and Decline of the Medici Bank, 1397–1494* (Cambridge: Harvard University Press, 1963), pp. 28–31, 75, 95.

29. As the material assembled in Chapter 4 suggests.

30. See, for example, the following by Jonathan Glixon: "*Con canti et organo:* Music at the Venetian *Scuole Piccole* during the Renaissance," in *Music in Renaissance Cities and Courts,* pp. 123–40; "Music and Ceremony at the *Scuola Grande* di San Giovanni Evangelista: A New Document from the Venetian State Archives," in *Crossing the Boundaries: Christian Piety and the Arts in Italian Medieval and Renaissance Confraternities* (Kalamazoo: Western Michigan University, 1991), pp. 56–89; "Music at the *Scuole* in the Age of Andrea Gabrieli," in *Andrea Gabrieli e il suo tempo* (Firenze: Olschki, 1987), pp. 59–74; "A Musicians' Union in Sixteenth-Century Venice," *Journal of the American Musicological Society* 36 (1983): 392–421; and "Music at the Venetian *Scuole Grandi,* 1440–1540," in *Music in Medieval and Early Modern Europe: Patronage, Sources and Texts,* ed. Iain Fenlon (Cambridge: Cambridge University Press), pp. 193–208. See most recently Glixon's monumental, full-length study of the scuole and related institutions of Venetial musical patronage, *Honoring God and the City: Music at the Venetian Confraternities, 1260–1806* (Oxford: Oxford University Press, 2003).

31. Martha Feldman, "The Academy of Domenico Venier, Music's Literary Muse in Mid-*Cinquecento* Venice," *Renaissance Quarterly* 44(3) (1991): 476–512. See also Feldman's book *City Culture and the Madrigal at Venice* (Berkeley: University of California Press, 1995).

32. I am referring to the phenomenon of the "cantasi come" rubrics, where a given lauda text is designated in a sixteenth-century source as "cantasi come" (i.e., "sung like") a given canto carnascialesco whose title is specified.

33. See Feldman, "Academy of Domenico Venier," pp. 501–2, and its reflection in Anne MacNeil, *Music and Women of the Commedia dell'Arte in the Late Sixteenth Century,* Oxford Monographs on Music (Oxford: Oxford University Press, 2003), p. 43 and n. 19.

34. Doni, after all, has Verdelot claim that he himself composed at least one work in the carnival song tradition; see Anton Francesco Doni, *I marmi,* ed. Ezio Chiòrboli, 2 vols. (Bari: Gius. Laterza & Figli, 1928), 1:203: "Giá feci un canto per carnesciale, che diceva di cotesta novella: *Il canto de' pescatori senza frugatoio,* si chiamava, cred'io." For assistance with this passage and its context, I am grateful to Linda L. Carroll.

35. Bernard Bailyn, *Education in the Forming of American Society: Needs and Opportunities for Study* (New York: W. W. Norton & Company, 1960), pp. 85–86.

36. See my article "Giulio de' Medici's Music Books," esp. pp. 97–100.

37. Iain Fenlon, "Context and Chronology of the Early Florentine Madrigal," *La Letteratura, La Rappresentazione, La Musica al tempo e nei luoghi di Giorgione,* ed. Michelangelo Muraro (Rome: Società Editoriale Jouvence, 1987), pp. 281–93, esp. p. 284. Fenlon observed that the French chanson was one of the important elements in the Florentine musical culture of the early sixteenth century from which the madrigal emerged and, further, that the chanson was disseminated in Italy in four distinct manuscript traditions between 1460 and 1525, the last of which is specifically Florentine and comprises sources assembled in Florence during the second and third decades of the century: Florence, Biblioteca del Conservatorio, MS Basevi 2442, and Florence, Biblioteca Nazionale Centrale, MSS Magliabechi XIX.107[bis], Magliabechi XIX.117, Magliabechi XIX.121, and Magliabechi XIX.164–67.

38. James Haar, "The Early Madrigal: A Re-Appraisal of Its Sources and Its Character," in *Music in Medieval and Early Modern Europe: Patronage, Sources and Texts,* ed. Iain Fenlon (Cambridge: Cambridge University Press, 1981), pp. 163–92, esp. pp. 189–90 and p. 191 n. 167. Haar suggested (p. 189) that the madrigal's "roots are in the French chanson—not that of Claudin or Janequin but an earlier one, represented by the simpler pieces, sometimes dubbed 'modern' in style, in Petrucci's *Odhecaton, Canti B,* and *Canti C."* Thus both Haar and Fenlon (see the preceding note) identify a French polyphonic antecedent for the madrigal, whereas I shall be arguing for the importance of specifically Florentine musical antecedents for what was, at least in its initial phases, a specifically Florentine genre.

39. Pirrotta, "Novelty and Renewal," p. 173.

40. John Shearman, "The Florentine *Entrata* of Leo X," *Journal of the Warburg and Courtauld Institutes* 38 (1975): 136–54, esp. p. 146 n. 30.

Chapter One

1. Steven E. Ozment, *Homo Spiritualis: A Comparative Study of the Anthropology of Johannes Tauler, Jean Gerson, and Martin Luther in the Context of Their Theological Thought,* Studies in Medieval and Reformation Thought 6 (Leiden: E. J. Brill, 1969), p. ix.

2. There is much regarding the Rucellai gardens that has not been treated sufficiently thoroughly in the musicological literature; moreover, I wish to place the activities of the Rucellai group in a broader context.

3. See J. R. Hale, *Florence and the Medici: The Pattern of Control* (New York: Thames and Hudson, 1977), pp. 87–94.

4. On Rucellai and the family gardens, see, above all, Felix Gilbert, "Bernardo Rucellai and the Orti Oricellari: A Study on the Origin of Modern Political Thought," *Journal of the Warburg and Courtauld Institutes* 12 (1949): 101–31, to which the following paragraphs are heavily indebted; for substantiation of the material in the foregoing sentences, see esp. pp. 108–10. On the Orti Oricellari, see also Gianandrea Piccioli, "Gli Orti Oricellari e le istituzioni drammaturgiche fiorentine," *Contributi dell'Istituto di filologia moderna, Serie Storia del teatro* I, Pubblicazioni dell'Università Cattolica del Sacro Cuore, Contributi, Serie terza: Scienze, filologiche, e letteratura 17 (1968): 60–93. On Rucellai's voluntary exile in Provence and his intellectual activity during this time, see also Eric Cochrane, *Historians and Historiography in the Italian Renaissance* (Chicago: University of Chicago Press, 1981), p. 30 and the accompanying notes. On Rucellai's 1506 departure for Provence, see H. C. Butters, *Governors and Government in Early Sixteenth-Century Florence, 1502–1519* (Oxford: Clarendon Press, 1985), p. 108. That the Rucellai were among the very wealthiest of Quattrocento-Florentine families (see Raymond de Roover, *The Rise and Decline of the Medici Bank, 1397–1494* [Cambridge: Harvard University Press, 1963], pp. 30–31) suggests the economic basis for their robust patronage practices.

5. See Pietro Crinito's poem "Ad Faustum: De sylva Oricellaria," in his *Commentarij De Honesta Disciplina* (Florence: Florentię impressum est hoc opus Petri Criniti: opera & impensa Philippi de Giunta bibliopolę flore[n]tini. anno salutis M.D.IIII. cale[n]dis de-

cembris): "Sic ille nil miratur actus principum / Nec sceptra regum suspicit / Sed in virenti detinetur gramine." The translation is from Gilbert, "Bernardo Rucellai and the Orti Oricellari," p. 109 and n. 3.

6. On the reference to Fièsole's position overlooking the gardens, see Crinito, "Ad Faustum": "Hinc sat videbis alta Flora mœnia / Et Fæsulas bivertices."

7. *Machiavelli and Guicciardini: Politics and History in Sixteenth-Century Florence* (Princeton, N.J.: Princeton University Press, 1965), pp. 203–4. On Pontano's academy, see also Cochrane, *Historians and Historiography,* p. 151.

8. Delio Cantimori, "Rhetoric and Politics in Italian Humanism," *Journal of the Warburg Institute* 1 (1937–38): 83–102, esp. p. 87. On this tradition, see also Gilbert, "Bernardo Rucellai and the Orti Oricellari," p. 126.

9. Machiavelli, *Arte della guerra e scritti politici minori,* ed. Sergio Bertelli, Niccolò Machiavelli, Opere II, Biblioteca di classici italiani 8 (Milan: Giangiacomo Feltrinelli Editore, 1961), pp. 329–30. My English translation is taken from Machiavelli, *The Chief Works and Others,* trans. Allan Gilbert, 3 vols. (Durham, N.C.: Duke University Press, 1965), 2:569–70. As Linda L. Carroll observed, Lorenzo di Piero de' Medici held the title "Duke of Urbino" in the three years between the 1516 conquest of Urbino and his death in 1519; the scene Machiavelli describes can therefore be dated in those years (assuming its historicity, of course).

10. Gilbert ("Bernardo Rucellai and the Orti Oricellari," p. 114 and n. 1) was among those who made the assertion about the display of statues, based on Eugène Müntz, *Les Collections des Médicis au XVe siècle: Le musée.—La bibliothèque.—Le mobilier,* Bibliothèque internationale de l'art (London: Gilbert Wood & Co., and Paris: Jules Rouam, Éditeur, 1888), p. 107. Müntz in turn based his assertion on Angelo Maria Bandini, *CATALOGVS CODICVM LATINORVM BIBLIOTHECÆ MEDICÆ LAVRENTIANÆ,* 4 vols. (Florence: Præsidibvs Adventibvs, 1774–77), vol. 3, col. 486, where Verini's letter is published, which Müntz quoted as evidence that "Un certain nombre de statues [theretofore belonging to the Medici] trouvèrent un asile chez les Ruccellai [*sic*], dans les *Orti Oricellarij* ": "Eiusdem Simoni Canisiano Epist. LXIX. Cum Cosmo Oricellario magna est tibi familiaritas; is habet vetustissimas imagines æreas, & argenteas, non solum Romanorum Principum, sed Oratorum, & Poëtarum, quas doctissimus pater eius, partimque avunculus Medices, ex toto orbe collegit. Proinde quum sis quoque tu studiosorum hominum amator, velim inquiras, si aut Ciceronis, aut Virgilij, vel Plinij ulla cum inscriptione cum illis reperiatur, & per pictorem insignem imago pingatur. Arduum est imaginem effingere ex vero, sed longe difficillima imitatio est imitationis. Quorum doctrinam imitamur, delectat habere figuras, quæ Persicis gazis nobis erunt chariores. Vale." But since Verini died in 1483 (as was indicated by Bandini, *CATALOGVS,* col. 461 n. 1), his letter is a fifteenth-century reference and therefore cannot constitute evidence that art objects from the Medici collection were displayed in the Rucellai garden in the early sixteenth century. On Guarino's characterization of the limitations of paintings and statues, see Michael Baxandall, *Giotto and the Orators: Humanist Observers of Painting in Italy and the Discovery of Pictorial Composition, 1350–1450,* Oxford-Warburg Studies (Oxford: Clarendon Press, 1971), p. 90.

11. Gilbert, "Bernardo Rucellai and the Orti Oricellari," p. 114, and Piccioli, "Gli Orti Oricellari," p. 74. Documentation for their assertion about the house that Rucellai had had constructed in the garden is provided by Giorgio Vasari in the life of Leon Batista Alberti (*Le opere con nuove annotazioni e commenti di Gaetano Milanesi,* 9 vols. [Florence: G. C. Sansoni, Editore, 1878–85], 2:542–43). Documentation for their assertion about the benches is provided by Machiavelli's account in the *Arte della guerra,* pp. 329–30.

12. Von Albertini, *Firenze dalla repubblica al principato, Storia e coscienza politica,* 2d ed., trans. Cesare Cristofolini, Biblioteca di cultura storica, 109 (Turin: Giulio Einaudi s.p.a., 1970), pp. 69–70.

13. Stephen Greenblatt, *Renaissance Self-Fashioning: From More to Shakespeare* (Chicago: University of Chicago Press, 1980).

14. Hale, *Florence and the Medici.*

15. Throughout this study, the terms "member," "members," and "membership" are used loosely, because the sources rarely permit a more discriminating usage. In some instances, the individual in question clearly enjoyed the benefits of "full membership"; he may have participated in the institution's activities with great regularity, for example, or have been regarded by his fellows as critical to the institution's ability to realize its objectives (for example, Luigi Alamanni, Francesco Guidetti, or Niccolò Machiavelli, in the case of the Rucellai group). In other instances, the individual attended infrequently, or even only once (at least according to the testimony of the sources), and in such instances can scarcely be considered a "member" at all (for example, La Nannina Zinzera cortigiana, in the case of the Rucellai group). Clearly, there were different degrees of involvement with the institutions' activities and corresponding levels of membership. One potentially useful index of membership status is the extent and nature of the documentary record attesting individuals' relationships to the institution. Individuals whose participation in the activities of the Rucellai group is attested by multiple sources, or by sources of more than one type—private correspondence *and* a contemporary history or two *and* a contemporary literary work or two (e.g., a *dialogo*)—may be likelier to have been full members than those whose more infrequent attendance resulted in a single documentary witness, or one that is less consequential as evidence, or one that has a more questionable epistemological status. In every instance, the documentary basis for our knowledge of the membership roster of the various institutions is reviewed and specified (see Tables 1, 2, 4, and 5, and see the reconstruction of the membership of the Company of the Cazzuola at the beginning of Chapter 3); the memberships are summarized, and the overlap in membership illustrated, in Table 6 at the beginning of the Conclusion.

16. See Pietro Crinito, *De Honesta Disciplina,* Book 2, Chapter 14, Book 5, Chapter 14, and Book 11, Chapter 12, which I consulted in the edition of Carlo Angeleri, Edizione nazionale dei classici del pensiero italiano, serie II, 2 (Rome: Fratelli Bocca Editori, 1955), pp. 98–99, 156–57, and 256–57.

17. The testimony of Crinito's text as to the approximate dates of this initial phase of activity is substantiated by Filippo de' Nerli's *Commentarij dei fatti civili occorsi dentro la città di Firenze.* Nerli refers to Rucellai's "voluntary exile, which he had undertaken shortly after the [1502] elevation of Piero Soderini to *gonfaloniere;* however, [Rucellai] had returned to

Florence from his voluntary exile, and in his most delightful garden citizens would often meet, and especially a particular sort of young person who had begun to run afoul of the *gonfaloniere.*" Nerli, *COMMENTARIJ DEI FATTI . . . DALL'ANNO 1215 AL 1537,* which I consulted in the two-volume edition of 1859 (Trieste: Colombo Coen Tip. Editore). The reference here is from 1:158: "volontario esilio, che s'era preso poco dopo l'assunzione di Piero Soderini al Supremo Magistrato; però se n'era ritornato a Firenze, e nel suo molto dilettevol giardino convenivano spesso de' cittadini e massimamente una certa qualità di giovani che avevano cominciato ad urtare il Gonfaloniere." On the chronology of Rucellai's 1502 departure from the city upon Soderini's election, his return, and the beginning of the meetings in the family garden, see Butters, *Governors and Government,* pp. 48 and 59.

18. I.e., Giovanni Corsi.

19. I.e., Francesco da Diacceto *"il Nero."* See Crinito, *De Honesta Disciplina,* Book 11, Chapter 12 (p. 256 in the Angeleri edition).

20. See Book 3, Letter 5, in Bartolomeo Fonzio, *Epistolarum Libri III,* ed. Ladislaus Juhász, Bibliotheca Scriptorum Medij Recentisque Ævorum, Sæc. XV–XVI (Budapest: Királyi Magyar Egyetemi Nyomda, and Florence: Messaggerie italiane, 1931), p. 49.

21. See Gelli, *Opere,* ed. Agenore Gelli (Florence: Felice Le Monnier, 1855), pp. 292–93: "Bartoli . . . e massimamente quando essi parlatori hanno atteso a le lettere, esercitandosi in gli studij, come ne' tempi de la tua fanciullezza erano Bernardo Rucellai, Francesco da Diacceto, Giovanni Canacci, Giovanni Corsi, Piero Martelli, Francesco Vettori e altri litterati che allora si ragunavano a l'orto dei Rucellai, dove tu, quando potevi tal volta penetrare in maniera alcuna, stavi con quella reverenza e attenzione a udirli parlare tra loro, che si ricerca proprio a gli oracoli. E di più mi ricorda ancora averti sentito dire che andavi sì volentieri, quando ci venivano ambasciatori, a udirli fare l' orazioni, essendo in que' tempi usanza che parlassino la prima volta pubblicamente."

22. As is suggested by his correspondence with Rucellai; see especially Fonzio, *Epistolarum Libri III.* In one of his letters, Fonzio flatters Rucellai with a compliment that compares him, as author of the *De Bello Italico,* to Caesar; see Cochrane, *Historians and Historiography,* p. 30 and the accompanying note.

23. As is suggested by references in the works of Giovanni Corsi to relationships between Rucellai and Pazzi and between Rucellai and Ricasoli, specifically (1) the foreword to Corsi's 1508 edition of Pontano's *De Prudentia* and (2) his 1506 biography of Marsilio Ficino, the earliest biography of Ficino, which is dedicated to Ricasoli; see Gilbert, "Bernardo Rucellai and the Orti Oricellari," p. 118. For the references in the foreword to Corsi's edition of Pontano's *De Prudentia* that suggest a relationship between Bernardo Rucellai and Cosimo de' Pazzi, see Phil. Villani, *Liber de civitatis Florentiæ famosis civibus,* ed. G. C. Galletti (Florence: J. Mazzoni, 1847), p. 214. Corsi's life of Ficino, *Commentarivs de platonicæ philosophiæ post renatas litteras apvd Italos instavratione, sive Marsilij Ficini vita, avctore Ioanne Corsio,* which contains the references suggesting Rucellai's relationship to Ricasoli, has been edited by Angelo Maria Bandini (Pisa: apud Augustinum Pizzorno, 1771) and by Raymond Marcel in *Marsile Ficin, 1433–1499,* Les classiques de l'humanisme, Collection publiée sous le patronage de L'Association Guillaume Budé (Paris: Société d'Édition «Les belles lettres,» 1958), pp. 680–89. Corsi's dedication to Ricasoli is on p. 680 of Marcel's edi-

tion; on the dedication, see also Paul Oskar Kristeller, "Per la biografia di Marsilio Ficino," in *Studies in Renaissance Thought and Letters,* Storia e letteratura, Raccolta di studi e testi, 54 (1956, 1969; reprint, Rome: Edizioni di storia e letteratura, 1984), pp. 191–211, esp. p. 192.

24. "called *'il Nero'*"

25. "surnamed *'il Pagonazzo* [the Purple]'" from his customary dress.

26. "called . . . *'il Diaccetino'*"

27. Von Albertini, *Firenze dalla repubblica al principato,* p. 69.

28. Jacopo Nardi, *Istorie della città di Firenze,* pub. per cura di Agenore Gelli, 2 vols. (Florence: F. Le Monnier, 1858), 2:71–72: "Iacopo . . . non . . . chiamato per altro nome che il Diaccetino: perciò che erano duoi altri della medesima famiglia uomini dotti, uno de' quali era Francesco da Diacceto cognominato il Pagonazzo . . . e l'altro Francesco da Diacceto vocato il Nero. . . . [E] costui [i.e., "il Diaccetino"] e Zanobi Buondelmonti e Luigi Alamanni erano stati molto frequenti amici e compagni di Cosimo, chiamato Cosimino perciò che esso era stato postumo, cioè nato dopo la morte di Cosimo figliuolo maggiore di Bernardo Rucellai: e col detto Cosimino conversavano quasi continuamente nel . . . orto dei Rucellai insieme con quegli altri Diacceti nominati di sopra, come facevano molti altri uomini dotti. . . . [A] questo Cosimo e agli altri compagni aveva già scritto e dedicato Niccolò Machiavelli i suoi Discorsi. . . . Per il che detto Niccolò era amato grandemente da loro . . . e della sua conversazione si dilettavano maravigliosamente, tenendo in prezzo grandissimo tutte l'opere sue."

29. See Machiavelli, *The Prince and the Discourses,* with an introduction by Max Lerner, Modern Library College Editions (New York: Random House, Inc., 1950), p. 101.

30. See Paul Oskar Kristeller, "Francesco da Diacceto and Florentine Platonism in the Sixteenth Century," in *Studies in Renaissance Thought and Letters,* pp. 287–336, esp. p. 300 n. 52.

31. Nerli, *Commentarij dei fatti civili occorsi dentro la città di Firenze,* 2:12–13: "avendo convenuto assai tempo nell'orto de'Rucellai una certa scuola di giovani letterati e d'elevato ingegno, mentrechè visse Cosimo Rucellai, . . . infra'quali praticava continuamente Niccolò Machiavelli (e io ero di Niccolò, e di tutti loro amicissimo, e molto spesso con loro conversavo) s'esercitavano costoro assai, mediante le lettere, nelle lezioni dell'istorie e sopra di esse, ed a loro istanza compose il Machiavello quel suo libro de' discorsi sopra Tito Livio, e anco il libro di que' trattati e ragionamenti sopra la milizia. Laonde andavano costoro pensando, per imitare gli antichi d'operare qualche cosa grande, che gl'illustrasse; e fermarono l'animo a fare una congiura contro al Cardinale e non considerarono bene nel congiurare a quello, che il Machiavello nel libro de' suoi discorsi aveva scritto loro sopra le congiure, che se bene lo avessero considerato, o non l'avrebbero fatto, o se pure fatto l'avessero, almeno più cautamente proceduti sarebbono. Furono i capi di tal congiura Zanobi Buondelmonti e Luigi Alamanni; disegnarono costoro d'ammazzare il Cardinal de'Medici, e così ridurre la città a governo libero, e rendere al popolo la libertà, come l'aveva innanzi al 1512, e dopo la morte di [Pope] Leone [X, in 1521] mandarono Batista della Palla, ch'era congiurato con loro, al Cardinale de'Soderini, mostrando, che Batista per qualche sdegno si fosse partito da Firenze malcontento del Cardinal de'Medici, acciocchè praticasse, come nimico de'Medici, col Cardinal Soderino e potesse, come fuoruscito, fare fuori col Signor Renzo da Ceri e co' Soderini."

The participation of Luigi Alamanni, Zanobi Buondelmonti, and Cosimino Rucellai is also confirmed by Gelli, *Ragionamento,* in his *Opere,* ed. Agenore Gelli (Florence: Felice Le Monnier, 1855), p. 311; see the passage quoted at n. 100 below.

32. Nerli recounted that it was as a result of discussions prompted by Machiavelli's composition of his *Discourses* on Livy and the *Arte della Guerra* that members of the Rucellai group, "in order to imitate the ancients in . . . some great matter," "fixed their minds on . . . a plot against the cardinal, and in conspiring, they did not consider well what Machiavelli had written about conspiracies in the book of *Discourses* written for them, for if they had . . . , either they would not have done it or . . . at least . . . would have proceeded more cautiously." "The heads of the conspiracy were Zanobi Buondelmonti and Luigi Alamanni; they contrived to murder the cardinal [Giulio de' Medici] and thus restore the city to free government and return liberty to the people, as it was before 1512, and after the death [in 1521] of Pope Leo X [Giovanni di Lorenzo de' Medici], they sent Batista della Palla, who had conspired with them, to Cardinal [Francesco] Soderini [Piero's brother]." See Nerli, *Commentarij dei fatti civili occorsi dentro la città di Firenze,* pp. 12–13.

33. See Machiavelli, *Arte della guerra,* pp. 325–520. Kristeller, "Francesco da Diacceto," p. 300 n. 52, also cites correspondence to and from Machiavelli as evidence that perhaps corroborates the testimony of Nardi's and Nerli's accounts as to the membership during this phase: among Machiavelli's correspondents in precisely this period were Zanobi Buondelmonti, Filippo de' Nerli, and Batista della Palla; their letters to Machiavelli make mention of *"la compagnia nostra"* and *"questi amici di meriggio,"* which must be oblique references to the Rucellai group, and of Luigi [Alamanni?], Zanobi, *il Diaccetino,* il Guidetto, and Batista della Palla. In addition, Machiavelli's 17 December 1517 letter to Luigi Alamanni's brother Ludovico makes mention of Buondelmonti, Nerli, della Palla, and Cosimino. Machiavelli's correspondents also make mention of other figures not identified in Nardi's and Nerli's accounts (an Alexandro [de' Pazzi?], an Antonfrancesco [degli Albizzi?], Jacopo Nardi, and Pierfrancesco Portinari), and Machiavelli's letter to Ludovico Alamanni makes mention of Anton Francesco delli Albizzi. I consulted these letters in the edition of Franco Gaeta, Niccolò Machiavelli, *Lettere,* Niccolò Machiavelli, Opere VI, Biblioteca di classici italiani 6 (Milan: Giangiacomo Feltrinelli Editore, 1961), nos. 170, 174, 176, 177, and 178. Machiavelli's *Dell'occasione,* which is addressed to Nerli, is further evidence of their relationship; see Machiavelli, *Tutte le opere,* ed. Mario Martelli (Florence: Sansoni Editore, 1971), p. 987.

34. See the *Lezioni* in the *Opere,* 2 vols., Biblioteca classica italiana, Secolo XVI., No. 6. (Trieste: Dalla sezione letterario-artistica del Lloyd Austriaco, 1859), 2:718: "Siccome tra' Latini è dubbio chi fosse il ritrovatore de' versi elegi, di maniera che ancora pende la quistione: così non è certo fra i Toscani che colui fosse, il quale primo i versi sciolti, o vero senza rima ponesse in uso. Conciosia cosa che alcuni cotale ritrovamento di M. Giovangiorgio Trissino dicono che fu, e alcuni a M. Luigi Alamanni l'attribuiscono, allegando sì molte altre delle sue opere, e sì principalmente la Coltivazione. Noi di ciò, non sapendone la certezza altro non diremo, eccetto che se per conghiettura a valere avesse, penderemmo nella parte del Trissino sì per lo essere egli alquanto più antico stato e prima fiorito dell'Alammani: e sì perchè mi ricorda che già, essendo io fanciullo, con Zanobi Buondelmonti e Nicolò Machiavelli, M. Luigi essendo garzone andava all'orto de' Rucellai, dove insieme con M.

Cosimo e più altri giovani udivano il Trissino, e l'osservavano più tosto come maestro o superiore, che come compagno o eguale."

35. Brucioli's references to Guidetti, Lascaris, and Trissino are in the "Dialogo V," "Del modo dello instruire i figliuoli," of his *Dialoghi* [*della morale filosofia*], which is set in the gardens; see Brucioli, *Dialogi* [*della morale filosofia*], ed. Aldo Landi, «Corpus reformatorum Italicorum» (Chicago: The Newberry Library; Naples: PRISMI, Editrice Politecnica Napoli, 1982), pp. 71–94, for example, pp. 72–73, where the participation of Alamanni and Buondelmonti is also confirmed. Brucioli cast Guidetti, Cosimino, and Trissino in the role of *interlocutore*. Gelli's reference to Trissino is in the *Ragionamento*, p. 305 (see n. 96 below); his reference to Guidetti is in ibid., pp. 310–11, where the participation of Alamanni and Buondelmonti is confirmed (see n. 100 and the accompanying text below); his reference to Lascaris is in the "*RAGIONAMENTO IV.*" of *I capricci del Bottaio*, which I consulted in the edition in the Biblioteca Berenson at Villa I Tatti, the Harvard University Center for Italian Renaissance Studies in Florence (n.p., 1619), pp. 56–57. The text is also quoted in Henri Hauvette, *Un exilé florentin a la cour de France au XVIᵉ Siècle: Luigi Alamanni (1495–1556), Sa vie et son oeuvre* (Paris: Librairie Hachette & Cⁱᵉ, 1903), p. 18 n. 1 (see the following note). I should note that Varchi, in the *Lezioni*, also attested the participation of Trissino. Gelli's reference is to "M. Costantino Lascari," but this must be a confusion of Constantine with Janus Lascaris: Constantine Lascaris died in 1501, before even the first phase of activity of the Rucellai group (for assistance on this point, I am grateful to Professor Deno J. Geanakoplos of Yale University). On the place of the *Capricci* in the debate about language, see Robert A. Hall Jr., *The Italian Questione della Lingua: An Interpretative Essay*, University of North Carolina Studies in the Romance Languages and Literature, No. 4 (Chapel Hill: University of North Carolina Press, 1942), esp. pp. 18–19, 58; Gelli adopted an "antiarchaicist" perspective, arguing for freedom in linguistic usage and the virtues of neologism in enriching a language.

36. See Gelli, *I capricci*, pp. 56–57: "io mi ricordo gia sentir dire, che M. Constantino Lascari, quel greco, di chi questi moderni fanno si grande stima; usò di dir nell'orto de' Rucellai à tavola ... che non conosceva il Boccaccio inferiore ad alcuno loro scrittore greco, quanto alla facondia ed al modo del dire; et che stimava il suo Cento novelle, quanto cento de' loro Poeti." In the translation, I have substituted the name "Janus" for "M. Constantino," for the reasons given in the preceding note.

37. Nardi, *Istorie della città di Firenze*, 2:74–77; Nerli, *Commentarij dei fatti civili occorsi dentro la città di Firenze*, 2:13–14. Both mention Alamanni, Buondelmonti, and Jacopo da Diacceto as conspirators; Nerli adds the name of della Palla. Both (Nardi, p. 73; Nerli, p. 14) also mention Luigi [di Tommaso] Alamanni, who is not to be confused with either our madrigal poet Luigi di Piero or his brother Ludovico. Indeed, at this point, I must distinguish carefully between the brothers Ludovico di Piero and Luigi di Piero Alamanni, which some authors have failed to do. In the index to Iain Fenlon and James Haar's *The Italian Madrigal in the Early Sixteenth Century: Sources and Interpretation* (Cambridge: Cambridge University Press, 1988), for example, the entry for Alamanni reads "Alamanni, Lodovico (Luigi)" (p. 363), which clearly indicates that Fenlon and Haar assumed they were identical. That they cannot have been is proved, for example, by evidence like that given in

n. 44 below, which also suggests the importance of distinguishing carefully between them. Later, I shall discuss in more detail the significance of the distinction between the two for understanding the historical circumstances behind the emergence of the madrigal.

38. On Brucioli's *Dialoghi* and the evidence they contain for the activity of the Rucellai group, see n. 35 above.

39. "On the administration of the family." See Cantimori, "Rhetoric and Politics," pp. 90–91 n. 6.

40. "On friendship." See ibid., p. 91 and n. 1.

41. See n. 35 above on the dialog entitled "On the method of educating children," which suggests the participation of Luigi di Piero Alamanni, Buondelmonti, Cosimino, Guidetti, Lascaris, and Trissino.

42. Biobibliographical information about many of those who frequented the Rucellai gardens is relegated to the Appendix. In other cases, the information is important enough to an understanding of the Rucellai group that it is summarized here, specifically in order to convey some sense of the cultural distinction of the membership and the cultural ambiente of a setting that may well have been frequented by such important early madrigalists as Layolle, Pisano, and Verdelot. Such information has been summarized especially in those cases in which the members were engaged in professional activities typifying the program of the Rucellai group, such as classical scholarship or other kinds of literary activity; in addition, short biographical profiles have been developed for those musicians known to have been members (or intimates of members) of the group.

43. This is suggested by Alamanni's important political treatise of 1516, the "Discorso di Lodovico Alamanni sopra il fermare lo stato di Firenze nella devozione de' Medici," which is published in von Albertini, *Firenze dalla repubblica al principato,* pp. 376–84, and extensively discussed in Gilbert, *Machiavelli and Guicciardini,* and his contribution to the poetic anthology *Lauretum, sive carmina in laudem Laurentij Medicis* (n.p., n.d.), probably issued at the time of Lorenzo de' Medici the Younger's wedding in 1518. See Francesco Bausi, "Politica e poesia: il 'Lauretum,'" *Interpres* 6 (1985–86): 214–82, esp. p. 250. For bringing this article to my attention, I am grateful to Dr. Julian Kliemann of the Bibliotheca Hertziana in Rome. For Alamanni's other important associations with the Medici, see von Albertini, *Firenze dalla repubblica al principato,* p. 33 n. 2.

44. For the texts of the letters and a discussion of their music-historical significance, see H. Colin Slim, *A Gift of Madrigals and Motets,* 2 vols. (Chicago: University of Chicago Press, 1972), 1:92–94. Once again, on the careful distinction that must be made between Ludovico Alamanni and his brother Luigi, see n. 37 above. In this instance, the Ludovico mentioned in Machiavelli's letter cannot possibly be Luigi, since by 1525 Luigi was no longer in Florence, which he and other members of the Rucellai group had fled in order to escape punishment for their putative role in the 1522 conspiracy against Cardinal Giulio de' Medici; indeed, Luigi did not return to Florence until May of 1527, after the expulsion of the Medici (see Roberto Weiss, "Alamanni, Luigi," *Dizionario biografico degli italiani* [Rome: Istituto della Enciclopedia Italiana, 1960–], 1:568–71, esp. p. 569). On the "*canzona* before the comedy," see Pirrotta, *Music and Theatre from Poliziano to Monteverdi,* trans. Karen Eales (Cambridge: Cambridge University Press, 1982), p. 144, and p. 8 of the transla-

tion of *Mandragola* by Mera J. Flaumenhaft (Prospect Heights, Ill.: Waveland Press, Inc., 1981), which is careful to explain the many such allusions in the text. I am grateful to Professor Harvey Mansfield of Harvard University for bringing this translation to my attention. The text of the gesture toward Clement VII reads as follows: "Per tal grazia superna, / Per sì felice stato, / Potete lieti stare, / Godere e ringraziare—/ chi [i.e., Clement] ve lo [i.e., Guicciardini] ha dato."

45. In a 1517 letter to Alamanni, for example, Machiavelli wrote: "These days, I've read Ariosto's *Orlando Furioso*.... If he's there [in Rome] ... tell him I'm just sorry that—having mentioned lots of poets—he left me out, like a prick." "Io ho letto a questi dí Orlando Furioso dello Ariosto, ... Se si truova costí ... ditegli che io mi dolgo solo che, avendo ricordato tanti poeti, che m'habbi lasciato indietro come un cazzo." See Sebastian de Grazia, *Machiavelli in Hell* (Princeton, N.J.: Princeton University Press, 1989), pp. 48 and 396; my translation is adapted from de Grazia's.

46. See Ernest H. Wilkins, "A General Survey of Renaissance Petrarchism," *Comparative Literature* II (Eugene, Ore.: University of Oregon with the Cooperation of the Comparative Literature Section of the Modern Language Association of America, 1950), pp. 327–42, esp. p. 330.

47. See my Chapter 4, p. 156.

48. On Piero di Francesco Alamanni, see Gilbert, *Machiavelli and Guicciardini*, pp. 132 and 339, and von Albertini, *Firenze dalla repubblica al principato*, references in the index to Alamanni.

49. On Piero Alamanni as Lorenzo's agent, see, for example, Alison Brown, "Lorenzo, the Monte and the Seventeen Reformers," in Brown, *The Medici in Florence: The Exercise and Language of Power*, Italian Medieval and Renaissance Studies, University of Western Australia, 3 (Florence: Leo S. Olschki Editore, and Perth: University of Western Australia Press, 1992), pp. 151–211, esp. pp. 181 and 184. For bringing this study to my attention, I am grateful to Charles T. Davis. It was Butters, *Governors and Government*, p. 301, who characterized Piero Alamanni as "one of the pillars of the regime." On his service as Lorenzo's envoy in Rome, see Brown, *Medici in Florence*, p. 184. The letters concerning the exchange of music, from the *fondo* Florence, Archivio di Stato, Medici-Tornaquinci, Filza 3, lettera 123, fol. 239v, and lettera 126, fol. 250r, are published in Martin Staehelin, *Die Messen Heinrich Isaacs*, 3 vols., Publikationen der Schweizerischen Musikforschenden Gesellschaft, Serie II, vol. 28/I–III (Bern: P. Haupt, 1977), 2:33–35. My translations are borrowed from Walter Rubsamen, "The Music for 'Quant'è bella giovinezza' and Other Carnival Songs by Lorenzo de' Medici," *Art, Science, and History in the Renaissance*, ed. Charles S. Singleton (Baltimore: Johns Hopkins University Press, 1968), pp. 163–84, esp. p. 184. On these texts, see Bonnie J. Blackburn, "Lorenzo de' Medici, A Lost Isaac Manuscript, and the Venetian Ambassador," in *Musica Franca: Essays in Honor of Frank A. D'Accone*, ed. Irene Alm, Alyson McLamore, and Colleen Reardon, Festschrift Series No. 18 (Stuyvesant, N.Y.: Pendragon Press, 1996), pp. 19–44.

50. Lascaris is so characterized by John Shearman in *Raphael's Cartoons in the Collection of Her Majesty the Queen and the Tapestries for the Sistine Chapel* (London: Phaidon Press Ltd., 1972), p. 60.

51. Shearman, *Raphael's Cartoons,* p. 61. For documentation, see, for example, Girolamo Amati, "Notizia di alcuni manoscritti dell'Archivio Secreto Vaticano," *Archivio storico italiano,* Serie Terza, Tomo III—Parte I (In Firenze: coi tipi di M. Cellini e C. alla Galileiana, 1866), pp. 166–236, esp. pp. 216–17, where there is a document addressed to "Dilecto filio *Ioanni Lascaro. . . .*"

52. Gelli, *I capricci,* pp. 56–57.

53. See the entry on Lascaris in the Appendix.

54. See Frank D'Accone, "Bernardo Pisano: An Introduction to His Life and Works," *Musica Disciplina* 17 (1963): 115–35, esp. p. 124. D'Accone argues thus on the basis of the large number of Pisano's works that are settings of Strozzi's verse.

55. See Frank A. D'Accone, "Alessandro Coppini and Bartolomeo degli Organi, Two Florentine Composers of the Renaissance," *Studien zur italienisch-deutschen Musikgeschichte* 4, Analecta musicologica 4 [1967], pp. 38–76, esp. pp. 47–48 and 52.

56. Frank A. D'Accone, "Transitional Text Forms and Settings in an Early 16th-Century Florentine Manuscript," in *Words and Music: The Scholar's View, A Medley of Problems and Solutions Compiled in Honor of A. Tillman Merritt by Sundry Hands,* ed. Laurence Berman ([Cambridge]: Department of Music, Harvard University, 1972), pp. 29–58, esp. p. 33 n. 16.

57. Strozzi's participation in the 1518 wedding ceremonies is attested by an account by Francesco d'Antonio Zeffi da Empoli, priest and canon of the Church of San Lorenzo, a member of the Accademia fiorentina, and tutor of Filippo Strozzi the Elder's sons; see the text of his account in Alessandro Parronchi, "La prima rappresentazione della Mandragola," *La bibliofilia* 64 (1962): 80–81.

58. See Bernardo Morsolin, *Giangiorgio Trissino; monografia d'un gentiluomo letterato nel secolo XVI* (Florence: Successori Le Monnier, 1894 [2d ed. corrected and amplified]). Trissino's conributions to the sixteenth-century debates concerning the Italian language are reviewed in Hall, *Italian Questione della Lingua,* esp. pp. 14–19, 40, and 57–58. Trissino advocated reforms in Italian orthography, which included an ill-fated attempt to introduce Greek letters; among those who responded negatively to Trissino's arguments was Luigi Martelli, who may have been a member of the Company of the Cazzuola, described in detail below.

59. See James S. Ackerman, *Palladio,* The Architect and Society (Harmondsworth: Penguin Books, Ltd., 1966), p. 20.

60. On all of the foregoing, see ibid., pp. 31–34, 178–82. Interestingly, there were evidently musical elements in the 1562 performance of Trissino's *Sofonisba* by the Accademia Olimpica; see Nino Pirrotta, ed., *Chori in musica composti sopra li chori della tragedia di Edippo Tiranno Recitati in Vicenza l'anno M.D.lxxxv. Con solennissimo apparato. Venezia, Angelo Gardano 1588,* Edizione nazionale delle opere di Andrea Gabrieli, [1533]-1585 / Edizione critica 12, Fondazione Giorgio Cini, Istituto per la Musica (Milan: G. Ricordi & C. s.p.a., 1995), p. 14 and accompanying n. 5.

61. See n. 161 and the accompanying text below.

62. "Signore messer Lascari. Io hebbi la vostra de' XIIIJ °, et quanto a la provisione del collegio venne dipoi da Roma da Bonachorso le paghe di aghosto et di septembre. . . . Quanto al m[aestr]o latino nuovo, io ho dato loro uno messer Bernardo Pisano, benché sia

fiorentino et nato in questa terra: quello che dissi che haveva buono stilo, et anche ha qual-
che lettere greche, el quale ha già loro lecto quindici giorni et cominciato certe exercitationi
di epistole; et chosí faranno qualche declamatione et traductione di grecho in latino. Et
insomma lui è molto studioso et ha facto loro venire gran volontà di studiare forte. . . . In
Firenze, a' dí XXVIIJ di septembre MDXXJ. Vostro Palla Rucellai." See Giovanni Rucellai,
Lettere dalla Nunziatura di Francia (1520–1521), ed. Giovanni Falaschi, Quaderni di «Filolo-
gia e critica,» 4 (Rome: Salerno Editrice, 1983), pp. 161–62.

 63. See Richard Agee, "Filippo Strozzi and the Early Madrigal," *Journal of the Ameri-
can Musicological Society* 38 (1985): 227–37; Benedetto Varchi claimed that Filippo enlisted the
services of Bernardo Pisano as his companion in his humanistic studies. In his paper in In-
ternational Musicological Society / Internationale Gesellschaft für Musikwissenschaft / So-
ciété Internationale de Musicologie, *Report of the Tenth Congress, Ljubljana 1967,* ed. Dragotin
Cvetko (Basel: Bärenreiter Kassel; University of Ljubljana, 1970), pp. 96–106, esp. p. 98 n. 5.
Professor D'Accone cited a letter, evidently unknown to Agee, in the Archivio di Stato, Flor-
ence, *Carte Strozziane,* Serie Prima, filza 137, fols. 127r–128r, in which Pisano thanks Filippo for
assistance in his studies; for furnishing me with a transcription of this Latin letter, addressed
"Magnifico viro Philippo / Stroza, Philippi filio, patrono honorando" on fol. 128v, and whose
salutation reads "B. Pis. Ph. Strozo Ph. F.S.," I am grateful to Dott. Gino Corti.

 64. In the interest of objectivity, I am compelled to observe that there is the issue of
whether it is likely that Pisano the musician could have absented himself from Rome,
where he was a papal singer, in order to assume the responsibilities of Pisano the Latin
master in Florence. So far as I know, the available evidence does not absolutely exclude
that possibility. To my knowledge, there is no available documentation that unequivocally
places Pisano in Rome in September of 1521 (see D'Accone, "Bernardo Pisano," pp. 122–
23, and Herman-Walther Frey, "Regesten zur päpstlichen Kapelle unter Leo X. und zu
seiner Privatkapelle," *Die Musikforschung* 8 [1955]: 58–73, 178–99, and 412–37, and 9 [1956]:
46–57, 139–56, and 411–19, esp. 8 [1955]: 63 and nn. 16–18, and 9 [1956]: 148 and 411–14),
whereas there is evidence that suggests that he frequently traveled back and forth between
Rome and Florence (D'Accone, "Bernardo Pisano," pp. 121–23). There is also the question
of whether Palla Rucellai, in a letter to Janus Lascaris, would have referred to Bernardo
Pisano, the well-known singer and composer, as "uno messer Bernardo Pisano," almost as if
he were unknown to either the writer or his reader, or both. How one resolves this ambigu-
ity depends to some extent on how one interprets the other evidence suggesting that the
musician and the classicist were one and the same person. D'Accone, "Bernardo Pisano,"
pp. 125–26, regards the matter as "inconclusive." Agee, "Filippo Strozzi," p. 229 n. 11, cites a
passage in Varchi in which Pisano is characterized as "piuttosto eccellente musico . . . che
grande e giudizioso letterato," which indeed seems to suggest that "the classical scholar and
. . . the musician were one and the same," in Agee's words. See also the reference in n. 63
above to a Latin letter from "B. Pis." to "Ph. Strozo" documenting the scholarly activities
of Pisano the letterato. At minimum, the new evidence introduced here adds to the dossier
of references attesting the professional activity of Pisano the classicist, whether or not the
Pisano mentioned in Rucellai's letter was identical with the musician.

65. The first edition of Brucioli's dialogs consists of a single book, devoted to *Dialoghi* [*della morale filosofia*], in which the interlocutors are given fictitious Greek and Roman names; see Cantimori, "Rhetoric and Politics," p. 89, and Landi's edition, Brucioli, *Dialogi,* p. 553. In subsequent editions, new books of dialogs were added, and Brucioli's friends and contemporaries are cast in the role of interlocutor; see Cantimori, "Rhetoric and Politics," and Landi's edition, Brucioli, *Dialogi,* p. 554. The third edition, the one on which Landi's edition is based (pp. 554, 574), differs from the second in a number of details, especially with respect to the identity of the interlocutors; see Landi's edition, Brucioli, *Dialogi,* pp. 574–75. For bibliographic information on these various editions, see ibid., pp. 571–74, 577. I consulted the copy at the Newberry Library in Chicago, where the five books of dialogs are as follows: (1) *DIALOGI / di Antonio Brvcioli. / della morale philosophia* (In Venetia: Stampato . . . nel. 1543); (2) *DIALOGI / di Antonio Brvcioli della na / tvrale philosophia / hvmana* (In Venetia, 1544); (3) *DIALOGI / di Antonio Brvcioli delea* [*sic*] *natv = / rale philosophia* (In Venetia, 1535); (4) *DIALOGI / di Antonio Brvcioli del = / la metaphisicale / philosophia* (In Venetia, 1545); and (5) *DIALOGI / di Antonio Brvcioli / libro qvinto* (In Venetia, 1538). The dialog in which Layolle appears is in the fourth of these books, on fols. 13v–18r, "DIALOGO QVARTO DELLA NATVRA DELLE stelle."

66. As Samuel Pogue noted (*Jacques Moderne: Lyons Music Printer of the Sixteenth Century,* Travaux d'humanisme et renaissance CI [Geneva: Librairie Droz, 1969], p. 35), the last known documents placing Layolle in Florence are dated 7 April 1518, and their contents suggest that he was preparing to leave the city at that time.

67. The texts of the letters are in Cesare Guasti, "Documenti della congiura fatta contro il cardinale Giulio de' Medici nel 1522," *Giornale storico degli archivi toscani* 3 (1859): 121–50, 185–232, 239–67, esp. pp. 144–45, 145, and 187–89. The first, dated 21 August 1522, is from Alamanni, then in Lyons, to della Palla, then at the French royal court, and is in Alamanni's hand; the second, also dated 21 August 1522, is from Alamanni and Buondelmonti in Lyons to della Palla at the court and is in Buondelmonti's hand; the third, dated 18 and 20 August 1523, is from Alamanni and Buondelmonti in Lausanne to della Palla at the court and is in Buondelmonti's hand. On these letters, see also Hauvette, *Un exilé florentin,* pp. 224 n. 2, 484, and 486. In the first of these, Alamanni writes della Palla that "when you come here [Lyons], inquire about Layolle, who will immediately instruct you as to where we are; otherwise, you wouldn't find us, because we're staying in a place where no one, neither Florentine nor others, knows where we are." Guasti, ibid., p. 144: "Quando venite qui, dimandate dello Aiolle, il quale subito vi insegnerà dove noi siamo; altrimenti non ci troverresti, perché stiamo in luogo che niuno sa dove ci siamo, né fiorentino, né altri."

68. In the *OPERE TOSCANE DI LVIGI ALAMANNI AL CHRISTIANISSIMO RÉ FRANCESCO PRIMO. M.D.XXXII* (In Firenze: N*ell'anno* M.D.XXXII. A*dì.* IX. *Luglio*).

69. Ibid., pp. 188, 190: *Aiolle mio gentil cortese amico.*

70. It is noteworthy, of course, that the eclogue is a lament on the death of Cosimino Rucellai. See *OPERE TOSCANE,* p. 108: "[i]l nostro Tosco Aiolle; in cui Fiorenza / Scorge quanta harmonia quant'arte mai / Da Terpsichore vien fra noi mortali." I should note that the "*ELEGIA DECIMA*" of *LIB. I* is dedicated to Francesco Guidetti and the "*ELEGIA PRIMA*" of *LIB. II* to Zanobi Buondelmonti (see ibid., pp. 31–35 and 36–40), both known

from other sources to have been Alamanni's colleagues in the Rucellai group. None of this proves that Layolle was also a member, of course, but the evidence is very suggestive.

71. On Alamanno de Layolle, see Frank A. D'Accone, "The Intavolatura di M. Alamanno Aiolli," *Musica Disciplina* 20 (1966): 151–74, esp. p. 154, 154–55 n. 16, 158 and n. 20, and 159–60 and n. 23.

72. Frank Dobbins, *Music in Renaissance Lyons* (Oxford: Clarendon Press, 1992), p. 41, and Pogue, *Jacques Moderne*, p. 35.

73. *S'alla mia immensa voglia.*

74. *Gite sospir dolenti dal mio bel Arno* and *Rompi de l'empio cor il duro scoglio.* As noted by Fenlon and Haar (*Italian Madrigal,* p. 67), these two texts by Strozzi were authored after the closing of the Rucellai gardens, and Layolle's conversance with them specifically therefore cannot be said to result from his having frequented the gardens and made the acquaintance of Strozzi as his fellow member of the Rucellai group. However, a general interest on Layolle's part in the 1520s and 1530s in Strozzi's poetic output may well have resulted from an acquaintance first made some years before in the Rucellai gardens.

75. *In sì honesto e'n sì pietoso giro* and *Questo mostrarsi lieta.*

76. *In fra bianche rugiade et verdi fronde* and *Lasso la bella fera.*

77. *Vien' dunque amor' cagion d'ogni mio bene.*

78. This list was compiled from the information contained in the inventories of manuscript and printed sources in Fenlon and Haar, *Italian Madrigal.* On Layolle's poetic choices, see also Dobbins, *Music in Renaissance Lyons,* p. 255.

79. Rondeau number 56 of *Les Divers rapportz* (Lyons: Pierre de Sainte Lucie, 1537), Rondeau 56, Feuillet xxviv; see Pogue, *Jacques Moderne,* p. 36.

80. "The fifty-sixth rondeau, in praise of a beautiful little garden on the Saône at Lyons belonging to Master Françoys Layola, expert musician and organist. / Musicians, take every care to ensure / That you come and see this garden that Mercury / Left . . . / To his dear son Françoys Layola. . . . / 'Tis he who . . . wants people / . . . / To come here, and most of all Musicians. / Come here, then, to enjoy nature / Morning and evening; for within these walls / You will hear the birds sing here and there / And divide their Ut-re-mi-fa-sol-la / In all the places that could be composed by Musicians." *Les Divers,* as quoted in Dobbins, *Music in Renaissance Lyons,* p. 48, and Pogue, *Jacques Modernes,* pp. 36–37, 36 n. 6, and 37 n. 1. My translation is adapted from Dobbins's and Pogue's.

81. For more on Layolle's activity in Lyons, see Dobbins, *Music in Renaissance Lyons,* pp. 176–77 and 298, and Pogue, *Jacques Modernes,* p. 36. The evidence that Layolle remained in contact with the strozzi is as follows. In 1534, Lionardo Strozzi wrote from Lyons to Ruberto Strozzi in Rome and reported that "noy ci troviamo spesso qua o In chaxa vrâ. o In chaxa nicholo Mañelli a Cantare e facciamo Bona Musi[ca] che ce el v° nery Capponi vinc.° v° ßnery, Layolle. E altri assaij che se ne dilettono E ancora habbiamo da firenze assaij Coxe nuove" (see Richard J. Agee, "Ruberto Strozzi and the Early Madrigal," *Journal of the American Musicological Society* 36 [1983]: 1–17, esp. pp. 9–11 n. 33); in 1536, Capponi wrote from Lyons to Filippo Strozzi in Venice and reported that "Laiolle vij manda la ïclusa canzona" (see Agee, "Filippo Strozzi," p. 236 and n. 35); in 1539, a Strozzi employee in Venice, Salvadori, wrote to Palla Strozzi in Lyons that "Sarà cõ q$_3$ta certe parole alle quale vorreij fussi mezzano col layolle far mieij

fare una canzona a 4. ma se la volessi fare piutosto a .5. l[']hareij più caro" (ibid., pp. 236–37 and n. 38). There is other evidence that Layolle maintained contact with Florentine cultural and intellectual figures. As Pogue indicated (*Jacques Modernes*, p. 38), a 1538 letter from the famous poet Annibale Caro, in Rome, to Luigi Sostegni, in Lyons, documents that an earlier letter from Sostegni to Caro had been accompanied by some *canzoni* of Layolle's, which were well received by Caro's employer Monsignor Giovanni Gaddi because of the beauty of the music and Gaddi's regard for Layolle; see Annibal Caro, *Lettere familiari*, ed. Mario Menghini, with a new introduction by Aulo Greco, Biblioteca Carducciana 24 (Florence: Sansoni, 1957), p. 126. Gaddi was an important cultural figure and member of a famous Florentine family, of whom we shall hear more in Chapter 3.

82. See, for example, Fenlon and Haar, *Italian Madrigal*, pp. 149–53, 164–67, and 169–72. The considerable size of the Florentine community in Lyons was in part a function of the presence there in the fifteenth century of a branch of the Medici bank; see de Roover, *Rise and Decline of the Medici Bank*, pp. 70–74.

83. Pogue, *Jacques Modernes*, p. 34.

84. See Cellini, *Vita*, ed. O. Bacci (Florence: G. C. Sansoni, 1901), p. 11, as quoted in François Lesure, "Layolle (Aiolle, Ajolla, dell'Aiolle, Layolla), Francesco," *Die Musik in Geschichte und Gegenwart*, 17 vols. (Basel: Im Bärenreiter-Verlag, 1949/51–86), vol. 8, cols. 397–99, esp. cols. 397–98: "Et si mise in bottega innun suo palco Francesco della iolle il quali era gran sonatore di horgano et bonissimo musico e conpositore. Così il detto Aiolle m'insegniava cantare e comporre et parendo al padre et al maestro che io fussi molto atto a tal cosa si promettevano gran cosa di me." As Samuel Pogue noted (*Jacques Modernes*, pp. 34–35), this passage was deleted in the final version of Cellini's autobiography.

85. See John Shearman, *Andrea del Sarto*, 2 vols. (Oxford: Clarendon Press, 1965), 1:14–15, 2:207. Layolle is at the extreme right; to his right is the sculptor Jacopo Sansovino; to Sansovino's right is Sarto himself. As Samuel Pogue notes (*Jacques Modernes*, p. 34 n. 3), the original identification of the three was made by Vasari.

86. See, for example, Archivio di Stato, Florence, Convento 119, No. 703, *Entrata e Uscita 1505–11*, c. 56, November 1505: "A francesco dellaiole che chanta le laude lire sei soldi 18 sono per suo salario," as transcribed in Shearman, *Andrea del Sarto*, p. 15 n. 1. On Layolle as a singer of laude at the Annunziata, see also Blake Wilson, *Music and Merchants: The Laudesi Companies of Republican Florence* (Oxford: Clarendon Press, 1992), pp. 98, 100 n. 98, 106 n. 128, and 177; Pogue, *Jacques Modernes*, p. 34 (where it is noted that Layolle was engaged as a singer at the Annunziata in 1505 and remained there until 15 July 1507); and Frank D'Accone, "The Musical Chapels at the Florentine Cathedral and Baptistery during the First Half of the 16th Century," *Journal of the American Musicological Society* 24 (1971): 1–50, esp. p. 12 and n. 24, where it is noted that surviving contracts from 1500, 1505, and 1506 document that three youths, among them Layolle, were hired to sing "in sul organo," a synonym for "cantare le laude"; on the basis of a documentary reference to "Francesco Aiolli" dated 1 January 1507, D'Accone (p. 13) suggests that the young Layolle also sang the upper parts in polyphonic works performed at the Annunziata. Wilson notes (*Music and Merchants*, pp. 87 and 106 n. 128) that the madrigalist Bernardo Pisano was also a laudese, an important point that we shall consider again.

87. See Sydney Freedberg, *Painting of the High Renaissance in Rome and Florence,* 2 vols. (Cambridge: Harvard University Press, 1961), 1:530–31, 2:470, illustration 653. On the date, see Shearman, *Andrea del Sarto,* 2:238. As Samuel Pogue notes (*Jacques Modernes,* p. 35 and n. 1), Pontormo's *Ritratto di un musicista* is described in the inventory of the possessions of the heirs of Cardinal Leopoldo as "Ritratto dell'Aiolle musico in mezz'età a sedere che tiene in mano un libro di musica . . . Andrea del Sarto" (Florence: Archivio di Stato, Guardaroba 826, Eredità of Cardinal Leopoldo, fol. 58v), a misattribution explained, in John Shearman's view, by the fact that in the seventeenth century, when the inventory was compiled, Sarto's name was better known than Pontormo's. However, there is some question about the identity of the subject in Pontormo's portrait.

88. This is a thesis advanced by Rubsamen in, for example, "From Frottola to Madrigal," in *Chanson and Madrigal, 1480–1530, Studies in Comparison and Contrast, A Conference at Isham Memorial Library, September 13–14, 1961,* ed. James Haar (Cambridge: Harvard University Press, 1964), pp. 51–87, and Joseph J. Gallucci Jr., "Festival Music in Florence, ca. 1480–1520: *Canti carnascialeschi, Trionfi,* and Related Forms," 2 vols. (Ph.D. diss., Harvard University, 1966), esp. 1:240–47.

89. On this phenomenon see, for example, Giulio Cattin, "I 'Cantasi come' in una stampa di laude della Biblioteca Riccardiana (Ed. r. 196)," *Quadrivium* 29 (1978): 5–52, or the Preface to Joseph J. Gallucci Jr., ed., *Florentine Festival Music, 1480–1520,* Recent Researches in the Music of the Renaissance XL (Madison, Wisc.: A-R Editions, Inc., 1981), pp. vii–xix.

90. On Verdelot's relationship to Machiavelli and on his madrigals for theatrical productions, see Pirrotta, *Music and Theatre,* pp. 120–51 and the accompanying notes; and Slim, *Gift of Madrigals,* pp. 92–104.

91. *Sio pensasse madonna che mia morte.* On Guidetti's poem, which is also attributed to Molza, see James Haar, "The Early Madrigal: A Re-Appraisal of Its Sources and Its Character," *Music in Medieval and Early Modern Europe: Patronage, Sources and Texts,* ed. Iain Fenlon (Cambridge: Cambridge University Press, 1981), pp. 163–92, esp. p. 178 and n. 44.

92. *Amor'io senta l'alma, Chi non fa prova amore, O dolce nocte, Quanto sia lieto il giorno,* and *Si suave e l'ighanno.*

93. *La bella donna a cui donast'el core.*

94. *Italia mia ben che'l parlar sia indarno, Ite calde sospiri al freddo core, Non può far mort' el dolc' vis' amaro, Passer mai solitario in alcun tetto, Per alti monti et per selv' aspre trovo,* and *Quand' amor i begl' occhi a terr'inchina.* This list was compiled from the information contained in the inventories of manuscript and printed sources in Fenlon and Haar, *Italian Madrigal.*

95. On the date when Machiavelli first began frequenting the Orti (late summer of 1515), see Hans Baron, "Machiavelli on the Eve of the Discourses: The Date and Place of His *Dialogo intorno alla nostra lingua,*" *Bibliothèque d'Humanisme et Renaissance* 23 (1961): 449–76, specifically p. 464 and *passim.*

96. Gelli, *Opere,* p. 305: "Gelli. . . . Ma se voi forse non ve ne ricordate, avvertite che que'litterati de l'Orto de' Rucellai, disputando, ne la venuta di Papa Leone, col Trissino (perché egli fu che ci condusse la prima volta questa opera [i.e., the *De vulgari eloquentia* of Dante]) sopra lo essere o non esser ella di Dante." However, as Gianandrea Piccioli has ob-

served ("Gli Orti Oricellari," p. 83 n. 72), Trissino was at the court of Maximilian as apostolic nuncio during the period of Leo's visit, as is documented by correspondence addressed to him there by Giovanni di Bernardo Rucellai, who was in the papal retinue. Therefore, Gelli's reference to "la venuta di Papa Leone," insofar as we are at all justified in reading it as fact, has to be interpreted to mean that Trissino visited the gardens at some point during that year and not during the period of the pope's visit per se. See also Baron, "Machiavelli on the Eve of the Discourses," p. 460, who argued that Trissino was in Florence around the end of August or the first half of September 1515. On the place of the argument about the *De vulgari eloquentia* in the debate about language, see Hall, *Italian Questione della Lingua,* esp. pp. 16–17, 58: in 1529, Trissino published a translation of the *De vulgari eloquentia,* where he adopted Dante's position that standard Italian was actually what Dante claimed it to be theoretically, that is, a composite of linguistic elements drawn from all of the languages of the Italian peninsula.

97. The "Questione della lingua" is addressed most notably in the writings (e.g., *Gli Asolani* and the *Prose della volgar lingua*) and the professional activities of Leo X's secretary, Pietro Bembo, on whom see the standard publications of Carlo Dionisotti (e.g., his editions of Bembo's *Prose della volgar lingua, Gli Asolani, Rime,* 1° ed. nei "I Classici italiani TEA," Classici italiani TEA II [Milano: TEA, Editori associati, 1989] and *Prose e rime,* 2° ed., accresciuta, Classici italiani [Unione tipografico-editrice torinese], n. XX [Torino: Unione Tipografico-Editrice Torinese, 1966]). An accessible older standard account in English, though now outdated, is Hall, *Italian Questione della Lingua,* esp. pp. 14–19, 40, 51–54, and 57–58.

98. With respect to Dante and Petrarch, see also the reference in one of the writings of Trissino, who frequented the gardens, to the effect that Dante and Petrarch represented the highest standard of artistic production in poetry. See the facsimile edition of Trissino's 1529 publication *LA PⲰETICA DI M. GIⲰVAN GIORGIⲰ TRISSINⲰ,* Poetiken des Cinquecento, Band 24 (Munich: Wilhelm Fink Verlag, 1969), pp. 6–7: "E cosi nelle imitationi, che si fanno con gli essametri, Homero imitò i migliori, e Theocrito i peggiori, medesimamente nelle Canzoni e Sonetti, il Burchiello, e 'l Berna, imitò i peggiori, e Da[n]te, e Petrarca i migliori." A tendency to group the "Three Crowns" somewhat indiscriminately was implicitly challenged by Italian intellectuals later in the century, who—depending in part on whether the cultural tradition they represented was Florentine or Venetian—had sharply differing reactions to Dante and Petrarch based on their poetic language and linguistic and literary practices; on this point see Martha Feldman, *City Culture and the Madrigal at Venice* (Berkeley: University of California Press, 1995), p. 131 and, more important, p. 141 and n. 70; and Feldman's earlier "Rore's 'selva selvaggia': The *Primo libro* of 1542," *Journal of the American Musicological Society* 42 (1989): 547–603, esp. pp. 588–92. On the place of evocations of the "Three Crowns" in the debate about language, see Hall, *Italian Questione della Lingua,* esp. p. 51.

99. This passage corroborates the conclusion drawn from Gelli's text about two phases in the activity of the Rucellai group, since it implicity refers back to his own earlier reference (*Opere,* pp. 292–93), where he had identified a different, older group of participants hosted by Bernardo Rucellai.

100. Gelli, *Ragionamento,* pp. 310–11: "Lo avere adunque i nostri atteso a la mercatura e non a le lettere, e la moltitudine de' travagli che sempre ci sono stati, fecero per lungo tempo restare in dietro e quasi che perdersi interamente gli avvertimenti e l'arte usata da' tre sopra

detti [Gelli had earlier referred to the three; *Ragionamento,* p. 310] ne la nostra lingua; e i primi che cominciassero in Firenze a riosservargli, e ne la favella e ne la scrittura, furono quegli stessi litterati che usavano a l'Orto de' Rucellai.... Da costoro avvertiti Cosimo Rucellai, Luigi Alamanni, Zanobi Buondelmonti, Francesco Guidetti e alcuni altri, i quali, praticando con esso Cosimo, si trovavano spesso a l'Orto con que' più vecchi, cominciarono a cavar fuori le dette considerazioni, e a metterle tanto in atto, che la lingua n'è poi tornata in quel pregio che voi vedete." For a recent treatment of Gelli's literary theorizing, see Michael Sherberg, "The Accademia Fiorentina and the Question of the Language: The Politics of Theory in Ducal Florence," *Renaissance Quarterly* 56(1) (2003): 26–55.

101. For these astute observations, I am grateful to the anonymous reader of my manuscript for the American Philosophical Society. Although the earliest experiments in the new genre were termed "canzone," by 1530 the first print to employ the term "madrigali" had been published: RISM 1530², the *Madrigali / ... de diversi excellentissimi Musici / Libro Primo de la Serena* (Rome, 1530).

102. See the beginning of Chapter 2 on this same phenomenon.

103. See Nino Pirrotta's comments in the discussion following Walter Rubsamen's paper "From Frottola to Madrigal," pp. 86–87, and Alfred Einstein, *The Italian Madrigal,* trans. Alexander H. Krappe, Roger H. Sessions, and Oliver Strunk, 3 vols. (Princeton, N.J.: Princeton University Press, 1949), 1:117. On the restitution of the Trecento nomenclature as evidence of a concern with the Italian past, see also the quotation from Pirrotta's remarks in response to Rubsamen's paper at n. 184 below.

104. Nardi, *Istorie della città di Firenze,* 2:71–72.

105. Nerli, *Commentarij dei fatti civili occorsi dentro la città di Firenze,* 2:12–13.

106. See nn. 28 and 31 above for the texts of Nardi's and Nerli's accounts.

107. See Adrian Nicholas Sherwin-White, *The Letters of Pliny: A Historical and Social Commentary* (Oxford: Clarendon Press, 1966), pp. 115, 253, 421, 473–74, and 509 (letters i.13, iii.18, vii.17, viii.21, and ix.27).

108. Feldman, *City Culture and the Madrigal,* p. 48.

109. Anne MacNeil, *Music and Women of the Commedia dell'Arte in the Late Sixteenth Century,* Oxford Monographs on Music (Oxford: Oxford University Press, 2003), esp. pp. 96, 110–11, 178. MacNeil analyzes Giaches de Wert's setting of Guarini's dialog *Tirsi morir volea,* where "[t]hrough most of the composition, both the narrator's and Tirsi's words occupy the same musical space, in the lower four voices of the texture, while the upper three parts are reserved for the voice of the Nymph," which is thus a late sixteenth-century instance of the practice of contrasting putatively male and female voices through specific music-compositional means. However, MacNeil suggests that "as Rocke would argue, Guarini's nymph may have been a boy" (110).

110. See Nino Pirrotta, "Florence from Barzelletta to Madrigal," *Musica Franca: Essays in Honor of Frank A. D'Accone,* ed. Irene Alm, Alyson McLamore, and Colleen Reardon, Festschrift Series No. 18 (Stuyvesant, N.Y.: Pendragon Press, 1996), pp. 7–18, esp. p. 14.

111. See the text at nn. 9, 36, and 157.

112. The reference is to the famous promotion of 1 July 1517, when Leo X created thirty-one cardinals.

113. See Rucellai, *Lettere dalla Nunziatura di Francia*, p. 14 and n. 18: "In Firenze, la mattina che vi si pubblicorno i Cardinali furono molti principali cittadini a trovare Palla all'Horto de' Rucellai, perché credevano certo che Giovanni suo fratello fusse fatto Cardinale." This reference recalls the passage in Gelli's *Ragionamento* wherein Gelli recounted that the gardens witnessed the public reports of the Florentine ambassadors.

114. "la compagnia nostra"

115. "questi amici di meriggio." See n. 33 above. On the informal state of organization of the Rucellai group, see also Kristeller, "Francesco da Diacceto," p. 301, where it is observed that "[a]lthough the Rucellai Gardens are often classed among the academies, they seem to have been even less of an organized institution than Ficino's Academy had been."

116. On the points expressed in the previous two sentences, see Haar, "Early Madrigal," p. 177 and the accompanying notes. Haar's remarks are a useful corrective to the view expressed by Dean T. Mace, which is perhaps a bit too extravagant; see Mace, "Pietro Bembo and the Literary Origins of the Italian Madrigal," *Musical Quarterly* 55 (1969): 65–86.

117. See the passages from the writings of Giovan-Battista Gelli in nn. 21, 36, 96, and 100 above; see also the passage from Anton Francesco Doni, *I marmi*, ed. Ezio Chiòrboli, 2 vols. (Bari: Gius. Laterza & Figli, 1928), 1:202, 206–7, quoted *in extenso* and translated at n. 124 below.

118. Gelli, *Ragionamento*, pp. 310–11.

119. The characterization is Eric Cochrane's; see *Historians and Historiography*, p. 266.

120. To my knowledge, first brought to the attention of musicologists by H. Colin Slim; Slim, *Gift of Madrigals*, 1:50–51.

121. On the possible identity of these fellow musicians of Verdelot's, see Slim, *Gift of Madrigals*, p. 51 and the accompanying notes; and Frank D'Accone, "Musical Chapels," esp. pp. 22–23 n. 59. Specifically: the "Cornelio" may be the "Cornelio Snalaart" (or "chornelio," "Cornelio," or "Cornelio Senolart") documented by D'Accone and Anne-Marie Bragard (D'Accone, "Musical Chapels," pp. 17, 21–22, and 41 Doc. 9; and Bragard, "Verdelot en Italie," *Revue Belge de Musicologie* 11 [1957]: 109–24, esp. pp. 122 No. II and 124 No. IX; the "Cornelio *cantore da Fiorenza*" who paid four ducats from the papal treasury in 1526 must be the same person, especially since Senolart had earlier visited the papal court, in 1523, in the company of Verdelot [Bragard, p. 122 No. II, Frey, "Regesten zur päpstlichen Kapelle," 9:144 and 145]); the "Ciarles" may be the "Carlo d'Argentina *franciese, cantore*" documented by D'Accone ("Musical Chapels," pp. 22–23 n. 59); and the "Bruett" may be the "Brueto" or "Urbech" documented by D'Accone and Bragard (D'Accone, "Musical Chapels," pp. 18 and n. 41 and 21 and n. 56; and Bragard, "Verdeot en Italie," pp. 121 No. I and 124 No. IX). Documentation on Verdelot, Chornelio, and Urbech is also furnished in D'Accone, "Matteo Rampollini and His Petrarchan Canzoni Cycles," *Musica Disciplina* 27 (1973): 65–106, esp. p. 101. The fact that the names of Doni's characters thus correspond to those of musicians known from documentary sources to have been in Florence perhaps inclines one to give somewhat more credence to his account.

A suggestion of Slim's (*Gift of Madrigals*, p. 51) is surely correct: that the "Ubretto *suo* [i.e., Verdelot's] *compagno, cantore*" identified by Vasari as the figure accompanying Verdelot in my Figure 1.1 is Doni's "Bruett" (and, therefore, D'Accone's "Brueto"). In the context of

both Doni's and Vasari's statements, Bruett/Ubretto figures expressly as Verdelot's companion and a singer, and the names are similar enough that—by a simple act of metathesis (in this instance, from "Bru- " to "Ubr- ")—one could easily have been transformed into the other.

122. Doni quotes lines 1, 2, and 4 of one of Petrarch's extant lyric poems; for the full text, see Robert M. Durling, trans. and ed., *Petrarch's Lyric Poems: The* Rime sparse *and Other Lyrics,* (Cambridge: Harvard University Press, 1976), pp. 226–33, esp. pp. 226–27. My translation is taken from Durling's. As James Haar notes, it is an interesting fact that there is a setting of this text preserved in the manuscript Bologna, Civico Museo Bibliografico Musicale, Q21, one of the most important Florentine madrigal manuscripts of the 1520s. See Haar, "Early Madrigal," esp. pp. 191–92 n. 70.

123. The speaker is quoting the first line of another of Petrarch's extant lyrics; for the full text, see Durling, *Petrarch's Lyric Poems,* pp. 572–73.

124. Doni, *I marmi:* "VERDELOTTO: Almanco ci fossero Bruett, Cornelio e Ciarles, ché diremmo una dozzina di franzesette e pasteggieremmo qua questo mucchio di plebei. PLEBEI. Da che voi non potete sodisfare a noi con la musica, noi disturberen voi con certe nostre novellaccie che contiamo l'uno all'altro. ZINZERA. Anch'io ne dirò una, quando avrò udito dire a voi altri ciascun la sua. PLEBEI. Noi saremo i primi, sián contenti. . . . VERDELOTTO. Bellissima! Ditene un'altra. ZINZERA. Vo' dirla io, che mi trovai l'altra sera all'Orto de' Rucellai a cantare, dove si faceva fra quei dotti una gran disputa sopra il Petrarca; e v'era chi voleva che questa Laura fosse stata la filosofia e non donna altrimenti, per quella canzone che comincia Una donna piú bella assai che'l sole / e di bellezza e d'altretanta etade . . . acerbo ancor mi trasse alla sua schiera. . . . Alla fine egli vi fu uno che disse: Tennemi Amore anni vent'uno ardendo. E un altro rispose:—Queste sono cose impossibili, star tanto tempo ad abarcarsi il cervello e non attigner nulla delle dolcitudini amorose.—Al quale mi voltai io con un mal piglio e gli disse:—Io conosco una donna che stette venticinque, che sempre volle bene uno, e lui a lei, e mai, mai si copularono in leggittimo adulterio.—Qui si levaron le risa. . . . [L]oro non volevan credere e io l'affermava. Il Guidetti disse:—A Dio, Zinzera, tu dovesti esser tu, n'è vero, questa continente?—Io giurava e spergiurava di no; ma non ci fu ordine che dicessin mai altrimenti che:—Tu dovesti esser, Zinzera. . . . Allor tutti a una boce mi dettero vinta la partita, con dire:—La non fu lei! la non fu lei!—e si rise un altro poco, poi ci demmo alla musica."

125. See Gelli, *Ragionamento,* p. 305.

126. For general assistance on La Zinzera and the place of courtesans in Italian cultural life of the Cinquecento, I am grateful to Donna G. Cardamone Jackson (specifically for reading an earlier draft of this entire section and suggesting a number of improvements), to Dr. Alexandra Amati-Camperi (specifically for permitting me to read her article on Verdelot's madrigal *Chi bussa?* in typescript), and to Linda L. Carroll. On the place of courtesans in the musical culture of the sixteenth century, see also Nino Pirrotta, "*Commedia dell'arte* and Opera," in *Music and Culture in Italy from the Middle Ages to the Baroque* (Cambridge: Harvard University Press, 1984), pp. 343–60 and 465–70, esp. pp. 347–48 and the accompanying notes; Georgina Masson, *Courtesans of the Italian Renaissance* (London: Secker & Warburg, 1975); and Anthony Newcomb, "Courtesans, Muses, or Musicians? Professional

Women Musicians in Sixteenth-Century Italy," in *Women Making Music: The Western Art Tradition, 1150–1950,* ed. Jane Bowers and Judith Tick (Urbana: University of Illinois Press, 1986), pp. 90–115, esp. p. 102–3.

127. On Il Lasca, see Luigi Russo, "Novellistica e dialoghistica nella Firenze del '500," *Belfagor* 16 (1961): 261–83.

128. One of Il Lasca's works is a *madrigalone* addressed "Alla Nannina Zinzera Cortigiana"; the second is a *capitolo* "In lode della Nannina Zinzera cortigiana"; on the third poem, see the text at n. 133 below. On La Zinzera generally and specifically on Grazzini's *madrigalone* in her honor ("Oh più d'una regina, / più d'una imperatrice"), see Pirrotta, *Music and Theatre,* p. 146 n. 47, quoting Carlo Verzone, ed., *Le rime burlesche edite e inedite di Antonfrancesco Grazzini detto Il Lasca,* Raccolta di opere inedite o rare di ogni secolo della letteratura italiana (Florence: G. C. Sansoni, Editore, 1882), p. 244–45; see also H. Colin Slim, ed., *Ten Altus Parts at Oscott College Sutton Coldfield* ([Santa Ana], [1978]), p. 9. Il Lasca's *capitolo* ("Se tu non porgi a' prieghi miei l'orecchio") is in Verzone, *Le rime,* pp. 569–73.

129. Masson, *Courtesans of the Italian Renaissance,* pp. 115–18.

130. Lynne Lawner, *Lives of the Courtesans: Portraits of the Renaissance* (New York: Rizzoli International Publications, Inc., 1987), p. 82.

131. Presumably from "zenzero," i.e., "ginger."

132. "Non so per qual cagion l'alma mia donna"

133. It is an interesting coincidence that this last poem received a musical setting at the hands of one of the earliest madrigalists. On this third poetic reference to La Zinzera, see Verzone, *Le rime,* p. 231. On the musical setting, see Alfred Einstein, *The Italian Madrigal,* trans. Alexander H. Krappe, Roger H. Sessions, and Oliver Strunk, 3 vols. (Princeton, N.J.: Princeton University Press, 1949), 1:176–77, where the complete text is also printed, and Fenlon and Haar, *Italian Madrigal,* pp. 252 and 267; the musical setting appears in Arcadelt's *[V]ero secondo libro* (the reprints of which attribute the work to Corteccia), and in Corteccia's *Libro primo . . . a quattro voci.*

134. "Non è nel ciel fra gli spirti contenti / soave tanto, e sì dolce armonia, / da fare i monti andar, fermare i venti." "Not among the happy souls in heaven / is there so much gentle and such sweet harmony / as to make the mountains move, to still the winds." Verzone, *Le rime,* p. 571; the translation is mine.

135. See Martha Feldman, "The Academy of Domenico Venier, Music's Literary Muse in Mid-*Cinquecento* Venice," *Renaissance Quarterly* 44(3) (1991): 476–512, and its evocation in MacNeil, *Music and Women,* p. 40 and n. 14.

136. For this material, see Einstein, *Italian Madrigal,* 1:180–81, quoting pp. 29, 30, 38f., and 44 of L. A. Ferrai, *Lettere di cortigiane del secolo XVI* (Florence: Libreria Dante, 1884) (reviewed in A. Luzio, *Giornale storico della letteratura italiana* III, pp. 433f.); and Donna G. Cardamone Jackson, *The Canzone Villanesca alla Napolitana and Related Forms, 1537–1570,* 2 vols. (Ann Arbor, Mich.: UMI Research Press, 1975, 1981), 1:168.

137. Lawner, *Lives of the Courtesans,* p. 82.

138. "but there was never a disposition to say anything other than: 'It must have been you, *Zinzera.*'"

139. "Then all of them at once accorded me the victory in the exchange, saying: 'It wasn't she! It wasn't she!'"

140. Newcomb, "Courtesans, Muses, or Musicians," p. 103; see also Lawner, *Lives of the Courtesans,* p. 106, on the place of women in Venetian salons of the sixteenth century.

141. MacNeil, *Music and Women,* p. 90.

142. Ibid.

143. Ibid., p. 116; MacNeil makes reference to "the gendered hierarchies propounded by academicians."

144. See Lawner, *Lives of the Courtesans,* p. 82.

145. MacNeil, *Music and Women,* pp. 121–22, 184.

146. On Salutati and her portrait, see H. Colin Slim, "A Motet for Machiavelli's Mistress and a Chanson for a Courtesan," Sergio Bertelli and Gloria Ramakus, eds., *Essays Presented to Myron P. Gilmore,* 2 vols., Villa I Tatti, The Harvard University Center for Italian Renaissance Studies II (Florence: La Nuova Italia Editrice, 1978), 2:457–72. The enumeration of the conventionally expected abilities of courtesans is from Newcomb, "Courtesans, Muses, or Musicians," p. 102.

147. See Slim, "Motet for Machiavelli's Mistress"; Haar, "Early Madrigal"; and Fenlon and Haar, *Italian Madrigal,* p. 42.

148. Haar, "Early Madrigal," p. 191. Haar characterizes an attempt to posit Verdelot's presence in Florence by 1522 on the basis of Doni's text as "based on optimistic reading of an undependable source." On this point, see also the following note.

149. See Richard Sherr, "Verdelot in Florence, Coppini in Rome, and the Singer 'La Fiore,'" *Journal of the American Musicological Society* 37 (1984): 402–11, esp. pp. 404 and 409. It had been argued (see Slim, *Gift of Madrigals,* 1:92–94) that because the Rucellai gardens were closed in 1522 after the discovery of the *congiura* against Cardinal Giulio, Doni's tale documents Verdelot's presence in Florence by that date. However, as I suggest in the text, one needs to be cautious in arguing from the evidence of Doni's text, given its nature. The Florentine phase of Verdelot's biography has been reviewed most recently, and our understanding of it enriched with new documentary information, in Alexandra Daniela Amati-Camperi, "An Italian Genre in the Hands of a Frenchman: Philippe Verdelot as Madrigalist, with Special Emphasis on the Six-Voice Pieces," 2 vols. (Ph.D. diss., Harvard University, 1994), 1:12–24. I am grateful to Dr. Amati-Camperi for providing me with a copy of her dissertation.

150. To be more precise, Rucellai's *Rosmunda* and Trissino's *Sofonisba* were being written virtually simultaneously; for documentation, see Giovanni Rucellai, *Le opere,* ed. Guido Mazzoni (Bologna: Nicola Zanichelli Editore, 1887), pp. xvii–xviii. As Piccioli observes (see "Gli Orti Oricellari, p. 86), Trissino was composing *Sofonisba* during precisely the time he visited the Rucellai gardens: the passage in Gelli's *Ragionamento* (see n. 96 above) that documents his visit connects it with Leo X's 1515/16 visit to Florence, which, according to the documentation provided in Rucellai, *Le opere,* is about the time *Sofonisba* was being written.

151. See, for example, Gilbert, "Bernardo Rucellai and the Orti Oricellari," p. 118, and von Albertini, *Firenze dalla repubblica al principato,* p. 69. On the tradition concerning the

performance, see also Ilaria Ciseri, *L'ingresso trionfale di Leone X in Firenze nel 1515,* Biblioteca storica toscana, Serie I, a cura della Deputazione di storia patria per la Toscana 26 (Florence: Leo S. Olschki Editore, 1990), pp. 145–46, and the literature cited there.

152. Transmitted by: (1) the eighteenth-century literary historian Giulio Negri; see P. Giulio Negri Ferrarese, *Istoria degli scrittori fiorentini* (In Ferrara: Per Bernardino Pomatelli Stampatore Vescovale. Con licenza de' Superiori., 1712), pp. 292–93: "ed era tale la Passione, che aveva per la Poesia; che insorta un'emulazione amorosa tra Lui, e GiamGiorgio Trissini gran Poeta, e suo grande Competitore; composero à virtuosa gara; Questi la Sofonisba; *el Rucellai* la Rosmonda; e Baccio Martelli Vescovo di Lecce narrava, averli veduti salir' in Banco, e à competenza l'uno dell'altro recitare squarci delle loro Tragedie, attendendo dagli Amici Ascoltatori il Giudicio, e l'Approvazione della migliore. Quella però di Giovanni ebbe il vantaggio glorioso, d'essere rappresentata in suo Giardino, alla presenza del Pontefice Leone X, e di tutti i Cardinali; che servendo Tutti il Papa in quel tempo in Firenze; Tutti con esso Lui furono serviti ad un magnifico Banchetto da Giovanni; nel tempo del quale fece recitare la sua Rosmonda"; and (2) Francesco Saverio Quadrio; see *Il luogo teatrale a Firenze: Brunelleschi, Vasari, Buontalenti, Parigi,* Spettacolo e musica nella Firenze medicea, ed. Mario Fabbri, Documenti e restituzioni I (Milan: Electa Editrice, 1975), p. 80, catalogue entry no. 6.1.1., where Elvira Garbero Zorzi indicates that the notice of the performance of Rucellai's *Rosmunda* "nella sua casa agli Orti Oricellari per il carnevale del 1515" is "trasmessa dal Quadrio," by which she presumably means Quadrio's *Della storia e della ragione d'ogni poesia volumi quattro* (Bologna: F. Pisarri, and Milan: Nelle stampe di F. Agnelli, 1739–44). I did not find a reference in Quadrio that substantiates Zorzi's statement, but I cannot claim to have conducted an exhaustive search. In any event, Quadrio, like Negri, was an eighteenth-century author, and until now there was no documentation for this tradition concerning the performance of Rucellai's *Rosmunda* earlier than the eighteenth century.

153. Zorzi, catalogue entry 6.1.11, in *Il luogo teatrale a Firenze,* p. 80.

154. "Otherwise, I don't know what to say for myself, except that, as you know, I'm all yours, and that I commend myself to you; and you just keep your *Sofonisba* in mind, because *my* Falisco might be performing his rôle during this papal visit to Florence." Rucellai, *Le opere,* p. 247: "Altro non so che dirmi, se non che sono tucto vostro, come voi sapete, et mi vi raccomando et habbiate a mente Sofonisba vostra, che forse Phalischo farà l'acto suo in questa venuta del Papa a Firenze. In Viterbo 5 de Novembre 1515. Il Tucto vostro *GIOVANNI RUCCELLAIJ.* Al Magnifico *GIOVANGIORGIO TRISSINO* Nunzio Apostolico Appresso la Maestà Cesarea." My translation in this case is freer than usual because I thought it important to attempt to capture the sense of competition that I believe is implicit in Rucellai's reference to Trissino's *Sofonisba* and the projected performance of his own *Rosmunda*, a competition alluded to in Negri's text in n. 152 above, that must ultimately be dependent in turn on a reference in Scipione Ammirato's *Opuscoli* (see Rucellai, *Le opere,* pp. xvii–xviii): "Trovandosi in camera [Trissino and Rucellai], molte volte saltavano in banco, et recitando ciascuno di loro un pezzo della lor tragedia, attendevano dagli amici spettari il giudicio, qual giudicasse la migliore." For assistance with my translation, I am grateful to Father Salvatore Camporeale and Dott. Maurizio Gavioli.

155. See Rucellai, *Le opere,* pp. xvii–xviii. However, Piccioli ("Gli Orti Oricellari," p. 89 n. 88) argues that since Paris was away from Florence during a part of the pope's stay there, the absence of a reference to the performance need not signify that there was not one. Piccioli acknowledges that the complete absence of references in the contemporary narrative accounts is striking—he does not cite Ferreri's poetic account (see n. 156 below) and was perhaps unaware of it—but rightly observes that an argument based on the absence of evidence to the contrary does not exclude the possibility of a performance.

156. The *Itinerarium Divi Leonis decimi Pontificis Maximi* (Rome, 1516).

157. See Guido Mazzoni, "Noterelle su Giovanni Rucellai," *Il propugnatore,* Nuova serie III—Parte I (1890), pp. 375–88, esp. pp. 387–88: "Post ea dum reditum [Leo X] Latiam decernit ad Urbem / Tuscaque Ioannes Oricellaria Proles / Pontifici sobrinus agit convivia, quæ sunt / Florida doctiloqui Tempe et viridaria patris, / Nuncia venerunt, ut Ferdinandus ab orbe / Raptus erat, qui iam felici sidere gessit / Regia sceptra, diu gentem moderatus Hiberam." See, however, the qualification in n. 155 above about arguing from the absence of evidence.

158. See Rucellai, *Lettere dalla Nunziatura di Francia,* p. 14 and n. 18 and esp. p. 18 and n. 22.

159. For bibliographic information on the appendix (fols. 241r–253v) to the *Zibaldone,* see ibid., p. 14 n. 18; and Giovanni di Paolo di Paolo Rucellai, *Il Zibaldone Quaresimale,* ed. A. Perosa, Studies of the Warburg Institute 24 (London: The Warburg Institute, University of London, 1960), p. xxv; and F. W. Kent, "Due lettere inedite di Giovanni di Bernardo Rucellai," *Giornale storico della letteratura italiana* 149 (1972), pp. 565–69, esp. p. 568 and n. 23.

160. *Zibaldone Quaresimale,* fol. 252r: "L'anno 1515 ritrovandosi Papa Lione in Firenze fu convitato all'horto de' Rucellai con tutt'i cardinali, et alla sua presenza Giovanni Rucellai fece recitare la tragedia di Rosmunda l'anno 1516." I am grateful to Dott. Gino Corti of Villa I Tatti, The Harvard University Center for Italian Renaissance Studies, Florence, for the transcription of this reference. I must point out, however, that even this reference does not unequivocally state that the performance took place in the garden.

161. In F. W. Kent's words, "the fort became a center of literary discussions; in the gardens of the castello, to which [Rucellai] himself had had improvements made—certainly with his father's famous *Orti Oricellari* in mind—Rucellai would converse with Trissino and other friends, and there he finished work on *Le Api.*" On the performance of Trissino's *Sofonisba* by the Vicentine Accademia Olimpica, see n. 60 above and the accompanying text. On Rucellai as castellano of Castel Sant'Angelo, see Kent, "Due lettere," esp. p. 567. On the Castel Sant'Angelo garden and the activities that took place there, see also David R. Coffin, *Gardens and Gardening in Papal Rome* (Princeton, N.J.: Princeton University Press, 1991), pp. 236–37, where Coffin reproduces a mid-sixteenth-century engraving of the castello depicting the garden and observes that Trissino's dialog *Il Castellano* is set there. On the place of the *Castellano* in the debate about language, see Hall, *Italian Questione,* esp. pp. 16–17, 40, 58; Trissino's 1524 letter to Clement VII, prefixed to the edition of his *Sofonisba,* contains a defense of his advocacy of reform of Italian orthography, on which see the text at n. 58 above, where Trissino's biography and intellectual achievements are briefly reviewed.

The *Castellano* was a further defense of Trissino's position first advanced in his translation of the *De vulgari eloquentia* (on which see above, n. 96).

162. See n. 124 above.

163. See n. 152 above.

164. See n. 160 above.

165. "Del modo dello instruire i figliuoli." See Cantimori, "Rhetoric and Politics," p. 97, on the general content and substance of the fifth dialog, where the discussion of music occurs.

166. "Wouldn't you want to have them learn music, once [held] in high regard among the ancients and moderns?" Landi's edition, Brucioli, *Dialogi*, p. 88: "COSIMO. Non vorresti voi far loro ... apprendere la musica, stata già tanto in pregio appo gli antiqui e moderni?"

167. Landi's edition, Brucioli, *Dialogi*, pp. 89–90: "M. GIANGIORGIO.... E circa la musica, della quale mi domandasti, non curerei che si affaticassi il giovane, perché niente ha di retto o di decoro quella cosa che non è sostentata da alcuna siede di parole e di sentenze. Senza che quando le delicate voci e voluttuosi accenti con moderamento di concento toccano gl'orecchi, intenerendo l'animo, o inducano alle libidini i giovinili animi, o gli fanno languidi ne' dolori, o precipitosi a' subiti moti dell'animo, le quali cose non poco contaminano la virtù. E certamente in questo modo in prima corroppe la Grecia il suo retto costume antico e laudabile, frequentando i teatri, le scene e i cori, co' quali movevano gli orecchi e gli animi con varii affetti. Di poi fu portata questa effeminata pernicie in Roma, la quale gli spezzò i nervi della sua antiqua gravità. E che cosa possa sperare di bene questa nostra età da simile musica vocale si potrà vedere se si considererà di che costumi e di che sapienza sieno oggi dotati quegli che ne fanno professione, per la qual cosa non giudico che quella sia degna di uomo libero che a sé e a altri possa giovare."

168. "[T]he theatre shall be filled with *song to the music of harp and flute,* the only limitation being that of *moderation,* as the law prescribes. For I agree with Plato that nothing gains an influence so easily over youthful and impressionable minds as the various notes of song, the greatness of whose power both for good and evil can hardly be set forth in words. For it arouses the languid and calms the excited; now it restrains our desires, now it gives them free rein. Many Greek States considered it important to retain their old tunes; but when their songs became less manly, their characters turned to effeminacy at the same time, perhaps because they were corrupted by the sweetness and debilitating seductiveness of the new music, as some believe, or perhaps when other vices had first caused a relaxation of the strictness of their lives, and their ears and their hearts had already undergone a change, room was offered for this change in their music as well. For this reason the man who was by far the wisest and by far the most learned whom Greece has produced was very much afraid of such a degeneration. For he says there can be no change in the laws of music without a resulting change in the laws of the State. My opinion, however, is that such a change is neither so greatly to be feared, nor, on the other hand, to be considered of no importance at all; and yet I do observe that audiences which used to be deeply affected by the inspiring sternness of the music of Livius and Nævius, now leap up and twist their necks and turn their eyes in time with our modern tunes. Ancient Greece used to punish such offences severely, perceiving long before the event that corruption gradually creeps

into the hearts of citizens, and, by infecting them with evil desires and evil ideas, works the swift and total destruction of States—if indeed it be true that the strict Sparta of tradition ordered all the strings above seven to be removed from Timotheus' harp." See Cicero, *De Re Publica, De Legibus,* trans. Clinton Walker Keyes, The Loeb Classical Library (London: William Heinemann, and New York: G. P. Putnam's Sons, 1928), pp. 416–21; my translation is taken from Keyes.

169. See *The Republic of Plato,* ed. James Adams, 2 vols. (Cambridge: At the University Press, 1969 [2d ed.]), 1:215–17. My translation is taken from *The Collected Dialogues of Plato,* ed. Huntington Cairns and Edith Hamilton, Bollingen Series 62 (Princeton, N.J.: Princeton University Press, 1961), pp. 665–66. For Socrates' quotation from Homer, see Homer, *The Odyssey: A New Verse Translation,* trans. Albert Cook (New York: W. W. Norton & Company, Inc., 1967), p. 13. For other Platonic statements of this theme, see, for example, the *Republic* III.404.e, and III.410.c–d, as in *The Collected Dialogues,* pp. 649 and 654–55. The theme is also invoked in Aristotle's writings, as, for example, in the *Politics: The Complete Works of Aristotle, The Revised Oxford Translation,* ed. Jonathan Barnes, 2 vols., The Bollingen Series 71, 2 (Princeton, N.J.: Princeton University Press, 1984), 2:2127: "As to the vulgarizing effects which music is supposed to exercise, this is a question which we shall have no difficulty in determining when we have considered to what extent freemen who are being trained to political excellence should pursue the art, what melodies and what rhythms they should be allowed to use, and what instruments should be employed in teaching them to play; for even the instrument makes a difference. The answer to the objection turns on these distinctions; for it is quite possible that certain methods of teaching and learning music do really have a degrading effect. It is evident then that the learning of music ought not to impede the business of riper years, or to degrade the body or render it unfit for civil or military training, whether for bodily exercises at the time or for later studies." For evidence of a late sixteenth-century conversance with Aristotle's views on music, see Giovanni Bardi's "*Discorso mandato a Giulio Caccini,*" in Claude V. Palisca, *The Florentine Camerata: Documentary Studies and Translations* (New Haven, Conn.: Yale University Press, 1989), pp. 78–131, esp. 112–13.

170. "inquinata, impudens, corrupta atque corruptrix." See Sassuolo's text in Eugenio Garin, ed., *Il pensiero pedagogico dell'umanesimo,* I classici della pedagogia italiana (Florence: Giuntine and Sansoni, 1958), p. 530: "SAXOLI PRATENSIS DE VICTORINI FELTRENSIS VITA Saxolus Pratensis Leonardo Datho.... Is enim hanc a Dijs immortalibus nobis datam dicit fidelissimam certissimamque animorum nostrorum custodem et ducem, modo educata sit (ut iubet) in philosophiæ gremio, bene morata, modesta, pudens, verecunda; non hæc huius temporis inquinata, impudens, corrupta atque corruptrix, quæ de philosophorum sententia deque Sparthiatarum decreto e civitatibus, tamquam rerum publicarum labes, exigenda atque exterminanda sit."

171. I consulted the original Latin text in Maria Walburg Fanning, ed., *Maphei Vegij Laudensis De Educatione Liberorum Et Eorum Claris Moribus Libri Sex: A Critical Edition of Books I–III,* The Catholic University of America Studies in Medieval and Renaissance Latin I (Washington, D.C.: Catholic University of America, 1933), p. 105 (*LIBER III, CAPUT III,* "De Musica, in qua pueri erudiri debent"): "musicam fuerunt qui non reciperent, quod

lasciviæ magis causa non pauci in ea erudiantur; in qua re maxima cura adhibenda est. nam propter impudica enervataque carmina multos sæpe adulescentes perditos corruptosque ac virilis nihil unquam roboris adeptos fuisse compertum est." My translation is taken from William Harrison Woodward, *Vittorino da Feltre and Other Humanist Educators: Essays and Versions: An Introduction to the History of Classical Education* (Cambridge: Cambridge University Press, 1921), p. 240. As Fanning noted in her introduction (p. xx), Vegio's third book is devoted to the education of youth, which is important for our purposes, since his discussion of music thus occurs in the same kind of context as Brucioli's.

172. See Cortese's text in Nino Pirrotta, "Music and Cultural Tendencies in 15th-Century Italy," in *Music and Culture in Italy from the Middle Ages to the Baroque* (Cambridge: Harvard University Press, 1984), pp. 80–112 and 382–91, esp. 98: "sed eam etiam inutilem esse opinātur: propterea q[uod] ea quedam sit ignauæ uoluptatis inuitatrix / maximeq$_3$ eius iucunditate soleat libidinum excitari malum." My translation is taken from ibid., p. 102. For the foregoing three references, I am indebted to an article by Elizabeth B. Welles, "Orpheus and Arion as Symbols of Music in Mantegna's *Camera degli sposi*," *Studies in Iconology* 13 (1989–90): 113–44, esp. pp. 125–26 and the accompanying notes. I am grateful to Mary Ann Pinto for bringing this interesting article to my attention.

173. *Charoli ualgulij Proœmiũ in Musicã Plutarchi Ad Titum Pyrrhinum* (Brescia: Angelo Britannico, 1507), facsimile edition in Palisca, *Florentine Camerata*, pp. 21–30.

174. Ibid., pp. 31–32.

175. Lodovico Antonio Muratori, *Della perfetta poesia italiana*, ed. Ada Ruschioni, 3 books in 2 volumes, Scrittori italiani (Milan: Marzorati editore, 1971), Book 3, 2:573.

176. Muratori, *Della perfetta*, Book 3, 2:575. My translations are adapted from Nino Pirrotta, "Metastasio and the Demands of His Literary Environment," *Studies in Music from the University of Western Ontario* 7 (1982): 10–27, esp. pp. 15, 23.

177. MacNeil, *Music and Women*, p. 86.

178. Suzanne Cusick, "Gendering Modern Music: Thoughts on the Monteverdi-Artusi Controversy," *Journal of the American Musicological Society* 46 (1993): 1–25, esp. p. 18, as reflected in MacNeil, *Music and Women*, p. 86 and the accompanying notes.

179. Castiglione, *The Book of the Courtier*, trans. and with an introduction by George Bull, Penguin Classics (Harmondsworth, Middlesex: Penguin Books Ltd., 1967), p. 120. For yet another critical reference to a dependence on musical notation, see the concluding pages of Chapter 1 in Pirrotta's *Music and Theatre*.

180. See Pirrotta, *Music and Theatre*, p. 248. On humanistic attitudes toward music in general, see also Pirrotta, "Music and Cultural Tendencies," *passim*. The second explanation Pirrotta offers concerns the melodic qualities of the individual lines of a polyphonic composition. I shall return to this matter below; see nn. 207–8 and the accompanying text.

181. Cantimori, "Rhetoric and Politics," p. 97. The passage quoted above (at n. 170) from Sassuolo Pratese's life of Vittorino da Feltre corroborates Cantimori's claim that such ideas about education are "of a Spartan character." That other members of the Rucellai group besides Brucioli were concerned about the consequences of emulating the "delicate," "soft," "false," and "corrupt" practices of the ancients is suggested by a passage in Machiavelli's *Arte della guerra*. The passage translated at n. 9 above continues: "Quanto meglio arebbono fatto quelli [i.e., the 'prin-

cipi del Regno'] ... a cercare di somigliare gli antichi nelle cose forti e aspre, non nelle delicate e molli, e in quelle che facevano sotto il sole, non sotto l'ombra, e pigliare i modi della antichità vera e perfetta, non quelli della falsa e corrotta; perché, poi che questi studi piacquero ai miei Romani, la mia patria rovinò."This seems to have been a theme in the discussions of the Rucellai group, and an awareness of it thus informs a reading of Brucioli's reference to music.

182. See, above all, Pirrotta, "Music and Cultural Tendencies in 15th-Century Italy." Pirrotta returned to the theme regularly in his writings.

183. Once again, see the reference from Trissino's writing quoted in n. 98 above that implicitly identifies Dante's and Petrarch's literary achievements with Homer's.

184. Cantimori, "Rhetoric and Politics," pp. 99–100. On this point, see also Michael Baxandall, *Giotto and the Orators,* pp. 6–7; and Nino Pirrotta's comments in the discussion following Walter Rubsamen's paper "From Frottola to Madrigal," esp. pp. 76–77. Pirrotta remarked: "Latin was admired to such an extent that it was thought necessary to write in it, to use classical prosody and forms. Bembo tried to extend this admiration to Greek, Provençal, and Trecento Italian poets, so that one could have a modern classicism not directly in imitation of ancient patterns. This is important because a wider concept of classicism made room for developments such as the madrigal. Italian, then, had to be dignified to the stage where it could express as well as, even better, since more contemporary, than Latin, humanistic sentiments. Resurrection of the Italian past accounts for the renewed use of the word 'madrigal.'"

185. On the other hand, as Pirrotta suggested (see Rubsamen, "From Frottola to Madrigal," p. 77), an elevated literary style could lead in the opposite direction as well, toward a contrapuntal treatment of the text: "music was to have as high a standard as poetry, and this led to elaboration of style."

186. See n. 57 above and the accompanying text.

187. In a reference in his 1506 biography of Ficino to Ficino's resurrection of the tradition of Orphic song to the accompaniment of the lyre: "Orphei hymnos exposuit, miraque, ut ferunt, dulcedine ad lyram antiquo more cecinit." See Corsi's life of Ficino in the edition by Marcel, *Marsile Ficin,* pp. 680–89.

188. *I ritratti del Trissino* (Rome: Stampata in Roma per Lodovico degli Arrighi vicentino, & Lautitio perugino. nel MDXXIIII di ottobre con la prohibitione, & gratia di N.S. come ne l'altre).

189. "performed for Lorenzino [di Piero de' Medici]" in February 1513, at the conclusion of the Florentine carnival festivities.

190. On the comedy "facto ... per Lorenzino," see Marino Sanuto, *I diarii,* 59 vols. (Venice: 1879–1903), vol. 15, col. 572; the "stanze si cantorono sula lyra in ꝑsona di Orpheo poeta ... Quando la ... comedia fu recitata nel cōspecto del ... Mag.ᶜᵒ ... Lorenzo de Medici" are contained in the manuscript source for the comedy, Vatican Barberini Lat. 3911 (*olim* XLV.5), fol. 24r. The Medicean conceits employed are also found, for example, in the text Nardi composed for the succession of floats during the 1513 carnival, on which see Chapter 3 in this volume.

191. That Pontano had an understanding of music and was conversant with musical activities at the Aragonese court and elsewhere in Naples is suggested or documented by various references: (1) the famous letter of 1487 in which he charges Tinctoris with respon-

sibility for the recruitment of singers for the royal chapel; see the Italian text in Ronald Woodley, "Iohannes Tinctoris: A Review of the Documentary Biographical Evidence," *Journal of the American Musicological Society* 34 (1981): 217–48, esp. p. 245; (2) the evidence that Raffaele Brandolini, brother of the famous singer Aurelio, frequented Pontano's academy; see, on Raffaele Brandolini's membership in Pontano's academy, the chapter titled "De cæcitate, & malis alijs corporis," in the "*LIBER POSTERIOR*" of the *De Fortitudine libri II,* which I consulted in the edition housed in the Rare Books Division of the Tulane University Library, *IOANNIS IOVIANI PONTANI OPERA OMNIA SOLVTA ORATIONE COMPOSITA,* 3 vols. (VENETIJS IN ÆDIBVS ALDI, ET ANDREÆ SOCERI, 1518–19), 1:80–81; see, on Aurelio Brandolini generally, F. Alberto Gallo, *Music in the Castle: Troubadours, Books, and Orators in Italian Courts of the Thirteenth, Fourteenth, and Fifteenth Centuries,* trans. Anna Herklotz and Kathryn Krug (Chicago: University of Chicago Press, 1995), Chapter 3; and (3) the reference in Pontano's *De Conviventia* to a banquet hosted by Alfonso, son of King Ferdinand (Ferrante) I, in honor of the envoys of Charles the Bold, which was accompanied by musical performances; see Giovanni Pontano, *I trattati delle virtù sociali: De Liberalitate, De Beneficentia, De Magnificentia, De Splendore, De Conviventia,* ed. Francesco Tateo, Testi di letteratura italiana (Rome: Edizioni dell'Ateneo, 1965), pp. 153–54. See also the text quoted in the following note documenting that the singers Serafino and Chariteo also frequented meetings of Pontano's academy. And on Pontano's conversance with the practice of singing to a stringed instrument, see Gallo, *Music in the Castle,* p. 76 and n. 26. All of these texts provide some insight into Pontano's musical experiences, which may have helped shape the musical program of his academy and, indirectly, that of the Rucellai group as well, for the reasons given in the text immediately following.

192. See "Vita del facondo poeta vulgare Serafino Aquilano per Vicenzio Calmeta composta," in Calmeta, *Prose e lettere edite e inedite,* ed. Cecil Grayson, Collezione di opere inedite o rare pubblicata per cura della Commissione per i testi di lingua 121 (Bologna: Commissione per i testi di lingua, 1959), p. 67. On Serafino as a member of Pontano's academy, see also Cardamone Jackson, *The* Canzone Villanesca alla Napolitana *and Related Forms,* 1:53 and 246 n. 73. Paolo Cortese reported that Il Chariteo sang verses at the behest of King Ferrante II (Ferrandino) of Naples (1467–96; reigned 1495–96); see Nino Pirrotta, "Music and Cultural Tendencies," esp. pp. 100 and 104. It is significant in this context to note that Il Chariteo was responsible for initiating a new phase of Petrarchism, destined to be influential; see Wilkins, "General Survey," esp. p. 330. Among Il Chariteo's followers in this initiative, according to Wilkins, was Serafino.

193. See Gilbert, *Machiavelli and Guicciardini,* pp. 203–4.

194. As Linda L. Carroll suggested to me.

195. "And such a division was the reason why those youths who would gather in the garden of the Rucellai were able to insult the gonfaloniere with greater confidence, . . . and . . . each day they were ever more courageous in opposing the gonfaloniere and were insulting him more boldly and less respectfully, as happened more than once with certain mascherate organized at that time at the behest of those of the *Orti [Oricellari],* all of which were staged in contempt of the gonfaloniere and in order to disgrace him." See Nerli, *Commentarij dei fatti civili occorsi dentro la città di Firenze,* p. 160: "Ed era cagione tal divisione, che

que' giovani i quali nell'orto de' Rucellai convenivano, con più sicurtà potessero offendere il Gonfaloniere, . . . e . . . ogni giorno pigliavano più animo contro al Gonfaloniere, e più animosamente e con meno rispetto l'offendevano, come più volte avvenne in certe mascherate che in que' tempi si feciono per ordine di quelli dell'orto, che tutte si facevano per dar carico al Gonfaloniere e in suo disonore."

196. Humfrey Butters has linked the passage in Nerli's history with the 1507 letter, if the letter in fact documents the same events that Nerli was describing, which seems plausible. See Butters, *Governors and Government,* p. 62 and accompanying n. 18.

197. The letter is preserved in the Archivio di Stato, Florence, *Carte Strozziane,* III Serie, 178, No. 46; it is transcribed in D'Accone, "Alessandro Coppini and Bartolomeo degli Organi," p. 52 n. 79: "maschere in chassa Prinzivalle, e la finzione fu della Dovitia, chome da Filippo . . . sarette raghuagliatto." Butters, *Governors and Government,* p. 108, mistakenly dated the letter 1506; by modern reckoning, the date 25 February 1506, in Florentine style, becomes 1507.

198. In a letter that provides still more informative details: "We portrayed 'Abundance,' which was [represented by] Antonfrancesco [degli Albizzi], dressed like a woman with a cornucopia in one hand and a basket full of different kinds of fruit on his head. We two [Antonio di Luca degli Albizzi and Filippo Strozzi], dressed in costumes of yellow silk trimmed with black velvet, were like youths who guided her. . . . There followed three singers . . . , dressed like us in black and yellow. . . . I'm sending you the *canto,* which is by Baccio [that is, Bartolomeo degli Organi], and the words, which are by Piero Rucellai." Although apparently unknown to Butters, this letter is preserved in the Archivio di Stato, Florence, *Carte Strozziane,* III Serie, 178, No. 46; it is transcribed in D'Accone, "Alessandro Coppini and Bartolomeo degli Organi," p. 76. My translation is adapted from D'Accone, ibid., pp. 52–53.

199. This would seem to confirm Butters's thesis that these letters indeed document the same events as those attested by Nerli's history; see n. 196 above.

200. Only the bassus part of Baccio's setting is preserved, in the manuscript Florence, Biblioteca Nazionale Centrale, Banco rari 337 (*olim* Palat. 1178), fol. 64v. See D'Accone, "Alessandro Coppini and Bartolomeo degli Organi," p. 53 and accompanying n. 80 and p. 56. The text is published in Charles S. Singleton, ed., *Canti carnascialeschi del Rinascimento* (Bari: Gius. Laterza & Figli, Tipografi—Editori—Librai, 1936), pp. 163–64.

201. Pasquale Villari, *Niccolò Machiavelli e i suoi tempi,* 3 vols. (Milan: Ulrico Hoepli, 1895 [2d ed.]), 1:574. My translation is taken from Coffin, *Gardens and Gardening,* p. 230.

202. For a brief, accessible discussion of the phenomenon of the stock airs, see Claude V. Palisca's excellent book *Baroque Music,* Prentice Hall History of Music Series (Englewood Cliffs, N.J.: Prentice-Hall, Inc., 1991 [3d ed.]), pp. 22–24, 44–46, and 53, and Palisca, "Vincenzo Galilei and Some Links between 'Pseudo-Monody' and Monody," in Claude V. Palisca, *Studies in the History of Italian Music and Music Theory* (Oxford: Clarendon Press, 1994), pp. 346–63, esp. p. 356.

203. Pirrotta, "Novelty and Renewal in Italy, 1300–1600," in *Music and Culture in Italy,* pp. 159–74 and 406–8, esp. pp. 173 and 408 n. 19.

204. See Anthony Newcomb, *The Madrigal at Ferrara, 1579–1597,* 2 vols., The Princeton Studies in Music 7 (Princeton, N.J.: Princeton University Press, 1980), 1:62. On this point see

also Newcomb, "Courtesans, Muses, or Musicians," esp. p. 97; and Laura Macy, "Speaking of Sex: Metaphor and Performance in the Italian Madrigal," *Journal of Musicology* 14 (1996): 1–34, esp. pp. 10, 17. On the large-scale social conditions that lay behind the emergence of the madrigal, see also Richard A. Goldthwaite, *Wealth and the Demand for Art in Italy, 1300–1600* (Baltimore: Johns Hopkins University Press, 1993), p. 240: "In the history of music the development of the madrigal and other forms involving amateur performance is closely tied to the increase of social activities by the upper class within the privacy of their homes."

205. See, for example, my discussion of the repertory of the Cortona/Paris partbooks in "Giulio de' Medici's Music Books," *Early Music History* 10 (1991): 63–120, esp. pp. 97–100 and the accompanying notes.

206. I am quoting Iain Fenlon and James Haar, *Italian Madrigal,* p. 11.

207. Pirrotta, *Music and Theatre,* pp. 248–49. On the characteristics of aria and solo singing that the humanists found compelling, see also Palisca, "Vincenzo Galilei," esp. p. 361, and Palisca, "Vincenzo Galilei's Arrangements for Voice and Lute," in *Studies in the History of Italian Music and Music Theory,* pp. 364–88, esp. p. 374. Galilei wrote: "The greater the number of parts that sing at one time, the less will the air be grasped by the sense and the less efficaciously will its character work upon the souls of those who listen to it." That Galilei's remark dates from the late sixteenth-century documents the persistence of this humanistic view.

208. Fenlon and Haar, *Italian Madrigal,* p. 11.

209. I cannot resist observing that *O passi sparsi* is among the Petrarchan verses set by Rucellai group familiar Francesco Layolle; see Table 3 above.

210. Fols. 15v–16r. On the piece, see Frank D'Accone, "Lorenzo the Magnificent and Music," *Lorenzo il Magnifico e il suo mondo, Convegno internazionale di studi (Firenze, 9–13 giugno 1992),* ed. Gian Carlo Garfagnini, Istituto Nazionale di Studi sul Rinascimento, Atti di Convegni 19 (Florence: Leo S. Olschki Editore, 1994), pp. 259–90, esp. pp. 273–74. The piece is also found, with a different text, in the MS London, British Library, Egerton 3051/ Washington, Library of Congress, M.2.1.M6 Case, fols. 15v–16r.

211. D'Accone, "Lorenzo the Magnificent and Music," pp. 273–74.

212. Something of the same kind of argument is made by Donna G. Cardamone Jackson in her description of the style of the "earliest Neapolitan *villanesche,* . . . characterized by . . . syllabic declamation in the cantus supported by a discreet background of sonority in the tenor and bass, which often parallels the tune in similar motion. . . . The three-voice style, in which the supporting parts have little autonomy, was probably inspired by the habits of popular singers (or *citaredi*) who accompanied their lyrical recitations with simple chords on a stringed instrument." See Donna G. Cardamone Jackson, *Adrian Willaert and His Circle: Canzone Villanesche alla Napolitana and Villotte,* Recent Researches in the Music of the Renaissance XXX (Madison, Wisc.: A-R Editions, Inc., 1978), p. xiii.

213. RISM 1504[4] (Venice: Ottaviano Petrucci, 1504) (fol. 46r), ascription: "Micha."

214. Pirrotta, *Music and Theatre,* pp. 71–72. See also William F. Prizer, *Courtly Pastimes: The Frottole of Marchetto Cara* (Ann Arbor, Mich.: UMI Research Press, 1974, 1980), p. 111. For an example of the musical effects resulting from such compositional practices, see, for instance, Einstein, *Italian Madrigal,* 1:101.

215. Perugia, Biblioteca Comunale Augusta, 431 (G 20).

216. Florence, Biblioteca Nazionale Centrale, Magl. XIX.121. Serafino's piece is conveniently accessible in Atlas's *Music at the Aragonese Court of Naples* (Cambridge: Cambridge University Press, 1985), p. 223. See also Atlas's critical report, p. 237, and his discussion, pp. 147–48. On Florence 121, see Bonnie J. Blackburn's excellent article "Two 'Carnival Songs' Unmasked: A Commentary on MS Florence Magl. XIX.121," *Musica Disciplina* 35 (1981): 121–78.

217. MacNeil, *Music and Women*, pp. 62–64, 134–41, 186.

218. On both of these works, see Walter Rubsamen's characteristically insightful piece, "Sebastian Festa and the Early Madrigal," *Bericht über den Internationalen Musikwissenschaftlichen Kongress, Kassel, 1962,* ed. Martin Just and Georg Reichert (Basel: Bärenreiter Verlag, 1963), pp. 122–26.

L'ultimo dì di maggio is no. 44 (fols. 52v–53r) in the manuscript Florence Magl. XIX.164–67 and is without attribution there; it is also found in the manuscripts Florence, Biblioteca del Conservatorio di Musica, Basevi 2440, no. 49 (fols. 88v–89r; pp. 176–77) (anonymous) and Venice, Biblioteca Nazionale Marciana, Cl. It. 4, 1795–98, no. 97 (fol. 83v) (anonymous), and in the print *Canzoni frottole & Capitoli Da Diuersi Eccellentissimi Musici Composti Nuouamente Stampati & Correcti. Libro Primo. De La Croce* [RISM 1526[6]] (Rome: Jacopo Pasoti and Valerico Dorico, 1526), fols. 30v–31r (Sebastian Festa).

O passi sparsi is no. 25 (fols. 34v–35r) in the MS Florence Magl. XIX.164–67 and is without attribution there; it is also found in the following manuscripts and prints: Bologna, Civico Museo Bibliografico Musicale, Q 21, no. 24 (fols. 27r–28v) (anonymous); Florence, Biblioteca Nazionale Centrale, Magl. XIX.111, no. 10 (anonymous); Modena, Biblioteca estense, γ, L. II.8, no. 2 (fols. 2v–3r) (anonymous); New Haven, Connecticut, Yale University, John Herrick Jackson Music Library Misc. 179, no. 29 (fol. 34r) (anonymous); Venice, Biblioteca del Conservatorio "Benedetto Marcello," Fondo Torrefranca, B 32, no. 5 (fols. 7v–9r) (anonymous); RISM 1526[6], fols. 6v–8r (Sebastian Festa); *Chansons musicales à quatre parties* ... (Imprimees a Paris: par Pierre Attaingnant., Mense april, 1533), no. 3 (fol. ii[v]) (anonymous); *Second liure cõtenãt xxix. chansons* ... [RISM 1549[18]] (Imprimees a Paris: Par Pierre Attaingnãt, 1549), fol. ix[v] (Constantius Festa); *Premier recueil des recueilz de chansons, à quatre parties* ... [RISM 1561[7]] (Paris: Le Roy and Ballard, 1561) (reprinted by Le Roy and Ballard in 1567 [RISM 1567[12]] and 1573 [RISM 1573[14]]); and nine reprints of the publication *DI VERDELOTTO / TUTTI LI MADRIGALI DEL PRIMO, ET SECONDO Libro a Quatro Voci. ...* [RISM 1540[20]] (Apud Hieronymum Scotum, 1540):

1. RISM 1544[18] (Gardane), no. 57 (S. Festa)
2. RISM 1545[19]
3. RISM 1549[33] (Scotto)
4. RISM 1552[26] (Scotto)
5. RISM 1555[33] (Scotto)
6. RISM 1556[27] (Gardane)
7. RISM 1557[26] (Pietrasanta)
8. RISM 1565[20] (Gardane)
9. RISM 1566[22] (Claudio Merulo)

The piece also appears, arranged for instrumental performance, in a great many print-ed books of lute and guitar intabulations; see Howard Mayer Brown, *Instrumental Music Printed Before 1600: A Bibliography* (Cambridge: Harvard University Press, 1967), pp. 139–42 (no. 94), 148 (no. 13), 167–68 (no. 4), 202 (no. 1), 248–50 (no. 8), and 275–76 (no. 25).

219. On the date of the manuscript, see Joshua Rifkin, "Scribal Concordances for Some Renaissance Manuscripts in Florentine Libraries," *Journal of the American Musicological Society* 26 (1973): 305–26, esp. p. 313 n. 30, where Rifkin makes the important point that the manuscript does not contain any music by Verdelot, "who clearly dominated the musical scene in Florence soon after his arrival there," which suggests a dating for the manuscript before Verdelot's arrival.

220. In this respect, however, the repertory of MS Florence Magl. XIX.164–67 may not be reflective of the musical tastes of the Rucellai group, if my interpretation of those tastes is correct. Pisano's settings of Petrarchan verse are, in many instances, contrapuntal and, indeed, imitative, in a style reminiscent of the contemporary motet. This kind of writing was unlikely to have met with Brucioli's approval, as I have argued. On Pisano's associations with members of the Rucellai cultural orbit, see nn. 62–64 above.

221. The manuscripts Florence, Biblioteca Nazionale Centrale, Banco rari 337 (*olim* Palat. 1178), and Banco rari 230 (*olim* Magliabechi XIX.141); for an inventory of the Italian material in Magl. XIX.164–67, see Fenlon and Haar, *Italian Madrigal,* pp. 173–76, which shows the concordances with the two canto carnascialesco manuscripts. I argue for the importance of the canto carnascialesco tradition to the origins of the madrigal, partly on the basis of the demonstrable conversance with that tradition on the part of members of the Florentine cultural elite with whom Layolle, Pisano, and Verdelot almost certainly frat-ernized, and partly on the basis of stylistic reminiscences between the canto carnascialesco and the madrigal identified by Gallucci and Rubsamen.

222. See Chapter 3 in this volume.

223. The possible scribal relationship between Banco rari 230 and FlorBN Magl. 164–67 is most easily studied by examining, on the one hand, Plates I and II (pp. xx–xxi) in Gallucci, *Florentine Festival Music,* (fols. 88v and 89r of MS Banco rari 230) and, on the other, either Plates 2 and 3 (between pp. 86 and 87) in Fenlon and Haar, *Italian Madrigal* (no. 42 in MS Magl. XIX.164–67 and fol. 88v of MS Florence, Biblioteca del Conservatorio di Musica, 2440, which was copied by the same scribe) or Figures 5 and 6 (pp. 316 and 317) in Rifkin, "Scribal Concordances" (no. 13 in MS Magl. XIX.164–67 and fols. 83v–84r of MS 2440). I especially draw the reader's attention to the designations "Bass[us]," "Tenor," and "Cont[ra]" in the various illustrations, as well as other similarities. One can also make detailed and exhaustive comparisons using the facsimile editions of these two manuscripts: *Florence, Biblioteca Nazio-nale Centrale MS Banco Rari 230,* Introduction by Frank A. D'Accone, Renaissance Music in Facsimile, Sources Central to the Music of the Late Fifteenth and Sixteenth Centuries 4, A Garland Series (New York: Garland Publishing, Inc., 1986) and *Florence, Biblioteca Nazionale Centrale MSS Magl. XIX.164–167,* Introduction by Howard Mayer Brown, 4 vols., Renais-sance Music in Facsimile, Sources Central to the Music of the Late Fifteenth and Sixteenth Centuries V, A Garland Series (New York: Garland Publishing, Inc., 1987).

On the scribal concordance between Florence, Biblioteca del Conservatorio di Musica, 2440, and Magl. XIX.164–67, see Rifkin, "Scribal Concordances," pp. 312–13 and nn. 28–31 and Figures 5 and 6.

In the interest of objectivity, I am compelled to observe that, although the hand that entered the music—the actual notes—in Banco rari 230 and Magl. 164–67 is the same, to my eye, the text hands are different. Moreover, there are some notational practices—the treatment of the custos and clef among them—that differ in the two manuscripts.

224. Further, one of the watermarks found in manuscript Magl. XIX.164–67 is also found in the manuscript Bologna, Civico museo bibliografico musicale, Q 21 (see Rifkin, "Scribal Concordances," p. 312 n. 28), perhaps the first important madrigal manuscript, which also contains a number of works by Sebastiano Festa, several of which are also contained in manuscript Magl. XIX.164–67. On the Bologna manuscript, see Fenlon and Haar, *Italian Madrigal*, pp. 137–42.

225. Like Bologna Q21, Yale 179 lies at the other end of the continuum from the important sources of the transitional period.

226. Festa's *Madonna, io mi consumo* appears on fols. 58v–61r.

227. Pesenti's *Ahime ch[']io moro, In hospitas per alpes,* and *Integer vitæ scelerisque purus* are found arranged for solo voice and lute accompaniment in *Tenori e contrabassi intabu / lati, etc. Li / bro primo. Francisci Bossinensis / Opus.* (Impressum Venetijs: Per Octavianum Petrutium forosemproniensem, Die 27 Martij. 1509), fols. 41v–42r, 35r, and 36r. The *Ahime lasso ahime dolente, Deh chi me sa dir novella, Non è pensier ch[']è[']l mio secreto, Poi chè ciel e la fortuna, S[']io son[o] stato a ritornare,* and *Spenta m[']hai del pecto amore* are found arranged in *Tenori e co[n]trabassi intabu / lati col soprano in canto fi / gurato per cantar e so / nar col lauto Li / bro Secundo. / Francisci Bossinensis / Opus.* (Impressum in Forosempronij: per Octavianun petrutiũ Forosemproniensem, Die 10 Madij Anno d[omi]ni, 1511), fols. 51r–52r, 13v [11v]–14v [12v], 49v–50v, 16r–16v, 31v–32r, and 29r–30r.

228. *Ahime ch[']io moro, In hospitas per alpes, Integer vitæ scelerisque purus, Poi chè ciel e la fortuna,* and *S[']io son[o] stato a ritornare.*

229. No. 33; fols. 44v–45r; ascription: anonymous.

230. Fol. 82r; ascription: "Michael."

231. Fols. 30v–31r; ascription: "pre michele." It is also preserved in the manuscript Florence, Biblioteca del Conservatorio di Musica, Basevi 2440, no. 35 (fols. 61v–62r; pp. 122–23) and the prints RISM 1504⁴, no. 40 (fol. 37v–38r), where it is attributed to "Micha. C. & V.," and CON. FESTA, *IL VERO LIBRO DI MADRIGALI A TRE VOCI DI CONSTANTIO FESTA NOVAMENTE RACOLTI ET CON UNA NOVA GIONTA Stampatti & Corretti A TRE VOCI* [RISM 1543] (Venetijs Apud Antonium Gardane, 1543), no. 21 (fol. 20r). As Fenlon and Haar note (*Italian Madrigal*, p. 236), "The four-voice piece by Michele Pesenti (?) is the source [for the piece in the Festa print], which simply dispenses with the altus." See also Einstein, *Italian Madrigal*, 1:121, where Einstein characterized it as "an irony of history that this composition, with the omission of one part . . . , was printed among the three-part madrigals of Costanzo Festa." In manuscript Basevi 2440, Festa's *Madonna, io mi consumo* (see n. 226 above) immediately precedes the three Pesenti villotte; this may

explain why *O me, che la brunetta mia*, which is the first of the Pesenti villotte, was later misattributed to Festa.

232. Published in VERDELOT, *LA PIÙ DIVINA, ET PIÙ BELLA MUSICA, CHE SE udisse giàmai delli presenti Madrigali, a Sei voci. . . .* [RISM 1541[16]] (VENETIJS APUD ANTONIUM GARDANE, 1541) (no. 16; p. 17). The piece is also contained in the 1546 reprint of the *Madrigali, a Sei voci*, the print *VERDELOT A SEI / MADRIGALI DI VERDELOT ET DE ALTRI AUTORI A SEI VOCI novamente con alcuni madrigali novi ristampati & corretti / A SEI VOCI* [RISM 1546[19]] (In Venetia: Apresso di Antonio Gardane, 1146), p. VIII. On Verdelot's use of Pesenti's discant, see Rubsamen, "From Frottola to Madrigal," esp. p. 65 and n. 51; on the Verdelot madrigal and the prints containing it, see Fenlon and Haar, *Italian Madrigal*, pp. 309 and 318. For further evidence that Pesenti's piece was known to devotees of the madrigal, see the preceding note on a three-voice arrangement of this piece published under Costanzo Festa's name.

233. Florence, Biblioteca Nazionale Centrale, Magl. XIX.121 and the canto carnascialesco manuscript Banco rari 337.

234. On the potential importance of this genre to madrigal origins, see my "Giulio de' Medici's Music Books," p. 99, and the quotation from Pirrotta accompanying text for n. 203 above. On the anonymous *Tambur tambur* as an example of the genre of four-part polyphonic arrangements of French popular tunes, see Blackburn, "Two 'Carnival Songs' Unmasked," esp. pp. 134–38, 154–55, and 176–77.

Chapter Two

1. Paul Oskar Kristeller, "Francesco da Diacceto and Florentine Platonism in the Sixteenth Century," *Studies in Renaissance Thought and Letters*, Storia e letteratura, Raccolta di studi e testi 54 (1956, 1969; reprint, Rome: Edizioni di storia e letteratura, 1984), pp. 287–336, esp. p. 293. On sixteenth-century Tuscan academic life generally, see Eric W. Cochrane, *Tradition and Enlightenment in the Tuscan Academies, 1690–1800* (Chicago: University of Chicago Press, 1961), esp. Chapter 1, "From the Cinquecento to the Settecento."

2. Kristeller, "Francesco da Diacceto," pp. 302, 328–29. On the "Platonic academy" of the fifteenth century, see also Kristeller, *Eight Philosophers of the Italian Renaissance* (Stanford, Calif.: Stanford University Press, 1964), pp. 41–42, and n. 47 below. But on the question of the very existence of the "academy," see James Hankins's important recent article "The Myth of the Platonic Academy of Florence," *Renaissance Quarterly* 44 (1991): 429–75, and the condensed presentation in *Plato in the Italian Renaissance*, Columbia Studies in the Classical Tradition 17, 1 (Cologne: E. J. Brill, 1991 [second impression]), pp. 269 n. 5 and 288–300.

3. Of 1 June 1515, 13 June 1515, and 23 October 1516, respectively. All of these texts are published in *Il sepolcro di Dante*, ed. Ludovico Frati and Corrado Ricci, Scelta di curiosità letterarie inedite e rare 135 (Bologna: Premiato Stab. Tip. Succ. Monti, 1889), pp. 43–57; the letter to Cardinal Giulio describes the academy as Leo's Sacred Academy ("sua sacra Academia"). See also Kristeller, "Francesco da Diacceto," pp. 328–29, for the fragment of a 15 March 1515 letter drafted by academy member Girolamo Beniveni for Lucrezia de' Medici

Salviati to send on behalf of the Sacred Academy to her brother Pope Leo X, requesting the return of Dante's remains.

4. The reference to the revision of Palmieri's *Città di Vita* is in Kristeller, "Francesco da Diacceto," p. 328. The quotation from Procacci is in *History of the Italian People*, trans. Anthony Paul (Auckland: Penguin Books, 1968), pp. 164–65. The quotation from Cochrane is in "A Case in Point: The End of the Renaissance in Florence," *The Late Italian Renaissance, 1525–1630*, ed. Eric Cochrane (Evanston: Harper Torchbooks, Harper & Row, 1970), pp. 43–73, esp. p. 55.

5. On Cerretani, see the Appendix.

6. Rudolf von Albertini, *Firenze dalla repubblica al principato, Storia e coscienza politica*, trans. Cesare Cristofolini, Biblioteca di cultura storica, 109 (Turin: Giulio Einaudi s.p.a., 1970 [2d ed.]), p. 104.

7. On Modesti, see the Appendix.

8. On Benivieni, see the Appendix.

9. See n. 65 and the accompanying text in Chapter 1.

10. On his writings and their significance, see Felix Gilbert, "Alcuni discorsi di uomini politici fiorentini e la politica di Clemente VII per la restaurazione medicea," *Archivio storico italiano* 43/2 (1935), pp. 3–24, and von Albertini, *Firenze dalla repubblica al principato*, pp. 179–201.

11. See my Conclusion and the Appendix.

12. Kristeller, "Francesco da Diacceto," pp. 328–36.

13. The letters to Rucellai are in Kristeller, "Francesco da Diacceto," pp. 333 and 334: "Magnifice Domine Protector et Benefactor noster colendissime" and "Magnifice Domine proteptor et benefactor noster precipue."

14. Ibid., pp. 332, 334–35.

15. Ibid., p. 332.

16. Ibid., p. 334: "electa per nostro proteptore in compagnia della Signoria del Unico."

17. Evidence of Corso's activity as poet-singer is furnished in a letter of 4 January 1493 from Paolo Cortese in Rome to Piero di Lorenzo de' Medici. See Maria Teresa Graziosi Acquaro, "Note su Paolo Cortesi e il dialogo 'De hominibus doctis,'" Istituto universitario orientale di Napoli, *Annali*—Sezione Romanza X, 2 (1968), pp. 355–76, esp. p. 357 n. 2.

The circumstances of Corso's death—though perhaps fabricated—are related in a letter of 18 February 1493 from Stefano Taverna in Rome to Lodovico Sforza "il Moro." They, too, furnish evidence of Corso's activity as a literary-musical figure. See Pio Paschini, "Una famiglia di curiali nella Roma del quattrocento: i Cortesi," *Rivista di storia della chiesa in Italia* 11 (1957): 1–48, esp. p. 33 and n. 127.

18. Baccio played the title role in Poliziano's *Orfeo* in Mantua in 1480. For some representative texts on him, see, for example, Isidoro del Lungo, *Florentia, Uomini e cose del Quattrocento* (Florence: G. Barbèra, 1897), pp. 307 n. 4, 308 n. 1, 308–9 n. 2; Adrien de la Fage, *Essais de Diphtherographie Musicale* (Paris: O. Legouix, 1864), p. 64; Arnaldo della Torre, *Storia dell'Accademia platonica* (Florence: Carnesecchi, 1902), p. 798–800; and Antonio Cammelli detto "il Pistoia," *Rime* (Livorno: Coi tipi di F. Vigo, 1884), p. 54.

19. "Mirificeq$_3$ etiam uoluptas ex his hominibus capi honesta potest / qui ex tempore dicuntur plebeio sermone canere solere ad lyram : quo ex genere ut nuper .B. Vgolinus / & Iacobus Corsus / in Italia sũt laudari soliti / sic hodie maxime debet Bernardus Accoltus celebrari / q$_3$ quanq$_3$ uersus ex tẽpore dicat / ita tamẽ apte sentẽtiis uerba cõcinna iungit / ut cũ celeritati sẽper parata sit uenia / magis in eo sint laudanda / quæ fundat q$_3$ ignoscendum / q$_3$ ex tempore & partu repentino dicat / quæ sit gignentis ingenii / non dicentis cogitate laus:" *De cardinalatu libri tres* (Castel Cortesiano, 1510), Book III, fols. 164v–165r. The translations are taken from Nino Pirrotta, "Music and Cultural Tendencies in 15th-Century Italy," *Music and Culture in Italy from the Middle Ages to the Baroque* (Cambridge: Harvard University Press, 1984), pp. 80–112 and 382–91, esp. p. 112. Pirrotta's luminous article is the seminal study of the practice of solo singing to string accompaniment and of the humanist intellectual tradition of which it is an expression.

20. "Fioriva . . . in Roma a quel tempo la nostra Academia in casa di Paulo Cortese, . . . Concorrevano ivi ogni giorno gran multitudine de elevati ingegni . . . , sotto la cui ombra altri de minore etade, che de amplettere la virtù tuttavia erano desiderosi, a soggiornare e prendere delettazione ancora se reducevano. Erano de' poeti vulgari in grandissimo pregio li ardori de lo [Unico] Aretino. . . . Serafino [Aquilano] adunque, il quale più meco che con altra persona vivente ebbe commercio, de frequentare medesimamente questa Accademia prese deliberazione . . . ; imperocché a tempo con l'armonia di soa musica e con l'arguzia di suoi strammoti [*sic*] spesse volte li ardui certami di quelli altri litterati interpellava. La qual cosa de accrescere più il suo nome li fu assai giuvamento, essendo emulazione tra tutti quelli dotti a cui più recondita invenzione di fare strammoti [*sic*] li poteva ritrovare. Per la qual cosa, avvenga che lui avesse tanto ostaculo e paragone como era l'Aretino, e tanta fraterna emulazione como era dil Cortese e nostra, nientedimeno a qual se voglia poeta del presente seculo in questo stile non è stato inferiore; anzi, che più è, un tempo durò che se strammoto [*sic*] novo si sentiva, ancora che d'altro auttore fusse stato composto, a Serafino se attribuiva." See the "Vita del facondo poeta vulgare Serafino Aquilano per Vincenzio Calmeta composta," in Calmeta, *Prose e lettere edite e inedite (con due appendici di altri inediti)*, ed. Cecil Grayson, Collezione di opere inedite e rare pubblicata per cura della Commissione per i testi di lingua 121 (Bologna: Commissione per i testi di lingua, Casa Carducci, 1959), pp. 63–64. The fact that Accolti dedicated a sonnet and an epitaph to Serafino upon Serafino's death is evidence beyond the testimony of Calmeta's account of a relationship between the two; see L. Mantovani, "Accolti, Bernardo, detto L'Unico Aretino," *Dizionario biografico degli italiani* (Rome: Instituto della Enciclopedia Italiana, 1960–), 1:103–4, esp. p. 104.

21. On Corso and his relationship to Cortese, see n. 17 above.

22. Pirrotta, "Music and Cultural Tendencies," p. 112.

23. See Figures 2.1 and 2.2. The identification is made by Vasari himself in his *Ragionamenti:* "P. Chi è quel prete, vecchio, magro, raso, che fa l'uffizio di suddiacono con quella toga rossa, portando la croce del papa? G. Quello è M. Francesco da Castiglione, canonico fiorentino, il quale ha accanto à se, e sopra, tutti i segretari del papa; quel primo accanto a lui è il dottissimo ed amico delle muse M. Pietro Bembo, ed allato a esso è il raro poeta M. Lodovico Ariosto, il quale ragiona col satirico Pietro Aretino, flagello de' principi; sopra fra tutt'a dua quel che ha quella zazzera, raso la barba, con quel nasone aquilino, è Bernardo

Accolti Unico, Aretino, che parla col Vida Cremonese, e col Sanga, e col Olosio; vicino gli è il dottissimo Sadoleto da Modana, il quale parla con quel vecchiotto raso ed in zazzera di capelli canuti, che è Iacopo Sanazzaro, Napolitano." See Vasari, *Opere,* vol. 8 (Florence: G. C. Sansoni, Editore, 1882), p. 142.

24. Sigismondo Fanti, *Triumpho di fortuna* (Venice: Agostino da Portese ad instantiam di Giacomo Giunta, 1527), carte XXVI; see Figure 2.3. Notturno Napolitano was the author of an important poetic account of Giuliano de' Medici's 1513 investiture with Roman citizenship, which is full of references to the investiture's prominent musical element. An edition of Notturno's account may now be consulted in Fabrizio Cruciani, *Teatro nel Rinascimento, Roma 1450–1550* (Rome: Bulzoni, 1983), pp. 421–34. On Notturno, see the references in H. Colin Slim, "Dosso Dossi's Allegory at Florence about Music," *Journal of the American Musicological Society* 43 (1990): esp. p. 45 n. 7, and Cruciani's introductory notes to his edition of the account of the investiture ceremony in *Teatro nel Rinascimento,* pp. 406–15, esp. p. 415, where he quotes the following contemporary text documenting Notturno's activities as singer in Cesena in 1517: "Nocturno partenopeo ... cantò in piazza degnissimamente e vendé molte opere" (Cesena, Biblioteca comunale, manuscript copy of G. Fantaguzzi, "Caos, cronaca cesenate," 1521, I, 5 48).

25. Indeed, the explicit pairing of the portraits of Accolti and Notturno further locates Accolti within the tradition of solo singing, of which Notturno was a famous representative.

26. Canto XLVI/X: "Il cavallier che tra lor viene, e ch'elle / onoran sì, s'io non ho l'occhio losco, / da la luce offuscato de' bei volti, / è 'l gran lume aretin, l'Unico Accolti." See Ludovico Ariosto, *Orlando furioso,* ed. Lanfranco Caretti (Milan: Riccardo Ricciardi Editore, 1954), p. 1211.

27. "Heri sera l'Unico Aretino disse a l'improviso inanti al Papa, per tre hore, con grandissima audientia: secondo il suo consueto mirabelmente." See Baldassar Castiglione, *Le lettere* I (1497–marzo 1521), ed. Guido La Rocca, Tutte le Opere di Baldassar Castiglione I, I Classici Mondadori (Verona: Arnoldo Mondadori, 1978), p. 711. Another reference to Accolti appears in ibid., p. 456, in a letter of Castiglione's of 12 August 1519, also to Federico Gonzaga.

For a sample of the great many of the contemporary literary references to Accolti, see the reference in one of Pietro Aretino's *pasquinate* (a "popular" genre named for the scurrilous verses posted on the antique statue of Pasquino in Rome), published by G. A. Cesareo in "Una satira inedita di Pietro Aretino," *Raccolta di studi critici dedicata ad Alessandro D'Ancona* (Florence: Tipografia di G. Barbèra, 1901), pp. 175–91, esp. p. 179: "[H]o detto che [Pietro Accolti, called the Cardinal of] Ancona fa pratica di volere tuor moglie di novo, et ch'io credo che toglierà la femina dell'Unico, suo fratello."

28. Naldius's verses may be found in Naldus Naldius Florentinus, *Epigrammaton Liber,* ed. Alexander Perosa, Bibliotheca Scriptorum Medij Recentisque Ævorum (Budapest: K. M. Egyetemi Nyomda, 1943). The verses in honor of Migliorotti are on pp. 44 and 52–53.

29. In the so-called anonimo gaddiano. Cornelio de Fabriczy, "Il codice dell'anonimo gaddiano (Cod. magliabechiano XVII, 17) nella Biblioteca nazionale di Firenze," *Archivio storico italiano,* 5th series, 12 (1893): 15–94, 273–334, esp. p. 87: Leonardo "[f]u eloquente nel parlare, et raro sonatore di lira, et fu maestro dij quella d'Atalante Migliorottij. Stette

da giovane col Magnifico Lorenzo de Medicij, . . . et ~~da luij~~ haveva 30 annij, che dal detto Magnifico Lorenzo fu mandato al duca di Milano a presentarlij insieme con Atalante Migliorottij una lira, che unico era in sonare tale extrumento."

30. On the lost Leonardo sketch that may have been of Migliorotti, see *Codice atlantico di Leonardo da Vinci, nella Biblioteca Ambrosiana di Milano,* 8 vols. (Milan: Hoepli, 1894), text volume 4, p. 1106, and facsimile volume 4, fol. 324r.

31. The first item in the series, Girolamo Stanga's letter of 29 October 1490 to the Marchese Francesco Gonzaga, in which Stanga wrote that "Mandarò per cavallaro a posta a Firenze per aver quello Athlante, e farò scrivere una lettera a Piero de Medici in nome de la Ex. V.ra," is excerpted in Alessandro D'Ancona, *Origini del teatro italiano,* 2 vols. (Turin: Ermanno Loescher, 1891), 2:359. The Marchese's letter of 31 October to Piero de' Medici is excerpted in Emma Tedeschi, "La 'Rappresentazione d'Orfeo' e la 'Tragedia d'Orfeo'" *Atti e memorie,* Reale Accademia virgiliana di Mantova, R. Deputazione di storia patria per l'antico ducato, new series, 17–28 (1924–25): 47–74, esp. p. 69; Migliorotti is described there as *"Athalante vostro* [that is, Piero de' Medici's]." The third item in the series, Stanga's letter of 7 November to the Marchese, in which it is said that "Messer Fhilippo e Zafrano hanno preparato quanto si po' per la festa: pure che Athlante vegni, che qui non si troverà persona che satisfacesse per Orfeo," is in Tedeschi, "La 'Rappresentazione d'Orfeo,'" p. 69. The letters of 1491 (31 May, from Matteo degli Antimachi, the Marchese's chancellor, to the Marchese; 7 June, from the Marchese to Migliorotti; and 3 July, from Migliorotti to the Marchese) are in D'Ancona, *Origini del teatro italiano,* 2:363–64. William Prizer has suggested that a reference in a letter of 3 February 1492 in the Archivio Gonzaga to an otherwise unnamed "fiorentino che canta in lira" may also be to Migliorotti; see *Courtly Pastimes: The Frottole of Marchetto Cara* (Ann Arbor, Mich.: UMI Research Press, 1980), p. 8.

32. "lo ambassatore dell'Ill.mo Signor Duca de Ferrara." Pertinent portions of Isabella's letter (Archivio di Stato di Mantova, Archivio Gonzaga, Busta 2991, libro 3, fol. 69r [copialettere]) are excerpted in Antonino Bertolotti, *Musici alla Corte dei Gonzaga in Mantova dal secolo XV al XVIII,* Biblioteca Musica Bononiensis, Sezione III. N. 17 (Bologna: Forni Editore, 1969 [Ristampa anastatica]), p. 15. I have corrected Bertolotti's reading on the basis of a transcription graciously provided by Professor William Prizer. On that same day, the Marchesa also wrote directly to Manfredi himself concerning Migliorotti; once again, I am very grateful to Professor Prizer for providing me with a transcription of Isabella's letter and for generously granting me permission to publish it here for the first time. The letter contains the important information that Migliorotti was at that time associated in some way with Cardinal Giovanni de' Medici (later Pope Leo X) and thus provides a bit of evidence about Leo's activity as a music patron while still a cardinal: (Archivio di Stato di Mantova, Archivio Gonzaga, Busta 2991, libro 3, fol. 69r [copialettere], Marchesa Isabella d'Este Gonzaga, Porto Mantovano, to Manfredo de' Manfredi) "Domine Manfredo de Manfredis, / Oratori Duci Ferrarie in Florentia / Magnifice, et cetera. Scrivamo per la inclusa ad Atlante Fiorentino cithared, qual sta cum el Reverendissimo Monsignore Cardinale di Medici, che'l voglia farne fare una bella citharra picola per uso nostro de quante corde parerà a lui. Pregamovi che gli faciati dare la lettera et sollecitare che siamo servite et, bisognandoli dinari, dategli, che ve li rimeteremo subito, pigliando etiam cura de mandar-

cela, facta che la sia, che da vui haveremo gratissimo. Offerendone a li vostri piaceri sempre paratissime. Ut supra [Ex Palatio nostro Portus, 22 Junij 1493]."

33. Niccolò da Correggio's letter is in William Prizer, "Isabella d'Este and Lorenzo da Pavia, 'Master Instrument Maker,'" *Early Music History* 2 (1982): 87–127, esp. pp. 107–8 and 125–26. On Niccolò da Correggio and his relationship to the musical culture of the time, see also, among other representative references, Alfred Einstein, *The Italian Madrigal,* trans. Alexander H. Krappe, Roger H. Sessions, and Oliver Strunk, 3 vols. (Princeton, N.J.: Princeton University Press, 1949), for example, pp. 45, 97, 104–5.

34. See Bertolotti, *Musici alla Corte,* p. 16, and D'Ancona, *Origini del teatro italiano,* p. 362.

35. "nuova et inusitata forma di lyra." See D'Ancona, *Origini del teatro italiano,* p. 362.

36. *Introitus et exitus Cameræ Apostolicæ,* 1671, 16 June 1513.

37. Alberto de Zahn, "Notizie artistiche Tratte dall'Archivio Segreto Vaticano," *Archivio storico italiano,* 3d series, vol. 6, part 1 (1867): 166–94, esp. p. 183. De Zahn noted that the entry is repeated in the following volumes until 1516, the name variously written "Atebanti de Maglonettis," "Atlati de Miglieratis," or "Athalanti de Miliorottis." See also the reference in G. Amati, "Notizia di alcuni manoscritti dell'Archivio secreto vaticano," *Archivio storico italiano,* 3d series, vol. 3, part 1 (1866), pp. 166–236, esp. p. 225: "Mandamus solvi faciatis dilecto filio Athalanti de Mygliorottis duc. quatuordecim et carl. quatuor de bon. 72 pro quolibet duc., singulis mensibus."

38. I should also note that one of the academy's members, Lorenzo Strozzi himself played the lute, as is suggested by a reference in Francesco d'Antonio Zeffi's life of Strozzi; see the pertinent passage of the text in Alessandro Parronchi, "La prima rappresentazione della Mandragola," *La bibliofilia* 64 (1962): 80–81.

39. Kristeller, "Francesco da Diacceto," p. 332.

40. Ibid., p. 335: "per nostra deliberatione et partito di tucte le fave nere sotto di XX del presente vi habbiamo electo perpetuo cytharedo della nostra Sacra Academia, et facto nostro ambasciatore per uno anno da cominciarsi il primo di maggio proximo alla Santità di nostro Signore, per supplicare da quella più cose come alla giornata visi dirà."

41. Ibid.: "Eci piace che tu habbi acceptato quello ufficio che questa Sacra Academia tiha per tua virtù et sua liberalità largito." I cannot satisfactorily explain the inconsistency between de Zahn's remark that payments to Migliorotti are recorded in the Vatican accounts until 1516 (see my nn. 36 and 37 above) and the evidence of Migliorotti's appointment to an office in the Medici Sacred Academy in 1515. Of course, the fact that he was appointed ambassador to Leo suggests that he was expected to spend much of his time in Rome, but why would the Academy's members have appointed him their "lutenist in perpetuity" if he was not also expected to be in Florence for part of the time and attend their meetings?

42. Pirrotta demonstrated this fact in a series of evocative and stimulating articles. See, above all, "Music and Cultural Tendencies." See also "The Oral and Written Traditions of Music" and "Novelty and Renewal in Italy: 1300–1600," in *Music and Culture in Italy,* pp. 72–79 and 159–74 and the accompanying notes.

43. This is suggested not only by the fact of Accolti and Migliorotti's having been associated with the academy but also by a reference in the formal petition to Leo to solo singing to the accompaniment of the lyre, as was observed by A. F. Gori in the edition of Condivi's

life of Michelangelo, *Vita di Michelagnolo Buonarroti pittore, scultore, architetto, e gentiluomo fiorentino pubblicata mentre viveva dal suo scolare Ascanio Condivi* (In Firenze: Per Gaetano Albizzini. All'insegna del sole. Con licenza de' superiori, 1746), p. 112. The petition is printed on pp. 112–15 and also in *Il sepolcro di Dante,* pp. 50–57.

44. For a brief description of Cortese's Roman academy and information on its musical practices as exemplified by the activities of Accolti and Serafino Aquilano (see the following note), see John F. D'Amico, *Roman Humanism in Papal Rome: Humanists and Churchmen on the Eve of the Reformation,* Johns Hopkins University Studies in Historical and Political Sciences, 101st series (1983), I (Baltimore: Johns Hopkins University Press, 1983), pp. 102–7; see esp. pp. 102–3 for Vincenzo Calmeta's account of the academy's activities, which is an important source of information on the possible musical experiences of its members. On Accolti's and Serafino's musical activities and their relationship to other musical practices of the time, see also James Haar, *Essays on Italian Poetry and Music in the Renaissance, 1350–1600,* Ernest Bloch Lectures (Berkeley: University of California Press, 1986), p. 61.

45. Serafino Aquilano, the most celebrated of the solo singers of the late fifteenth century and a member of Cortese's Roman academy, may have been an intimate of Giuliano di Lorenzo de' Medici, Leo X's brother, as is suggested by Giuliano's sonnet *Perchè hai Serafin, Morte, offeso tanto?,* written "Pro morte Seraphini. Agosto 1500." See Giuliano de' Medici, *Poesie,* ed. Giuseppe Fatini, Centro Nazionale di Studi sul Rinascimento (Florence: Vallechi Editore, 1939), p. 75. In this respect see my discussion in Chapter 1 of the musical setting of Serafino's "Sufferir so disposto," which may give some sense of the kind of solo song with which Giuliano de' Medici was familiar.

46. Several other solo singers of the time are known to have been intimates of Leo's. On the Sienese singer Niccolò Campani (1478–1523), known as "Strascino" from the title of a farce in which he performed in 1511, see Castiglione, *Le lettere,* p. 1276 n. 9, and the documentary texts in ibid., pp. 1276 (27 August 1518 and 25 December 1520), 666 (1 January 1521), 680 (9 January 1521), 682 (12 January 1521), 683–84 (14 January 1521), and 687 (16 January 1521), and Fabrizio Cruciani, *Teatro nel Rinascimento, Roma 1450–1550* (Rome: Bulzoni editore, 1983), p. 484, where there is the text of a letter of 18 February 1520 from Alfonso Paolucci in Rome to the duke of Ferrara, in which Paolucci reported that "trovai il Papa in mensa che audiva Strassino, con la sua citara, dicendo all'improvviso." On the famous singer Querno, see, for example, Alessandro Luzio, "Federico Gonzaga, Ostaggio alla corte di Giulio II," *Archivio della R. Società di Storia Patria* 9 (1886), pp. 509–82, esp. pp. 575–76, where there is the text of a fascinating letter of 1 October 1519 from Alessandro Gabbioneta, the Archdeacon of Mantua, in which Gabbioneta reported on "uno poeta neapolitano quale sta cum el Papa, nominato el Querno, servitor del Ducha de Hadri," who, according to Leo's own testimony, "faceva boni versi, ma me [i.e., Gabbioneta] par che lo habiano redutto al termine del quondam abbate de Gaieta, cum sit che il giorno di S.to Cosmo e Damiano, che fu alli 27 del passato, fu vestito da Venere cum dui Cupidini e recitò un quaderno de versi. El Papa ge dà 100 duc. de provisione et lo hanno posto in rotulo cum 150 fiorini di stipendio alla lectura de le feste et fa la oracione del studio. El papa lo fa manzare in su uno schabelletto basso alla presentia sua et inanci ch'el manza ogne vivanda canta sei versi de diversa sententia."

47. On solo singing to string accompaniment as a quintessentially humanistic activity, see also, for example, the famous reference to Cosimo de' Medici's request, as he lay dying, that Ficino come "with ... the book of our Plato *On the Highest Good, ...* and ... not without your Orphic lyre" in Hankins, *Plato in the Italian Renaissance,* p. 267. See also Arthur Field, *The Origins of the Platonic Academy of Florence* (Princeton, N.J.: Princeton University Press, 1988), pp. 3–4 and n. 3, where the original text is reprinted, Hankins, "Cosimo de' Medici and the 'Platonic Academy,'" *Journal of the Warburg and Courtauld Institutes* 53 (1990): 144–62, esp. pp. 149–50 and 159–60, for example, for the text of one of Ficino's letters attesting the practice, and Kristeller, "The Scholastic Background of Marsilio Ficino," in *Studies in Renaissance Thought and Letters,* pp. 52–53 and n. 86, for yet other references to the practice. See also Kristeller, *Eight Philosophers,* and once again I must refer to Hankins's writings cited in n. 2 above on the question of the very existence of the fifteenth-century academy.

48. For recent examples, see Haar, *Essays on Italian Poetry and Music,* Chapter 4; and the brief but characteristically stimulating and insightful discussion in Reinhard Strohm, *The Rise of European Music, 1380–1500* (Cambridge: Cambridge University Press, 1993), pp. 550–52. See also F. Alberto Gallo, *Music in the Castle: Troubadours, Books, and Orators in Italian Courts of the Thirteenth, Fourteenth, and Fifteenth Centuries,* trans. Anna Herklotz and Kathryn Krug (Chicago: University of Chicago Press, 1995), Chapter 3.

49. In *The Arte of English Poesie* (1589), George Puttenham describes "small & popular Musickes song by these *Cantabanqui* upon benches and barrels heads where they have none other audience then boys or countrey fellowes that passe by them in the streete, or else by blind harpers or such like taverne minstrels that give a fit of mirth for a groat, & their matters being for the most part stories of old time ... & such ... old Romances or historicall rimes, made purposely for recreation of the common people at Christmasse diners and *brideales,* and in taverns & alehouses and such other places of base resort, also they be used in Carols and rounds and such light or lascivious Poemes, which are more commodiously uttered by these buffons or vices in plays than by any other person." Puttenham, facsimile reprint (Menston: Scolar Press Facsimile, 1968), vol. II, ix, p. 69, as quoted in François Laroque's stimulating *Shakespeare's Festive World: Elizabethan Seasonal Entertainment and the Professional Stage,* trans. Janet Lloyd (Cambridge: Cambridge University Press, 1991), p. 34. See also the informative review of Laroque's book by Mark Thornton Burnett in the *London Review of Books* 14(1) (9 January 1992): 14–15.

50. See Calmeta, "Qual stile tra' volgari poeti sia da imitare," in *Prose e lettere edite e inedite,* pp. 20–25, and Nino Pirrotta's remarks in James Haar, ed., *Chanson and Madrigal, 1480–1530, Studies in Comparison and Contrast, A Conference at Isham Memorial Library, September 13–14, 1961* (Cambridge: Harvard University Press, 1964), p. 77.

51. See n. 20 above on Calmeta's account of Cortese's academy.

52. Calmeta, *Prose e lettere,* pp. 63–64: "Saranno alcuni ... i quali, dilettandosi d'arte di canto, disiderano col cantar, massimamente diminuito, gratificar la sua donna. ... Costoro ... circa le stanze, barzelette, frottole e altri pedestri stili devono essercitarsi, e non fondarsi sopra arguzie e invenzioni ..., le quali, quando con la musica s'accompagnano, sono non solo adombrate, ma coperte per modo che non si possono discenere. ..."

53. See Calmeta, *Prose e lettere:* "Altri . . . nel modo del cantare deveno Cariteo o Serafino imitare, i quali a' nostri tempi hanno di simile essercizio portata la palma, e sonosi sforzati d'accompagnar le rime con musica stesa e piana, acciocché meglio la eccellenza delle sentenziose e argute parole si potesse intendere, avendo quel giudicio che suole avere un accorto gioielliero, il quale, avendo a mostrare una finissima e candida perla, non in drappo d'oro la tenerà involta, ma in qualche nero zendado, a ciò che meglio possa comparire." My translations here and in the previous note are adapted from Nino Pirrotta, "Before the Madrigal," which appeared in a special issue entitled *Aspects of Musical Language and Culture in the Renaissance: A Birthday Tribute to James Haar* of *Journal of Musicology* 12 (1994): 237–52, esp. pp. 239 and 242.

54. Pirrotta's remarks in Haar, *Chanson and Madrigal,* p. 76.

55. Pirrotta, "Monteverdi's Poetic Choices," in *Music and Culture,* pp. 271–316, esp. p. 287. See also Gary Tomlinson's discussion of Pirrotta's observations in "Madrigal, Monody, and Monteverdi's 'via naturale alla immitatione,'" *Journal of the American Musicological Society* 34 (1981): 60–108, esp. p. 66.

56. *Integer vitæ* is found in the manuscript Florence, Biblioteca Nazionale Centrale, Panciatichi 27, fol. 40v (ascription: anonymous), and the prints *Frottole libro primo* (Venice: Ottaviano Petrucci, 1504), fol. 44r (ascription: "Micha."), and *Tenori e contrabassi intabu / lati col sopran in canto fi / gurato per cantar e so / nar col lauto Li / bro primo. / Francisci Bossinensis / Opus.* (Impressum Venetijs: Per Octavianum Petrutium forosemproniensem, Die 27 Martij. 1509), fol. 36r (ascription: "D.M.").

57. See the most recent summary of questions concerning Pesenti's identity in Bonnie J. Blackburn, "Music and Festivities at the Court of Leo X: A Venetian View," *Early Music History* 11 (1992): 1–37, esp. p. 7 n. 15, and the literature cited there. Although there has been some disagreement concerning the identity of the figure documented by Herman-Walther Frey in his article cited by Dr. Blackburn, Professor Richard Sherr has found archival material documenting unequivocally that Pesenti was in Leonine Rome; details will be presented in his forthcoming book for the Casa Palestrina on the history of the Cappella Sistina. I am grateful to Professor Sherr for informing me of his findings. Also, see William Prizer, "Local Repertories and the Printed Book: Antico's Third Book of Frottole (1513)," *Music in Renaissance Cities and Courts: Studies in Honor of Lewis Lockwood,* ed. Anthony M. Cummings and Jessie Ann Owens (Warren, Mich.: Harmonie Park Press, 1997).

58. See Palisca's remarks in *Chanson and Madrigal,* pp. 127–28, and Nino Pirrotta's in ibid., p. 135. On these characteristics, see also Palisca, "Vincenzo Galilei and some Links between 'Pseudo-Monody' and Monody," in Palisca, *Studies in the History of Italian Music and Music Theory* (Oxford: Clarendon Press, 1994), pp. 346–63, esp. p. 360.

59. See my review of Bernhard Meier's *The Modes of Classical Vocal Polyphony Described according to the Sources,* trans. Ellen S. Beebe (New York: Broude Brothers, 1988), in *Music and Letters* 62 (1991): 79–84, esp. pp. 83–84.

60. Babbitt, "Contemporary Music Composition and Music Theory as Contemporary Intellectual History," *Perspectives in Musicology,* ed. Barry Brook, Edward O. D. Downes, and Sherman van Solkema (New York: W. W. Norton, 1972), p. 171.

61. *Orlando furioso* makes explicit mention of "l'Unico Accolti."

62. The reference to the recommendation on Tromboncino's behalf is in Alessandro Ferrajoli, *Il ruolo della corte di Leone X (1514–1516)*, a cura di Vincenzo De Caprio (Rome: Bulzoni editore, 1984), p. 49 n. 4. There does not appear to be independent confirmation of a relationship between Tromboncino and the Leonine musical establishment. (For assistance on these two points, I am grateful to Professors William Prizer and Richard Sherr.) For procuring a copy of this important document, I am grateful to Dott. Giuliano di Bacco. For assistance with the transcription, I am grateful to Dott. di Bacco and Dott. Gino Corti. I should note that the identification of the author of the letter as Leo's agent Gabriele-Stefano Merino is Ferrajoli's: [Rome, Biblioteca Angelica, MS 1888, fols. 11v–12r] [fol. 11v] "Eruditissime vir tanq[uam] f[rate]r amantiss[ime]. L[itte]ras tuas habuimus gratissimas Tum illis te incolumem ad urbem Venetā appulisse certiores facti: Tum etiam q[uia] te n[ost]ri non immemorē effectum fiducia quā ostendis liquido percepimus. Quapropter cum hoc et tuis animi dotibus tibi plurimū debeamus. Si S[anctissi]mus D[ominus] N[oster] hic fuisset: pro viribus conati essemus: ut nō frustra d[ominus] Bartholomeus Trombōcinus a Gaurico p[re]sertim comēndatus fuisset et quāprimū sua Bea[titu]do hic redierit: quod [fol. 12r] cupis efficere quantum in nobis erit studebimus: Siquid[em] et maiora si qua possumus nō iniuria de nobis tibi polliceri potes et debes. Interim nolens ut isto locor[um] intervallo n[ost]ri penitus obliviscaris: Sed scribendo aliquidq$_3$ cudendo id de te specimen exhibeas ut clare omnibus pateat Gauricū n[ost]r[u]m ubiq$_3$ locor[um]: ubiq$_3$ terrar[um] erga amicos et sibi affectos semper eundem esse et ut hact[enu]s solitus offi[ci]osum." On Gaurico, see Ernst H. Gombrich, "The *Sala dei Venti* in the Palazzo del Te," *Symbolic Images: Studies in the Art of the Renaissance* (Chicago: University of Chicago Press, 1985 [3d ed.]), pp. 109–18, esp. pp. 116–18 and the accompanying notes; and Erasmo Percopo, "Luca Gaurico, ultimo degli astrologi," *Società Reale di Napoli, Atti della Reale Academia di Archeologia, Lettere e Belle Arti di Napoli* XVII, parte II (1895), pp. 1–49.

63. On letters of recommendation written by (and, by extension, to) members of the Medici family on behalf of musicians, and their status as evidence of a relationship between the musician and the Medici, see my "Gian Maria Giudeo, Sonatore del Liuto, and the Medici," *Fontes Artis Musicæ* 38 (1991): 312–18, esp. p. 318. That Gaurico had "the closest relations with the Gonzagas" explains why he would have been in a position to recommend the Mantuan musician Tromboncino to Leo; see Gombrich, as in n. 62, esp. pp. 118 and 224–25 nn. 33–37.

64. See the letter from Tromboncino to Lorenzo in Knud Jeppesen, *La frottola*, 3 vols., Acta jutlandica XL:2, XLI:1, and XLII:1 (Aarhus: Universitetsforlaget I Aarhus, and Copenhagen: Einar Munksgaard, and Wilhelm Hansen, Musikforlag, 1968–70), 1:145. The letter is also in Bianca Becherini, "Relazioni di musici fiamminghi con la corte dei Medici," *La rinascita* 4 (1941): 84–112, esp. pp. 108–9.

65. See fols. 3v–4r of *CANZONI. SONETTI. STRAMBOTTI. ET. FROTTOLE. LI-BRO. QVARTO* [RISM 1517²] (Impresso in Roma per Andrea Anticho da Montona / Et Nicolo de Iudicibus nel anno M.D.[X]VII. / A dì xv. di Agosto). Tromboncino's piece is also contained in: (1) the reprint of RISM 1517², the [*Frottole libro quarto*] (Venetijs impressum opera & arte Andree Antiqui: Impen / sis vero. D. Luce Antonij de giunta florentini / Anno. 1520. Die. XV. Octobris); (2) the *Frottole de Misser Bortolomio Trōbō / cino & de Misser*

Marcheto Carra / con Tenori & Bassi tabulati & cō / soprani in cāto figurato per / cātar & sonar col / lauto. / Sāctissimus d[omi]n[u]s d[omi]n[u]s n[oste]r Papa Leo .x. / vetat nequis alius hos cātus ī primat to- / to decē̄nio sub excōmunicationis pena. / ([no colophon]: [Venice: Antico and L. A. Giunta, 1520]), fols. 45v–45v (ascription: "B.T."); and (3) the manuscript Venice, Biblioteca nazionale di San Marco, Ital. Cl. LV, 1795–98, no. 67 (ascription: anonymous).

66. *CANZONI. SONETTI. STRAMBOTTI. ET. FROTTOLE. LIBRO. QVARTO,* fols. 53v–54r.

67. Sadoleto is portrayed with the Unico Aretino in Vasari's fresco of Leo X's 1515 Florentine *entrata;* see n. 23 above. It is an interesting coincidence that Sadoleto himself expressed an opinion (in characteristic humanist fashion) on the putative defects of vocal polyphony and, implicitly, the virtues of the kind of musical practice exemplified by Tromboncino's piece; in the *De pueris recte instituendis* (Basel, 1538), he wrote that if he were to teach his son about music, he would say nothing of the "common and trivial harmony, which is essentially a pandering caress of the ear with sweetness and . . . consists of hardly anything but variation and running of notes." On Sadoleto's views of music, see Claude V. Palisca, *Humanism in Italian Renaissance Musical Thought* (New Haven, Conn.: Yale University Press, 1985), p. 14 and n. 44, where the excerpt given here is published and translated: "Sed ego non ea dicam quæ huius uulgatæ, & triuialis symphoniæ sint, cuius auribus tantum suauitate demulcendis omne est lenocinium, & quæ in sola penè uocum felxione ac modulatione ipsa consistunt." An English translation of the Leonine privilege printed in RISM 1517[2] appears on pp. 452–53 of Catherine Weeks Chapman, "Andrea Antico" (Ph.D. diss., Harvard University, 1964); a photostat of the text of the privilege appears as Plates 19a–19b of ibid. The original text of the privilege and an English translation now appear, more accessibly, in Martin Picker, ed., *The Motet Books of Andrea Antico,* Monuments of Renaissance Music, 8 (Chicago & London: University of Chicago Press, 1987), Plate II (between pp. 64 and 65) and p. 3.

68. See Haar, *Essays on Italian Poetry and Music,* p. 95. On this piece, see also an unpublished paper by Alexandra Daniela Amati-Camperi, "Una stanza ariostesca nella tradizione madrigalistica del '500," p. 5 of the version of the text read at the October 1995 meeting of the Società Italiana di Musicologia in Florence. I am grateful to Dr. Amati-Camperi for furnishing me with a copy of her paper.

69. See Chapter 1, nn. 191 and 192 and the accompanying text.

70. *Tenori e co[n]trabassi intabulati col soprano in canto figurato per cantar e sonar col lauto Libro Secundo. Francisci Bossinensis Opus* (Impressum in Forosempronij: per Octavianun petrutiū Forosemproniensem, Die 10 Madij Anno d[omi]ni, 1511), fols. 11v (13v)–12r. Chariteo's piece is also found in *Frottole Libro Nono* (Venice: Ottaviano Petrucci, 1508), fol. 55v.

71. As is suggested by a famous reference that he took part, costumed "alla moresca," in a performance of his own "Commedia in versi" in the Palazzo Medici in 1518, on the occasion of the wedding of Lorenzo di Piero de' Medici and Madeleine de la Tour d'Auvergne. Strozzi's participation in the 1518 wedding ceremonies is attested by an account by Francesco d'Antonio Zeffi da Empoli, priest and canon of the Church of San Lorenzo, a member of the Accademia fiorentina, and tutor of Filippo Strozzi the Elder's sons; see the text of his account in Alessandro Parronchi, "La prima rappresentazione della Mandragola," *La bibliofilia* 64 (1962): 80–81.

72. *Madrigali a cinque Libro primo* (Venice [?]: Ottaviano Scotto [?], 1536–37 [?]).

73. *Comedia del preclarissimo messer Bernardo Accolti Aretino Scriptore Apostolico & Abreuiatore* … [*& Capitoli & Strambocti*] (Florence: Alessandro di Francesco Rossegli, 1513), fol. n iiv. See H. Colin Slim, "Un coro della 'Tullia' di Lodovico Martelli messo in musica e attribuito a Philippe Verdelot," *Firenze e la Toscana dei Medici nell'Europa del '500*, 3 vols., Biblioteca di Storia toscana moderna e contemporanea, Studi e documenti 26 (Florence: Leo S. Olschki Editore, 1983), 2:487–511, esp. p. 495; Slim, *A Gift of Madrigals and Motets*, 2 vols. (Chicago: University of Chicago Press, 1972), 1:101 n. 169; Slim, review of Wolfgang Osthoff, *Theatergesang und darstellende Musik in der italienischen Renaissance (15. und 16. Jahrhundert)*, 2 vols. (Tutzing: Hans Schneider, 1969), in *Journal of the American Musicological Society* 23 (1970): 337–43, esp. p. 338; and, on the printed source and the possibility that the madrigal setting may be by Verdelot, Iain Fenlon and James Haar, *The Italian Madrigal in the Early Sixteenth Century: Sources and Interpretation* (Cambridge: Cambridge University Press, 1988), pp. 304–5. In "Un coro," pp. 496–97, Slim printed the opening of the surviving altus and bassus parts and offered a reconstruction of the opening of the others, which are missing; in his review of Osthoff, p. 338, he noted that an exemplar of the altus partbook, formerly in the Landau collection in Florence, was then in the University of California Music Library, Berkeley, on which basis he presumably edited the altus part.

Chapter Three

1. In Florence, the phrase "to go for the '*maggiore*'" was originally applied to families enrolled in one of the seven principal guilds, whose members were therefore eligible for election to the Florentine *Signoria;* it came to signify excellence of any type. The "*minori*" were members of one of the fourteen lesser guilds. See *Le opere di Giorgio Vasari*, ed. Gaetano Milanesi, 9 vols. (Florence: G. C. Sansoni, Editore, 1878), 6:612 n. 2, and David Herlihy and Christiane Klapisch-Zuber, *Tuscans and Their Families: A Study of the Florentine Catasto of 1427*, Yale Series in Economic History (London and New Haven: Yale University Press, 1985), p. 10.

2. I have relied almost exclusively on the translation of de Vere. See Giorgio Vasari, *Lives of the Most Eminent Painters, Sculptors, and Architects*, trans. Gaston Du C. de Vere, 10 vols. (London: Macmillan and Co., Ltd., & The Medici Society, Ltd., 1912–15), 8:111–29, esp. pp. 119–26; the Italian text may be found in Milanesi, ibid., pp. 609–18.

3. John Shearman, *Andrea del Sarto*, 2 vols. (Oxford: Clarendon Press, 1965), 1:2–3.

4. See the long quotation from the life of Rustici at the beginning of this chapter.

5. Isaac's *quodlibet Donna di dentro / Dammene un pocho / Fortuna d'un gran tempo* is contained in the manuscript Florence, Biblioteca Nazionale Centrale, Banco rari 229 (*olim* Magl. XIX.59; Gaddi 1024), a late fifteenth-century source (see Howard Mayer Brown, ed., *A Florentine Chansonnier from the Time of Lorenzo the Magnificent: Florence, Biblioteca Nazionale Centrale MS Banco Rari 229*, 2 vols., Monuments of Renaissance Music, 7 [Chicago: University of Chicago Press, 1983], Text Volume p. 268, Music Volume pp. 317–20). Therefore, its composition cannot be a direct result of the activities of the Company of the Cazzuola, which formed in 1512. However, it could, in some general sense, be a reflection of the sort of "popular" cultural activity that lay behind the formation of groups like the Cazzuola.

On the meaning of the word "cazzuola," see Riccardo Bruscagli, ed., *Trionfi e canti carnascialeschi toscani del Rinascimento,* 2 vols. (Rome: Salerno Editrice, 1986), 1:228 n. 19. On the possible meanings of mazzacroca and some of the extant polyphonic settings of the popular tune, see William Prizer, "Games of Venus: Secular Vocal Music in the Late Quattrocento and Early Cinquecento," *Journal of Musicology* 9 (1991): 3–56, esp. pp. 38–39 and nn. 113–14 and the references cited there.

Professor Linda L. Carroll observed that sexual doubles entendres in the sobriquets of individuals or groups whose profession was entertainment were not uncommon at the time. Beolco, for example, made a subtle linguistic commentary in choosing "Ruzante" as his sobriquet, which he explains in the *Anconitana* in such a way as to clarify that he was employing it with the sexual meaning that the verb had in Tuscan, rather than the purely playful meaning of the dialects of the Veneto.

6. For a summary of the membership of the Cazzuola in tabular form, see Table 6 in the Conclusion.

7. On Granacci, see Christian von Holst, *Francesco Granacci,* Italienische Forschungen herausgegeben vom Kunsthistorischen Institut in Florenz, Dritte Folge 8 (Munich: Verlag F. Bruckmann KG, 1974). It is von Holst's thesis that the portrait reproduced here as Figure 18 may be of Granacci.

8. On Sarto, see, above all, John Shearman's masterful study *Andrea del Sarto.*

9. For Granacci's contributions, see John Shearman, "The Florentine *Entrata* of Leo X, 1515," *Journal of the Warburg and Courtauld Institutes* 38 (1975): 136–54, esp. p. 146 n. 31; and Giorgio Vasari's *Vita* of Granacci in Vasari, *Lives of the Most Eminent Painters, Sculptors, and Architects;* for Sarto's contributions, see John Shearman, "Pontormo and Andrea del Sarto, 1513," *Burlington Magazine* 104 (1962): 478–83, Shearman, "The Florentine *Entrata,*" and Shearman, *Andrea del Sarto,* 2:317–18.

10. On Gaddi, see the Appendix. On his relationship to Layolle, see the material quoted in n. 81 in Chapter 1.

11. On Giuliano, see the Appendix.

12. See Paolo Minucci del Rosso, "Di alcuni personaggi ricordati dal Vasari nella Vita di Gio. Francesco Rustici," *Archivio storico italiano,* 4th series, 3 (1879): 475–82, esp. p. 482. On his service in the Florentine Chapels, see Frank A. D'Accone, "The Musical Chapels at the Florentine Cathedral and Baptistery during the First Half of the 16th Century," *Journal of the American Musicological Society* 24 (1971): 1–50, esp. p. 38: "sovrani / ser Raffaelem Petri del Bechaio, cum salario L. trium pro mense L. 3." I am grateful to Professor D'Accone for bringing this reference to my attention.

13. See Frank D'Accone's paper in *Internationale Gesellschaft für Musikwissenschaft: Report of the Tenth Congress, Ljubljana, 1967* (Kassel: Im Bärenreiter-Verlag, 1970), pp. 96–106, esp. p. 98. On Pisano generally, see D'Accone, "Bernardo Pisano: An Introduction to His Life and Works," *Musica Disciplina* 17 (1963): 115–35.

14. See Joseph J. Gallucci Jr., "Festival Music in Florence, ca. 1480–ca. 1520: *Canti Carnascialeschi, Trionfi,* and Related Forms," 2 vols. (Ph.D. diss., Harvard University, 1966), nos. 8, 17, 19, 21, 23–25, 38, 43, 46, 49, and 68, and possibly nos. 42 and 64.

15. Martin Picker, "A Florentine Document of 1515 Concerning Music Printing," *Memo-*

rie e contributi alla musica dal mediœvo all'età moderna offerti a F. Ghisi, 2 vols., volume 12 of *Quadrivium* (1971), pp. 283–90.

16. In the *Libro delle Provvisioni della Repubblica dall'anno 1509 al 1510,* p. 57, it is recorded "che a dì cinque Dicembre 1509 furono deputati al servizio della signoria Giovanni di Benedetto Fei … detto Feo e Michele di Bastiano detto Talina[,] sonatori di zuffolo e di tamburino."

17. The materials published by Keith Polk, "Civic Patronage and Instrumental Ensembles in Renaissance Florence," *Augsburger Jahrbuch für Musikwissenschaft* 3 (1986): 51–68, contain references to a Bartolomeo trombone of Venice in the service of the Florentine Signoria in 1520 and a Giovanni trombone in their service in 1513 and 1520; they may be identical to Vasari's Bartolomeo and Giovanni tromboni.

18. On Pierino, see Richard Sherr, "Lorenzo de' Medici, Duke of Urbino, as a Patron of Music," *Renaissance Studies in Honor of Craig Hugh Smyth,* 2 vols., ed. Andrew Morrogh et al. (Florence: Giunti Barbèra, 1985), 1:627–38, esp. p. 635 n. 19 and p. 636 n. 30.

19. Slim's suggestion about the identity of the Cazzuola's Luigi Martelli is in *A Gift of Madrigals and Motets,* 2 vols. (Chicago: University of Chicago Press, 1972), 1:103 n. 180. On Martelli, see also the Appendix.

20. Verdelot's [*T*]*erzo libro de madrigali* … was published in Venice by Ottaviano Scotto in 1537. On Verdelot's settings of Ludovico's poetry, which include more than the chorus from *Tullia,* see Slim, "Un coro della 'Tullia' di Lodovico Martelli messo in musica e attribuito a Philippe Verdelot," *Firenze e la Toscana dei Medici nell'Europa del '500,* 3 vols., Biblioteca di Storia toscana moderna e contemporanea, Studi e documenti 26 (Florence: Leo S. Olschki Editore, 1983), 2:487–511, *passim;* Slim, *Gift of Madrigals,* pp. 86–87; and the inventories of sources in Iain Fenlon and James Haar, *The Italian Madrigal in the Early Sixteenth Century: Sources and Interpretation* (Cambridge: Cambridge University Press, 1988); on Layolle's settings, see the inventories of sources in ibid.

21. Shearman, *Andrea del Sarto,* remarks on the mixed character of the Cazzuola, I:2–3.

22. See Laroque, *Shakespeare's Festive World: Elizabethan Seasonal Entertainment and the Professional Stage,* trans. Janet Lloyd (Cambridge: Cambridge University Press, 1991), p. 5.

23. John Dominic Crossan, *Jesus: A Revolutionary Biography* (New York: Harper Collins Publishers, 1994), p. 68.

24. Ibid.

25. Peter Farb and George Armelagos, *Consuming Passions: The Anthropology of Eating* (Boston: Houghton Mifflin, 1980), pp. 4, 211.

26. Lee Edward Klosinski, *The Meals in Mark* (Ann Arbor, Mich.: University Microfilms, 1988), pp. 56–58.

27. Crossan, *Jesus,* p. 69.

28. Ibid., p. 70.

29. On Barlacchi, see, above all, Abd-el-Kader Salza, "Domenico Barlacchi araldo, attore e scapigliato fiorentino del secolo XVI," *Rassegna bibliografica della letteratura italiana* 9 (1901): 27–33.

30. Barlacchi's redaction, copied by Machiavelli into a manuscript that is still extant, may have been undertaken in preparation for a performance of the work by the Cazzuola. The "Commedia in versi" was copied by Machiavelli into the manuscript Florence, Biblio-

teca Nazionale Centrale, Banco rari 29 (*olim* Magliabecchi VIII, 1451 *bis*; n. 336 degli in-4°
della strozziana), and on the basis of that copy the work had been erroneously attributed
to Machiavelli himself. Pio Ferrieri was the first to demonstrate that it is instead Lorenzo
Strozzi's; see "Lorenzo di Filippo Strozzi e un codice ashburnhamiano," *Studi di Storia e
critica letteraria* (Milan: Enrico Trevisini, Editore, 1892), pp. 221–32. On Barlachi's redaction
of the work, see Alessandro Parronchi, "La prima rappresentazione della Mandragola: Il
modello per l'apparato—L'allegoria," *La bibliofilia* 64 (1962): 37–86, esp. pp. 71–73, and For-
tunato Pintor, "'Ego Barlachia recensui,'" *Giornale storico della letteratura italiana* 39 (1902):
103–9, and Parronchi, "La prima rappresentazione della Mandragola," p. 73, on the thesis
that the redaction was prepared for a performance of the work. On the 1518 performance
of the "Commedia in versi" in Palazzo Medici, see Cummings, *The Politicized Muse: Music
for Medici Festivals, 1512–1537,* Princeton Essays on the Arts (Princeton, N.J.: Princeton
University Press, 1992), Chapter 9. The manuscript copy of Lorenzo Strozzi's comedy *La
Nutrice* (Florence: Biblioteca Medicea-Laurenziana, Ashburnham 606) contains several
sonnets by Strozzi in honor of Barlachi, which further suggests a relationship between
the two; see Elvira Garbero Zorzi, catalogue entry no. 6.2.2, in *Il luogo teatrale a Firenze:
Brunelleschi, Vasari, Buontalenti, Parigi,* Spettacolo e musica nella Firenze medicea, Docu-
menti e restituzioni I (Milan: Electa Editrice, 1975), p. 80.

31. See Maria-Luisa Minio-Paluello, *La «fusta dei matti»: Firenze—San Giovanni 1514,
Una barca di folli alla ricerca del metodo nella follia, E umori ed emulazioni fra Firenze, Roma e
Venezia, primavera 1514* (Florence: Franco Cesati Editore, 1990), pp. 115, 128–29 nn. 68–69,
and 186, quoting in turn Marino Sanuto, *I diarii,* 53 vols. (Venice: Tipografia del Com-
mercio di Marco Visentini, 1879–1903), vol. 28, col. 313: "e il giorno, dopo disnare, sopra un
lungo carro andò fuora una fusta . . . fornita di huomeni piazevoli e bufoni . . . , fra quali el
Barlachij."

32. For the Italian texts of the references translated here—*"FECE RECITARE LA
NATIONE FIORENTINA À RICHIESTA DI SUA MAESTÀ CHRISTIANISSIMA," "LA
MAGNIFICA ET TRIVMPHALE ENTRATA DEL CHRISTIANISS. RE DI FRANCIA
HENRICO SECONDO . . . FATTA NELLA . . . CITTÀ DI LYONE A LUY ET À LA SUA
SERENISSIMA CONSORTE CHATERINA ALLI 21 DI SEPTEMB.* 1548," and "fece
donare alli strioni cinquecento scudi d'oro, et la Regina trecento, di modo che il Barlacchi
et li altri strioni che di Firenze si feciono venire in giù se ne tornano con una borsa piena
di scudi per ciascuno"—see Angelo Solerti, "La rappresentazione della *Calandria* a Lione
nel 1548," *Raccolta di studi critici dedicata ad Alessandro D'Ancona* (Florence: Tipografia di G.
Barbèra, 1901), pp. 693–99, and, on the important musical *intermedii,* Nino Pirrotta, *Music
and Theatre from Poliziano to Monteverdi,* trans. Karen Eales (Cambridge: Cambridge Uni-
versity Press, 1982), pp. 170–71. On the musical activities in Lyons in connection with these
events, see generally Frank Dobbins, *Music in Renaissance Lyons* (Oxford: Clarendon Press,
1992), pp. 109–17.

33. Representative texts, and interpretations in terms of their sexual references, may
be found in Bruscagli, *Trionfi e canti.* Florentine carnival songs, in Pirrotta's words, "were
humorous and sparkled with *risqué* double-entendres as required by the playful mood of
the days preceding Lent; . . . " See Pirrotta, "Florence from Barzelletta to Madrigal," *Musica*

Franca: Essays in Honor of Frank A. D'Accone, ed. Irene Alm, Alyson McLamore, and Colleen Reardon, Festschrift Series No. 18 (Stuyvesant, N.Y.: Pendragon Press, 1996), pp. 7–18, esp. p. 12. See also Nerida Newbigin, "Piety and Politics in the *Feste* of Lorenzo's Florence," *Lorenzo il Magnifico e il suo mondo, Convegno internazionale di studi (Firenze, 9–13 giugno 1992),* ed. Gian Carlo Garfagnini, Istituto Nazionale di Studi sul Rinascimento, Atti di Convegni 19 (Florence: Leo S. Olschki Editore, 1994), pp. 17–41, esp. p. 36 and n. 60 and the references cited there.

34. See n. 30 above.

35. The life of Aristotile.

36. I.e., Jacopo di Filippo Falconetti, *detto* "il Fornaciaio."

37. The life of Aristotile.

38. Further documented by a February 1525 letter from Filippo de' Nerli to Machiavelli; see Nerli in Machiavelli, *Lettere,* ed. Franco Gaeta, Opere VI (Milan: Giangiacomo Feltrinelli Editore, 1961), pp. 417–18. The various references thus suggest that the Cazzuola's performance of *Mandragola* took place in late 1524 or very early in 1525; since Vasari stated that Aristotile executed the scenery for the early 1525 performance of *La Clizia* "not long" after the Cazzuola's performance of *Mandragola,* the performance of *Mandragola* presumably occurred some few weeks or months before.

39. Slim, *Gift of Madrigals,* pp. 92–100; and Pirrotta, *Music and Theatre,* pp. 121–22, 134 and n. 32.

40. On these performances and Verdelot's possible connection with them and the Company of the Cazzuola, see also Slim, *Gift of Madrigals,* pp. 99–100

41. See nn. 7 and 8 above and the accompanying text.

42. *Canzona della Morte. Canzona del bronchone. Canzona del Diamante & della Chazuola.* (n.p., n.d.). The call number is Palatino E, 6, 6, 154, n. 14.

43. Pirrotta, "Florence from Barzelletta to Madrigal," esp. p. 13.

44. Ottonaio's canzona beginning "Perch'ogni cosa il suo proprio fin brama," Jacopo Nardi's *canzona* beginning "Colui che dá le legge alla natura," and the anonymous canzona beginning "Quel primo eterno amor, somma giustizia" are identified in the print as the *Canzona della Morte,* the *Septe TriomPhi . . . Facti dalla côpagnia del Brôchone,* and the *Canzona del Diamante,* which leaves *La gran memoria* as the only possible candidate for identification as the *Canzona . . . della Chazuola. La gran memoria* is attributed to Ottonaio in the manuscript Florence, Biblioteca riccardiana, 2731. Though anonymous in the printed pamphlet, *La gran memoria* and *Quel primo eterno amor* follow *Perch'ogni cosa il suo proprio fin brama,* also anonymous in the pamphlet but known to be by Ottonaio. Nonetheless, Charles Singleton chose not to attribute the two anonymous *canzoni* to him, given that they do not appear in the edition prepared by Ottonaio's brother Paolo (Singleton, ed., *Canti carnascialeschi del Rinascimento* [Bari: Gius. Laterza & Figli, Tipografi—Editori—Librai, 1936], p. 477). However, I would observe once again that *La gran memoria* can be shown to be the *Canzona . . . della Chazuola* and that Ottonaio was demonstrably a member of that company. Those facts argue for his authorship of the *Canzona . . . della Chazuola.* Ottonaio's *Perch'ogni cosa* was set to music by "M° Alexan [Coppini]," whose setting appears on fols. 100v–101r of the famous canto carnascialesco manuscript Florence, Biblioteca Na-

zionale Centrale, Banco rari 230 (*olim* Magliabechi XIX.141). A modern edition is in Frank A. D'Accone, ed., *Music of the Florentine Renaissance,* Corpus Mensurabilis Musicae XXXII (n.p.: American Institute of Musicology, 1967), 2:14.

45. See Pirrotta, "Florence from Barzelletta to Madrigal," p. 13.

46. The text is transcribed, with emendations, from the printed pamphlet Palatino E, 6, 6, 154, n. 14 in the Biblioteca Nazionale Centrale, Florence. I am extremely grateful to Professor Linda L. Carroll for invaluable assistance with the translation and interpretation of the poem.

47. On the freer metrical schemes of the canto carnascialesco repertory and the consequent relationship to the early madrigal, see also Gallucci, "Festival Music in Florence," 1:240–47.

48. See n. 53 below.

49. For editions of the text of *Quel primo eterno amor, somma giustizia,* see Gallucci, "Festival Music in Florence," 1:331; Joseph J. Gallucci Jr., ed., *Florentine Festival Music, 1480–1520,* Recent Researches in the Music of the Renaissance XL (Madison, Wisc.: A-R Editions, Inc., 1981), pp. 85–87; or Singleton, *Canti carnascialeschi,* pp. 198–99.

50. Felix Gilbert, *Machiavelli and Guicciardini: Politics and History in Sixteenth-Century Florence* (Princeton, N.J.: Princeton University Press, 1965), pp. 112–13, 262–63.

51. See my article "Giulio de Medici's Music Books," *Early Music History* 10 (1991): 65–122, esp. pp. 90–91.

52. See the material below on the 1513 Florentine Carnival and the overtly propagandistic texts sung on that occasion.

53. The manuscript Florence, Biblioteca Nazionale Centrale, Banco rari 230 (*olim* Magliabechi XIX.141), fols. 90v–91r. The musical setting is edited as no. 42 in Gallucci, "Festival Music in Florence," 2:168–72; the text and basic bibliographic information are provided in ibid., 1:306, where the piece is entitled the *Canto della pace.* The sources for the text are the manuscripts Florence, Biblioteca Riccardiana, MS Riccardiano 2731, which is the only source to ascribe the text to Ottonaio, and Lucca, Biblioteca Governativa, MS Moucke 27 (= MS 1512), and the prints *Canzona della Morte, Canzona del bronchone, Canzona del Diamante, & della Chazuola* (n.p., n.d.), and *Tutti i trionfi....* (Lucca: Benedini, 1750 [2d ed.]). The MS Riccardiano 2731 and the print *Canzona della Morte* indicate that *La gran memoria* is the *risposta* to *Quel primo eterno amor,* which is the *Canzona del Diamante* of the print *Canzona della Morte; Quel primo eterno amor* is also known as the *Trionfo delle tre parche* (see Gallucci's no. 64).

54. See n. 14 above.

55. Slim, *Gift of Madrigals,* p. 99.

56. Pirrotta, "Florence from Barzelletta to Madrigal," esp. p. 18.

57. On that element of the carnivalesque as exemplified in the activities of the Cazzuola—sexual imagery—and its relationship to the Cinquecento madrigal, see Laura Macy, "Speaking of Sex: Metaphor and Performance in the Italian Madrigal," *Journal of Musicology* 14 (1996): 1–34, esp. pp. 7, 8 and n. 19, and 17, for example. As evidence of the increasing interest in this feature of the sixteenth-century madrigal repertory, especially as expressed in an academic setting, see, for example, Melanie Marshall, "Power, Pornography, and Enter-

tainment in a Cinquecento Academy," and Donna G. Cardamone-Jackson, "Erotic Jest and Gesture in Roman Anthologies of Canzoni Villanesche," *Program and Abstracts of Papers Read at the Joint Meetings of the American Musicological Society, Sixty-Seventh Annual Meeting, and the Society for Music Theory, Twenty-Fifth Annual Meeting, October 31–November 3, 2002, Hyatt Regency Hotal, Columbus, Ohio* ([Philadelphia]: The American Musicological Society, Inc., and The Society for Music Theory, Inc., 2002), pp. 104–5. Recently, however, as Professor Ruth DeFord pointed out to me, Stefano La Via has questioned the reading of one famous sixeenth-century madrigal text, in which the author had posited the existence of obliquely expressed sexual references; see La Via, "*Eros* and *Thanatos:* A Ficinian and Laurentian Reading of Verdelot's *Sì lieta e grata morte*," *Early Music History* 21 (2002): 75–116, esp. p. 77.

58. The text of Cerretani's account is in manuscript Florence, Biblioteca Nazionale Centrale, II.IV.19, fol. 17v; see the Appendix.

59. The date of Cardinal de' Medici's departure is suggested by an entry in Luca Landucci's diary; see Landucci, *A Florentine Diary from 1450 to 1516,* ed. Iodoco del Badia and trans. Alice de Rosen Jarvis (London: J. M. Dent & Sons Ltd., and New York: E. P. Dutton & Company, 1927), p. 263.

60. Guicciardini's letter is in Francesco Guicciardini, *Le lettere,* ed. Pierre Jodogne, 5 vols. (Rome: Istituto storico italiano per l'età moderna e contemporanea, 1986–93), 1:325: "Giuliano, circa un mese et mezo fa fondò una compagnia. . . . Chiamonla el Diamante. Et il simile fecie Lorenzo, figluolo di Piero. . . . Chiamono questa il Bronchone. Doverranno questo charnesciale fare feste e buon tempo."

61. The original of Cerretani's text reads as follows (Bartolomeo Cerretani, "Sommario e ristretto cavato dalla historia di Bartolomeo Cerretani, scritta da lui, in dialogo delle cose di Firenze, dal'anno 1494 al 1519," Florence, Biblioteca Nazionale Centrale [BNC], MS II.IV.19, f. 17v, collated with the corresponding passages of Cerretani, "Storia in dialogo della mutazione di Firenze," Florence, BNC, MS II.I.106): "Papa Giulio . . . commesse alLegato [Cardinal Giovanni] che s'inviasse all'imp[re]sa di Ferrara, . . . et così fe', raccomandando a tutti gl'amici e pare[n]ti Giuliano suo fratello, il quale creò p[er] nostro ordine una Compagnia come haveva Lorenzo Vecchio, et chiamossi il Diamante p[er]chè tra loro era impresa vecchia. Hebbe p[ri]ncipio in questo modo: che facemo una list[a] de' trenta sei, quasi tutti figli de' quei padri che, con Lorenzo Vecchio, furono nel Zampillo, o, [se] volete, ne' Magi, e fatti li richiedere p[er] una sera in casa e Medici dove si cenò, parlò Giuliano, ramentando come la casa loro, con quelle di chi vi si trovò presente, havevono felicemente goduta la città, e p[oi]ch[è] quel medesimo haveva a essere, confortò et offerì et ordissi feste p[er] il futuro carnovale, pensando di dare ordine che questa compagnia governassi la città, et di già no[n] si faceva magistrato dove no[n] fussi alcuno di noi. Cominciò la benignità di Giuliano, non vi vincendo alcuno con la presuntione dalquanti, a chiedere di gratia ch[e] il tale vincessi di sorte ch[e] si mescolò quel seme stretto di giovani, ch[e] erano del'età sua, come si era fatto de vecchi. Accadde che in questa lor[o] tornata venne Lorenzo, figlio di Piero et di Madonna Alfonsina Orsini, di età d'anni diciotto in circa, allevato in Roma, non riccamente ma liberale. Non mancò chi lo p[er]suadesse che egli era figlio di Piero, . . . et che a lui s'apparteneva lo stato della citta, 'sendo stato di suo padre, il che lo spinse a volere fare una Compagnia, et feciela, e chiamolla il

Broncone, tutti suoi pari di età e delle p[ri]me case, et ordinorono fare anche una mummiera che havevamo fatto noi già." On the Company of the Magi in the fifteenth century, see Rab Hatfield's excellent article "The Compagnia de' Magi," *Journal of the Warburg and Courtauld Institutes* 33 (1970): 107–61, esp. p. 140 n. 161.

62. Florence, Biblioteca Nazionale Centrale, MS Nuovi acquisti 985, *Priorista Fiorentino dal 1282 al 1562*, fol. 274r, marginal note: "Giuliano de medici φ corroborare lo Stato suo ordinò una compaGnia in casa sua di 13 Giovani . . . io ho visto l'ordinale sottoscritto da loro et Gli nomi sono Gli infrascriti. . . . Chiamòssi la compaGnia del Diamante."

63. Acciaiuoli authored a collection of *Ode acciaioli* in honor of Leo X's election, which may suggest a relationship to the Medici family. See Maria-Luisa Minio-Paluello, *La «fusta dei matti»: Firenze — San Giovanni 1514, Una barca di folli alla ricerca del metodo nella follia, E umori ed emulazioni fra Firenze, Roma e Venezia, primavera 1514* (Florence: Franco Cesati Editore, 1990), pp. 131–32 n. 96. I am grateful to my friend Dott. Valerio Pacini of the Biblioteca Berenson at Villa I Tatti, The Harvard University Center for Italian Renaissance Studies, Florence, for providing me with a copy of this publication.

64. Giuseppe Palagi, ed., *I capitoli della Compagnia del Broncone* (Florence: coi tipi dei successori Le Monnier, 1872). For the thesis that Nardi may have drafted the statutes, see Palagi's introduction, pp. 7–8; Palagi also suggests Nerli as the possible author. For the references to Nerli and Pazzi's association with the company, see p. 11; the passage indeed suggests that Nerli may have been the author of the statutes and indicates that Nerli and Pazzi's responsibility was solely to draft statutes and outline an organizational structure: "they have elected the prudent and noble youths Alessandro di Guglielmo de' Pazzi, Filippo de' Nerli [gap], who shall have the fullest authority to be able to draft statutes and create those officers that they shall judge to be appropriate, not solely as to founding their company but [also] as to maintaining it, which authority shall be understood to be terminated as soon as the statutes will be adopted [. . . hanno electi e prudenti et nobili giouani Alexandro di Guglielmo de' Pazi, Filippo de' Nerli . . . e quali habino auctorità pienissima di potere formare e capitoli et creare quelli magistrati che loro giudicheranno essere a proposito, non solo quanto al fondare la loro Compagnia, ma quanto al mantenerla: la quale auctorità s'intenda essere finita, subito che saranno confermati e Capitoli]." For the reference to Lorenzo as captain, one of the principal offices, see ibid., pp. 12–14: " . . . per dare principio, vogliono che per questa prima volta sieno eletti per Capitani e nobili giouani, Lorenzo etc." For obtaining a copy of this rare publication for me, I am grateful to Dr. Sabine Eiche.

65. In any number of important respects, the Broncone's "articles of association" are not dissimilar to other such documents drafted for altogether different purposes: business purposes, for example. For a representative text, see Robert S. Lopez and Irving W. Raymond, *Medieval Trade in the Mediterranean World: Illustrative Documents Translated with Introductions and Notes,* Records of Civilization, Sources and Studies (New York: W. W. Norton & Company, Inc., n.d.), pp. 206–11, where one finds the fifteenth-century articles of association between Angiolo di Jacopo Tani and various of the Medici concerning the management of the Bruges branch of the Medici bank; and the analysis of the articles in Raymond de Roover, *The Rise and Decline of the Medici Bank, 1397–1494* (Cambridge: Harvard University Press, 1963), pp. 86–95.

66. Palagi, *I capitoli*, p. 10: "Hanno e nobili et graui sopradecti giouani dua intenti principali; vno, essere uniti e concordi fra loro quanto è possibile; l'altro dilectare la città generosamente, secondo le loro facultà."

67. Ibid., p. 26: "Acciochè si possa dare dilecto alla città e farsi beniuola la moltitudine." The same objective was identified by Filippo de' Nerli in his *Commentarij dei fatti civili occorsi dentro la città di Firenze;* see ibid., p. 6: "Furono ordinate queste due compagnie per due effetti principali; prima per tenere il popolo . . . in allegrezza con trionfi, feste e pubblici spettacoli . . . e per mantenere . . . ben disposta la gioventù nobile verso di Giuliano e di Lorenzo e così andar facendo ristringimento di partigiani più dichiarati a benefizio dello Stato." The close correspondence of Nerli's statement as to the company's objectives to that given in the statutes (see n. 66) suggests that Nerli may indeed have been the author; see n. 64.

68. Ibid., pp. 26–27: "sia vficio particulare de' Capitani di commettere a 4 del numero de' frategli, . . . e quali, . . . debbino referire e loro concetti a' Capitani, a' quali stia mettere in executione tutto quello che fussi riferito, o altro, se meglio o più magnifico spectaculoi hauessino pensato. E quali Capitano, . . . debbino creare e festaiuoli, e quali mettino in opera que' tali spectaculi, che saranno ordinati da loro."

69. Ibid., pp. 11, 10: "ogni anno la mattina di Santo Lorenzo si celebri nel luogo della loro residentia vna messa solenne a honore di Santo Lorenzo, dove intervenga tutta la Compagnia."

70. Ibid., p. 23: "each of the founders of our company . . . shall be obliged to pay . . . entrance fees: 'fiorini,' 1 'd'oro in oro larghi'; 'lire,' 1; 'sol[di],' 1"; "ciaschuno de' fondatori della nostra Compagnia . . . sia obligato a pagare per tassa di sua entrata fiorini uno d'oro in oro larghi, lire una, sol. uno."

71. The iconography of the artistic elements of the carnival festivities is discussed most recently in Cummings, *The Politicized Muse: Music for Medici Festivals, 1512–1537,* Princeton Essays on the Arts (Princeton, N.J.: Princeton University Press, 1992), Chapter 2.

72. Ibid.

73. From his hand we have a portrait of a musician who may be Francesco de Layolle, which suggests a relationship between them.

74. The text is edited, with emendations, from the printed pamphlet Palatino E, 6, 6, 154, n. 14 in the Biblioteca Nazionale Centrale; the translation is mine.

75. The account of the artistic elements of the 1513 Florentine carnival is Vasari's, in the *Vita* of Pontormo, in the de Vere translation of Vasari, *Lives of the Most Eminent Painters, Sculptors, and Architects.*

76. Antonio Alamanni (1464–1528) was the first cousin of Ludovico and Luigi, members of the Rucellai group and Medici Sacred Academy. Antonio's father, Jacopo di Francesco di Piero di Tommaso (1437–1505), was the younger brother of Ludovico and Luigi's father, Piero (1434–1519). See Antonio Alamanni, *Commedia della conversione di Santa Maria Maddalena,* ed. Pierre Jodogne, Scelta di curiosità letterarie inedite o rare dal secolo XIII al XIX in appendice alla Collezione di Opere inedite o rare, Dispensa CCLXVIII (Bologna: Commissione per i testi di lingua, 1977), p. xi n. 3; and Pierre Jodogne, "Antonio Alamanni da Firenze (1464–1528)," *Les lettres romanes* 16 (1962): 27–51.

77. See the text at nn. 48–49 above and thereafter.

78. A conversance with the carnival song repertory on the part of the Albizzi, and specifically of Antonfrancesco, is also suggested by the interesting text published by D'Accone in which Filippo Strozzi reported to his brother Lorenzo on the Florentine carnival of 1507. See D'Accone, "Alessandro Coppini and Bartolomeo degli Organi: Two Florentine Composers of the Renaissance," *Studien zur italienisch-deutschen Musikgeschichte* 4, Analecta musicologica 4 (1967): 38–76, esp. p. 76. This text is reprinted and discussed in Chapter 1 above, nn. 198–200 and the accompanying text.

79. The setting of Nardi's poem is in the manuscript Florence, Biblioteca Nazionale Centrale, Banco rari 230 (*olim* Magliabechi XIX.141), fols. 88v-89r.

80. The setting of Alamanni's poem is in the manuscripts Florence, Biblioteca Nazionale Centrale, Banco rari 230 (*olim* Magliabechi XIX.141), fols. 135v–137r; and Florence, Biblioteca Nazionale Centrale, Banco rari 337 (*olim* Palat. 1178) (bass only; fifth and sixth verses of first stanza only), fol. 64v.

81. "ciaschuno de' detti dua trionfi avevano un chanto della finzione de' trionfi, alle chase di chi gli aveva fatti fare, ho loro amici, andavano cantando"; Giovanni Cambi, "Istorie," ed. Fr. Ildefonso di San Luigi, 4 vols., in *Delizie degli eruditi toscani* 20–23 (Florence: Gaet[ano] Cambiagi, 1785–86), 3:2–3.

82. Pirrotta, "Florence from Barzelletta to Madrigal," esp. p. 13.

83. Vasari, the *Vita* of Granacci, in Vasari, *Lives of the Most Eminent Painters, Sculptors, and Architects.*

84. Bruscagli, *Trionfi e canti carnascialeschi,* 1:74–75.

85. Filippo di Cino Rinuccini, *Ricordi storici,* ed. Giuseppe Aiazzi (Florence: Stamperia Piatti, 1840), p. 180.

86. Giuseppe Odoardo Corazzini, ed., *Ricordanze di Bartolomeo Masi, Calderaio Fiorentino, dal 1478 al 1526* (Florence: G. C. Sansoni, 1906), p. 205.

87. Florence, Biblioteca Nazionale Centrale, Magliabechi VII, 1041, fol. 86v. The topical allusions in the canzona's text closely match the historical developments that prompted the 1516 festivities.

88. "*Sommario e ristretto cavato dalla historia di Bartolomeo Cerretani, scritta da lui, in dialogo delle cose di Firenze, dal'anno 1494 al 1519,*" Florence, Biblioteca Nazionale Centrale, MS II.IV.19, fols. 49v–50v.

89. This notwithstanding the fact that the text of his canzona makes reference to three goddesses, whereas the contemporary account of the festival specifies that the three divinities represented included Mars, the god of war; in other respects, Nardi's text is altogether too appropriate to the historical context for the 1518 festival for it to be excluded from consideration as one of those performed on that occasion. See Francesco Bausi, "Jacopo Nardi, Lorenzo duca d'Urbino e Machiavelli: L'occasione' del 1518," *Interpres* 7 (1987): 191–204, esp. pp. 191–92.

90. This argument on grounds of instrumentality is invoked by Pirrotta in his edition of the *Chori in musica composti sopra li chori della tragedia di Edippo Tiranno Recitati in Vicenza l'anno M.D.lxxxv. Con solennissimo apparato. Venezia, Angelo Gardano 1588,* Edizione nazionale delle opere di Andrea Gabrieli, [1533]–1585 / Edizione critica 12, Fondazione Giorgio Cini, Istituto per la Musica (Milan: G. Ricordi & C. s.p.a., 1995), pp. 14–15 and 19 and accompanying nn. 14 and 16.

91. See the text at n. 46 above.

92. See the text at n. 74 above.

93. Pirrotta, *Music and Theatre,* p. 122.

94. This same argument about the effects of performance venue on performance prac-
tice is invoked, once again, by Pirrotta, ibid., p. 14.

95. Fenlon and Haar, *Italian Madrigal,* p. 28.

96. For useful discussion of the historiographic issues raised in this paragraph, I am
grateful to my colleagues in the Department of History at Tulane University, George L.
Bernstein and the late Charles T. Davis.

Chapter Four

1. For a statement of the thesis to which I am taking exception, see Iain Fenlon and
James Haar, *The Italian Madrigal in the Early Sixteenth Century: Sources and Interpretation*
(Cambridge: Cambridge University Press, 1988), pp. 21–22.

2. In the *"Ricordi Storici fiorentini,"* Vatican City, Biblioteca Apostolica Vaticana, MS
Vat. Lat. 13, 651, fol. 154.

3. See H. C. Butters, *Governors and Government in Early Sixteenth-Century Florence*
(Oxford: Clarendon Press, 1985), p. 167; Cerretani's remark in the *"Ricordi Storici fiorentini"*;
and, on the reference concerning the seizure of the Palazzo Vecchio, Butters, *Governors and
Government,* pp. 183–84 n. 79.

4. See E. H. Gombrich, "Renaissance and Golden Age," in *Norm and Form: Studies in
the Art of the Renaissance* I (London: Phaidon Press Limited, 1966), pp. 29–34, esp. pp. 31
and 144 n. 9, quoting Fonzio, *Carmina,* ed. Iosephus Fógel and Ladislaus Juhász, Biblio-
theca scriptorum medij recentisque ævorum (Leipzig: B. G. Teubner, 1932): "Tempora nuna
tandem per te Saturnia surgunt . . . / Nunc surgunt artes, nunc sunt in honore poetæ."

5. On Rucellai as Lorenzo's relative (husband to Lorenzo's sister Nannina di Piero di
Cosimo) and a member of the balìa, see Felix Gilbert, "Bernardo Rucellai and the Orti
Oricellari: A Study on the Origin of Modern Political Thought," *Journal of the Warburg and
Courtauld Institutes* 12 (1949): 101–31, esp. p. 133 n. 1; on his requesting of tax concessions, see
Butters, *Governors and Government,* p. 13.

6. Rudolf von Albertini, *Firenze dalla repubblica al principato,* Storia e coscienza politica,
trans. Cesare Cristofolini, Biblioteca di cultura storica, 109 (Turin: Giulio Einaudi editore
s.p.a., 1970 [2d ed.]), p. 70.

7. Machiavelli, *Arte della guerra e scritti politici minori,* ed. Sergio Bertelli, Niccolò Machiavelli,
Opere II, Biblioteca di classici italiani 8 (Milan: Giangiacomo Feltrinelli Editore, 1961), p. 329.

8. Felix Gilbert, *Machiavelli and Guicciardini: Politics and History in Sixteenth-Century
Florence* (Princeton, N.J.: Princeton University Press, 1965), p. 346. On Pazzi, see also the
Appendix.

9. Pazzi, *Discorso al cardinale Giulio de' Medici,* ed. G. Capponi, *Archivio storico italiano*
I (1842), pp. 420–32.

10. See Jacopo Nardi, *Istorie,* as quoted in Gianandrea Piccioli, "Gli Orti Oricellari e
le istituzioni drammaturgiche fiorentine," *Contributi dell'Istituto di filologia moderna, Serie*

Storia del teatro I, Pubblicazioni dell'Università Cattolica del Sacro Cuore, Contributi, Se-
rie terza: Scienze, filologiche, e letteratura 17 (1968): 60–93, esp. p. 82 n. 64: "Ma di quelle
persone più segnalate che scrissero in lode della libertà e della buona mente del prefato
cardinale fu Alessandro de' Pazzi."

11. See my Appendix. But one should also take careful account of the evidence cited
there that may suggest agreement with the objectives of the 1522 conspiracy.

12. See Filippo di Cino Rinuccini, *Ricordi storici,* ed. Giuseppe Aiazzi (Florence: Stam-
peria Piatti, 1840), p. 180.

13. Cambi, "Istorie," ed. Fr. Ildefonso di San Luigi, 4 vols., in *Delizie degli eruditi toscani*
20–23 (Florence: Gaet. Cambiagi, 1785–86), 3:202.

14. Francesco Bausi, "Politica e poesia: il 'Lauretum'," *Interpres* 6 (1985–86): 214–82, esp.
p. 250.

15. On this point, see the observations of Francesco Bausi, "Jacopo Nardi, Lorenzo duca
d'Urbino e Machiavelli: l'«occasione» del 1518," *Interpres* 8 (1987): 191–204, esp. p. 191: "Nardi
non fu certo quel campione integerrimo del repubblicanesimo e quello strenuo e quasi ana-
cronistico paladino della *florentina libertas* che molti storici, antichi e moderni, hanno voluto
presentare." Nardi's overtly Medicean stanzas introducing his comedy *I due felici rivali* appear
in the principal manuscript source for the comedy, Vatican City, Biblioteca apostolica vaticana,
Barb. lat. 3911 (*olim* XLV.5); see also Chapters 2, 5, 7, 8, and 9 of my book *The Politicized Muse:
Music for Medici Festivals, 1512–1537,* Princeton Essays on the Arts (Princeton, N.J.: Princeton
University Press, 1992), for Nardi's contributions and possible contributions to Medici festi-
vals, both the texts of explanatory canti and possible "programs" for the feste.

16. See Nardi, *Istorie,* p. 83, as quoted in Piccioli, "Gli Orti Oricellari," p. 82 n. 64:
"[A]lcune persone . . . composero formule di governo libero, e alcune orazioni in lode sin-
gularissima della persona del Cardinale; del numero de' quali principalmente fu Niccolò
Machiavelli il quale scrisse poi le Istorie Fiorentine ad instanza del medesimo cardinale."

17. Von Albertini, *Firenze dalla repubblica al principato,* p. 20 and n. 1. On Albizzi's pos-
sible sympathies with the aims of the 1522 congiura, see the text at n. 33 below.

18. Eric Cochrane, *Historians and Historiography in the Italian Renaissance* (Chicago:
University of Chicago Press, 1981), p. 176.

19. On the matter of dependence on one's political superiors, and the resentment thereof, see
also John M. Najemy's *Between Friends: Discourses of Power and Desire in the Machiavelli-Vettori
Letters of 1513–1515* (Princeton, N.J.: Princeton University Press, 1993), pp. 70–71 and n. 31.

20. On the question of the political sensibilities and allegiances of the members of the
Rucellai group, see von Albertini, *Firenze dalla repubblica al principato,* pp. 69–70. On the
assertion of Machiavelli's nineteenth-century biographer Villari that "erano allora anch'essi
amici de' Medici, come quasi tutti coloro che frequentavano gli Orti Oricellari" and the
letter that "prova come allora gli Alamanni fossero tuttavia amicissimi de' Medici," see
Niccolò Machiavelli e i suoi tempi, 3 vols. (Milan: Ulrico Hoepli, 1895 [2d ed.]), 3:47 and n. 2
and pp. 406–8, Documento VI. On Kristeller's assertions, see "Francesco da Diacceto and
Florentine Platonism in the Sixteenth Century," *Studies in Renaissance Thought and Letters,*
Storia e letteratura, Raccolta di studi e testi 54 (Rome: Edizioni di storia e letteratura, 1956,
1969, 1984 [nuova ristampa anastatica]), pp. 287–336, esp. p. 300.

21. Von Albertini, *Firenze dalla repubblica al principato*, p. 70.

22. Ibid., p. 78.

23. The clearest articulation of the thesis to which I am taking exception is to be found in Fenlon and Haar, *Italian Madrigal*, pp. 21–22. More recent musicological opinion suggests an interpretation of the Rucellai group more aligned with that offered here; see, for example, Stefano La Via, "*Eros* and *Thanatos*: A Ficinian and Laurentian Reading of Verdelot's *Sì lieta e grata morte*," *Early Music History* 21 (2002): 75–116, esp. pp. 78–79, where La Via characterizes the *Orti Oricellari* as "the main center of intellectual life in Florence between 1513 and 1522," and his nn. 10 and 38.

24. On these texts, see Richard Sherr, "Verdelot in Florence, Coppini in Rome, and the Singer 'La Fiore,'" *Journal of the American Musicological Society* 37 (1984): 402–11, esp. p. 409; and Herman-Walther Frey, "Regesten zur päpstlichen Kapelle unter Leo X. und zu seiner Privatkapelle," *Die Musikforschung* 8 (1955): 58–73, 178–99, and 412–37, and 9 (1956): 46–57, 139–56, and 411–19, esp. 9 (1956): 144.

25. See the relevant documentation in Frank A. D'Accone, "The Musical Chapels at the Florentine Cathedral and Baptistery during the First Half of the 16th Century," *Journal of the American Musicological Society* 24 (1971): 1–50, esp. p. 41. Fenlon and Haar (*Italian Madrigal*, pp. 21–22) argue that there is no evidence of a Medici connection on Verdelot's part other than the circumstances of his initial appointment. But does not this assertion overlook the evidence of his having absented himself from Florence in order to visit Pope Clement?

26. See Alamanni's treatise in von Albertini, *Firenze dalla repubblica al principato*, pp. 376–84, esp. p. 380.

27. Butters, *Governors and Government*, p. 302 and n. 152.

28. See the references in Chapter 1, nn. 44 and 49.

29. Butters, *Governors and Government*, pp. 257–58 and n. 184.

30. On Modesti, see Chapter 2 above; on Acciaiuoli, see von Albertini, *Firenze dalla repubblica al principato*, p. 180.

31. Von Albertini, *Firenze dalla repubblica al principato*, pp. 194–95 and accompanying n. 2; see especially the reference to the date of Acciaiuoli's *Discorso secondo*.

32. On these documentary references, see von Albertini, *Firenze dalla repubblica al principato*, p. 182 and accompanying nn. 3–7. The original text of Strozzi's letter of 26 October 1530 is in von Albertini's n. 7: "Dite a Roberto Acciaiuoli che io ho parlato della sua faccenda, et il Papa è risoluto compiacerlo come prima si possa et gli è dispiaciuto costí se ne sia resoluto per qualche mese senza sua saputa."

33. Cochrane, *Historians and Historiography*, p. 176. In the interest of objectivity, however, I should point out that Academy members "Antonfrancesco Albizi" and "Alphonso Strozzi" are named in the 1526 deposition given by one of the conspirators in the 1522 *congiura* as prospective members of a government magistracy that would have been formed had the conspirators succeeded in ending the Medici regime. Of course, this does not necessarily prove Albizzi and Strozzi's complicity; it only suggests that, as prominent members of the Florentine aristocracy, they were logical candidates for any such government office. Von Albertini, *Firenze dalla repubblica al principato*, p. 84 n. 1. Strozzi is the one member of these various academies and companies who is most susceptible to being characterized as "anti-Medicean"; see, for example, Butters, *Governors and Government*, pp. 131, 185–86 and 272.

34. Von Albertini, *Firenze dalla repubblica al principato,* and the text accompanying n. 17 above.

35. See Najemy, *Between Friends,* p. 93 and accompanying n. 84.

36. Butters, *Governors and Government,* p. 207.

37. Von Albertini, *Firenze dalla repubblica al principato,* p. 357: "Li antecessori vostri, cominc[i]andosi da Cosimo e venendo infino a Piero, usorno in tenere questo Stato piú industria che forza. A voi è necessario usare piá forza che industria, perché voi ci avete piá nimici e manco ordine a saddisfarli."

38. Ibid., p. 180.

39. Ibid., p. 104.

40. The constitution, *Provisio, et creatio novi Status reip[ublicæ] fior[entinæ] obtenta, et edita per DD.XII. reformatores eiusdem reipub[licæ] die 27. aprilis 1532,* is published in Modesto Rastrelli, *STORIA D'ALESSANDRO DE' MEDICI, PRIMO DUCA DI FIRENZE, Scritta, e corredata di inediti Documenti DALL'ABATE MODESTO RASTRELLI FIORENTINO,* 2 vols. (In Firenze: NELLA STAMPERIA DI ANTONIO BENUCCI, E COMPP. Con Approv. Per Luigi Carlieri in Via Guicciardini, 1781), 1:304ff.; see p. 304 for the names of the "12 Magnificent Reformers."

41. Von Albertini, *Firenze dalla repubblica al principato,* pp. 202 and 204.

42. See Butters, *Governors and Government,* pp. 161, 164 and 184.

43. Ibid., p. 180.

44. Ibid., p. 203.

45. On the relationship of many of the members of the various academies and companies to the Medici, see also ibid., p. 77 (on Antonfrancesco di Luca degl'Albizzi, Giovanni Corsi, Piero Martelli, Giovanni Rucellai, and Bartolomeo Valori), citing Guicciardini's *Storie fiorentine,* and p. 167 (on Albizzi, Rucellai, and Valori), citing Cerretani.

46. On the earliest documentation attesting Festa's biography, which is equivocal, see Knud Jeppesen, "Festa, Costanzo," *Die Musik in Geschichte und Gegenwart,* ed. Friedrich Blume, 17 vols. (Kassel: Bärenreiter, 1949–86), vol. 4, cols. 90–102, esp. 90. On the 1517 reference, see Frey, "Regesten zur päpstlichen Kapelle unter Leo X," p. 64.

47. See Sherr, "Verdelot in Florence," p. 409, and D'Accone, "Musical Chapels," p. 41, for the reference documenting that Giulio's "volontà" was instrumental in appointments to the public institutions.

48. See Florence, Archivio di Stato, Carte strozziane, serie I, 13, 3, fol. 12r, "Nota delle boche di chasa di Sua Ex.ᵗⁱᵃ, levata questo dì VIII di luglio MDXXXV," available in Warren Kirkendale, *The Court Musicians in Florence during the Principate of the Medici, With a Reconstruction of the Artistic Establishment,* «Historiae Musicae Cultores» Biblioteca 61 (Florence: Leo S. Olschki Editore, 1993), p. 57 n. 105.

49. See the "Vita" of Aristotile *detto* Bastiano da San Gallo in Giorgio Vasari, *Lives of the Most Eminent Painters, Sculptors, and Architects,* trans. Gaston Du C. de Vere, 10 vols. (London: Macmillan and Co., Ltd., & The Medici Society, Ltd., 1912–15). On Ippolito and Alessandro as music patrons and their musical experiences, see, on Ippolito, H. Colin Slim, "The Keyboard Ricercar and Fantasia in Italy c. 1500–1550" (Ph.D. diss., Harvard University, 1960), pp. 170–73; Hieronimo Garimberto, *La prima parte delle vite, overo fatti memorabili*

d'alcuni papi, et di tutti i cardinali passati (Venice: Appresso Gabriel Giolito de' Ferrari, 1567), p. 515; Paolo Giovio, *Gli elogi: Vite brevemente scritte d'huomini illustri di guerra, antichi e moderni* (Venice: Apresso Giovanni de' Rossi, 1557), fols. 280r–280v; James Haar, "Cosimo Bartoli on Music," *Early Music History* 8 (1988): 37–79, esp. pp. 62 and 65; Giovanni Andrea Gilio da Fabriano, *Due Dialogi* (Camerino: per A. Giojoso, 1564), fol. 7r; and Elzear Geneti, *Opera omnia,* ed. Albert Seay, 5 vols., Corpus mensurabilis musicae 58 (n.p.: American Institute of Musicology, 1972–73), 3:9–12; and, on Alessandro, my *Politicized Muse,* pp. 123–24, 128–39, 140–50, and 151–57 and the accompanying notes.

50. For some illustrative texts, see my "Medici Musical Patronage in the Early Sixteenth Century: New Perspectives," *Studi musicali* 10 (1981): 197–216, esp. p. 207; Richard Sherr, "Lorenzo de' Medici, Duke of Urbino, as a Patron of Music," *Renaissance Studies in Honor of Craig Hugh Smyth,* 2 vols., ed. Andrew Morrogh et al. (Florence: Giunti Barbèra, 1985), 1:627–38, esp. p. 637 n. 36; and Howard Mayer Brown, "Chansons for the Pleasure of a Florentine Patrician," *Aspects of Medieval and Renaissance Music: A Birthday Offering to Gustave Reese,* ed. Jan LaRue (New York: W. W. Norton & Company, Inc., 1966), pp. 56–66, esp. p. 64 n. 22.

51. See his "Before the Madrigal," *Journal of Musicology* 12 (1994): 237–52, esp. p. 251.

52. Slim, *A Gift of Madrigals and Motets,* 2 vols. (Chicago: University of Chicago Press, 1972), 1:55.

53. Fenlon and Haar, *Italian Madrigal,* p. 22.

54. Eric Cochrane, *Florence in the Forgotten Centuries, 1527–1800: A History of Florence and the Florentines in the Age of the Grand Dukes* (Chicago and London: University of Chicago Press, 1973), p. 4.

55. J.N. Stephens, *The Fall of the Florentine Republic, 1512–1530* (Oxford: Clarendon Press, 1983), pp. 220–41.

56. See my article "Giulio de' Medici's Music Books," *Early Music History* 10 (1991): 65–122.

57. The initials SPQF, perhaps meaning "Senatus populusque florentinus."

58. The initials AMDF, perhaps meaning "Alexander Medici Dux Florentinæ"; the Medici stemma; and the Medici party cry "*PALLE V[I]V[A] PALLE.*" See Fenlon and Haar, *Italian Madrigal,* pp. 58–59. Fenlon and Haar's discussion is based on Haar's earlier article "Madrigals from the Last Florentine Republic," in *Essays Presented to Myron P. Gilmore,* ed. S. Bertelli and G. Ramakus, 2 vols. (Florence: La Nuova Italia, 1978), 2:383–403. On p. 385, Haar interprets as follows the significance of the evidence other than the putatively-Medicean evidence: "there are other initials and mottos present, some of them suggesting that the manuscript was by no means intended as a gift to the Medici—or at least, not to start with." And on p. 386, he similarly interprets the evidence for Medicean ownership: "the presence of these initials near the end of the Quinta volume hardly suggests that the manuscript was designed for presentation to the first of the Medici dukes.... As for the 'Palle viva palle,'... there are several oddities here: it is found near the end of the Bassus partbooks."

Linda L. Carroll suggests, alternatively, that the broad, overlapping "VV" would be read by Italians as "vittoria" rather than "viva"; i.e., "PALLE V[ITTORIA] PALLE." Either way, the general meaning of the phrase is the same.

59. Fenlon and Haar, *Italian Madrigal*, pp. 58–59; see also Haar, "Madrigals from the Last Florentine Republic," p. 385.

60. Fenlon and Haar, *Italian Madrigal*, p. 170.

61. Ibid., p. 22.

62. Ibid., p. 169.

63. See the text of the constitution, *Provisio, et creatio novi Status reip[ublicæ] fior[entinæ] obtenta, et edita per DD.XII. reformatores eiusdem reipub[licæ] die 27. aprilis 1532* (note that it, too, makes explicit reference to the Republic of Florence, notwithstanding the change in Alessandro's status), as published in Rastrelli, *STORIA D'ALESSANDRO DE' MEDICI, PRIMO DUCA DI FIRENZE;* see p. 313 for the reference to Alessandro's title.

64. Haar's contrasting interpretation of this evidence in "Madrigals from the Last Florentine Republic," pp. 387–88, is as follows: "[S]*enato* was a term applied in a loose fashion to various legislative and governing bodies over a long period of time. Its use for the *quarantotto* elected to aid Duke Alessandro on his assumption of power might indicate that S P Q F should be viewed as a Medicean counterpart to the Roman S P Q R. But there is other evidence to suggest that the initials stood for Florentine independence and republican sentiments. . . . Thus the appearance of S P Q F on the title page of the Cantus partbook suggests that the manuscript was begun during a period of republican sentiment."

65. See the summary of Rubsamen's thesis in the Introduction.

66. In this my findings agree with Rubsamen's earlier findings.

67. See my article "Giulio de' Medici's Music Books," *Early Music History* 10 (1991): 65–122.

68. As examples of the "new" chanson, Rubsamen cited Ninot's *En l'ombre d'ung aubepin,* Bruhier's *Frapez petit coup* and *Jacquet, jacquet,* and Compère's *Alons fere nos barbes,* all of which are preserved in Florence Magl. XIX.164–67, which is concordant with the Cortona/Paris manuscript in the case of the Compère work. As examples of polyphonic elaborations of Italian popular tunes, he cited Isaac's quodlibet *Donna di dentro,* Compère's *Che fa la ramaçina,* and Josquin's *Scaramella va alla guerra;* the first two works are preserved in the Cortona/Paris manuscript, and the Compère piece is also preserved in Florence 164–67; the Josquin work is preserved in Florence 164–67 and in the Florentine canto carnascialesco manuscript Florence, Biblioteca Nazionale Centrale, Banco rari 337. Rubsamen emphasized the importance of Michele Pesenti's compositional output, and both of Pesenti's surviving motets are preserved in Cortona/Paris. He made special mention of Sebastiano Festa, whose settings of the Petrarchan sonnet *O passi sparsi* and *L'ultimo dì di maggio* are preserved in Florence 164–67.

69. For some documentation on the readings of the works in common, see, for example, the following studies: Martin Just, "Studien zu Heinrich Isaacs Motetten," 2 vols. (Ph.D. diss., Eberhard-Karls-University, Tübingen, 1960), 1:54 (on the Isaac motet *Prophetarum maxime*); Cummings, "The Transmission of Some Josquin Motets," *Journal of the Royal Musical Association* 115 (1990): 1–32, esp. p. 10 (on the Josquin motet *Missus est Gabriel angelus*); and Cummings, "Notes on a Josquin Motet and its Sources," *Music in Renaissance Cities and Courts: Studies in Honor of Lewis Lockwood,* ed. Jessie Ann Owens and Anthony M. Cummings (Warren, Mich.: Harmonie Park Press, 1997), pp. 113–22, esp. pp. 117 and 118–22 (on the Josquin motet *Alma Redemptoris Mater/Ave, Regina Cœlorum*).

70. See Pirrotta, "Rom," in *Die Musik in Geschichte und Gegenwart*, as in n. 46, vol. 11, cols. 695–707, esp. 706.

Conclusion

1. Malcolm Gladwell, "Group Think," *New Yorker*, 2 December 2002, pp. 102–7. For this reference, and for stimulating conversation generally about the subject of my book, I am grateful to my very gifted colleague Molly A. Rothenberg of the Department of English at Tulane.

2. On the relationships detailed in this and the following paragraphs, see the entries in the Index to the particular individuals named, in addition to the specific bibliographic references cited in the notes below.

3. On Luigi di Tommaso's relationship to his relatives Ludovico and Luigi di Piero and Antonio di Jacopo, see Pompeo Litta, *Famiglie celebri di Italia* (Milan: Paolo Emilio Giusti [etc.], 1819[–83]).

4. See the genealogical chart in Richard A. Goldthwaite, *Private Wealth in Renaissance Florence: A Study of Four Families* (Princeton, N.J.: Princeton University Press, 1968), p. 30.

5. Zanobi's great-great-great-great-grandfather Loteringo and Roberto's great-great-great-great-grandfather Guidalotto were brothers; see Litta, "Famiglie celebri di Italia."

6. See *Sylloges Epistolarum a viris illustribus scriptarum*, 5 vols., ed. Petrus Burmannus (Leyden: apud S. Luchtmans, 1727), 2:200–202, as cited in Felix Gilbert, "Bernardo Rucellai and the Orti Oricellari: A Study on the Origin of Modern Political Thought," *Journal of the Warburg and Courtauld Institutes* 12 (1949): 101–31, esp. p. 110 n. 2.

7. On the sonnet, see Machiavelli, *Erotica*, ed. Gerolamo Lazzeri (Milan: Studio editoriale "Corbaccio," 1924), p. 207, as cited in James Haar, "The Early Madrigal: A Re-Appraisal of Its Sources and Its Character," *Music in Medieval and Early Modern Europe: Patronage, Sources and Texts*, ed. Iain Fenlon (Cambridge: Cambridge University Press, 1981), pp. 163–92, esp. pp. 178–79 and n. 47. On Machiavelli's illuminating correspondence with Vettori, see John M. Najemy's excellent book *Between Friends: Discourses of Power and Desire in the Machiavelli-Vettori Letters of 1513–1515* (Princeton, N.J.: Princeton University Press, 1993).

8. Eric Cochrane, *Historians and Historiography in the Italian Renaissance* (Chicago: University of Chicago Press, 1981), p. 176. On Cerretani's familiarity with Rucellai's work, see also Gilbert, "Bernardo Rucellai," p. 125 n. 2. On the *De Bello Italico*, see H. C. Butters, *Governors and Government in Early Sixteenth-Century Florence* (Oxford: Clarendon Press, 1985), p. 32.

9. Gilbert, "Bernardo Rucellai," p. 110 n. 2.

10. See Giorgio Vasari, *Lives of the Most Eminent Painters, Scupltors, and Architects*, trans. Gaston Du C. de Vere, 10 vols. (London: Macmillan and Co., Ltd., & The Medici Society, Ltd., 1912–15).

11. Anthony Newcomb, *The Madrigal at Ferrara, 1579–1597*, 2 vols., The Princeton Studies in Music 7 (Princeton, N.J.: Princeton University Press, 1980), 1:69.

12. Though given that his name is Latinized in the only document attesting his membership in the Sacred Academy, there is the possibility that the academy's "Ludovicus" is one Luigi Alamanni or the other, and not Ludovico di Piero.

13. If the Sacred Academy's "Ludovicus" is instead Luigi di Piero, a link with the early madrigal on the part of a member of the academy is nonetheless documented by virtue of Luigi di Piero's demonstrable relationship with Layolle.

14. The passage from Varchi is quoted in Richard J. Agee, "Filippo Strozzi and the Early Madrigal," *Journal of the American Musicological Society* 38 (1985): 227–37, esp. p. 229: "[Filippo] aveva tolto per impresa di volere . . . correggere . . . i Libri della Storia naturale di Plinio, servendosi, per compagno de' suoi studi, di messer Bernardo da Pisa, chiamato da chi il Pisano . . . piùtosto eccellente musico in que' tempi, che grande e giudizioso letterato." The Latin letter is in Florence, Archivio di Stato, *Carte Strozziane*, Serie Prima, filza 137, fols. 127r–128r. Agee was apparently unaware of the existence of this letter, despite the fact that it was cited in Frank D'Accone's paper for the *Internationale Gesellschaft für Musikwissenschaft: Report of the Tenth Congress, Ljubljana, 1967* (Kassel: Im Bärenreiter-Verlag, 1970), p. 98 n. 5; see Chapter 1, n. 63 above.

15. On settings of Luigi Alamanni's madrigal verse, see also *I musici di Roma e il madrigale*, ed. Nino Pirrotta, Accademia Nazionale di Santa Cecilia, L'Arte Armonica, Serie II: Musica Palatina I (Florence: Libreria Musicale Italiana, 1993), p. xxxiii.

16. Important in this context is Ernest H. Wilkins's observation that Michelangelo made use of Petrarchan material in his verse; see Wilkins, "A General Survey of Renaissance Petrarchism," *Comparative Literature* II (Eugene, Ore.: Published by the University of Oregon with the Cooperation of the Comparative Literature Section of the Modern Language Association of America, 1950), pp. 327–42, esp. pp. 330–31.

17. See Nino Pirrotta, "Novelty and Renewal in Italy, 1300–1600," *Music and Culture in Italy from the Middle Ages to the Baroque, A Collection of Essays* (Cambridge: Harvard University Press, 1984), pp. 159–74 and 406–8, esp. p. 173 and n. 20.

18. See Haar, "Early Madrigal," esp. p. 177 and n. 38. On Martelli's role in the debate about language, see also Robert A. Hall Jr., *The Italian Questione della Lingua: An Interpretative Essay*, University of North Carolina Studies in the Romance Languages and Literature, No. 4 (Chapel Hill: University of North Carolina, 1942), esp. pp. 16 and 57. Martelli took particular exception to Trissino's proposed reform of Italian orthography.

19. For information about the Cathedral's membership and editions of works composed by musicians associated with the Cathedral, we are indebted to Frank D'Accone's important studies. See D'Accone, "The Musical Chapels at the Florentine Cathedral and Baptistery during the First Half of the 16th Century," *Journal of the American Musicological Society* 24 (1971): 1–50, and, for the repertory, D'Accone's editions in the series *Music of the Florentine Renaissance*, Corpus Mensurablis Musicæ XXXII (n.p.: American Institute of Musicology, 1966–[85]).

20. See Chapter 1, nn. 215–16 and the accompanying text, where I suggest that an extant musical setting of Serafino's "Sufferir so disposto" may give us a sense of the kind of solo singing familiar to members of the early Cinquecento Florentine cultural elite.

21. On Strozzi's involvement with the 1533 festa, see Florence, Biblioteca Nazionale Centrale, MS N.A.982, fol. 163v.

22. I am pleased to note that this characterization of the Cinquecento madrigal is not dissimilar to that offered by Lorenzo Bianconi in the opening pages of his magisterial

survey "Parole e Musica: Il Cinquecento e il Seicento," *Teatro, musica, tradizione dei classici,* Letteratura italiana VI, Direzione: Alberto Asor Rosa (Turin: Giulio Einaudi editore s.p.a., 1986), pp. 319–63. Bianconi refers to "tecniche polifoniche raffinate e sofisticate ma anche temperate e morigerate ch'è vistosa nel madrigale musicale" (p. 322).

23. For just one example (among many) of an observation about the homophonic textures of Verdelot's madrigals, see H. Colin Slim, "Un coro della 'Tullia' di Lodovico Martelli messo in musica e attribuito a Philippe Verdelot," *Firenze e la Toscana dei Medici nell'Europa del '500,* 3 vols., Biblioteca di Storia toscana moderna e contemporanea, Studi e documenti 26 (Florence: Leo S. Olschki Editore, 1983), 2:487–511, p. 492. Musicological opinion is essentially unanimous on this point. See also Stefano La Via, "*Eros* and *Thanatos:* A Ficinian and Laurentian Reading of Verdelot's *Sì lieta e grata morte,*" *Early Music History* 21 (2002): 75–116, esp. pp. 84–85 and n. 27.

24. See Walter H. Rubsamen's important article "The Music for 'Quant'è bella giovinezza' and Other Carnival Songs by Lorenzo de' Medici," in *Art, Science, and History in the Renaissance,* ed. Charles S. Singleton (Baltimore: Johns Hopkins University Press, 1968), pp. 163–84, esp. pp. 167 and 171. On the rubric containing the reference to the polyphonic *canto* having been "composed" or "arranged" for lute, see Nino Pirrotta, *Music and Theatre from Poliziano to Monteverdi,* trans. Karen Eales (Cambridge, London, Melbourne, New Rochelle, New York City, Sydney: Cambridge University Press, 1982), pp. 21 and 29 n. 71.

25. On this point, see James Haar, *Essays on Italian Poetry and Music in the Renaissance, 1350–1600* (Berkeley: University of California Press, 1986), pp. 113–14.

26. Pirrotta, *Music and Theatre,* p. 147.

27. Richard Crocker, "Discant, Counterpoint, and Harmony," *Journal of the American Musicological Society* 15 (1962): 16.

28. On the tonal properties of the carnival song repertory, see also Reinhard Strohm, *The Rise of European Music, 1380–1500* (Cambridge: Cambridge University Press, 1993), p. 582, and Frank D'Accone, ed., *Florence, Biblioteca Nazionale Centrale MS Banco Rari 230,* Renaissance Music in Facsimile, Sources Central to the Music of the Late Fifteenth and Sixteenth Centuries, A Garland Series 4 (New York: Garland Publishing, Inc. 1986), p. v; D'Accone also comments on the distinctive tonal language of the carnival-song repertory.

29. Pirrotta, "Florence from Barzelletta to Madrigal," in *Musica Franca: Essays in Honor of Frank A. D'Accone,* ed. Irene Alm, Alyson McLamore, and Colleen Reardon, Festschrift Series No. 18 (Stuyvesant, N.Y.: Pendragon Press, 1996), pp. 7–18, esp. p. 18.

30. John Shearman, *Only Connect . . . Art and the Spectator in the Italian Renaissance,* The A. W. Mellon Lectures in the Fine Arts, 1988, Bollingen Series 35/37 (Princeton, N.J.: Princeton University Press, and Washington, D.C.: The National Gallery of Art, 1992), p. 261.

Index